COOL

Style, Sound, *and* Subversion

"FASHION IS INSTANT LANGUAGE"

—MIUCCIA PRADA

COOL

Style, Sound, *and* Subversion

Greg Foley | *Andrew Luecke*

RIZZOLI
NEW YORK

New York · Paris · London · Milan

"HIP HAD MET THE ENEMY AND IT WAS ENGAGEMENT"

—JOHN LELAND

PREFACE

As creatives living and working in the world of style, culture, and music, we often found ourselves wondering—and debating—do subcultures even exist anymore? What were the real elements of this mashup world we often hear designers, artists, and musicians referring to in their work? Words like vintage, retro, old school, nostalgia, and throwback all seemed to be touchstones of today's global culture, but there was no clear picture of what these references really meant. We researched, trying to find sources that had explored the full history of subcultures, especially their connection with fashion and music, but we came up short. Soon we found ourselves facing a crucial question: what exactly is a subculture? Where do fashion trends, musical genres, or political movements end and subcultures begin?

In our mission to help unpack the strange and wonderful subcultures that collectively feed today's creative fields, we realized that classifying them was impossible. Not only was it logically tricky, it was no fun. Every subculture overlapped with another, borrowing from each other, popping in and out of the mainstream. We recorded these interactions in our gatefold infographic, which shows a complex web of mutual influence. But through the difficulty of categorization, we felt we had an opportunity take the conversation deeper and make truer connections that shine a light on the young, creative, and often repressed communities that used style to quite literally fight for their rights.

Because music was crucial to almost every group in this book, we created playlists featuring the most important songs for the decades between 1920 and today. To help bring the past to life we worked with legendary contributors to share their favorite songs from genres that influenced their lives or shaped their creativity. The group illustrations are based on thousands of historical images unearthed through meticulous research. We edited them to shape the layouts so they perfectly embody the ultra-specific details and idiosyncrasies of each subculture.

During the imperfect task of classification, we realized we'd never be able to comprehensively define subculture. Inevitably, we'd miss some pivotal group and leave them out. Because we know that now, we hope instead that this book serves to open a conversation, remind people of rebellions past, and contribute to the understanding of style, sound, and subversion.

CONTENTS

Following World War I, young women in New York and other big American cities undermined Victorian gender norms by getting jobs, living alone, drinking, smoking, dancing, and experimenting sexually—all while creating an iconic style.

Though "flapper" originally referred to underage prostitutes, by the 1920s it had come to describe any lively young woman who wore shift dresses, cloche hats, and listened to jazz.

The 1920 silent film The Flapper starring Olive Thomas as Ginger King, a teenager who dates an older man when sent to boarding school, codified the flapper lifestyle for American audiences.

Coco Chanel and her sporty, casual clothes influenced flapper fashion, particularly as the clothing allowed for wild new dances like the Charleston.

The booming economy of the Roaring Twenties let flappers get jobs and leave their parents' homes—a phenomenon personified by Lois "Lipstick" Long, a columnist, speakeasy reviewer, and pioneering fashion critic for The New Yorker.

Throughout the 1920s, film stars like Clara Bow, Louise Brooks, and Joan Crawford were crucial to perpetuating the flapper image.

Though flappers are often depicted as white, their style and rebellion were also shared by black Americans, particularly singer and dancer Josephine Baker and blues singer Bessie Smith, who was known for her close-fitting cloche flapper hat.

The 1929 stock market crash and ensuing depression made flapper optimism and excess obsolete, as most Americans struggled to get by.

Cloche hats, French for "bell," mimicked the shape of shockingly short haircuts like the Eton crop

Intricate art deco designs

THE CULTURE Flappers popularized a number of slang terms with exuberant and sexually rebellious meanings, including "heavy petting" and "necking" for making out; "the cat's pajamas" or "the cat's meow" for something cool; and "handcuff" or "manacle" to mean wedding ring.

FLAPPERS

ORIGIN: UNITED STATES, 1920s
JAZZ AGE WOMEN UPEND SOCIAL NORMS WITH THEIR JOIE DE VIVRE

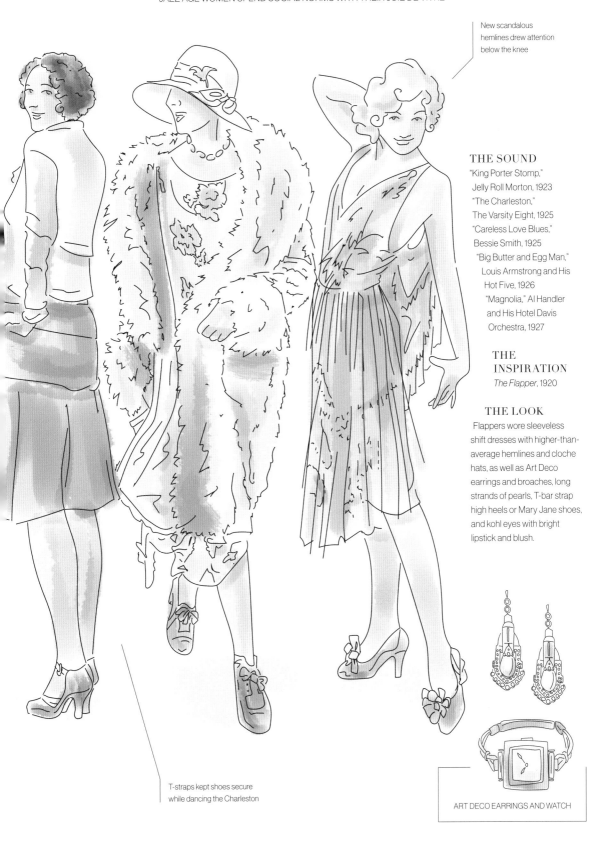

New scandalous hemlines drew attention below the knee

THE SOUND

"King Porter Stomp,"
Jelly Roll Morton, 1923
"The Charleston,"
The Varsity Eight, 1925
"Careless Love Blues,"
Bessie Smith, 1925
"Big Butter and Egg Man,"
Louis Armstrong and His
Hot Five, 1926
"Magnolia," Al Handler
and His Hotel Davis
Orchestra, 1927

THE INSPIRATION

The Flapper, 1920

THE LOOK

Flappers wore sleeveless shift dresses with higher-than-average hemlines and cloche hats, as well as Art Deco earrings and broaches, long strands of pearls, T-bar strap high heels or Mary Jane shoes, and kohl eyes with bright lipstick and blush.

T-straps kept shoes secure while dancing the Charleston

ART DECO EARRINGS AND WATCH

American college enrollment soared after the First World War as an increasingly industrialized nation required more executives, accountants, and lawyers. This higher education boom coincided with the explosion of mass media from the nascent radio, record, and film industries. American college students were at the nexus of a new form of capitalist identity formation that came with its own uniform. This demographic was the precursor to Ivy League Style and the forerunners to prep, championing a culture of stylish conspicuous consumption.

Though not necessarily subversive in the ways that underclass and street subcultures were, college students did change the formal, staid rules of upper class dressing. Male Ivy League students were the first to wear sportswear like button-down collars and letterman sweaters as regular street clothing.

Other collegiate style innovations included the infamous "sack suit," which was revolutionary in its natural shoulders, singled hooked vent, and three-roll-two buttons. Retailers like Brooks Brothers and J. Press mass-produced sack suits, turning the item into an Ivy League staple.

Dandy style was also popular with male college students, sparking a craze for massive raccoon coats and straw boater hats.

Female college students were influenced by flapper culture. These women also sought freedom from social and sexual norms while wearing flapper classics like sleeveless shift dresses and bobbed haircuts, mixed with men's waistcoats, trousers, and knickerbockers.

As America's new elite, college students helped create hierarchical styles of dress. At Princeton, freshman had to wear a uniform of black sweaters and corduroys, while seniors could wear anything, including the coveted white canvas "beer suit" for partying.

Like other young people during the 1920s, college students sought new freedoms in all things and were especially anti-Prohibition, consequently creating a lasting link between college life, alcohol, and perceived liberty.

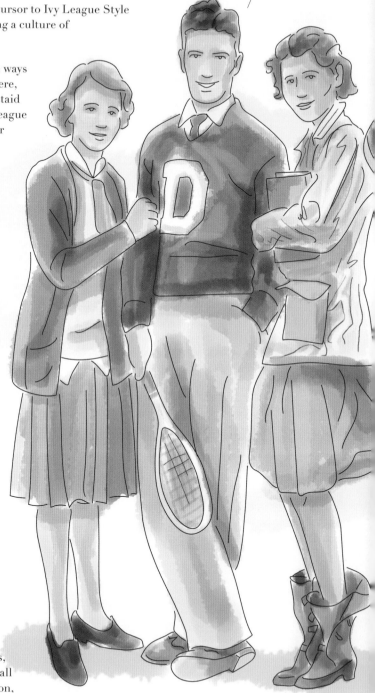

Varsity sweaters came off the playing field and onto the streets

Open galoshes inspired by flapper style

THE CULTURE American College kids of the the Jazz Age were likewise obsessed with sports, clubs, and secret societies. They took formerly elite groups like fraternities to the masses, and created new traditions like Homecoming football games.

ORIGIN: UNITED STATES, EARLY 1920s
THE FIRST YOUTH MARKET DEMOGRAPHIC ADDS AMERICAN COOL TO FASHION

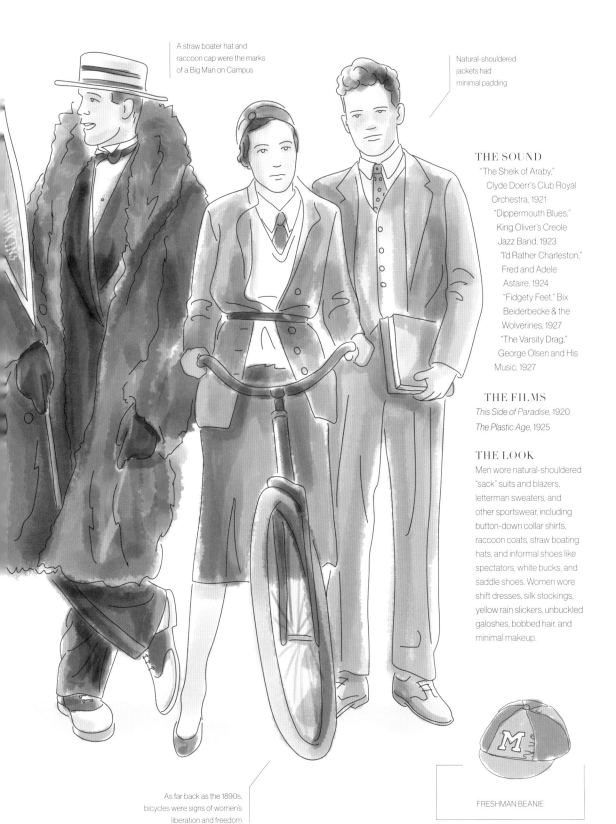

A straw boater hat and raccoon cap were the marks of a Big Man on Campus

Natural-shouldered jackets had minimal padding

THE SOUND

"The Sheik of Araby," Clyde Doerr's Club Royal Orchestra, 1921
"Dippermouth Blues," King Oliver's Creole Jazz Band, 1923
"I'd Rather Charleston," Fred and Adele Astaire, 1924
"Fidgety Feet," Bix Beiderbecke & the Wolverines, 1927
"The Varsity Drag," George Olsen and His Music, 1927

THE FILMS

This Side of Paradise, 1920
The Plastic Age, 1925

THE LOOK

Men wore natural-shouldered "sack" suits and blazers, letterman sweaters, and other sportswear, including button-down collar shirts, raccoon coats, straw boating hats, and informal shoes like spectators, white bucks, and saddle shoes. Women wore shift dresses, silk stockings, yellow rain slickers, unbuckled galoshes, bobbed hair, and minimal makeup.

As far back as the 1890s, bicycles were signs of women's liberation and freedom

FRESHMAN BEANIE

I f flappers were young middle-class women breaking the bounds of patriarchal propriety by adopting black jazz and dance styles, Harlem's Lindy Hoppers were African Americans doing the same thing on their own terms. African Americans had been using music and dance to subvert white hegemony since the days of Congo Square. By the late 1920s, mass media took this subversion worldwide, creating a dance craze remembered to this day.

The Lindy Hop originated in Harlem during the late 1920s and was an established dance by 1935. The Lindy Hop is an eight-count step offset by the "swingout," during which the dancers swing each other out to the side, allowing each person space to improvise.

Harlem's integrated Savoy ballroom was the home of the Lindy Hop and attracted top dancers like Herbert "Whitey" White and choreographer Frankie Manning, as well as their crew—Whitey's Lindy Hoppers—on a nightly basis between 1927 and the mid-1940s when the dance began to decline in popularity.

As with jazz, improvisation is a key, subversive aspect of the Lindy Hop, which differentiates it from static European dances and norms.

The Lindy Hop had ties to street culture and many of the dance's inventors were members of Harlem gangs, including Whitey White and George Snowden. They all belonged to the Jolly Fellows, a crew with its own clubhouse on 134th Street and an auxiliary female crew called the Jolly Flapperettes. Rival crews, like Harlem's Buffaloes or the Forty Thieves, adopted the Lindy Hop and spread it to dance halls on their own turf, including the Renaissance Ballroom.

With the increasing popularity of rhythm and blues and modern jazz, big band dances like the Lindy Hop and its surrounding subculture died away following World War II. The Savoy Ballroom closed in 1957.

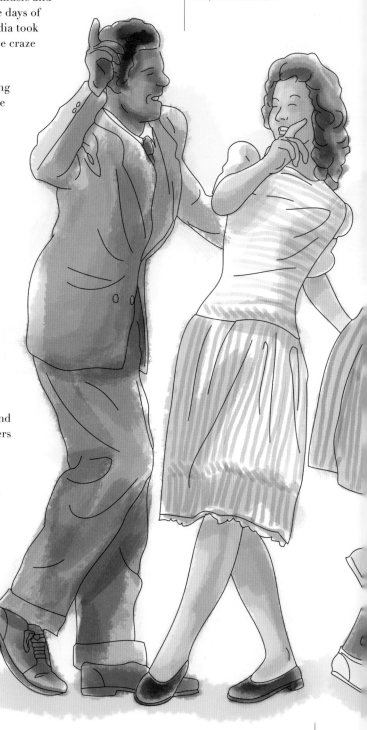

The Lindy Hop's "breakaway" solo moves can be traced to African dance traditions where dancing sans partner was the norm

Special knickers were worn under skirts for flipping with confidence

THE CULTURE The Lindy Hop may have been named after Charles Lindbergh, the American aviator who completed the first solo flight across the Atlantic Ocean from New York to Paris in 1927.

ORIGIN: NEW YORK, LATE 1920s AND EARLY 1930s
HARLEM POOL HUSTLERS HIT THE DANCEHALLS WITH ACROBATIC NEW MOVES

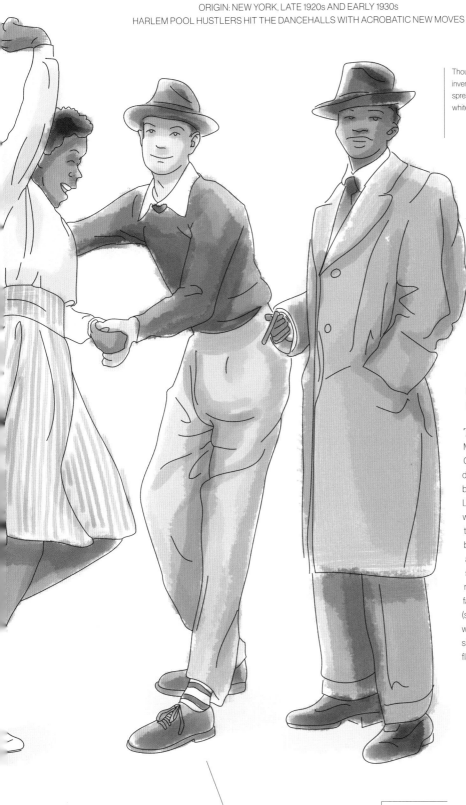

Though black Harlemites invented the Lindy Hop it soon spread worldwide, attracting white appropriators

THE SOUND

"The Dipsy Doodle," Chick Webb and His Orchestra, 1937
"Jumpin' at the Woodside," Count Basie and His Orchestra, 1938
"Ridin' and Jivin'," Earl Hines and His Orchestra, 1939
"Are You All Reet?," Cab Calloway and His Orchestra, 1941
"Drinkin' Wine Spo-Dee-O-Dee," Lionel Hampton and His Orchestra, 1949

THE LOOK

Male Lindy Hoppers wore Chesterfield overcoats and derby hats, a look inspired by gangster movies. Other Lindy Hopper gear included wide-legged, high-waisted trousers, double-breasted suits, boutonnieres, and white belts, as well as sunglasses, striped socks and two-tone shoes for men. Female Lindy Hoppers favored A-line or pencil skirts (sometimes worn as part of a suit with a nipped-in waist), sweaters, silk stockings, and gloves with flats or low-heeled Mary Janes.

Striped socks drew the eye to fancy footwork

CREW'S EMBROIDERED INITIALS ON JACKET LAPEL

HOT JAZZ

*An earthier, bluesier take on the New Orleans sound,
hot jazz is the soundtrack of the Roaring '20s*

"St. Louis Blues," WC Handy, 1914

"Blues My Naughty Sweetie Gives To Me," Sidney Bechet, 1919

"Mabel's Dream," King Oliver & His Creole Jazz Band, 1923

"Tin Roof Blues," New Orleans Rhythm Kings, 1923

"Mr. Jelly Lord," Levee Serenaders, 1924

"Muskrat Ramble," Kid Ory, 1926

"Royal Garden Blues," Bix Beiderbecke, 1927

"Uncanny Banjo," Al Starita & The Kit-Cat Band, 1927

"Chinatown My China Town," Art Gillham, 1928

"Market Street Stomp," The Missourians, 1929

"Double Check Stomp," The Jungle Band, 1930

"Is That Religion?," Cab Calloway, 1930

"Sugarfoot Stomp," Fletcher Henderson, 1931

"Hot and Anxious," Don Redman & His Orchestra, 1932

"If It Ain't Love," Chick Webb, 1934

"Minor Swing," Quintette du Hot Club de France, 1937

"Kansas City Stomp," Jerry Roll Morton, 1938

"Tiger Rag," Django Reinhardt, 1947

"Fidgety Feet," Sidney Bechet, 1949

"Day Beyond Recall," Bunk Johnson & Sidney Bechet, 1951

DIXIELAND

*Born in New Orleans at the dawn of the 20th century,
Dixieland is the root of all jazz to come*

"Down By The Riverside," Preservation Hall Jazz Band, 1918

"Skeleton Jangle," Original Dixieland Jazz Band, 1918

"St. Louis Blues," Original Dixieland Jazz Band, 1921

"Wolverine Blues," Jelly Roll Morton, 1928

"After You've Gone," Miff Mole & His Little Molers, 1929

"Ain't Misbehavin'," Louis Armstrong And His Orchestra, 1929

"Beale Street Mama," Cab Calloway And His Orchestra, 1932

"You're Gonna Lose Your Gal," Henry "Red" Allen, 1934

"Summertime," Sidney Bechet, 1939

"Someday Sweetheart," Muggsy Spanier's
Ragtime Band, 1939

"Bugle Call Rag," George Wettling's Chicago
Rhythm Kings, 1940

"Irish Black Bottom," Lu Watters' Yerba Buena Jazz Band, 1941

"Tiger Rag," Benny Goodman Sextet, 1942

"That's A Plenty," Wild Bill Davison, 1943

"Burgundy Street Blues," George Lewis, 1944

"Franklin Street Blues," Bunk Johnson and
His New Orleans Band, 1944

"Firehouse Stomp," Firehouse Five Plus Two, 1949

"Haven't Got A Dollar To Pay Your Rent House Man,"
Genevieve Davis, Unknown

CHARLESTON

*Fast-paced and athletic, the Charleston
is the perfect dance for Prohibition-era swells
to show off their fanciest footwork*

"Oriental Jazz," Original Dixieland Jazz Band, 1919

"Avalon," Al Jolson, 1920

"Muscle Shoals Blues," Fletcher Henderson
& His Orchestra, 1924

"Charleston," Paul Whiteman & His Orchestra, 1925

"I'm Gonna Charleston Back to Charleston," Coon-Sanders
Original Nighthawks Orchestra, 1925

"Yes Sir, That's My Baby," The Hot Java Band, 1925

"Yes Sir! That's My Baby," Ace Brigode & His 14 Virginians, 1925

"Black Bottom," Johnny Hamp's Kentucky Serenaders, 1926

"Hitch Up the Horses," The Savoy Orpheans, 1926

"Ain't She Sweet," Jack Pettis, 1927

"Ain't She Sweet?," Joe 'Fingers' Carr, 1927

"Someday Sweetheart," The Charleston Chasers, 1927

"Let's Misbehave," Irving Aaronson, 1928

"That's My Weakness Now," Cliff Edwards, 1928

"Ain't Misbehavin'," Louis Armstrong And His Orchestra, 1929

"Keep Your Undershirt On," Ben Pollack & His Park Central
Orchestra, 1929

"The Minor Drag," Fats Waller, 1929

"What A Little Moonlight Can Do," Billie Holliday, 1935

"Basie," Count Basie Orchestra, 1955

VOCAL BLUES

*From the Delta and the Piedmont to Chicago and
beyond, blues singers channel joy and pain*

"Crazy Blues," Mamie Smith, 1920

"Arkansas Blues," Lucille Hegamin, 1921

"Downhearted Blues," Alberta Hunter, 1922

"He May Be Your Dog, But He's Wearing My Collar,"
 Rosa Henderson, 1923

"Shorty George Blues," Sippie Wallace, 1923

"Blues Please Go Away," Sara Martin, 1924

"Wild Women Don't Have the Blues," Ida Cox, 1924

"Shake That Thing," Ethel Waters, 1925

"Tennessee Blues," Viola Bartlette, 1925

"Dope Head Blues," Victoria Spivey, 1927

"Mean Old Bed Bug Blues," Betty Gray, 1927

"A Good Man Is Hard to Find," Lizzie Miles, 1928

"Dentist Chair Blues (Pt. 2)," Laura Bryant, 1929

"Nobody Knows You When You're Down and Out,"
 Bessie Smith, 1929

"Stormy Weather," Ethel Waters, 1933

"Get 'Em From the Peanut Man (Hot Nuts)," Lil Johnson, 1935

"Shave 'Em Dry," Lucille Bogan, 1935

"Candy Man," Rosetta Howard & The Harlem Hamfats, 1938

"Mail Man Blues," Tiny Mayberry, 1938

"Trouble Trouble," Betty Roche, 1946

STRING BAND

Good time music from before country was country

"The Farmer's Medley Quadrille," John Baltzell, 1923

"Don't Let Your Deal Go Down Blues," Charlie Poole
 & The North Carolina Ramblers, 1925

"Ya Gotta Quit Kickin' My Dog Aroun'," Gid Tanner
 & His Skillet Lickers, 1926

"The Bulldog Down in Sunny Tennessee,"
 Carolina Tarheels, 1927

"I've Got No Honey Babe Now," Frank Blevins
 & His Tar Heel Rattlers, 1927

"Way Down in Alabama," Smyth County Ramblers, 1928

"Salty Dog," The Booker Orchestra, 1928

 Wreck on the Mountain Road," The Red Fox Chasers, 1928

"Ground Hog," Jack Reedy & His Walker Mountain
 String Band, 1928

"Governor Al Smith For President," The Carolina
 Night Hawks, 1928

"The Nine-Pound Hammer," Grayson & Whittier, 1929

"Prisoner Boy," Fiddlin' Jim Pate, 1929

"Yodeling Fiddling Blues," Mississippi Sheiks, 1930

"Work Don't Bother Me," Carolina Buddies, 1931

"God's Getting Worried," Walter Smith, 1931

SWING

*Swing mixes sophisticated lyrics and melodies
with the syncopated beat of early New Orleans jazz*

"Cabin In The Cotton," Cab Calloway, 1933

"King Porter Stomp," Benny Goodman, 1935

"No Regrets," Billie Holliday, 1936

"The Way You Look Tonight," Fred Astaire, 1936

"One O' Clock Jump," Count Basie Orchestra, 1937

"The Image of You," Lucky Millinder, 1937

"Jeepers Creepers," Gene Krupa, 1938

"Begin the Beguine," Artie Shaw & His Orchestra, 1938

"Jada," Bobby Hackett, 1938

"Ain't She Sweet," Jimmie Lunceford, 1939

"Body and Soul," Coleman Hawkins, 1939

"Moonlight Serenade," Glenn Miller, 1939

"It Don't Mean A Thing (If It Ain't Got That Swing),"
 Duke Ellington & His Orchestra, 1943

"Baby, It's Cold Outside," Dean Martin, 1944

"Saturday Night is the Loneliest Night of the Week,"
 Frank Sinatra, 1944

"Mean to Me," Sarah Vaughan, 1945

"Ding Dong," Lester Young, 1949

"Walkin' My Baby Back Home," Nat King Cole, 1951

"Satin Doll," Ella Fitzgerald, 1953

"(Love Is) The Tender Trap," Debbie Reynolds
 & Frank Sinatra, 1955

In 1933, the Nazis made the Hitler Youth the only authorized young person's organization in Germany, and pulled teens aged 14–18 from their school teams, clubs, and scout troops. The Nazis dropped them into this paramilitary organization—the first step in an ever-tightening social control. Some teens, the so-called *Swingjugend* (Swing Youth) chafed under this control and fought back as early as 1939, asserting their freedom by dancing to American swing music and affecting an elegant English style, both things the Nazis hated as "un-German."

The cosmopolitan teenagers of Hamburg were the first Swingjugend in Germany, having developed a taste for jazz, English tailoring, and wild dancing thanks to constant contact with American and British ships anchored in the city's port.

The Swingjugend were decidedly pro-American and pro-British. Many claimed cowboy nicknames like "Texas Jack" and developed a jaunty British look, favoring English-style tailoring.

Swing dances across Germany began to take on the rebellious tenor of riots, attracting the attention of Nazi officials. In 1940, police in Altona busted one such dance and arrested sixty-three Swingjugend. By 1942, the Swingjugend in cities like Berlin and Dresden were openly mocking Hitler Youth, behavior that caught the attention of SS chief Heinrich Himmler, who demanded the swing youth be sent to concentration camps. The Nazis also tried to ban jazz and all other "hot" music.

Though the Nazis loathed swing because it was played by black and Jewish American musicians, the Swingjugend seem to have been more motivated by threats to their personal freedom than resisting National Socialist racism.

The Swingjugend movement faded away after World War II, but they left their mark on Germany as one of the few groups who dared to stand up to the Nazis.

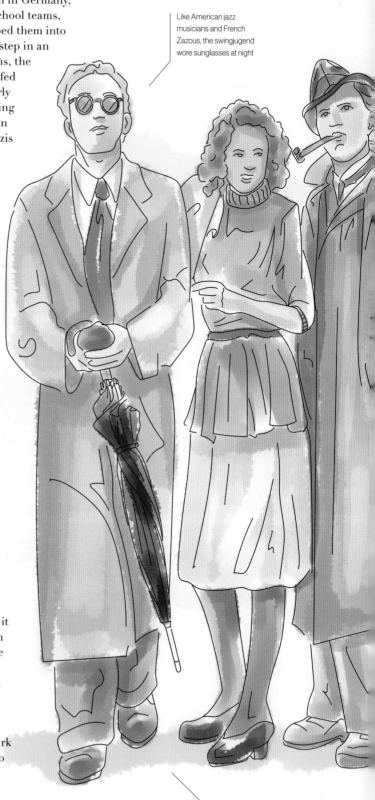

Like American jazz musicians and French Zazous, the swingjugend wore sunglasses at night

Carried umbrellas to look more English (no matter the weather)

THE CULTURE The Swingjugend found allies among other German youth resistance groups, including the legendary Weisse Rose (White Rose), the Edelweiss Pirates, and other street gangs.

SWINGJUGEND

ORIGIN: GERMANY, 1930s
GERMAN TEENS PROTEST NAZI OPPRESSION TO THE SOUNDS OF SWING MUSIC

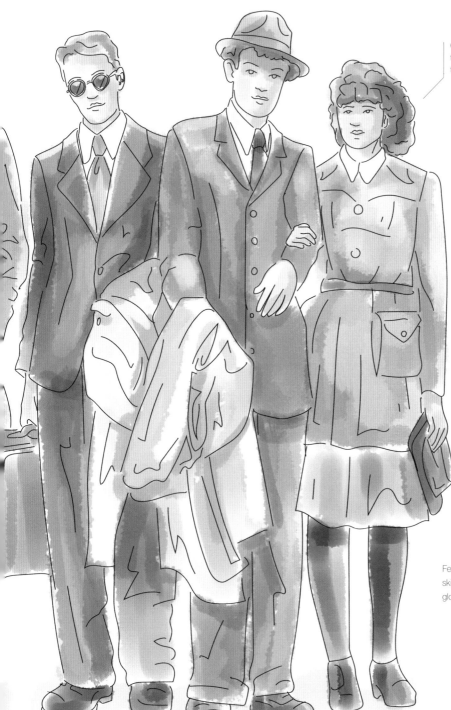

Curled hair rejected
the Nazis' preference
for braided hair

THE SOUND

"Tiger Rag Part 1,"
Duke Ellington and His
Famous Orchestra, 1929
"Dancing on a Rainbow,"
Hans Bund mit seinem
Tanzorchester, 1932
"(We're Going to Hang Out)
the Washing on the Siegfried
Line," Joe Loss and
His Band, 1940
"Bei Mir Bist Du Schön,"
The Andrews Sisters, 1937
"Kismet," Orchester Theo
Reuter, 1940

THE LOOK

Male Swingjugend wore
English or Scottish-style
jackets (some cut long and
low, like a zoot suit jacket),
baggy pleated trousers,
fedoras, and scarves. They
carried pipes, long cigarette
holders, and umbrellas even
when it wasn't raining, all in
order to seem more English.
Female Swingjugend wore A-line
skirts, cardigans, silk stockings, and
gloves with flats or low-heeled shoes.

English-style trench coats
were an act of rebellion in
Nazi Germany

PIPES AND
CIGARETTE HOLDERS
ADDED FLARE TO DANCING OUTFITS

A rising in the mid-1930s in the neighboring border towns of El Paso, Texas, and Ciudad Juarez, Mexico, pachucos were street-savvy Mexican American playboys who famously wore voluminous zoot suits while dancing to swing and the Chicano boogie of Lalo Guerrero.

Pachuco culture followed migrant workers west along the railroads to California, where the culture blossomed.

Though African Americans in Harlem created the first zoot suits during the 1930s, pachuchos were most closely associated with these custom-tailored outfits. The basic pachuco zoot suit featured an elongated drape jacket atop billowing, high-waisted pants with pegged ankles, often accompanied by an oversized fedora, two-tone dress shoes, and an extra-long pocket watch chain.

Starting in the late 1930s Lalo Guerrero began recording "pachuco songs," including "Los Chucos Suaves" and "Tequila," which mixed contemporary swing sounds with Spanish lyrics and Latin elements.

Pachucos first drew attention from the Anglo-American press during 1942's racist Sleepy Lagoon murder trial in which seventeen Mexican-American zoot suiters were unfairly convicted of murdering fellow Chicano José Gallardo Díaz near a Los Angeles swimming hole.

Pachucos had their most infamous moment in 1943, when they resisted attacks from racist white servicemen and cops in Los Angeles during what became known as the Zoot Suit Riots, an early example defending subcultural sovereignty with blood.

Due to racism, immigration status, or minor criminal records, many zoot suiters were unwilling or ineligible to serve during World War II. When even their baggy clothes defied war-time restrictions on silk and wool, resentful American servicemen lashed out, attacking zoot suiters in a misguided, racist show or patriotism.

Elements of pachuco culture still exist in California and the Southwest, where pegged pants, Stacy Adams dress shoes, and fedoras are occasionally worn by cholos and other Mexican American men.

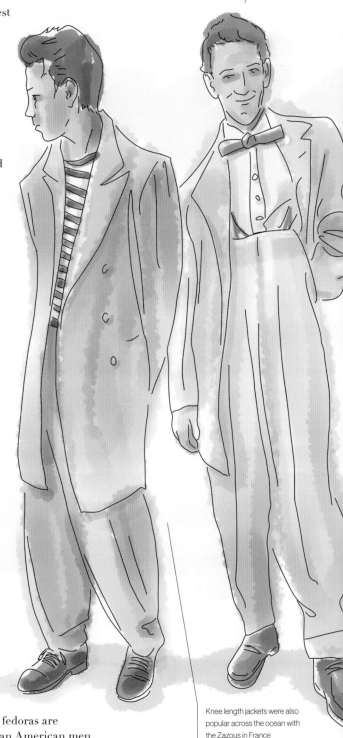

Ultra-suave pomade-slicked coifs

Knee length jackets were also popular across the ocean with the Zazous in France

THE CULTURE Pachucos spoke the Chicano street slang Caló, that mixed English, Spanish, and Gypsy slang from Mexico and Spain. *Firme* is the Caló word for cool, while *hyna* refers to a girl or girlfriend, and *mota* means marijuana.

PACHUCOS

ORIGIN: EL PASO, TEXAS, MID-1930s
CHICANOS FIGHT FOR THE RIGHT TO WEAR ZOOT SUITS

Wide brim fedoras added
movie gangster flair to
pachuco outfits

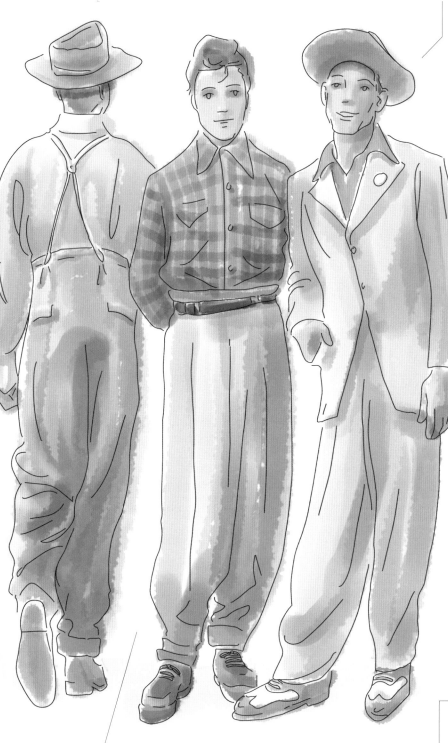

THE SOUND

"Pachuco Boogie," Cuarteto
Don Ramon Sr., 1948
"Los Chucos Suaves,"
Lalo Guerrero con Los
Cinco Lobos, 1949
"Marihuana Boogie,"
Lalo Guerrero con Los
Cinco Lobos, 1949
"Frijole Boogie,"
Jorge Cordoba,
late-1940s
"Mi Dolorcito," Conjunto
San Antonio Alegre,
early-1950s

THE LOOK

Pachucos wore
zoot suits (oversized,
draped jackets over
high-waisted, pleated
and pegged trousers)
with braces or skinny belts
(styled with the buckle to
the side), as well as fedoras,
pocket watches with extra-
long chains, wingtips or
Stacy Adams dress shoes,
and oversized bow ties
or neckties.

Voluminous trousers,
the more fabric the better

EXTRA-LONG SWINGING POCKET
WATCH CHAIN

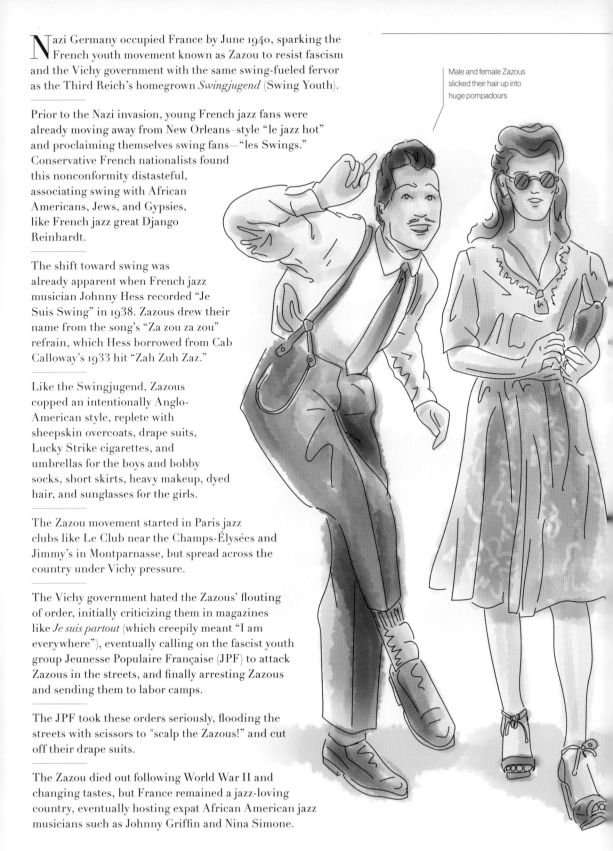

Nazi Germany occupied France by June 1940, sparking the French youth movement known as Zazou to resist fascism and the Vichy government with the same swing-fueled fervor as the Third Reich's homegrown *Swingjugend* (Swing Youth).

Prior to the Nazi invasion, young French jazz fans were already moving away from New Orleans–style "le jazz hot" and proclaiming themselves swing fans—"les Swings." Conservative French nationalists found this nonconformity distasteful, associating swing with African Americans, Jews, and Gypsies, like French jazz great Django Reinhardt.

The shift toward swing was already apparent when French jazz musician Johnny Hess recorded "Je Suis Swing" in 1938. Zazous drew their name from the song's "Za zou za zou" refrain, which Hess borrowed from Cab Calloway's 1933 hit "Zah Zuh Zaz."

Like the Swingjugend, Zazous copped an intentionally Anglo-American style, replete with sheepskin overcoats, drape suits, Lucky Strike cigarettes, and umbrellas for the boys and bobby socks, short skirts, heavy makeup, dyed hair, and sunglasses for the girls.

The Zazou movement started in Paris jazz clubs like Le Club near the Champs-Élysées and Jimmy's in Montparnasse, but spread across the country under Vichy pressure.

The Vichy government hated the Zazous' flouting of order, initially criticizing them in magazines like *Je suis partout* (which creepily meant "I am everywhere"), eventually calling on the fascist youth group Jeunesse Populaire Française (JPF) to attack Zazous in the streets, and finally arresting Zazous and sending them to labor camps.

The JPF took these orders seriously, flooding the streets with scissors to "scalp the Zazous!" and cut off their drape suits.

The Zazou died out following World War II and changing tastes, but France remained a jazz-loving country, eventually hosting expat African American jazz musicians such as Johnny Griffin and Nina Simone.

Male and female Zazous slicked their hair up into huge pompadours

THE CULTURE In line with their clothing and music choices, the Zazou incorporated English words like hello, bye-bye, darling, and OK into their slang—language they knew from their middle-class educations.

ZAZOUS

ORIGIN: PARIS, 1940s
HARD-SWINGING FRENCH KIDS FIGHT FASCISM

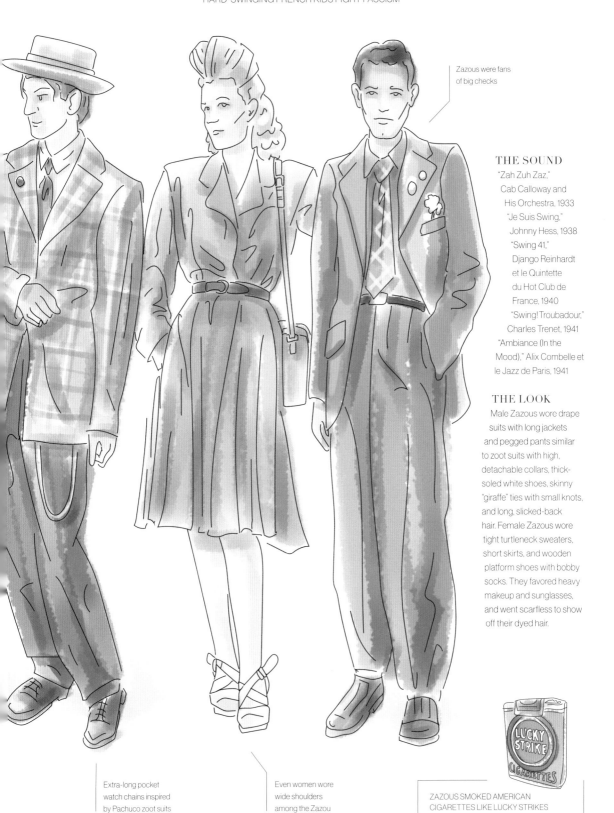

Zazous were fans of big checks

THE SOUND

"Zah Zuh Zaz,"
Cab Calloway and
His Orchestra, 1933
"Je Suis Swing,"
Johnny Hess, 1938
"Swing 41,"
Django Reinhardt
et le Quintette
du Hot Club de
France, 1940
"Swing! Troubadour,"
Charles Trenet, 1941
"Ambiance (In the
Mood)," Alix Combelle et
le Jazz de Paris, 1941

THE LOOK

Male Zazous wore drape suits with long jackets and pegged pants similar to zoot suits with high, detachable collars, thick-soled white shoes, skinny "giraffe" ties with small knots, and long, slicked-back hair. Female Zazous wore tight turtleneck sweaters, short skirts, and wooden platform shoes with bobby socks. They favored heavy makeup and sunglasses, and went scarfless to show off their dyed hair.

Extra-long pocket watch chains inspired by Pachuco zoot suits

Even women wore wide shoulders among the Zazou

ZAZOUS SMOKED AMERICAN CIGARETTES LIKE LUCKY STRIKES

MERCK MERCURIADIS'S DELTA BLUES TOP FIVE

"Cross Road Blues," Robert Johnson, 1936

"Pony Blues," Charley Patton, 1929

"I Can't Be Satisfied,"Muddy Waters, 1948

"Clarksdale Moan," Son House, 1930

"The Gallis Pole" Lead Belly, 1939

DELTA BLUES

Born at the crossroads with a hellhound on its trail,
American music truly gets its start on the Mississippi

"Milk Cow Blues," Freddie Spruell, 1926

"Cool Drink of Water Blues," Tommy Johnson, 1928

"Tell Me Man Blues," Henry "Son" Sims, 1929

"My Black Mama, Pt. 2," Son House, 1930

"M & O Blues," Willie Brown, 1930

"Devil Got My Woman," Skip James, 1931

"Baby Please Don't Go," Big Joe Williams, 1935

"Street Walkin'," Sonny Boy Nelson, 1936

"Come On In My Kitchen," Robert Johnson, 1937

"Old Devil," Bo Carter, 1938

"Po Boy," Bukka White, 1939

"Shake 'Em On Down," Tommy McClennan, 1939

"Black Spider Blues," Robert Jr. Lockwood, 1941

"Catfish Blues," Robert Petway, 1941

HOKUM / DIRTY BLUES

After the kids are asleep and the bottles are brought out,
it's time to get down to business

"It's Tight LIke That," Tampa Red, 1928

"The Duck's Yas-Yas-Yas," James "Stump" Johnson, 1928

"I'm a Mighty Tight Woman," Sippie Wallace, 1929

"Honey Dripper Blues," Hattie North & Roosevelt Sykes, 1929

"It Feels So Good Part 2," Lonnie Johnson & Spencer Williams, 1929

"Wipe It Off," Lonnie Johnson, 1930

"Elevator Papa, Switchboard Mama," Butterbeans & Susie, 1930

"Bed Spring Poker," Mississippi Sheiks, 1931

"Need a Little Sugar in My Bowl," Bessie Smith, 1931

"My Pencil Won't Write No More," Bo Carter, 1931

"Let Me Play With Your Yo-Yo," Blind Willie McTell, 1933

"She Done Sold It Out," Memphis Jug Band, 1934

"Tom Cat Blues," Cliff Carlisle, 1934

"Sissy Man Blues," Kokomo Arnold, 1934

"You Put It In, I'll Take It Out," Papa Charlie Jackson, 1934

"Shave 'Em Dry," Lucille Bogan, 1935

"If It Don't Fit (Don't Force It)," Lil Johnson, 1937

"Wet It," Frankie "Half Pint" Jackson & The Harlem Hamfats, 1937

"Good Cabbage," Victoria Spivey, 1937

"Down in the Alley," Memphis Minnie, 1937

COUNTRY BLUES

From the Piedmont to the Panhandle, the blues
are the heart of the countryside

"Kassie Jones Part 1," Furry Lewis, 1928

"Cross and Evil Woman Blues," Rev. Gary Davis, 1935

"Keep It Clean," Charley Jordan, 1930

"Papa's 'Bout to Get Mad," Pink Anderson & Simmie Dooley, 1928

"Kokomo Blues," Scrapper Blackwell, 1928

"Church Bells Blues," Luke Jordan, 1927

"Statesboro Blues," Blind Willie McTell, 1928

"Police Dog Blues," Blind Blake, 1929

"Rag, Mama, Rag," Blind Boy Fuller, 1935

"Broken Hearted, Ragged and Dirty Too," John Estes, 1929

"Candy Man Blues," Mississippi John Hurt, 1928

"Coal Man Blues," Peg Leg Howell, 1926

"How Long, How Long Blues," Leroy Carr, 1928

"Mississippi Heavy Water Blues," Barbecue Bob, 1927

"That Blake Snake Moan," Blind Lemon Jefferson, 1927

"Good Morning Blues," Lead Belly, 1941

"That's the Stuff," Brownie McGhee & Sonny Terry, 1947

"Frisco Whistle Blues," Ed Bell, 1927

PACHUCO BOOGIE

A Mexican-American variation on swing,
Pachuco boogie-woogie brings Latin rhythms
and bluesy punch to the dance floor

"Just A Gigolo / I Ain't Got Nobody," Louis Prima, 1929

"Sing, Sing, Sing," Benny Goodman, 1936

"Caravan," Barney Bigard & His Jazzopaters, 1936

"Flat Foot Floogie (With a Floy Floy)," Slim & Slam, 1938

"Five Guys Named Moe," Louis Jordan, 1943

"The Honeydripper," Cab Calloway, 1946

"Pachuco Boogie," Cuarteto Don Ramon Sr., 1948

"Los Chucos Suaves," Lalo Guerrero, 1949

"Wine-O-Boogie", Don Ramon Sr. y Su Orquesta, 1954

"Buena Vista Swing," Conjunto Alamo, Unknown

"Chicano Boogie," Cuarteto de Ramón Martínez, Unknown

"Chicas Patas Boogie," Lalo Guerro Y Sus Cinco Lobos, Unknown

"El Bracero Y La Pachuca," Duerto Taxco Con Mariachi Caporales Del Norte, Unknown

"El Pachuco Alegre," Los Hermanos Yañez, Unknown

"Frijole Boogie," Jorge Córdoba, Unknown

"Guisa Guaina," Don Tosti Y Su Trío, Unknown

"Las Pachuquitas," Conjunto San Antonio Alegre, Unkown

"Los Pachucos," Las Hermanas Mendoza, Unknown

"Pachuco Mambo," Los Chucos, Unknown

"Sólido Joaquin," Dacita & Her Orchestra, Unknown

CROONERS

With their intimate, close-miked vocal style,
crooners bring romantic sophistication even to their
upbeat tunes

"We Just Couldn't Say Goodbye," Annette Hanshaw, 1932

"It's the Talk of the Town," Connee Boswell, 1933

"Maria Elena," The Dorsey Brothers, 1941

"In Waikiki," Frances Longford & Dick McIntire

& His Harmony Hawaiians, 1941

"I'm In Love with Two Sweethearts," Teddy Foster and His Band, 1942

"Praise the Lord and Pass the Ammunition," Kay Kyser & His Orchestra, 1942

"The Very Thought of You," Ray Noble and his Orchestra with Al Bowlly, 1942

"They Didn't Believe Me," Johnny Mercer and His Mellowaires, 1942

"Goodbye, Sue," Perry Como, 1943

"Hit The Road To Dreamland," Perry Como and The Raymond Scott Orchestra, 1943

"Night And Day," Frank Sinatra, 1944

"Rum & Coca-Cola," Vaughn Monroe, 1944

"March of the Boyds," Boyd Raeburn & His Orchestra, 1945

"That's My Desire," Frankie Laine, 1946

"To Each His Own," Eddy Howard, 1946

"Nature Boy," Nat "King" Cole, 1947

'40s RHYTHM AND BLUES

The blues' sophisticated uptown cousin, R&B adds
dancefloor beats to emotional depth

"Roll 'Em, Pete," Joe Turner & Pete Johnson, 1938

"Cow Cow Boogie," The Ink Spots with Ella Fitzgerald, 1944

"R.M. Blues," Roy Milton, 1945

"The Honeydripper (Parts 1 and 2)," Joe Liggins, 1945

"Sentimental Journey," Louis Prima, 1945

"Baby, Don't You Cry," Johnny Moore's Three Blazers, 1946

"Ain't Nobody's Business," Jimmy Witherspoon, 1947

"Old Maid Boogie," Eddie Vinson, 1947

"Good Rocking Tonight," Roy Brown, 1947

"Bewildered," Amos Milburn, 1948

"Good Rockin' Tonight," Wynonie Harris, 1948

"Cornbread," Hal Singer, 1948

"I Love You Yes I Do," Bull Moose Jackson, 1948

"Long About Midnight," Roy Brown, 1948

"Messin' Around," Memphis Slim, 1948

"Pretty Mama Blues," Ivory Joe Hunter, 1948

"Baby Get Lost," Dinah Washington, 1949

"Country Boy," Dave Bartholomew, 1949

"Saturday Night Fish Fry," Louis Jordan and the Tympany Five, 1949

By 1944, the Second World War had created a booming economy with enough jobs and spare capital to fund a completely new demographic: the teenager. Not quite kids and not quite adults, girls would lead the teenage revolution, as the fashion and media industries were the first to recognize this new population niche. These girls were known as the bobby soxers.

Bobby soxers got their name from the white ankle socks that had become associated with teen girls by the mid-1940s. This association may have come from wartime nylon shortages that forced girls to turn to cotton bobby socks. Shirley Temple's 1947 flick *The Bachelor and the Bobby-Soxer* further cemented the association.

Bobby socks were also part of Catholic school uniforms, which may have helped them become a teen-girl signifier.

Bobby soxers were the first teenagers to scream, faint, and stampede after music stars, starting with Frank "The Sultan of Swoon" Sinatra in the 1940s, moving on to Elvis Presley in the 1950s. However, Sinatra's PR people were known to hire girls to scream outside his earlier performances, proving market-demographic synergy helped create bobby soxers, and thus teenagers.

However, bobby soxers were not just passive recipients of marketing mojo. They defined their own tastes and interests, particularly as the teenage phenomenon gained momentum during the 1950s.

Bobby soxers' cleancut male counterparts were known as "crew cuts."

Though bobby-soxer style and culture died out in the '60s on the heels of folk music, the British Invasion, and hippiedom, it has had a lasting impact on style and culture, helping inspire the fashion and spirit of subsequent female-powered scenes like riot grrrl.

Circle skirts were cut from a single piece of material, which made them cheaper

Bobby soxers and crew cuts both sported saddle shoes

THE CULTURE *Seventeen* magazine was founded in 1944 to directly appeal to bobby soxers. The comic strip *Archie*, which began in 1947, served a similar, but coed, demographic.

ORIGIN: UNITED STATES, 1940s
GIRLS LEAD THE TEENAGE REVOLUTION WHILE THEIR BOYFRIENDS FOLLOW

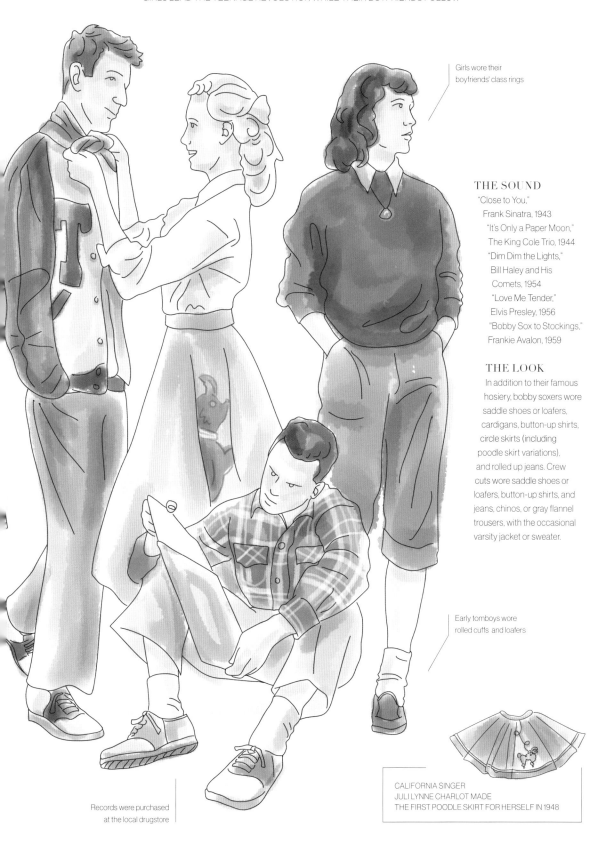

Girls wore their
boyfriends' class rings

THE SOUND

"Close to You,"
Frank Sinatra, 1943
"It's Only a Paper Moon,"
The King Cole Trio, 1944
"Dim Dim the Lights,"
Bill Haley and His
Comets, 1954
"Love Me Tender,"
Elvis Presley, 1956
"Bobby Sox to Stockings,"
Frankie Avalon, 1959

THE LOOK

In addition to their famous
hosiery, bobby soxers wore
saddle shoes or loafers,
cardigans, button-up shirts,
circle skirts (including
poodle skirt variations),
and rolled up jeans. Crew
cuts wore saddle shoes or
loafers, button-up shirts, and
jeans, chinos, or gray flannel
trousers, with the occasional
varsity jacket or sweater.

Early tomboys wore
rolled cuffs and loafers

Records were purchased
at the local drugstore

CALIFORNIA SINGER
JULI LYNNE CHARLOT MADE
THE FIRST POODLE SKIRT FOR HERSELF IN 1948

The Beats were a group of New York poets, writers, and wanderers who coalesced around Allen Ginsberg and Columbia University in 1944. The circle included luminaries like Jack Kerouac, William S. Burroughs, Lucien Carr, and Herbert Huncke, though they wouldn't gain fame until the late 1950s. These artists sought to transcend America's oppressive, capitalistic culture through their own form of spiritual hedonism that included sexual experimentation, drug taking (particularly booze, speed, marijuana, and sometimes opiates), travel, and writing.

Though "beat" was first used during the Civil War to describe lazy soldiers who shirked their duties, it was Times Square hustler Herbert Huncke who introduced the term to Jack Kerouac. Its usage referred to feeling beaten down, broke, and worn-out, physically and mentally. Later, through the lenses of Kerouac's French Canadian Catholicism and interest in Zen Buddhism, as well as Ginsberg's poem "Howl," which referred to "angel-headed hipsters" and repeatedly invoked a refrain of "Holy!"—the word beat came to connote a sense of spiritual ecstasy.

The Beats had been writing since the '40s, but success eluded them until 1956, when Ginsberg's "Howl" first found notoriety (and an obscenity charge) in 1956. The 1957 publication of Kerouac's *On The Road* put the Beats firmly on the cultural map.

The Beats idolized bebop musicians like Charlie Parker, but they were not racially diverse. They attracted only one prominent African American associate, the indomitable Amiri Baraka, who later denounced the Beats in favor of black nationalism before becoming the Poet Laureate of New Jersey.

Though the Beats were later criticized for being misogynistic, they did produce noted female writers like Joanna McClure and Diane di Prima.

Allen Ginsberg and Neal Cassady were instrumental in creating the hippie culture of 1960s San Francisco.

Hefty boots stood up to adventures on and off the road

No nonsense sandals were intentionally plain

THE CULTURE In addition to pushing postmodern writing forward with influential techniques like Kerouac's spontaneous prose and Burroughs' cut-up technique, Allen Ginsberg was one America's first prominent homosexual artists.

ORIGIN: NEW YORK, 1940s
FREEWHEELIN' POETS REWRITE THE AMERICAN DREAM

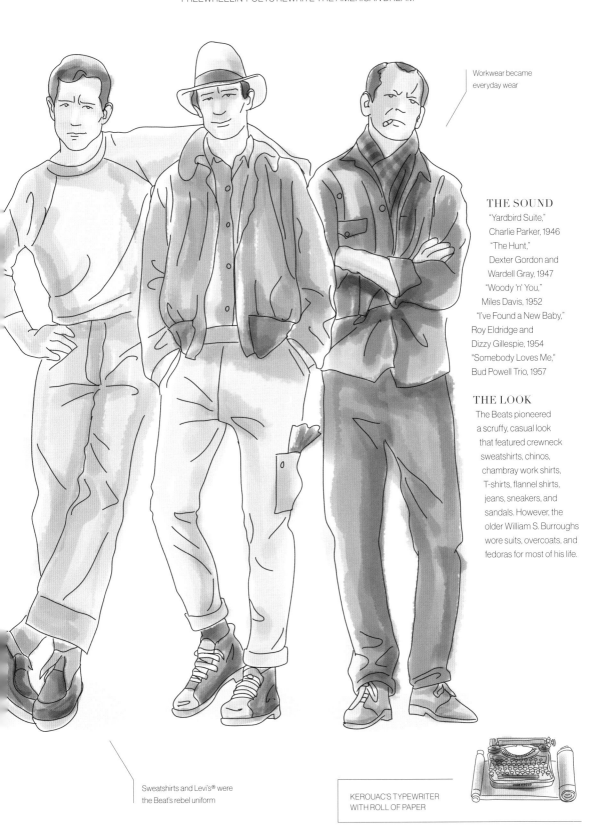

Workwear became everyday wear

THE SOUND

"Yardbird Suite,"
Charlie Parker, 1946
"The Hunt,"
Dexter Gordon and
Wardell Gray, 1947
"Woody 'n' You,"
Miles Davis, 1952
"I've Found a New Baby,"
Roy Eldridge and
Dizzy Gillespie, 1954
"Somebody Loves Me,"
Bud Powell Trio, 1957

THE LOOK

The Beats pioneered
a scruffy, casual look
that featured crewneck
sweatshirts, chinos,
chambray work shirts,
T-shirts, flannel shirts,
jeans, sneakers, and
sandals. However, the
older William S. Burroughs
wore suits, overcoats, and
fedoras for most of his life.

Sweatshirts and Levi's® were
the Beat's rebel uniform

KEROUAC'S TYPEWRITER
WITH ROLL OF PAPER

Though hot rods were most popular in the 1940s and 1950s, the culture can be traced to the 1920s when Los Angeles-area auto fanatics took their customized, four-cylinder Model T and Model A Fords to the dry lake beds of the Mojave desert to race. Builders modified these first hot rods for speed, not looks, hopping up the engines and lightening the bodies by stripping them of all nonessential parts, including bumpers, headlights, and even windshields, establishing the look of hot rods for decades to follow. In 1932, Ford introduced the Model B. Nicknamed "the deuce," this car changed hot rodding forever with its huge flathead V-8 engine and remains the most iconic hot rod to this day.

Following World War II, early innovators like Ed Iskenderian and Clay Smith began marketing their skills and parts to other car fans for a price. This new market coincided with the emergence of teenagers as a comerical demographic, creating the golden age of hot rods, which lasted from the mid-'40s until the early '60s.

Media attempted to cash in on this phenomenon, first from the inside, creating *Hot Rod* magazine in 1948, and later through movies like *Hot Rod Girl* (1956) and *High School Confidential!* (1958), the latter of which featured cars built by famed customizer George Barris.

At the same time, Wally Parks attempted to standardize hot rod drag racing founding the National Hot Rod Association in 1951, just as R&B and rock and roll were starting to attract white teenage listeners. With this, teenage hot rod culture shifted to street drag racing and cruising.

Though hot rodding saw a dip in popularity following the '60s, aficionados kept the art alive, and many still build hot rods the traditional way today with Ford parts and cars.

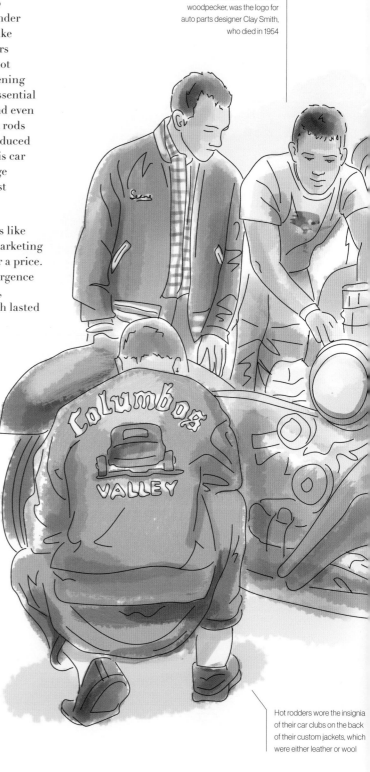

Mr. Horsepower, a cartoon woodpecker, was the logo for auto parts designer Clay Smith, who died in 1954

Hot rodders wore the insignia of their car clubs on the back of their custom jackets, which were either leather or wool

THE CULTURE Although car clubs had existed in California almost since the first automobiles were produced, the hot rod boom saw an explosion in organizations during the '50s. Many clubs bore colorful names like Diplomats, the Cogs, Swanx, the Toppers, El-Reys, Road Kings, Gear Grinders, Cambenders, and the Idlers, many of whom emblazoned their names across the back of jackets.

HOT RODDERS

ORIGIN: SOUTHERN CALIFORNIA, 1940s
CALIFORNIA KIDS REV UP YOUTH CULTURE WITH CUSTOM-MADE CARS

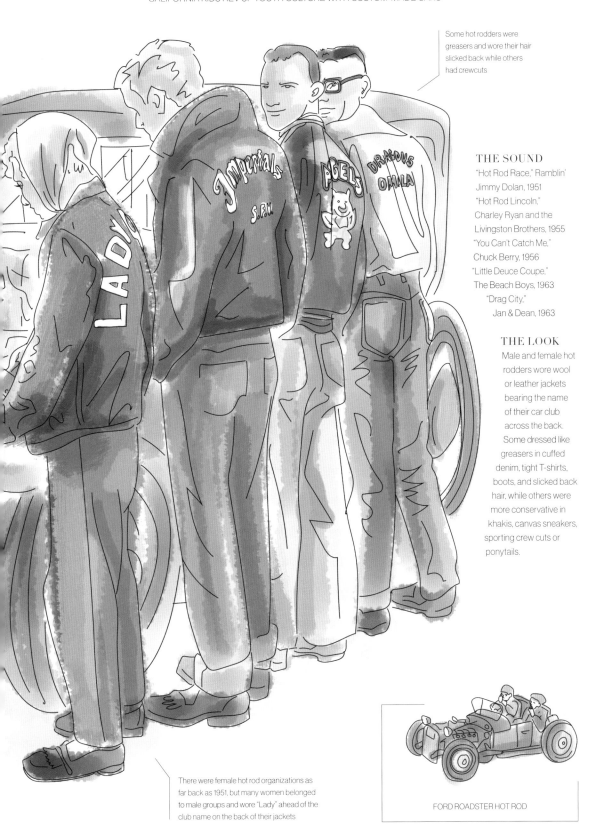

Some hot rodders were greasers and wore their hair slicked back while others had crewcuts

THE SOUND

"Hot Rod Race," Ramblin' Jimmy Dolan, 1951
"Hot Rod Lincoln," Charley Ryan and the Livingston Brothers, 1955
"You Can't Catch Me," Chuck Berry, 1956
"Little Deuce Coupe," The Beach Boys, 1963
"Drag City," Jan & Dean, 1963

THE LOOK

Male and female hot rodders wore wool or leather jackets bearing the name of their car club across the back. Some dressed like greasers in cuffed denim, tight T-shirts, boots, and slicked back hair, while others were more conservative in khakis, canvas sneakers, sporting crew cuts or ponytails.

There were female hot rod organizations as far back as 1951, but many women belonged to male groups and wore "Lady" ahead of the club name on the back of their jackets

FORD ROADSTER HOT ROD

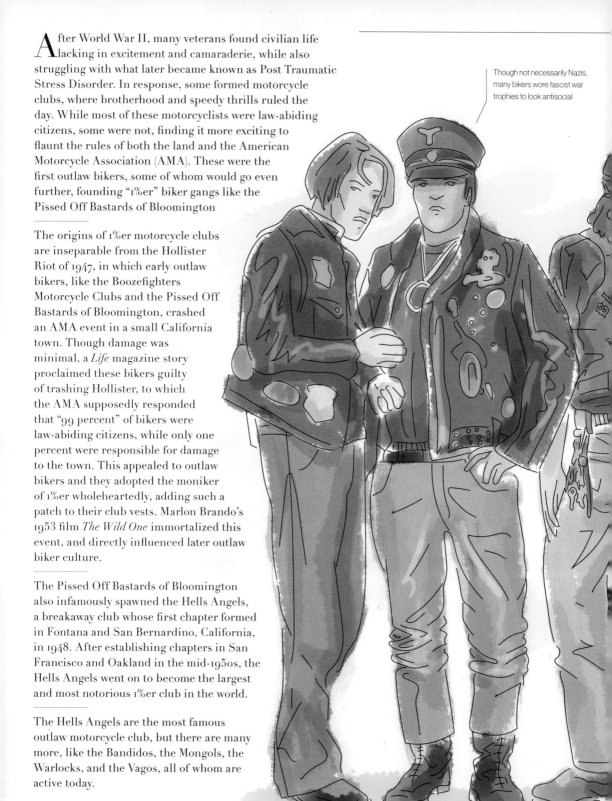

After World War II, many veterans found civilian life lacking in excitement and camaraderie, while also struggling with what later became known as Post Traumatic Stress Disorder. In response, some formed motorcycle clubs, where brotherhood and speedy thrills ruled the day. While most of these motorcyclists were law-abiding citizens, some were not, finding it more exciting to flaunt the rules of both the land and the American Motorcycle Association (AMA). These were the first outlaw bikers, some of whom would go even further, founding "1%er" biker gangs like the Pissed Off Bastards of Bloomington

The origins of 1%er motorcycle clubs are inseparable from the Hollister Riot of 1947, in which early outlaw bikers, like the Boozefighters Motorcycle Clubs and the Pissed Off Bastards of Bloomington, crashed an AMA event in a small California town. Though damage was minimal, a *Life* magazine story proclaimed these bikers guilty of trashing Hollister, to which the AMA supposedly responded that "99 percent" of bikers were law-abiding citizens, while only one percent were responsible for damage to the town. This appealed to outlaw bikers and they adopted the moniker of 1%er wholeheartedly, adding such a patch to their club vests. Marlon Brando's 1953 film *The Wild One* immortalized this event, and directly influenced later outlaw biker culture.

The Pissed Off Bastards of Bloomington also infamously spawned the Hells Angels, a breakaway club whose first chapter formed in Fontana and San Bernardino, California, in 1948. After establishing chapters in San Francisco and Oakland in the mid-1950s, the Hells Angels went on to become the largest and most notorious 1%er club in the world.

The Hells Angels are the most famous outlaw motorcycle club, but there are many more, like the Bandidos, the Mongols, the Warlocks, and the Vagos, all of whom are active today.

Though not necessarily Nazis, many bikers wore fascist war trophies to look antisocial

THE CULTURE Outlaw and 1%er motorcycle clubs are notorious for wearing colors on the backs of sleeveless denim vests. These colors have strict design rules and feature a "top rocker" with the club's name across the top, an emblem in the center, and a bottom rocker stating the chapter's territory. Gang wars have been fought over bottom rockers, such as the open battle between the Bandidos MC and the Cossacks MC that killed nine people in Waco, Texas, in 2015.

BIKERS

ORIGIN: THE INLAND EMPIRE, CALIFORNIA, 1940s
ROAD RIDING REBELS LIVE OUTSIDE THE LAW

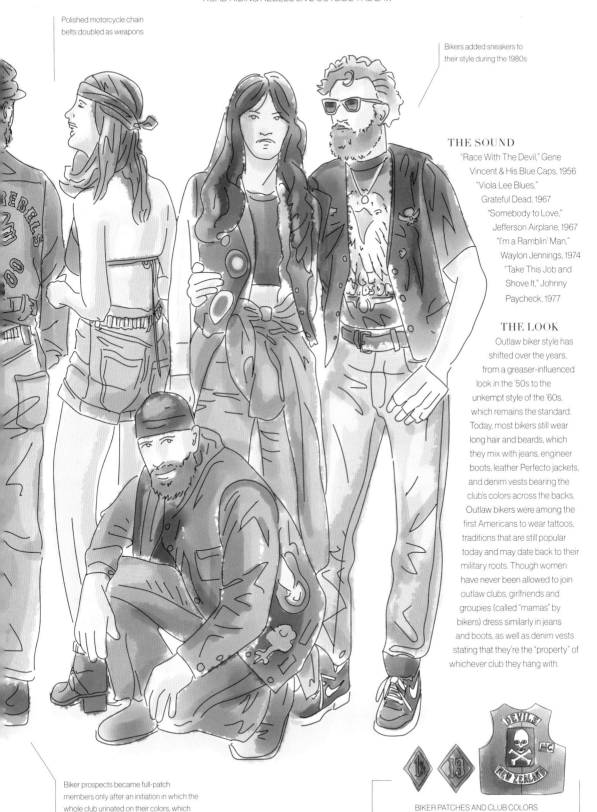

Polished motorcycle chain
belts doubled as weapons

Bikers added sneakers to
their style during the 1980s

THE SOUND

"Race With The Devil," Gene
Vincent & His Blue Caps, 1956
"Viola Lee Blues,"
Grateful Dead, 1967
"Somebody to Love,"
Jefferson Airplane, 1967
"I'm a Ramblin' Man,"
Waylon Jennings, 1974
"Take This Job and
Shove It," Johnny
Paycheck, 1977

THE LOOK

Outlaw biker style has
shifted over the years,
from a greaser-influenced
look in the '50s to the
unkempt style of the '60s,
which remains the standard.
Today, most bikers still wear
long hair and beards, which
they mix with jeans, engineer
boots, leather Perfecto jackets,
and denim vests bearing the
club's colors across the backs.
Outlaw bikers were among the
first Americans to wear tattoos,
traditions that are still popular
today and may date back to their
military roots. Though women
have never been allowed to join
outlaw clubs, girlfriends and
groupies (called "mamas" by
bikers) dress similarly in jeans
and boots, as well as denim vests
stating that they're the "property" of
whichever club they hang with.

Biker prospects became full-patch
members only after an initiation in which the
whole club urinated on their colors, which
could never be washed again

BIKER PATCHES AND CLUB COLORS

COOL JAZZ

Cerebral even when it was cookin',
cool jazz brought a thoughtful, understated
elegance to the clubs

"Freeway," Chet Baker, 1951

"East of the Sun," Russ Freeman, 1952

"Something Cool," June Christy, 1954

"Comes Love," Conte Candoli, 1955

"Ralph's New Blue," The Modern Jazz Quartet, 1955

"Elevation," Gerry Mulligan and his Sextet, 1956

"Get Out of Town," Chris Connor, 1956

"Kary's Trance," Lee Konitz, 1956

"Line Up," Lennie Tristano, 1956

"Mr. Moon," Zoot Sims with Bob Brookmeyer, 1956

"The Lady Is a Tramp," Al Cohn Quintet, 1956

"Ella Speed," Gil Evans, 1957

"People Will Say We're In Love," Helen Merrill, 1957

"You Are Too Beautiful," Warne Marsh, 1957

"Blues In Time," Paul Desmond & Gerry Mulligan, 1958

"I've Grown Accustomed To Her Face," The Cal Tjader Sextet With Stan Getz, 1958

"Slippery When Wet," Bud Shank, 1959

"So What," Miles Davis, 1959

"Take Five," Dave Brubeck Quartet, 1959

"The Easy Way," Jimmy Giuffre, 1959

BEBOP

Ratcheting up both the tempo and the complexity,
small bebop groups overtook the big bands in the
postwar '40s

"Au Privave," Charlie Parker, 1951

"Straight No Chaser," Thelonious Monk, 1951

"Lady Bird," Mary Lou Williams, 1953

"Gibson Boy," Tal Farlow, 1955

"Silver Plated," Dexter Gordon, 1955

"Cherokee," Clifford Brown & Max Roach, 1956

"Cool Eyes," Horace Silver, 1956

"St. Thomas," Sonny Rollins, 1956

"Thad's Blues," Hank Mobley, 1956

"A Night in Tunisia," Art Blakey, 1957

"Blue Train," John Coltrane, 1957

"Caravan," Oscar Peterson, 1957

"Easy To Love," Sonny Stitt, 1957

"On the Sunny Side of the Street," Dizzy Gillespie, Sonny Stitt & Sonny Rollins, 1957

"You'd Be So Nice To Come Home To," Art Pepper, 1957

"The Scene Changes," Bud Powell, 1958

"Yardbird Suite," Max Roach, 1958

"Old Folks," Kenny Dorham, 1959

"The Best Things In Life Are Free," Roland Hanna, 1959

"Yesterdays," Wes Montgomery Trio, 1959

ELECTRIC BLUES

Following post-war jobs up to the northern cities,
the blues plugs in and it hurts so good

"Boogie in the Park," Joe Hill Louis, 1950

"That's All Right," Jimmy Rogers, 1950

"Dust My Broom (I Believe My Time Ain't Long)," Elmore James, 1951

"High Society," T-Bone Walker, 1952

"Hound Dog," Big Mama Thornton, 1953

"Love My Baby," Little Junior's Blue Flames, 1953

"Three O'Clock Blues," B.B. King, 1953

"Cotton Crop Blues," James Cotton, 1954

"I'm Your Hoochie Coochie Man," Muddy Waters, 1954

"The Things That I Used To Do," Guitar Slim, 1954

"Evil Hearted Woman," Lightnin' Hopkins, 1955

"Smokestack Lightnin'," Howlin' Wolf, 1956

"All Your Love," Magic Sam, 1957

"Country Boy," Freddie King, 1957

"I'm a King Bee," Slim Harpo, 1957

"Double Trouble," Otis Rush, 1958

"Gangster of Love," Johnny "Guitar" Watson, 1958

"Baby What You Want Me to Do," Jimmy Reed, 1959

"Rooster Blues," Lightnin' Slim, 1959

"That's My Baby," Willie Dixon, 1959

'50s RHYTHM AND BLUES

A little harder, a little faster, and a little dirtier,
this is pre-rock and roll for the grown folks

"Cupid Boogie," Johnny Otis Orchestra, Little Esther,
 and Mel Walker, 1950
"I Got Loaded," Peppermint Harris, 1951
"Rocket 88," Jackie Brenston and his Delta Cats, 1951
"Feelin' Good," Little Junior Parker & His Blue Flames, 1952
"K.C. Loving," Little Willie Littlefield, 1952
"Lawdy Miss Clawdy," Lloyd Price, 1952
"Bear Cat," Rufus Thomas, 1953
"Hydramatic Woman," Joe Hill Louis, 1953
"Hearts of Stone," The Charms, 1954
"I Got a Woman," Ray Charles, 1954
"Okie Dokie Stomp," Clarence "Gatemouth" Brown, 1954
"Shake, Rattle and Roll," Big Joe Turner, 1954
"Ain't That a Shame," Fats Domino, 1955
"Stepping' Out," Pee Wee Crayton, 1956
"C.C. Rider," Chuck Willis, 1957
"Let the Four Winds Blow," Roy Brown, 1957
"Short Fat Fanny," Larry Williams, 1957
"You Send Me," Sam Cooke, 1957
"Try Me," James Brown and the Famous Flames, 1958
"There Is Something On Your Mind," Big Jay McNeely, 1959

COUNTRY

Country music imbues the Elizabethan-inspired
folk tunes of the rural south with bluesy intensity
and plain-spoken lyrics

"Hot Rod Race," Ramblin' Jimmie Dolan, 1950
"I'm Moving On," Hank Snow, 1950
"Long Gone Lonesome Blues," Hank Williams
 and His Drifting Cowboys, 1950
"Crying' Heart Blues," Johnnie & Jack, 1951
"I Love You a Thousand Ways," Lefty Frizzell, 1951

"Almost," George Morgan, 1952
"Hey Joe," Carl Smith, 1953
"Slowly," Webb Pierce, 1954
"A Satisfied Mind," Porter Wagoner, 1955
"Cry! Cry! Cry!," Johnny Cash, 1955
"Making Believe," Kitty Wells, 1955
"When I Stop Dreaming," The Louvin Brothers, 1955
"Honky-Tonk Man," Johnny Horton, 1956
"Walkin' After Midnight," Patsy Cline, 1957
"City Lights," Ray Price, 1958
"It's Only Make Believe," Conway Twitty, 1958
"Oh Lonesome Me," Don Gibson, 1958
"Big Iron," Marty Robbins, 1959
"He'll Have to Go," Jim Reeves, 1959
"White Lightning," George Jones, 1959

ROCK AND ROLL

When rhythm and blues met country,
popular music changed forever

"Birmingham Bounce," Hardrock Gunter, 1950
"Gee," The Crows, 1953
"Rock Around the Clock," Bill Haley & His Comets, 1954
"Bo Diddley," Bo Diddley, 1955
"Maybellene," Chuck Berry, 1955
"Pretty Thing," Bo Diddley, 1955
"Blue Suede Shoes," Elvis Presley, 1956
"Ooby Dooby," Roy Orbison, 1956
"The Train Kept A-Rollin'," Johnny Burnette
& The Rock 'N' Roll Trio, 1956
"Why Do Fools Fall in Love," Frankie Lymon
& the Teenagers, 1956
"Be-Bop-A-Lula," Gene Vincent, 1957
"I'm Walkin'," Fats Domino, 1957
"Wake Up Little Susie," The Everly Brothers, 1957
"Come On, Let's Go," Ritchie Valens, 1958
"Good Golly, Miss Molly," Little Richard, 1958
"High School Confidential," Jerry Lee Lewis, 1958
"Rave On!," Buddy Holly, 1958
"Rockin' The Joint," Esquerita, 1958
"Whistle Bait," The Collins Kids, 1958
"Somethin' Else," Eddie Cochran, 1959

If Jack Kerouac and his buddy Herbert Huncke helped coin the term "Beat generation," *San Francisco Chronicle* columnist Herb Caen created the term beatnik in 1958, combining "beat" with "nik," a Slavic/Yiddish suffix inspired by the recent launch of the Soviet Union's sputnik satellites.

In drawing even more media attention to the Beat lifestyle, Caen helped transform a self-defined, anti-materialistic artistic movement into a mass media marketing term. This blurred the lines between what had been a subculture of resistance and its subsequent popular iteration—a process that expanded Beat culture, but ultimately turned it into a parody of itself.

Where the Beat writers and characters favored simple uniforms of chinos, sneakers, button-down shirts, Levi's®, and crew-neck sweatshirts, the beatnik image turned into a stereotype featuring berets (probably adopted from Dizzy Gillespie and other bebop musicians), sunglasses, Breton striped shirts, goatees, and sandals.

The Beatnik stereotype also implied faux-intellectual superiority and the appropriation of African American lingo like "cool" and "hip," as well as the smoking of marijuana, playing the bongos, and a life dedicated to Expressionist painting and poetry.

The popularization of the Beat lifestyle via the beatnik phenomenon helped lay the groundwork for the subsequent hippie explosion of the 1960s.

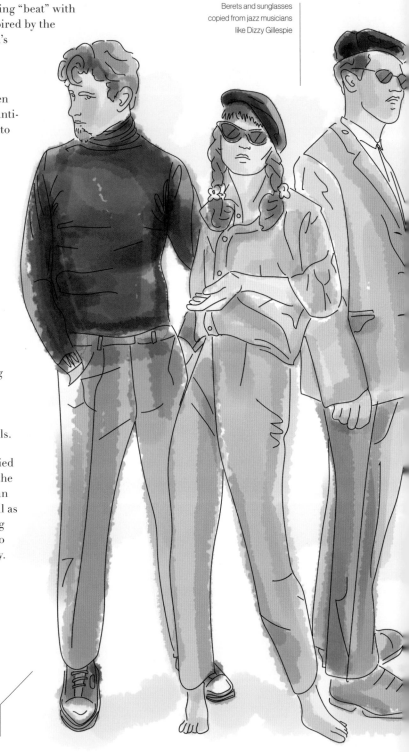

Berets and sunglasses copied from jazz musicians like Dizzy Gillespie

Beatniks took themselves seriously in black turtlenecks

THE CULTURE Though real beatniks listened to folk music and the same jazz the Beat writers cherished, the beatnik phenomenon as a pop-culture trope appeared in a numbers of movies and television shows, like *The Beat Generation* (1959), *The Beatniks* (1960), *The Beat Girl* (1960), and *The Many Loves of Dobie Gillis* (1959–1963), where Bob Denver played the main character's beatnik sidekick Maynard G. Krebs.

BEATNIKS

ORIGIN: SAN FRANCISCO, LATE 1950s
KIDS GO GAGA FOR THE BEAT LIFESTYLE WHEN IT GOES MASS MEDIA

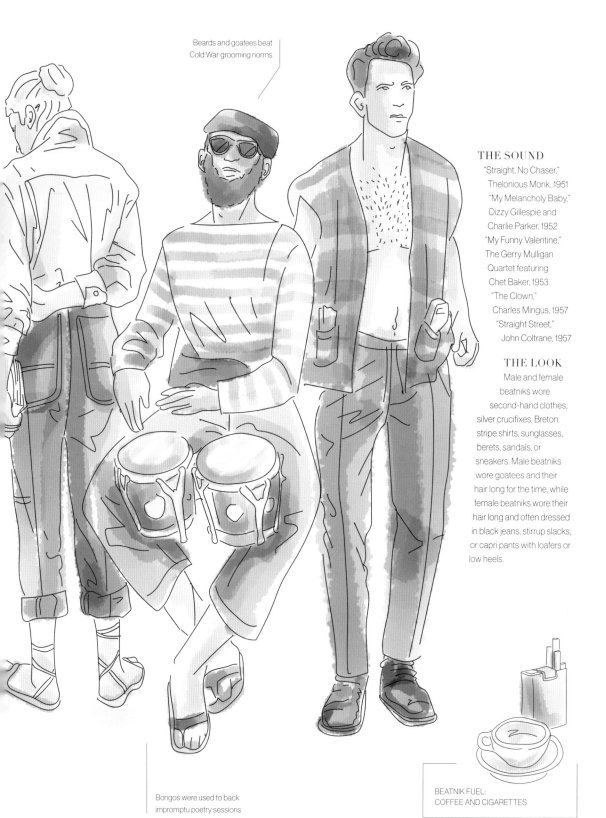

Beards and goatees beat
Cold War grooming norms

THE SOUND
"Straight, No Chaser,"
Thelonious Monk, 1951
"My Melancholy Baby,"
Dizzy Gillespie and
Charlie Parker, 1952
"My Funny Valentine,"
The Gerry Mulligan
Quartet featuring
Chet Baker, 1953
"The Clown,"
Charles Mingus, 1957
"Straight Street,"
John Coltrane, 1957

THE LOOK
Male and female
beatniks wore
second-hand clothes,
silver crucifixes, Breton
stripe shirts, sunglasses,
berets, sandals, or
sneakers. Male beatniks
wore goatees and their
hair long for the time, while
female beatniks wore their
hair long and often dressed
in black jeans, stirrup slacks,
or capri pants with loafers or
low heels.

Bongos were used to back
impromptu poetry sessions

BEATNIK FUEL:
COFFEE AND CIGARETTES

Greasers—more commonly called hoods (short for hoodlums) during their 1950s heyday—were a working-class American male subculture centered around rock and roll, cars, and rebellion. The greaser look is now a widely known cultural trope consisting of white T-shirts worn with the sleeves rolled up, leather motorcycle jackets, jeans, boots, and slicked-back hair.

From the nineteenth century on, "greaser" was a racist, anti-Mexican slur, and it's unknown how it came to be positively associated with the white working-class youth culture. It's possible that Anglo Americans applied it to Italian American immigrants who were seen, like Mexicans, as "Latin," or that it comes from the culture's association with cars and motorcycles. It may simply refer to the greasy, pompadour hairstyle favored by its adherents. Regardless, it seems to have been used less during the '50s and more after the renewed interest in greaser culture during the late '60s and '70s, when novels like *The Outsiders* and TV characters like Fonzie on ABC's *Happy Days* solidified it as a distinct culture.

Marlon Brando's appearances in *A Streetcar Named Desire* (1951) and *The Wild One* (1953), as well as the emergence of Elvis Presley as a mid-'50s superstar, and later James Dean's turn in *Rebel Without a Cause* (1955), helped establish the greaser look, ensuring that the era's teen rebels would wear tight T-shirts and disdainful sneers.

Greasers loved African American rock and roll but were suspicious and antagonistic toward black performers and peers.

Greasers were one of the first subcultures to sag their pants in a street-style statement of rebellion.

Greaser and hood culture spawned many offshoots, including rockabillies from Appalachia and the South, drapes from Baltimore (so named for their pegged trousers and drape jackets), rockers and ton-up boys in the England, and the raggare of Sweden.

Marlon Brando in *The Wild One* inspired greasers to wear Schott Perfecto motorcycle jackets

THE CULTURE Greaser hairstyles are varied, elaborate, and not limited only to the well-known pompadour style. The duck's ass—where the hair is slicked back and then parted down the back from crown to nape—and the jellyroll—in which hair is combed up and forward with a part down the center of the head—were also popular.

Working class greasers often wore baggy hand-me-down jeans that had to be cuffed

GREASERS

ORIGIN: UNITED STATES, 1950s
REBELLIOUS WORKING CLASS TEEN TOUGHS REDEFINE '50S FASHION

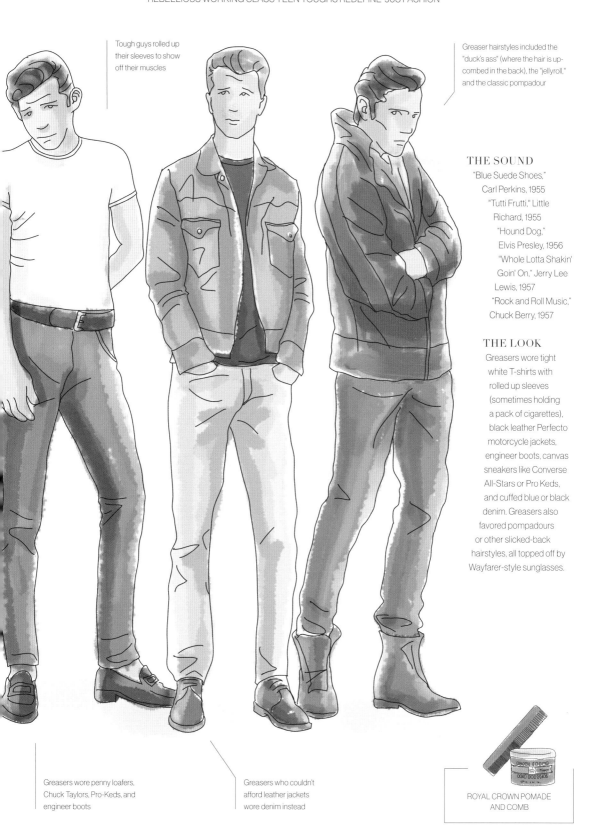

Tough guys rolled up their sleeves to show off their muscles

Greaser hairstyles included the "duck's ass" (where the hair is up-combed in the back), the "jellyroll," and the classic pompadour

THE SOUND

"Blue Suede Shoes,"
Carl Perkins, 1955
"Tutti Frutti," Little
Richard, 1955
"Hound Dog,"
Elvis Presley, 1956
"Whole Lotta Shakin'
Goin' On," Jerry Lee
Lewis, 1957
"Rock and Roll Music,"
Chuck Berry, 1957

THE LOOK

Greasers wore tight white T-shirts with rolled up sleeves (sometimes holding a pack of cigarettes), black leather Perfecto motorcycle jackets, engineer boots, canvas sneakers like Converse All-Stars or Pro Keds, and cuffed blue or black denim. Greasers also favored pompadours or other slicked-back hairstyles, all topped off by Wayfarer-style sunglasses.

Greasers wore penny loafers, Chuck Taylors, Pro-Keds, and engineer boots

Greasers who couldn't afford leather jackets wore denim instead

ROYAL CROWN POMADE AND COMB

In the late 1940s, London tailors revived Edwardian-period styles, marketing over-long drape jackets and slim trousers to rich young men. They didn't expect that the style's most ardent adopters would be working-class youth from the war-ravaged neighborhoods of East London, who saved up and bought their lavish new clothes in installments. These youth, known as Cosh Boys or Teddy Boys/Teddy Girls (short for Edward) would become Britain's first great youth cult and a media folk-devil, notorious for rocking, rolling, fighting, and rioting.

After a decade of post-war rationing, Teddy Boys flaunted the austerity of the day in a similar manner to American pachucos and their zoot suits, saving all their money to buy sumptuous, oversized drape jackets whose sheer volume threw two fingers up to England's stern, flinty society.

Chunky brothel creeper shoes were as synonymous with Teddy Boys as their drape jackets. The shoes, first designed by George Cox, featured thick, crepe rubber soles and came in monk-strap or lace-up styles. The origin of the shoe's name is obscure, but may come from the crepe-soled shoes US servicemen wore during World War II or from a dance done to the 1953 song "The Creep" by Ken Mackintosh.

Teddy Boys cemented their wild status when they rioted at a showing of the 1955 American film *Blackboard Jungle*, where they tore up seats and trashed the place to the film's soundtrack featuring Bill Haley & His Comets.

The Teddy Boy culture faded at the dawn of the 1960s to be replaced by the leather-clad rockers, who they had inspired with their wild ways.

Malcolm McLaren and Vivienne Westwood revived Teddy Boy style when they opened their "Let It Rock" store in 1971 on King's Road, cementing the often contentious relationship between Teddy Boys and punk.

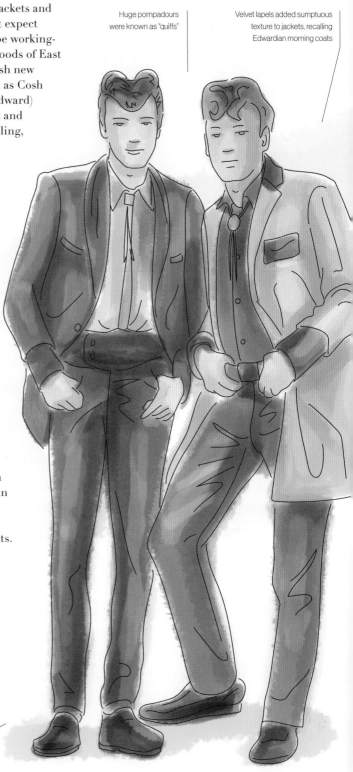

Huge pompadours were known as "quiffs"

Velvet lapels added sumptuous texture to jackets, recalling Edwardian morning coats

Teds pioneered skinny trousers which were called drainpipes during the '50s

THE CULTURE Though Teddy Boys were celebrated for their style and pioneering rebelliousness, the culture also had troubling racist undertones. The Teds were the driving force behind the Notting Hill race riots, during which white British youth attacked West Indians in that neighborhood for two weeks in 1958.

TEDDY BOYS

ORIGIN: LONDON, 1940s
WORKING CLASS DANDIES CREATE A NEW LOOK INSPIRED BY KING EDWARD VII AND ROCK AND ROLL

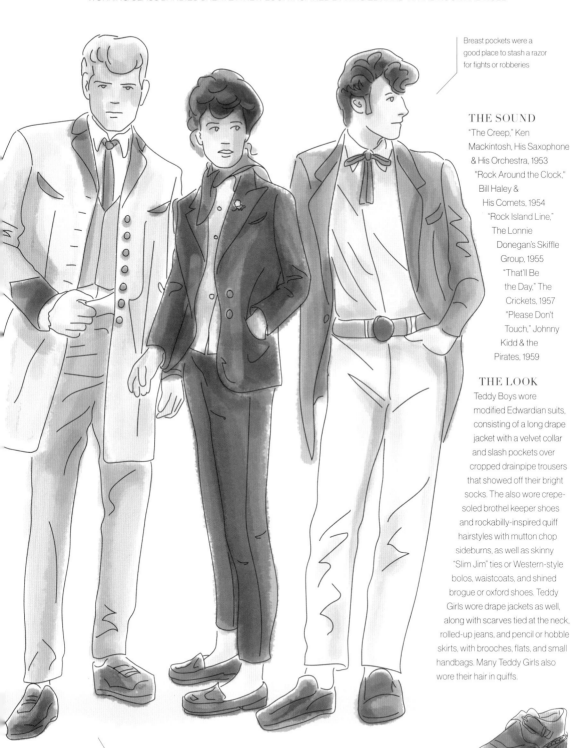

Breast pockets were a good place to stash a razor for fights or robberies

THE SOUND

"The Creep," Ken Mackintosh, His Saxophone & His Orchestra, 1953
"Rock Around the Clock," Bill Haley & His Comets, 1954
"Rock Island Line," The Lonnie Donegan's Skiffle Group, 1955
"That'll Be the Day," The Crickets, 1957
"Please Don't Touch," Johnny Kidd & the Pirates, 1959

THE LOOK

Teddy Boys wore modified Edwardian suits, consisting of a long drape jacket with a velvet collar and slash pockets over cropped drainpipe trousers that showed off their bright socks. The also wore crepe-soled brothel keeper shoes and rockabilly-inspired quiff hairstyles with mutton chop sideburns, as well as skinny "Slim Jim" ties or Western-style bolos, waistcoats, and shined brogue or oxford shoes. Teddy Girls wore drape jackets as well, along with scarves tied at the neck, rolled-up jeans, and pencil or hobble skirts, with brooches, flats, and small handbags. Many Teddy Girls also wore their hair in quiffs.

Many working class Teddy Boys spent entire paychecks on custom jackets from tailors like Sam Arkus in SoHo or Charkham's of Oxford Street

GEORGE COX BROTHEL CREEPERS WITH DOUBLE THICK CREPE SOLE

Stilyagi means "style hunter" in Russian, and is the name applied to a group of young people who wore American-style clothes while dancing to jazz, boogie-woogie, and rock and roll. Their culture was fueled by American movies salvaged from the war ruins of occupied East Germany, as well as any Western goods and music that could be smuggled into the Soviet Union.

Stilyagi was used somewhat derisively to describe the bright, mismatched outfits Soviet youth were able to cobble together despite communist rule. Many stilyagi referred to themselves as *statniki* or stateniks, a reference to their love for the United States.

Because of their dress and tendencies toward hooliganism and small scale crime, stilyagi were often compared to Teddy Boys, and indeed attempted to emulate these looks to some extent, favoring long drape jackets, cropped pants, and ties painted to replicate scenes from America, like women in bikinis on a California beach.

Like Germany's swingjugend and France's Zazous, Soviet stilyagi peppered their slang with English words, often adopting American-sounding names, while drinking *kokteili* (cocktails) and listening to *dzhaz* (jazz) they surreptitiously recorded off of Voice of America radio, which broadcast to the Soviet Union from Tangiers, Morocco.

Stilyagi were sticklers for detail, requiring that their brethren only wear clothes bearing four-hole buttons, since three- and two-hole buttons were deemed too cheap and Soviet.

Under Stalin, the stilyagi were repressed, but slowly became too popular to ignore, requiring Soviet propagandists to pretend they were a normal part of Soviet Culture. Though their rebellion was relatively mild, many Russians saw stilyagi as among the first dissidents, helping push the Soviet Union toward increased openness, particularly in the late 1950s.

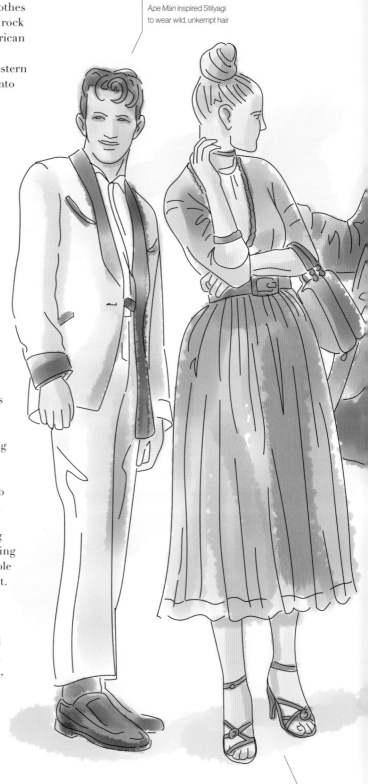

The 1932 film *Tarzan the Ape Man* inspired Stilyagi to wear wild, unkempt hair

Roman sandals were a sign of rebellion for female stilyagi

THE CULTURE Many stilyagi collected "bone records," which were bootleg pressings of banned foreign music that had been cut into the vinyl sheets of discarded X-ray prints.

STILYAGI

ORIGIN: SOVIET UNION, 1950s
SOVIET YOUTH REJECT COMMUNISM IN CLOTHES INSPIRED BY THE WEST

Ties were hand painted with palm trees and other American scenes

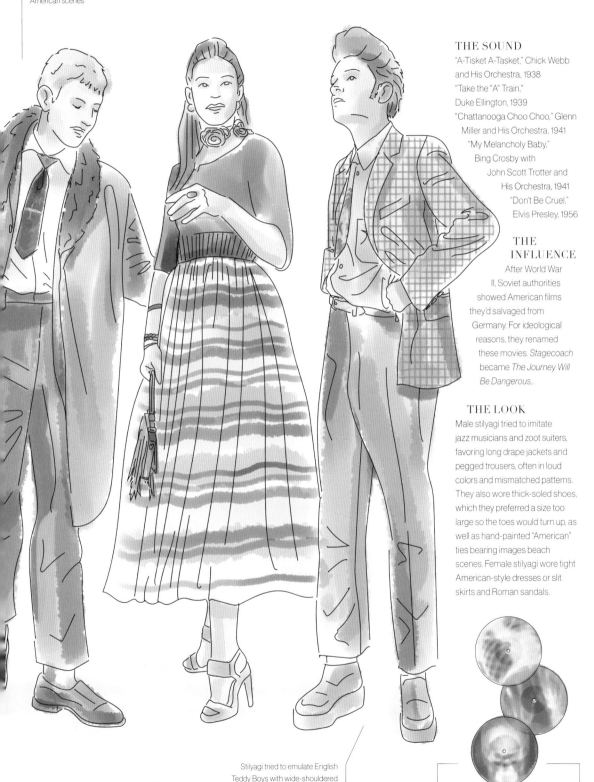

THE SOUND

"A-Tisket A-Tasket," Chick Webb and His Orchestra, 1938
"Take the "A" Train," Duke Ellington, 1939
"Chattanooga Choo Choo," Glenn Miller and His Orchestra, 1941
"My Melancholy Baby," Bing Crosby with John Scott Trotter and His Orchestra, 1941
"Don't Be Cruel," Elvis Presley, 1956

THE INFLUENCE

After World War II, Soviet authorities showed American films they'd salvaged from Germany. For ideological reasons, they renamed these movies. *Stagecoach* became *The Journey Will Be Dangerous,*.

THE LOOK

Male stilyagi tried to imitate jazz musicians and zoot suiters, favoring long drape jackets and pegged trousers, often in loud colors and mismatched patterns. They also wore thick-soled shoes, which they preferred a size too large so the toes would turn up, as well as hand-painted "American" ties bearing images beach scenes. Female stilyagi wore tight American-style dresses or slit skirts and Roman sandals.

Stilyagi tried to emulate English Teddy Boys with wide-shouldered jackets, cropped pants, and thick, crepe-soled shoes

BOOTLEG X-RAY "BONE RECORDS"

NILE RODGERS'S DOO-WOP TOP FIVE

"I Only Have Eyes For You," The Flamingos, 1959

"Smoke Gets in Your Eyes," The Platters, 1958

"To Know Him Is to Love Him," The Teddy Bears, 1958

"In the Still of the Night," The Five Satins, 1956

"Speedo," The Cadillacs, 1955

DOO-WOP

*Under a city streetlight on a warm summer night,
four or five kids create beauty and sophistication
with nothing more than their voices*

"Crying in the Chapel," The Orioles, 1953

"Earth Angel (Will You Be Mine)," The Penguins, 1954

"Boom Mag-Azeno Vip Vay," The Cashmeres, 1955

"Life Is But a Dream," The Harptones, 1955

""Sh-Boom," The Chords, 1955

"When You Dance," The Turbans, 1955

"One Kiss Lead To Another," The Coasters, 1956

"Oh, What a Night," The Dells, 1956

"Rubber Biscuit," The Chips, 1956

"That's My Desire," The Channels, 1957

"Tear Drops," Lee Andrews & The Hearts, 1958

"Tears On My Pillow," Little Anthony & The Imperials, 1958

"The Chapel of Dreams," The Dubs, 1958

"A Teenager in Love," Dion and the Belmonts, 1959

ROCKABILLY

*Revving up country rhythms with rock and roll energy,
rockabilly just might be punk rock's grandpappy*

"Blue Moon of Kentucky," Elvis Presley, 1954

"Blue Jean Bop," Gene Vincent, 1956

"Bottle to the Baby," Charlie Feathers, 1956

"Drugstore Rock and Roll," Janis Martin, 1956

"Get Rhythm," Johnny Cash, 1956

"Pretty Bad Blues," Ronnie Self, 1956

"Red Headed Woman," Sonny Burgess, 1956

"Ubangi Stomp," Warren Smith, 1956

"Fujiyama Mama," Wanda Jackson, 1957

"Flyin' Saucers Rock 'N' Roll," Billy Lee Riley, 1957

"I'm Through," Sleepy LaBeef, 1957

"Matchbox," Carl Perkins, 1957

"I Never Felt Like This," Jack Scott, 1958

"My Babe," Dale Hawkins, 1958

"Rockin' Bones," Ronnie Dawson, 1959

"Room to Rock," Levi & The Rockats, 1979

"I Don't Want To," The Blasters, 1980

"Jeepster," The Polecats, 1981

"Rock This Town," The Stray Cats, 1981

"This Ole House," Shakin' Stevens, 1981

 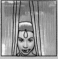 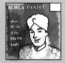

EXOTICA (LOUNGE)

*Warm up the hi-fi and shake up some cocktails,
because things are about to get swank*

"Virgin of the Sun God (Taita Inty)," Yma Sumac, 1950

"Holiday for Strings," The Voices of Walter Schumann, 1955

"Rhumba Uganda," Thurston Knudson - Augie Goupil
& Their Jungle Rhythmatists, 1956

"Africa Speaks," Guy Warren with
the Red Saunders Orchestra, 1956

"Quiet Village," Martin Denny, 1957

"Purple Islands," Les Baxter, 1957

"A Cafe in Sorrento," Raymond Scott, 1957

"Taboo," Arthur Lyman, 1958

"Patricia," Perez Prado, 1958

"Granada," Esquivel, 1958

"Tale of the Underwater Worshippers," Korla Pandit, 1958

"I Love Paris," Alvino Rey, 1958

"Tobago," Eden Abehz, 1959

"Este Seu Olhar," Walter Wanderley, 1959

"Maracatu," Elisabeth Waldo, 1959

"Aloha I Love You," Chick Floyd & His Orchestra, 1959

"Primitiva," Augie Colon, 1959

"Whatever Lola Wants," Enoch Light/The Command
 All-Stars, 1959
"Paris," Francis Bay, 1959
"Swamp Girl," Chaino, 1959

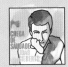 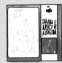

SAMBA

*Brazil's first great musical export introduces
the world to the sound of the favelas*

"Fita Amarela," Francisco Alves, 1932
"Âlo Âlo," Carmen Miranda and Mario Reis, 1934
"Carinhoso," Orlando Sllva, 1937
"Aquarela do Brasil," Silvio Caldas, 1939
"Dora," Dorival Caymmi, 1945
"Marina," Dick Farney, 1947
"Conversa de Botequim," Aracy de Almeida, 1950
"Errei Sim," Dalva de Oliveira, 1950
"Vingança," Linda Batista, 1951
"Risque," Herminia Silva, 1952
"Tabacco Samba," André Verchuren, 1954
"João Valentão," Vanja Orico, 1955
"Coisas de mulher," Dolores Duran, 1955
"Outra Vez," Elizeth Cardoso, 1956
"Mundo Nova," Maysa, 1956
"Silencio de Um Minuto," Nelson Gonçalves, 1956
"Samba No Rio," Carolina Cardoso de Menezes, 1957
"Samba de Bango," Ataulfo Alves, 1958
"Chega de Saudade," João Gilberto, 1958
"Dindi," Sylvia Telles, 1959

VOCAL GROUPS

*Bringing sophisticated harmonies to jazz, pop,
and R&B, these vocalists define class*

"Rag Mop," The Ames Brothers, 1950
"Can't We Talk It Over," The Andrews Sisters, 1950

"Tell Me Why," The Four Aces, 1951
"The Glow-Worm," The Mills Brothers, 1952
"Dream," The Pied Pipers, 1952
"P.S. I Love You,"The Hilltoppers, 1953
"Stardust," The Modernaires, 1953
"Istanbul (Not Constantinople)," The Four Lads, 1953
"Mood Indigo," The Four Freshmen, 1954
"Teach Me Tonight," The DeCastro Sisters, 1954
"Tonight You Belong To Me," The Lennon Sisters, 1956
"Deep Purple," The Hi-Lo's, 1957
"One O'Clock Jump," Lambert, Hendricks & Ross, 1957
"Things We Did Last Summer," The Four Preps, 1958
"It's the Talk of the Town," The Ray Conniff Singers, 1959
"Little Drummer Boy," The Mike Sammes Singers, 1959
"Lullaby of Birdland," The Kirby Stone Four, 1959
"Baubles, Bangles & Beads," Mel Torme & The Mel-Tones, 1960

CALYPSO

*More than an intoxicating rhythm,
calypso brings current news stories and incisive social
commentary to the island and expat populations*

"Victory Test Match," Lord Beginner, 1950
"Big Bamboo," Duke of Iron, 1952
"Bed Bug," Mighty Spoiler, 1953
"I Was There (At the Coronation)," Young Tiger, 1953
"The Lost Watch," Lion, 1953
"Camilla," George Simonette, 1953
"Bow Wow Wow," Mighty Spitfire, 1953
"Cat O Nine Tail," Sir Galba, 1954
"Wife & Mother," Lord Kitchener, 1954
"Brown Skin Girl," Lord Invader, 1955
"Men Smart, Women Smarter," The Mighty Zebra, 1956
"Day O," Harry Belafonte, 1956
"Destruction of Hurricane Janet," Lord Intruder, 1956
"Frozen Chicken," Lord Christo, 1956
"Creature From the Black Lagoon," Lord Melody, 1957
"Life in London," Mighty Terror, 1957
"Old Uncle Joe," The Talbot Brothers of Bermuda, 1958
"Lulu," Mighty Sparrow, 1959
"Evening News," Lord Creator, 1959
"Ban the Hula Hoop," Mighty Striker, 1959

Following World War II, gay leather culture arose from overlapping but not always connected— interests in motorcycles, S&M, and ultra-masculine gay identities that evoked freedom while overturning effete stereotypes.

Many WWII vets started motorcycle clubs to alleviate boredom and recapture wartime camaraderie. The bad behavior of some clubs, such as the Hollister riot of 1947, where bikers ran wild at a California motorcycle rally, helped cement bikers as outlaws and inspired films like 1953's *The Wild One*, starring Marlon Brando. In his black leather jacket and Muir cap, Brando helped codify both the look of the American biker and the emergent gay leatherman.

Some of these bikers were gay and, like their straight peers, started motorcycle clubs too. LA's Satyrs MC, founded in 1953, was the first gay motorcycle club in the world.

In 1962, leather bars "The Toolbox" and "Why Not?" opened in San Francisco's South of Market District, providing public homes for the culture.

Many leather bars had dress codes, like the one from New York's Mineshaft where "approved dress" included "cycle leather jackets & Western gear, Levis (*sic*), jocks, action ready wear, uniforms," but banned "colognes" and "suits."

Though artists like Tom of Finland and Bob Mizer helped spread the leather look with their work in men's "physique" magazines of the '50s and '60s, mainstream visibility for leather culture didn't arrive until the '70s, when straight audiences saw Glenn Martin's biker character from The Village People and Judas Priest's closeted gay singer Rob Halford began wearing leather onstage to promote the band's *Killing Machine* record.

Leather culture peaked in the '70s, before declining due to gentrification, AIDS, and changing tastes, but leather clubs and bars still exist today, putting on leather runs and parties while also engaging in community activism.

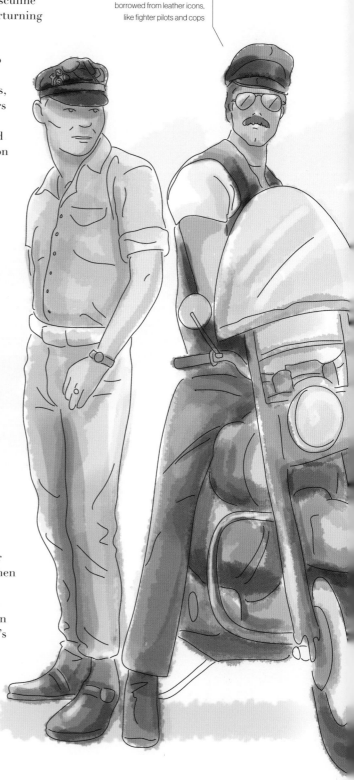

Aviator glasses were borrowed from leather icons, like fighter pilots and cops

THE CULTURE The military was a huge influence on leather culture. Many bikers, gay and straight, took their service motorcycles home from World War II, and most leather clubs ran on military rules. The military is also where many future leathermen had their first gay experiences, and leather culture arose in California because servicemen were dumped there returning from the Pacific Ocean theater of World War II.

ORIGIN: LOS ANGELES, SAN FRANCISCO, EARLY 1950s
GAY WWII VETS CREATE CULTURE FROM BLACK LEATHER, MOTORCYCLES, AND S&M

Military Muir caps
looked extra masculine
in custom leather

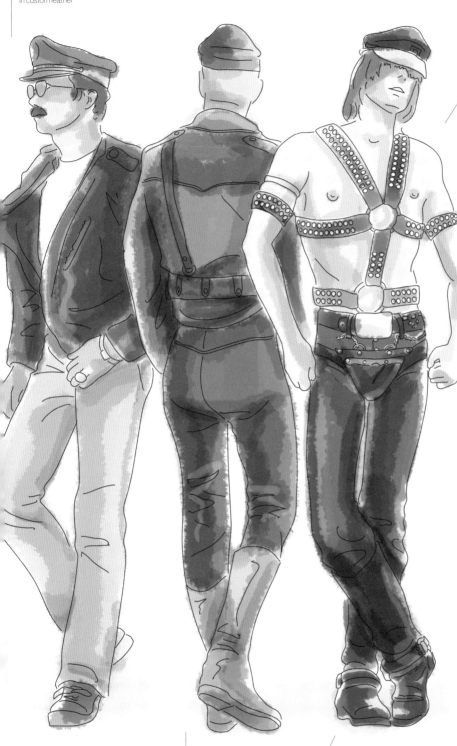

Studded harnesses were
worn to special events like
International Mr. Leather
in Chicago

THE
INFLUENCES
The Wild One (film), 1953
Scorpio Rising (film), 1963
*The Leatherman's
Handbook*, by Larry
Townsend, 1972
Drummer (magazine),
1975–1999
Honcho (magazine),
1978–2009

THE LOOK
Leathermen wore
leather garments,
including biker
jackets, leather military
pants, engineer boots,
gauntlets, chaps, and
military-style Muir caps.
Many leatherman also grew
handlebar moustaches or
beards, and wore black jeans
and aviator sunglasses.

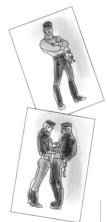

Head-to-toe leather outfits
ensured entry to scene
bars and clubs

A leather codpiece
added sex appeal to
leather trousers

LEATHERMEN
DRAWINGS BY TOM OF FINLAND

Some of the toughest cowboys ever were actually urban Congolese pot smokers from the 1950s. They lived in Leopoldville, called themselves Bills after characters from American Westerns like *Pony Express* (1953) starring Charlton Heston as Buffalo Bill Cody, and created their own idiosyncratic cowboy outfits and argot from sources both local and exotic.

Bills created their unique look with handkerchiefs, cowboy hats, homemade holsters, toy guns, and locally-made sandals and boots.

They named their territories, and often their gangs, after Western American locations, like Texas or Sante Fe, although they occasionally adopted names from non-American or non-Western films like *Godzilla* (1954).

The bills favorite drug was marijuana, which entered sub-Saharan Africa via Arab traders as early as the fourteenth century.

Though bills idolized American cowboys, many of their customs reflect India's influence on Africa. They called their own slang Hindubill, possibly after the Bollywood films also popular in the city at the time or maybe in reference to the source of the weed the Bills loved so much.

Bill culture arose at a politically volatile time for the Belgian Congo, as middle class Africans with European educations known as *évolués* organized and lobbied for political independence from Belgium. Bills were a lower-class response to the same factors that inflamed the évolués, inspiring them to organize and fight the colonial powers that still ruled the country at that time.

Bills wore jeans and checkered shirts purchased locally often at a bargain they called a *prix Yankee* or Yankee price

Due to lack of locally available models, many Bills settled for sandals instead of boots

THE CULTURE Hindubill was a mashup of Lingala, French, and English that included phrases like *dyamba*, meaning marijuana, and "faux type," a name for an untrustworthy person.

ORIGIN: LEOPOLDVILLE, BELGIAN CONGO, LATE 1950s
GLOBAL MASH-UP CULTURE LONG BEFORE THE INTERNET

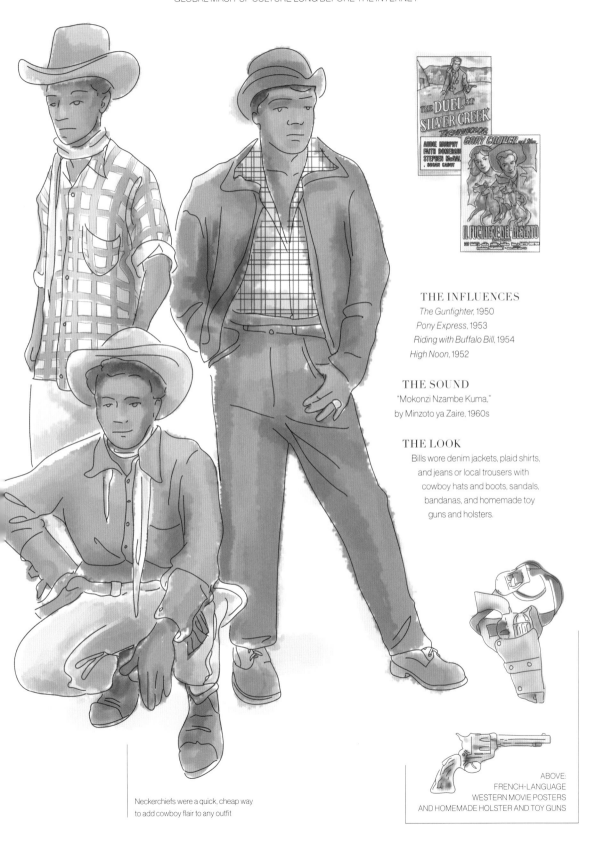

THE INFLUENCES

The Gunfighter, 1950
Pony Express, 1953
Riding with Buffalo Bill, 1954
High Noon, 1952

THE SOUND

"Mokonzi Nzambe Kuma,"
by Minzoto ya Zaire, 1960s

THE LOOK

Bills wore denim jackets, plaid shirts,
and jeans or local trousers with
cowboy hats and boots, sandals,
bandanas, and homemade toy
guns and holsters.

Neckerchiefs were a quick, cheap way
to add cowboy flair to any outfit

ABOVE:
FRENCH-LANGUAGE
WESTERN MOVIE POSTERS
AND HOMEMADE HOLSTER AND TOY GUNS

By the 1950s, Ivy League students had built their own culture and style on the shoulders of their collegiate predecessors, creating a casual, almost careless look that evoked easy confidence and prestige.

Like so many American fashion trends, Ivy League style was born on the sporting field. In 1954, when it became clear that athletes were being recruited illegally, presidents from eight elite universities signed "The Ivy Group" agreement, deciding to limit their college football seasons to round robin group play, turning down offers from postseason bowl games. This was the beginning of the Ivy League, which soon became synonymous with excellence and wealth.

By this time, men on Ivy League campuses had fostered a subtle, rebellious style, meant to separate themselves from the masses and their more conservative fathers. Items like two-button cuff jackets, madras blazers, and chinos became stylish calling cards for those in the know.

Suddenly, Ivy League mainstays like J. Press and Brooks Brothers—which had been outfitting wealthy Northeastern college students since before the turn of the century (1818, in the case of the latter)—became the beneficiaries of a fashion boom, as natural-shouldered sack suits became fashionable among ad men on Madison avenue and even with jazz musicians like Miles Davis.

Except for Cornell, which admitted women in the 1870s, Ivy League schools were all-male until the late '60s, when Yale and Princeton first accepted female students. However, young women from elite families had been attending Seven Sisters schools like Vassar and Wellesley since the nineteenth century, likewise developing a sporty, casual style that presaged prep.

With its natural-shouldered suits and club ties, Ivy League style was the more formal predecessor to prep. It also proved internationally influential, inspiring mods in the UK and Miyuki-zoku in Japan.

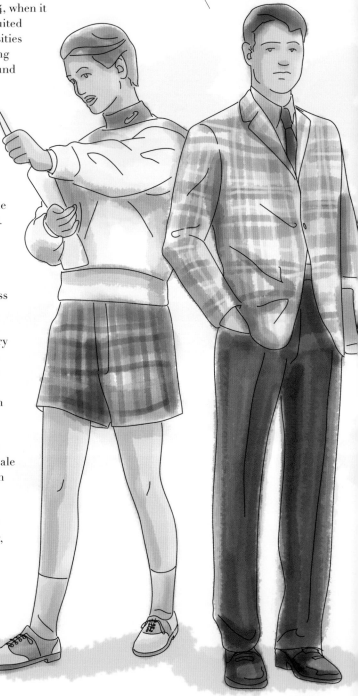

Short hair reigned supreme at Ivies, even during the British Invasion when others wore shaggy looks

True Indian madras was "guaranteed-to-bleed," with colors that ran when washed

THE CULTURE The competitive social scenes at Ivy League schools (like sports teams, eating clubs, acapella groups, fraternities, and secret societies) all helped fuel the evolution of Ivy League style, where the smallest detail of dress could help differentiate the initiated from the wannabes.

ORIGIN: NORTHEAST UNITED STATES, 1950s
ELITE COLLEGE KIDS CREATE A CASUAL COOL THAT'S IMPOSSIBLE TO RESIST

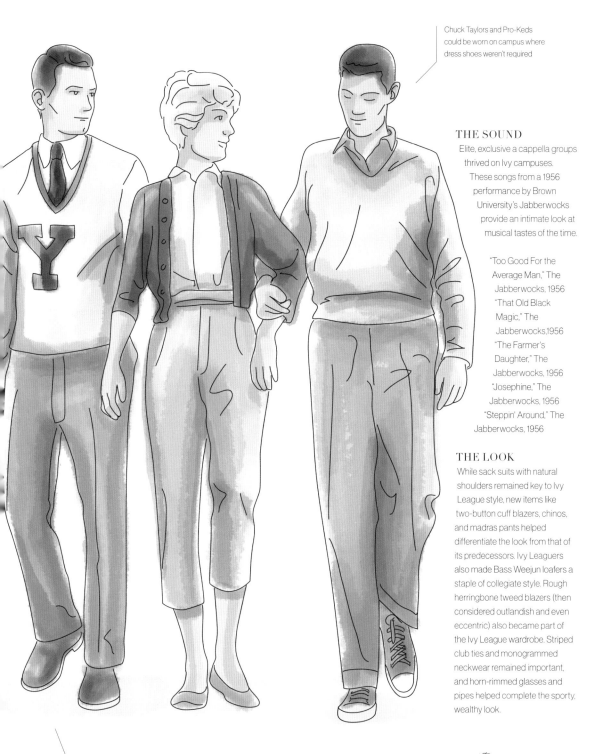

Chuck Taylors and Pro-Keds could be worn on campus where dress shoes weren't required

THE SOUND

Elite, exclusive a cappella groups thrived on Ivy campuses. These songs from a 1956 performance by Brown University's Jabberwocks provide an intimate look at musical tastes of the time.

"Too Good For the Average Man," The Jabberwocks, 1956
"That Old Black Magic," The Jabberwocks,1956
"The Farmer's Daughter," The Jabberwocks, 1956
"Josephine," The Jabberwocks, 1956
"Steppin' Around," The Jabberwocks, 1956

THE LOOK

While sack suits with natural shoulders remained key to Ivy League style, new items like two-button cuff blazers, chinos, and madras pants helped differentiate the look from that of its predecessors. Ivy Leaguers also made Bass Weejun loafers a staple of collegiate style. Rough herringbone tweed blazers (then considered outlandish and even eccentric) also became part of the Ivy League wardrobe. Striped club ties and monogrammed neckwear remained important, and horn-rimmed glasses and pipes helped complete the sporty, wealthy look.

Letterman sweaters still carried weight in the '60s

EATING CLUB
AND SECRET SOCIETY SIGILS

In the summer of 1964, a new group of Japanese teenagers began loitering on Miyuki Street in Tokyo's fancy Ginza district, where they'd roll up every afternoon in their school uniforms before changing into American clothes they pulled out of paper bags. What these teens changed into shocked Japan. The country had never seen its youth dressing as they pleased, hanging around in guaranteed-to-bleed madras, cropped, too-short chinos, three-roll-two blazers, and penny loafers with white socks. These were the Miyuki-zoku and they helped create Japanese youth culture.

By the late '50s Ivy League style dominated American menswear, with teenagers and grown men alike copping to its cool, elite look. But at the time, there was no real youth fashion market in Japan, where teens generally wore school uniforms. Two things changed that. First, men's clothier Kensuke Ishizu shifted the focus of his VAN clothing line to Ivy League styles in the late 1950s. Second, Heibon Punch, a new youth magazine trumpeting the Ivy League look, was released helping create the Miyuki-zoku.

To conservative Japanese authorities, the Miyuki-zoku flooding Ginza were a menace. To stamp them out, Tokyo officials turned to VAN label head Kensuke Ishizu. He'd started this mess, maybe he could end it. Plus, he could give free VAN bags to attendees at the anti-Miyuki-zoku rally the government was hoping to host, which would help guarantee attendance. When the rally came, two thousand teenage Ivy Leaguers showed up to hear Ishizu ask them to stop hanging around Miyuki Street. Some listened, but others wouldn't quit, and cops eventually stormed the Ginza, arresting two hundred Miyuki-zoku. In polite Japan, arrests were more than enough to finish Miyuki-zoku.

Though the Miyuki-zoku lasted mere months, their influence was huge, helping create Japanese youth culture and its corresponding clothing and media economies.

Letterman sweaters inspired by the photos in *Take Ivy*

White socks seemed scandalous in '60s Japan

THE CULTURE Kensuke Ishizu was also instrumental in helping editors of the Japanese magazine *Men's Club* shoot and produce *Take Ivy*, a legendary book documenting style at American Ivy League universities. He also sponsored the *VAN Music Break* TV show, which highlighted popular musicians wearing his clothes.

MIYUKI-ZOKU

ORIGIN: TOKYO, MID-1960s
REBELLIOUS JAPANESE YOUTH GO IVY LEAGUE

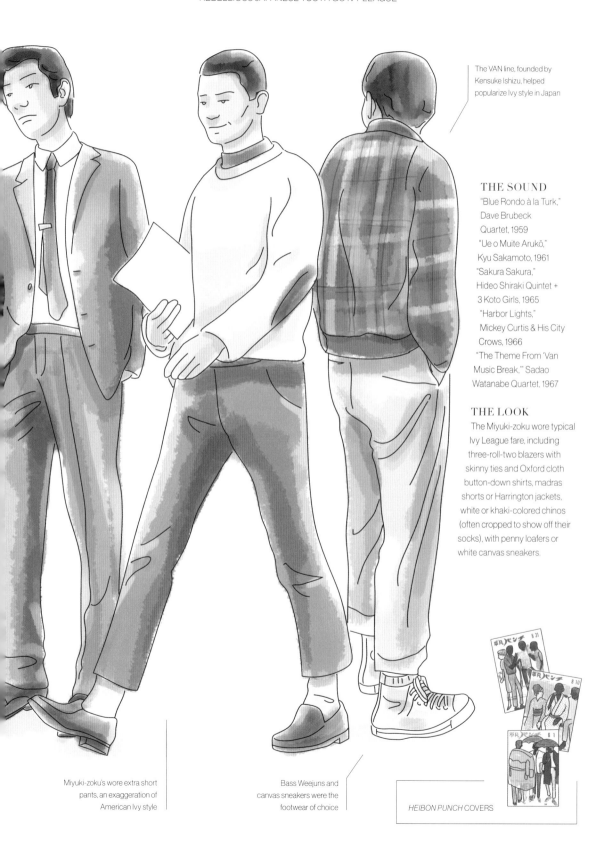

The VAN line, founded by
Kensuke Ishizu, helped
popularize Ivy style in Japan

THE SOUND

"Blue Rondo à la Turk,"
Dave Brubeck
Quartet, 1959
"Ue o Muite Arukō,"
Kyu Sakamoto, 1961
"Sakura Sakura,"
Hideo Shiraki Quintet +
3 Koto Girls, 1965
"Harbor Lights,"
Mickey Curtis & His City
Crows, 1966
"The Theme From 'Van
Music Break,'" Sadao
Watanabe Quartet, 1967

THE LOOK

The Miyuki-zoku wore typical
Ivy League fare, including
three-roll-two blazers with
skinny ties and Oxford cloth
button-down shirts, madras
shorts or Harrington jackets,
white or khaki-colored chinos
(often cropped to show off their
socks), with penny loafers or
white canvas sneakers.

Miyuki-zoku's wore extra short
pants, an exaggeration of
American Ivy style

Bass Weejuns and
canvas sneakers were the
footwear of choice

HEIBON PUNCH COVERS

In the late 1950s, working-class Swedish teenagers began to be able to afford automobiles. They chose big, loud American cars to differentiate themselves from the middle class. The public called them raggare, a derisive term that implied their main interest was cruising for girls—which it was. The public viewed raggare and their tail-finned American cars as low-class menaces. Though the raggare seldom referred to themselves as such, they soon embraced this outlandish image, adding intentionally gauche accessories like Christmas lights, raccoon tails, Confederate flags, and fuzzy dice to their vehicles.

Though raggare shared many characteristics with the American hot rodders of the '40s and '50s, they didn't substantially modify their cars beyond adding accessories and flashy paint jobs. The massive, chrome American monsters were different enough in Sweden that no big changes were needed to make them stand out as rebel rides.

Raggare comes from the verb *ragga*, which refers to driving around to pick up girls.

As with rockers in England, raggare fought Swedish mods, their sworn enemies. Still, despite their wild reputations for drinking, fighting, and cruising for women, most raggare were not criminals.

As with other subcultures, sensationalized media interest in the raggare actually helped widen their influence. In 1959, Swedish director Olle Hellbom released *Raggare!*, a flick about a crew of kids hanging out at a café who get into trouble with a rival gang.

Since the '50s and '60s, raggare have broadened their style, sometimes growing their hair long and adopting other elements of American working-class and redneck dress, or affecting outsized, caricatures of greaser style like massive pompadours.

The raggare still exist, and the lifestyle is as popular as ever, with car shows and road rallies across Sweden during the summer.

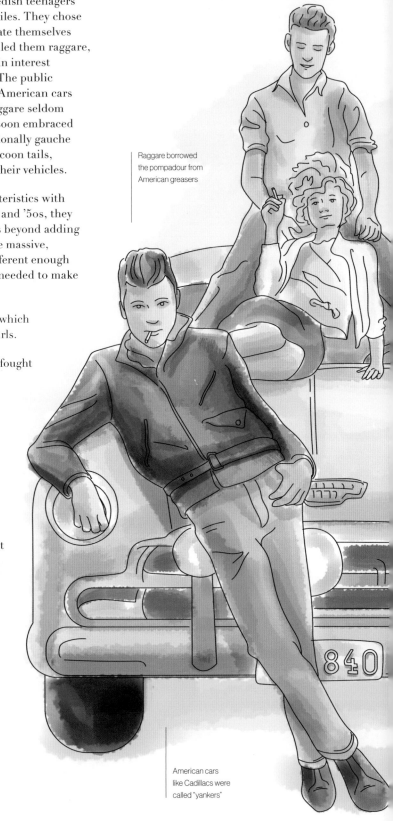

Raggare borrowed the pompadour from American greasers

American cars like Cadillacs were called "yankers"

THE CULTURE Raggare crews and informal clubs gave themselves colorful, American-sounding names like Road Devils and the Filthy Few.

RAGGARE

ORIGIN: SWEDEN, LATE 1950s
SWEDISH ROCKERS LIVE FOR HOT RODS, FREEDOM, AND GOOD TIMES

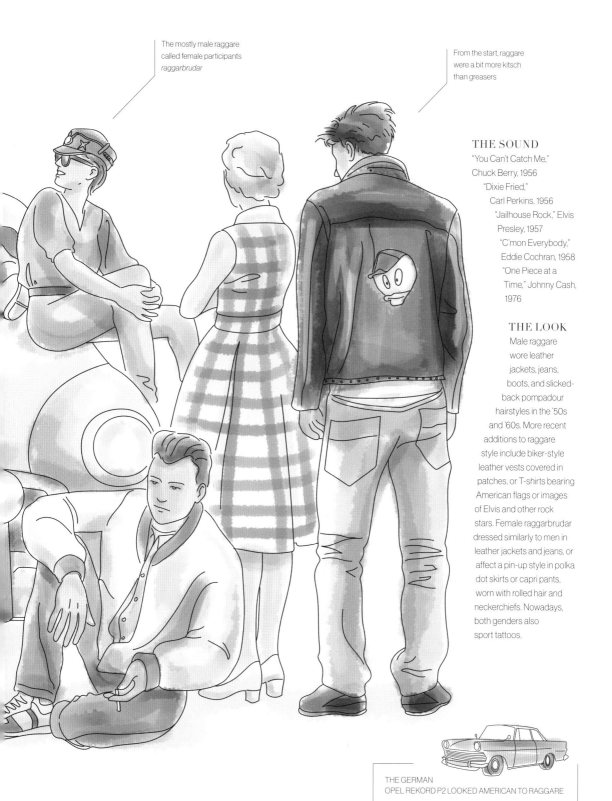

The mostly male raggare called female participants *raggarbrudar*

From the start, raggare were a bit more kitsch than greasers

THE SOUND

"You Can't Catch Me,"
Chuck Berry, 1956
"Dixie Fried,"
Carl Perkins, 1956
"Jailhouse Rock," Elvis
Presley, 1957
"C'mon Everybody,"
Eddie Cochran, 1958
"One Piece at a
Time," Johnny Cash,
1976

THE LOOK

Male raggare
wore leather
jackets, jeans,
boots, and slicked-
back pompadour
hairstyles in the '50s
and '60s. More recent
additions to raggare
style include biker-style
leather vests covered in
patches, or T-shirts bearing
American flags or images
of Elvis and other rock
stars. Female raggarbrudar
dressed similarly to men in
leather jackets and jeans, or
affect a pin-up style in polka
dot skirts or capri pants,
worn with rolled hair and
neckerchiefs. Nowadays,
both genders also
sport tattoos.

THE GERMAN
OPEL REKORD P2 LOOKED AMERICAN TO RAGGARE

FOLK

*Drawing on traditions that stretch across generations
and continents, folk music links the present and the past*

"John Riley," Joan Baez, 1960

"He Was a Friend of Mine," Dave Van Ronk, 1962

"Rosemary Lane," Anne Briggs, 1963

"The Times They Are A-Changin'," Bob Dylan, 1964

"Troubled," Odetta, 1964

"Blues Run the Game," Jackson C. Frank, 1965

"Catch the Wind," Donovan, 1965

"Courting Blues," Bert Jansch, 1965

"I Ain't Marching Anymore," Phil Ochs, 1965

"Pack Up Your Sorrows," Mimi & Richard Farina, 1965

"Carnival Song," Tim Buckley, 1967

"Follow," Richie Havens, 1967

"London Conversation," John Martyn, 1967

"So Long, Marianne," Leonard Cohen, 1967

"Waist Deep in the Big Muddy," Pete Seeger, 1967

"America," Simon & Garfunkel, 1968

"The Minotaur's Song," The Incredible String Band, 1968

"Who Knows Where the Time Goes," Judy Collins, 1968

"Chelsea Morning," Joni Mitchell, 1969

"Round and Round (It Won't Be Long)," Neil Young, 1969

"Time Has Told Me," Nick Drake, 1969

CLASSIC SKA

*Soul and R&B sounds from southern US radio mix with
Jamaican rhythms for a new international dance craze*

"Dumplins," Byron Lee & The Dragonaires, 1960

"Judgement Day," Laurel Aitken, 1960

"Housewife's Choice," Derrick Morgan, 1962

"Dr. Ring Ding," King Stitt, 1963

"King of Kings," Jimmy Cliff, 1963

"King & Queen (Babylon)," Lord Creator & The Skatalites, 1963

"He Is Real," Toots & The Maytals, 1964

"My Boy Lollipop," Millie Small, 1964

"Artibella," Ken Boothe & Stranger Cole, 1965

"Man in the Street," Don Drummond, 1965

"Provocation," Roland Alphonso & the Soul Brothers, 1965

"Vitamin A," Baba Brooks, 1965

"Dancing Mood," Delroy Wilson, 1966

"Ska-ing West," Sir Lord Comic, 1966

"0.0.7 (Shanty Town)," Desmond Dekker & The Aces, 1967

"Al Capone," Prince Buster, 1967

"Girl I've Got a Date," Alton Ellis, 1967

"Jackpot," The Pioneers, 1968

"Take It Easy," Hopeton Lewis, 1968

"The Liquidator," Harry J Allstar, 1969

GIRL GROUPS

*Sassy or swooning, the close harmonies and romantic
lyrics of the girl groups bring the feminine perspective
to rock and roll*

"Eddie My Love," The Teen Queens, 1956

"Mr. Lee," The Bobbettes, 1957

"Born Too Late," The Poni-Tails, 1958

"Will You Love Me Tomorrow," The Shirelles, 1960

"Please Mr. Postman," The Marvelettes, 1961

"Don't Hang Up," The Orlons, 1962

"Be My Baby," The Ronettes, 1963

"Sally Go 'Round the Roses," The Jaynetts, 1963

"Da Doo Ron Ron," The Crystals, 1963

"My Boyfriend's Back," The Angels, 1963

"I Have a Boyfriend," The Chiffons, 1963

"Popsicles & Icicles," The Murmaids, 1963

"The Kind of Boy You Can't Forget," The Raindrops, 1963

"Why Do Lovers Break Each Others Hearts?,"
 Bob B. Soxx, 1963

"Chapel of Love," The Dixie Cups, 1964

"Do Wah Diddy," The Exciters, 1964

"I Wanna Love Him So Bad," The Jelly Beans, 1964

"Leader of the Pack," The Shangri-Las, 1964

"Needle In a Haystack," The Velvelettes, 1964

"The Boy From New York City," The Ad Libs, 1964

"Where Did Our Love Go," The Supremes, 1964

"A Lover's Concerto," The Toys, 1965

BRITISH INVASION

*The British Invasion brings
a spunky new energy and exciting perspective
to American rock and R&B*

"Needles and Pins," The Searchers, 1963

"A Summer Song," Chad & Jeremy, 1964

"A World Without Love," Peter and Gordon, 1964

"Bad to Me," Billy J. Kramer & the Dakotas, 1964

"Can't Buy Me Love," The Beatles, 1964

"Downtown," Petula Clark, 1964

"Ferry Cross the Mersey," Gerry and the Peacemakers, 1964

"House of the Rising Sun," The Animals, 1964

"I Just Don't Know What To Do With Myself,"
Dusty Springfield, 1964

"She's Not There," The Zombies, 1964

"Yeh Yeh," Georgie Fame, 1964

"You Really Got Me," The Kinks, 1964

"For Your Love," The Yardbirds, 1965

"I'm Into Something Good," Herman's Hermits, 1965

"Alfie," Cilla Black, 1966

"Bus Stop," The Hollies, 1966

"Mother's Little Helper," The Rolling Stones, 1966

"Sunshine Superman," Donovan, 1966

"Green Circles," Small Faces, 1967

"To Sir With Love," Lulu, 1967

PSYCHEDELIC ROCK

*Psychedelia brings Eastern mysticism,
jazzy improvisation, and a freewheeling sense
of experimentation to rock*

"Sunshine Superman," Donovan, 1966

"Alone Again Or," Love, 1967

"A Whiter Shade of Pale," Procol Harum, 1967

"Break on Through," The Doors, 1967

"Flowers in the Rain," The Move, 1967

"Flying High," Country Joe & The Fish, 1967

"I Can See For Miles," The Who, 1967

"Incense and Peppermint," Strawberry Alarm Clock, 1967

"Itchycoo Park," Small Faces, 1967

"Keep Your Mind Open," Kaleidoscope, 1967

"Lucifer Sam," Pink Floyd, 1967

"Mr. Soul," Buffalo Springfield, 1967

"Purple Haze," Jimi Hendrix Experience, 1967

"Somebody to Love," Jefferson Airplane, 1967

"A Minha Menina," Os Mutantes,1968

"In-A-Gadda-Da-Vida," Iron Butterfly, 1968

"Magic Carpet Ride," Steppenwolf, 1968

"White Room," Cream, 1968

"China Cat Sunflower," Grateful Dead, 1969

SOUL

*As the civil rights era dawns, soul brings a more personal,
independent sound to R&B*

"Wonderful World," Sam Cooke, 1960

"Baby I Need Your Loving," Four Tops,1964

"Dancing In the Streets," Martha and the Vandellas, 1964

"My Guy," Mary Wells, 1964

"In the Midnight Hour," Wilson Pickett, 1965

"The Tracks of My Tears," Smokey Robinson, 1965

"Get Out of My Life Woman," Lee Dorsey, 1966

"Harlem Shuffle," Bob & Earl, 1966

"River Deep - Mountain High," Ike & Tina Turner, 1966

"I Got Soul," Art Grayson, 1966

"Try a Little Tenderness," Otis Redding, 1966

"What Becomes of the Brokenhearted," Jimmy Ruffin, 1966

"(She's So Fine) So Glad She's Mine," Carter Brothers, 1966

"Chain of Fools," Aretha Franklin, 1967

"I Was Made to Love Her," Stevie Wonder, 1967

"Soul Man," Sam & Dave, 1967

"I Heard It Through the Grapevine," Marvin Gaye, 1968

"I Wish It Would Rain," The Temptations, 1968

"Son of a Preacher Man," Dusty Springfield, 1968

"Walk on By," Isaac Hayes, 1969

"What a Man," Linda Lyndell, 1969

"California Soul," Marlena Shaw, 1969

"It's Your Thing," The Isley Brothers, 1969

Between the 1930s and the 1960s, American college enrollment doubled, providing a surge of high-minded young people searching for entertainment and meaning in the midst of the Civil Rights Movement and an increasingly violent war in Vietnam. Folk music, with its leftist history and allowance for personal reinterpretation of traditional songs, proved the perfect medium for these young intelligentsia.

In the 1930s, a folk music revival flourished on the populist wave created by the Great Depression. Though it didn't last, this first revival produced two key figures—Pete Seeger and Woody Guthrie—who'd act as folk tradition stewards, and inspire 1960s folkies like Bob Dylan.

The second folk music revival started in 1958 on the heels of the unexpected success of The Kingston Trio's "Tom Dooley." Even though Harry Belafonte's smash 1956 album *Calypso* contained mostly Jamaican and West Indian folk songs, it also served as inspiration for the revival as proof that traditional music could sell in big numbers.

Greenwich Village was the capital of the '60s folk scene, where singers like Dave Van Ronk performed in beatnik coffee houses like the Gaslight Cafe, while New York University students and others jammed down the street in Washington Square Park.

By the mid-1960s, Bob Dylan was the king of folk, reaching massive audiences with his original songs about the Civil Rights Movement. Because folk ideologues saw "pure" folk music as inextricable from these progressive causes, many were incensed and felt betrayed when Dylan played an electric set at the 1965 Newport Folk Festival, an act that forever changed the relationship between folk music and rock.

As rock music and psychedelic drugs became ever more popular, the '60s folk scene gave way to the hippie culture, though some stalwarts never gave up the tradition.

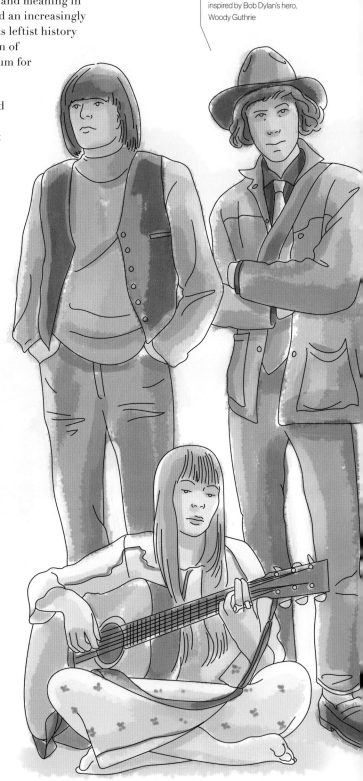

Rustic hats and vests were inspired by Bob Dylan's hero, Woody Guthrie

THE CULTURE Like the folk scene of the Great Depression, '60s folkies saw music as a vehicle for protest. Where earlier folkies favored labor causes, this latter generation championed the Civil Rights Movement and opposed the Vietnam War.

FOLKIES

ORIGIN: UNITED STATES, 1960s
AMERICAN KIDS TURN TO FOLK FOR MEANING AND PROTEST

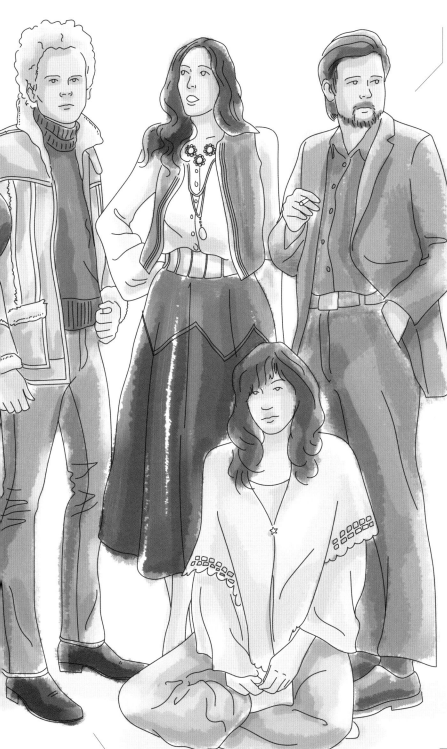

Folkies wore tweed
blazers in a hybrid
collegiate-beatnik style

THE SOUND

"All My Trials,"
Joan Baez, 1960
"Where Have All the
Flowers Gone?" Peter, Paul
and Mary, 1962
"Morning Dew,"
Bonnie Dobson, 1962
"Blowin' in the Wind,"
Bob Dylan, 1963
"The Power and the
Glory," Phil Ochs, 1964

THE LOOK

Male folkies wore workwear-
influenced versions of 1960s
collegiate looks, which
included chambray, flannel, or
Oxford cloth shirts, as well as
crewneck sweatshirts, rough
turtleneck sweaters, tweed
or corduroy blazers, and
jeans, chinos, or corduroys.
They also donned occasional
affectations like Breton caps
or Chelsea boots, but also
wore sneakers and sandals,
and often grew out shaggy
hair. Female folkies wore
peasant blouses or dresses,
crewneck sweaters, jeans,
and jumper dresses with dark
tights, as well as low-heeled
Mary Janes, sandals, or boots.
They preferred straight, long
hair and minimal makeup.

CIVIL RIGHTS PROTEST PINS

Chelsea boots added a
hint of modish English
charm to folk outfits

Blue jeans referenced folk
culture's history of supporting
labor movements

The first mods were modern jazz fans who took their inspiration from artists like Miles Davis, an influence they mixed with French and Italian cinema and tailoring, producing one of the best-dressed subcultures ever. Slim suits, pointy winklepicker shoes, and fringe haircuts became mod hallmarks as they shifted their interests from jazz to R&B, amphetamines, and riots, creating a style that still impacts pop culture today.

Because jazz musicians adopted Ivy League style as their own in the mid-'50s, American collegiate style was among the mods' first influences, a fact that can be seen in their love for button-down collars and tassel loafers.

European film, like Federico Fellini's *La Dolce Vita* (1960) and French New Wave, inspired mods to take European sensibilities and tailored suits as key aspects of their style. This influence also extended to their choice of vehicles, making mod culture synonymous with Italian scooters like Vespas and Lambrettas. Mods whose interest in scooters overtook all else became known as scooter boys.

Fine clothes required protection from scooter oil and weather, so mods wore American army fishtail parkas (especially the M-51 model) to keep clean and warm while scootering.

Mods first gained mainstream press from their rumbles with rockers, a culture that kept the greased quiffs and motorcycles of Marlon Brando's 1950s alive in the UK well into the 1960s.

Female mod style proved perhaps more influential than men's. Icons like Twiggy brought pixie cuts, miniskirts, ballet flats, and dark, cat-eye makeup to high fashion, where designers like Mary Quant and Pierre Cardin created collections based on this look.

As psychedelic Swinging London drew some mods toward more outlandish styles, others simplified their style, creating a look known as hard mod, which eventually morphed into the skinhead subculture.

THE CULTURE Though most mods listened to hardcore American R&B, the subculture spawned many famous rock groups, including The Who, The Small Faces, and John's Children.

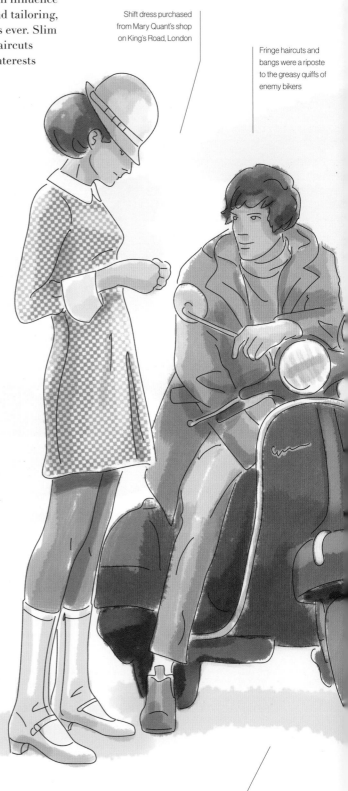

Shift dress purchased from Mary Quant's shop on King's Road, London

Fringe haircuts and bangs were a riposte to the greasy quiffs of enemy bikers

Mods rode Italian scooters like Vespas and Lambrettas

ORIGIN: LONDON, EARLY 1960s
ENGLISH DANDIES WITH MAYHEM ON THEIR MINDS CREATE A CULT OF STYLE

National icons like the Union Jack flag became personal pop art style statements in the hands of mods

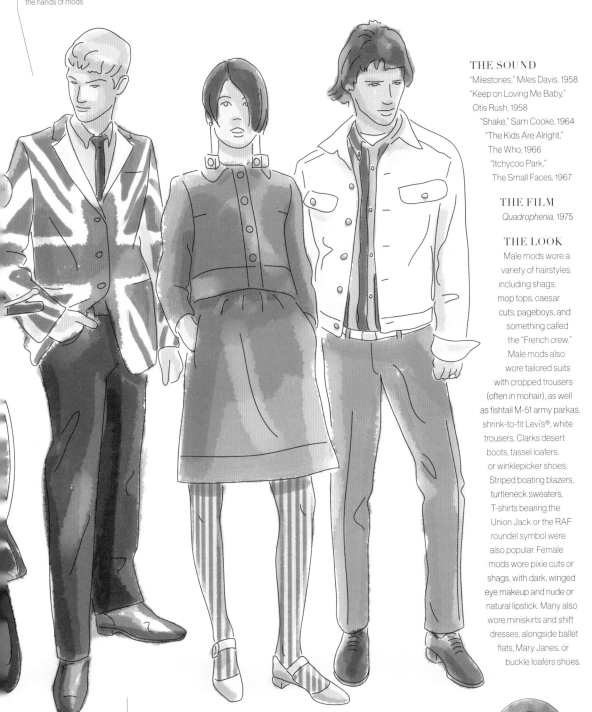

THE SOUND

"Milestones," Miles Davis, 1958
"Keep on Loving Me Baby," Otis Rush, 1958
"Shake," Sam Cooke, 1964
"The Kids Are Alright," The Who, 1966
"Itchycoo Park," The Small Faces, 1967

THE FILM

Quadrophenia, 1975

THE LOOK

Male mods wore a variety of hairstyles, including shags, mop tops, caesar cuts, pageboys, and something called the "French crew." Male mods also wore tailored suits with cropped trousers (often in mohair), as well as fishtail M-51 army parkas, shrink-to-fit Levi's®, white trousers, Clarks desert boots, tassel loafers, or winklepicker shoes. Striped boating blazers, turtleneck sweaters, T-shirts bearing the Union Jack or the RAF roundel symbol were also popular. Female mods wore pixie cuts or shags, with dark, winged eye makeup and nude or natural lipstick. Many also wore miniskirts and shift dresses, alongside ballet flats, Mary Janes, or buckle loafers shoes.

Pointy winklepicker shoes were named after the pin used to eat periwinkle snails at British seaside resorts

ROYAL AIR FORCE
ROUNDEL INSIGNIA

Hopes ran high in Jamaica after gaining its independence from Great Britain in 1962, but the country's struggles with poverty and partisan violence spawned the Rude Boys, a rebellious generation of razor-sharp street toughs in suits who based their personas on homegrown Jamaican outlaws and the gunmen from the American Westerns.

Rude Boys adopted the sharp, slim suits and ties of local Jamaican and American jazz musicians as their own style, often pairing this look with details of their own creation, like sunglasses and short cropped pants.

Rude Boys inspired a whole genre of ska and rocksteady, famously started by the Wailers featuring a young Bob Marley. The Wailers were Rudies themselves, and proved it by dropping their hit "Rude Boy" in 1965.

Though Jamaican outlaws like the notorious Vincent "Rhyging" Martin undoubtedly influenced Rude Boy culture, American and Italian Westerns and gangster movies were also influential. Many Rude Boys and reggae artists adopted names inspired by these films.

By the mid-1960s, Jamaican politics had become violently sectarian as the Jamaican Labour Party and People's National Party fought each other for votes and control of certain Kingston neighborhoods. A 1966 State of Emergency helped abate the violence, but by then, many Rude Boys and their neighbors were caught up in a cycle of violence, resulting in Jamaica's status as one of the most dangerous countries in the Western Hemisphere.

Because of this political violence, masses of Jamaicans immigrated to England in the 1960s, bringing their music and Rude Boy culture with them, where its style and music would influence mods and skinheads.

The two-tone ska revival of late 1970s England helped resurrect Rude Boy culture, though it never entirely went away in Jamaica, where it helped create the "shottas" and posses of the 1980s.

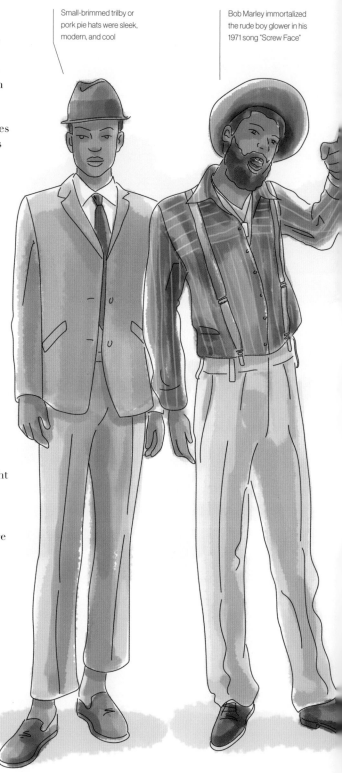

Small-brimmed trilby or pork pie hats were sleek, modern, and cool

Bob Marley immortalized the rude boy glower in his 1971 song "Screw Face"

THE CULTURE If they could afford it, Rude Boys rode customized Japanese motorcycles that were stripped down and fitted in chrome. They always carried a folding "ratchet knife," the finest of which were made in Germany by Okapi.

RUDE BOYS

ORIGIN: WEST KINGSTON, EARLY 1960s
JAMAICAN YOUTH TURN "BADMAN" COMBINING FINE SUITS WITH COWBOY SWAGGER

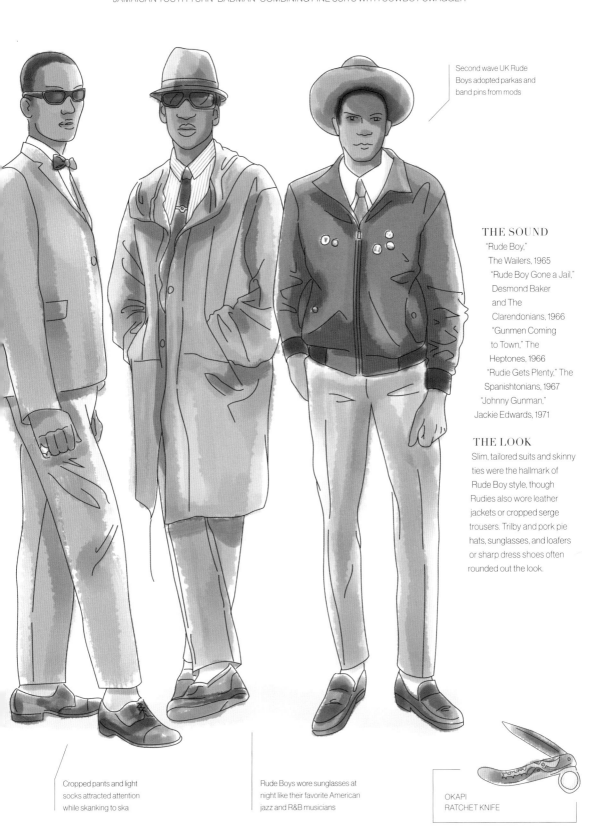

Second wave UK Rude Boys adopted parkas and band pins from mods

THE SOUND

"Rude Boy,"
The Wailers, 1965
"Rude Boy Gone a Jail,"
Desmond Baker
and The
Clarendonians, 1966
"Gunmen Coming
to Town," The
Heptones, 1966
"Rudie Gets Plenty," The
Spanishtonians, 1967
"Johnny Gunman,"
Jackie Edwards, 1971

THE LOOK

Slim, tailored suits and skinny ties were the hallmark of Rude Boy style, though Rudies also wore leather jackets or cropped serge trousers. Trilby and pork pie hats, sunglasses, and loafers or sharp dress shoes often rounded out the look.

Cropped pants and light socks attracted attention while skanking to ska

Rude Boys wore sunglasses at night like their favorite American jazz and R&B musicians

OKAPI
RATCHET KNIFE

In the mid-1950s, young men in the UK began riding and racing British motorcycles between roadside cafes. These were the Ton-up boys (reputedly named after English slang for going 100 miles per hour). They'd soon transform into the rocker subculture, later famous for battling mods in a series of seaside riots and for influencing a British sociologist to coin the term "folk devil" to refer to scapegoats created by sensationalized media and a panicked public.

Rockers, named for their preference for American '5os rock and roll, favored small, quick English motorcycles like Triumphs and Nortons. Sometimes they combined the two, as in the famous Triton motorbike, which featured a Norton frame holding a Triumph engine.

Well into the early '6os, rockers retained their love for Elvis and '5os rock and roll which, along with their rough style, put them at odds with the emerging mod scene, who viewed themselves as urbane sophisticates and looked to American jazz and Italian fashioin for inspiration.

Differences like these made rockers and mods natural enemies, and these indemnities eventually led to riots when hordes of mods and rockers descended upon the seaside towns of Brighton and Margate over a holiday weekend in 1964. The Brighton riot involved about one thousand teens and resulted in two jailings, while Margate saw four hundred kids go at it, with fifty-one arrests and two stabbings. England's hungry tabloid media seized on these massive brawls, creating a storm of public concern. The Who later immortalized the Brighton riot in their 1979 film *Quadrophenia*.

Perhaps due to overzealous media coverage of their riots with mods, rockers faded away after 1964. By 1965 rockers were calling themselves greasers, before drifting into obscurity amid psychedelic Swinging London and the hippie movement.

Greasy quiffs and pompadours kept the spirit of the '50s alive well into the '60s

Rockers claimed silk scarves kept wind off their necks, but they also lent the culture a dose of fighter pilot panache

THE CULTURE After the Margate beach riot, rockers supposedly stormed the boardwalk, chanting "Up the rockers!" in a show of defiance to mods and authorities.

ROCKERS

ORIGIN: UNITED KINGDOM, 1960s
RUMBLING REBELS RIDE ACROSS ENGLAND ON CUSTOM BIKES

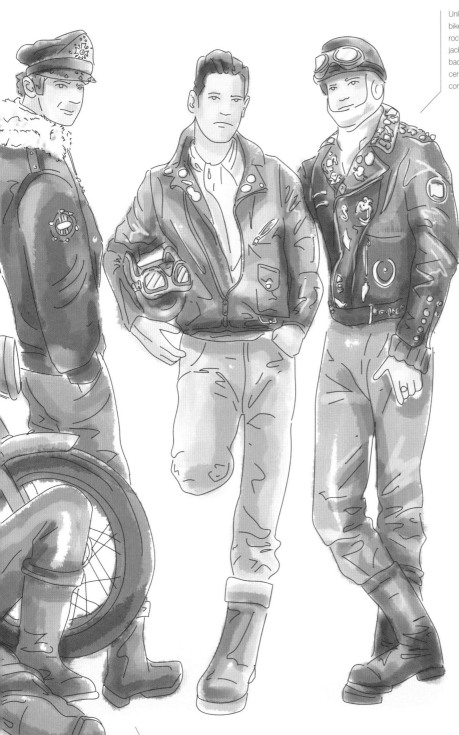

Unlike American greasers and bikers of the 1950s, English rockers encrusted their leather jackets with pins, patches, and badges proclaiming loyalty to certain motorcycle brands or commemorating races and runs

THE SOUND

"See You Later, Alligator,"
Bill Haley & His Comets, 1956
"Race With the Devil,"
Gene Vincent and
His Blue Caps, 1956
"Summertime Blues,"
Eddie Cochran, 1958
"(Marie's the Name)
His Latest Flame,"
Elvis Presley, 1961
"Shakin' All Over," Johnny
Kidd & the Pirates, 1960

THE LOOK

Both male and female rockers wore Levi's® or Wrangler jeans and heavily adorned leather jackets, replete with studs, badges, pins, and chains. They also favored functional accessories like silk scarves to keep the wind off their necks, goggles, and half-cut helmets. Rockers wore engineer boots and often added British touches to their looks, layering up for warmth in cable-knit fisherman sweaters or Fair Isle jumpers.

Like bikers everywhere, rockers wore engineer boots

ENGLISH CAFE
RACER WITH
CUSTOM WINDSCREEN

Hippie culture is expansive, but has a few clear predecessors, including California's "Nature Boys" of the 1940s, the Beats, the folk music scene, and Harvard professor Timothy Leary, who began conducting experiments with psychedelic drugs in 1960. With these influences in place, it's possible to say that Ken Kesey and his Merry Pranksters were the first large group of people living a hippie lifestyle. By the mid-'60s, Kesey and his informal band, which included Beat Neal Cassady, were living communally in Northern California and Oregon, eventually giving away free LSD and hosting the first Acid Test in 1965. The year before, the group traveled across the country to New York City on a school bus named Further, spreading their message across the country. From here, the hippies grew, creating one of the world's largest, longest lasting, and most important youth cultures.

The term hippie was used at least as early as 1966 to refer to antimaterialist, antiwar youth with a taste for psychedelic drugs and loud rock and roll.

Around this time, disaffected young people began flocking to the Haight-Ashbury neighborhood of San Francisco, seeking peace, free love, and drugs, a phenomenon that peaked during 1967's Summer of Love.

The 1969 Woodstock Music & Art Fair was the pinnacle of the hippie movement. As many as 400,000 young people attended performances by Carlos Santana, Joe Cocker, and Richie Havens on a farm outside of Bethel, New York.

But this wouldn't last. Mere days before Woodstock, followers of hippie cult leader Charles Manson murdered Sharon Tate and four of her friends in Los Angeles. Later, in December 1969, a Hells Angel murdered a man at the Rolling Stones performance at the Altamont Speedway Free Festival. The following spring, the Ohio National Guard fired on antiwar protesters at Kent State University, killing one student. Violence like this, as well as hard drug use among hippies, heralded the end of the first wave of hippie culture. Still, hippies proved resilient and still exist in some form today, popping up to influence high fashion every so often.

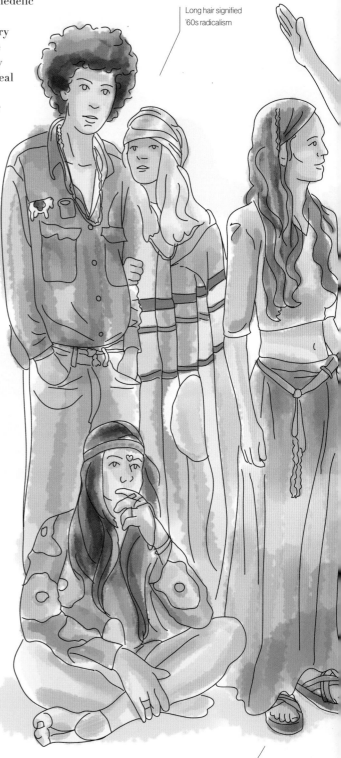

Long hair signified '60s radicalism

Long peasant skirts and sandals looked and felt free

THE CULTURE The '60s counterculturists actually hated the term "hippie" and preferred to call themselves freaks.

ORIGIN: SAN FRANCISCO AND NEW YORK, 1960s
YOUNG ACID HEADS FIGHT FOR THE RIGHT TO TUNE IN AND DROP OUT

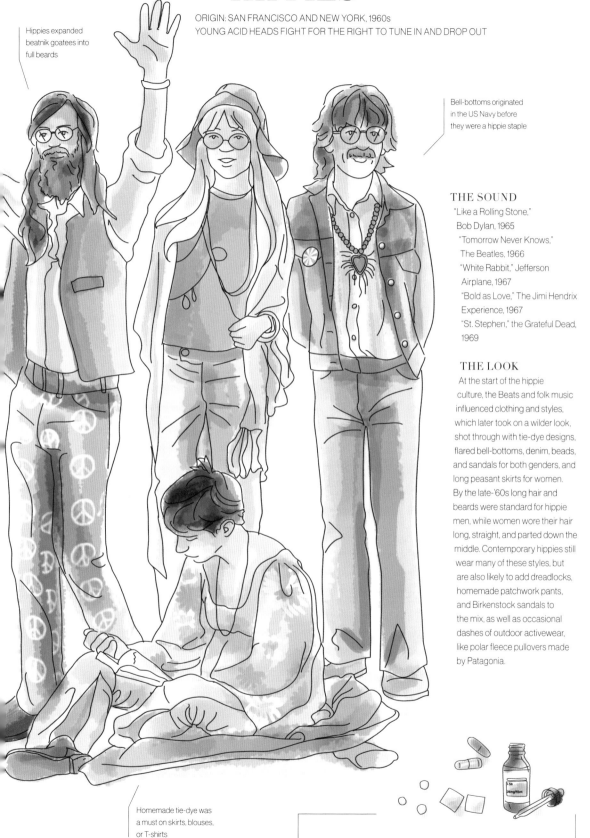

Hippies expanded beatnik goatees into full beards

Bell-bottoms originated in the US Navy before they were a hippie staple

THE SOUND

"Like a Rolling Stone,"
Bob Dylan, 1965
"Tomorrow Never Knows,"
The Beatles, 1966
"White Rabbit," Jefferson
Airplane, 1967
"Bold as Love," The Jimi Hendrix
Experience, 1967
"St. Stephen," the Grateful Dead,
1969

THE LOOK

At the start of the hippie culture, the Beats and folk music influenced clothing and styles, which later took on a wilder look, shot through with tie-dye designs, flared bell-bottoms, denim, beads, and sandals for both genders, and long peasant skirts for women. By the late-'60s long hair and beards were standard for hippie men, while women wore their hair long, straight, and parted down the middle. Contemporary hippies still wear many of these styles, but are also likely to add dreadlocks, homemade patchwork pants, and Birkenstock sandals to the mix, as well as occasional dashes of outdoor activewear, like polar fleece pullovers made by Patagonia.

Homemade tie-dye was a must on skirts, blouses, or T-shirts

EARLY LSD: MICRO DOTS, CAPSULES AND DROPLETS ON SUGAR CUBES

The Black Panthers were a political organization and not necessarily a subculture. But their calculated militaristic style, DIY activism, and refusal to submit to racism influenced everyone from scholars to rappers and—according to Tom Wolfe—editors at *Vogue*. They even had their own band, The Lumpen, who released "Free Bobby Now," a 1970 7-inch single dedicated to then-incarcerated Panther founder Bobby Seale. What could be cooler than that?

In 1966, Oakland community college students Huey P. Newton and Bobby Seale founded the Black Panther Party, an armed revolutionary organization initially intended to track and challenge racist police brutality.

Newton and Seale wrote the famous *Ten Point Platform and Program* outlining the Black Panthers' beliefs and goals in October 1966, but didn't release the document publically until 1967.

From here, the Panthers escalated their actions and felt law enforcement's wrath. They invaded the California State Capitol to protest the Mulford Act, which would have outlawed carrying guns in public. In 1967, Panthers co-founder Huey P. Newton was convicted and then released on manslaughter charges when a cop was shot after pulling him over. In 1968, Oakland police killed seventeen-year-old Panther treasurer Bobby Hutton.

But this only strengthened the Panthers' resolve. In 1968, they expanded, opening a chapter in Los Angeles and then spreading to Chicago, Baltimore, and everywhere in between. With this expansion came a shift in philosophy, as the Panthers moved away from confrontation toward community programs, founding their famous Free Breakfast for School Children Program.

By then, however, the Panthers had attracted the attention of J. Edgar Hoover and the FBI, who unleashed the full might of their COINTELPRO countersurveillance program on them. The FBI eventually wore the Panthers down, and they ceased to exist as a functioning organization by the early 1980s, but not before inspiring thousands of people worldwide.

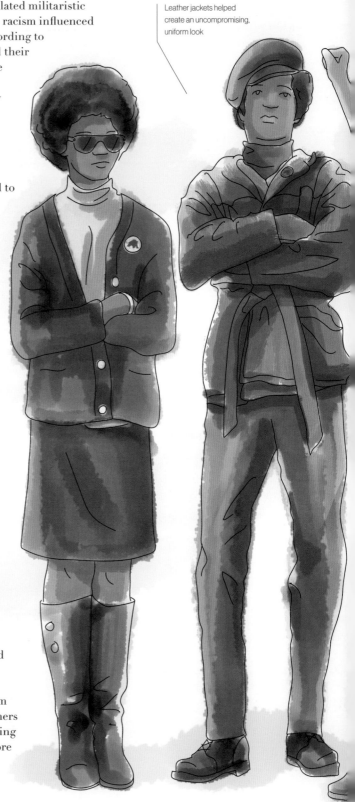

Leather jackets helped create an uncompromising, uniform look

THE CULTURE Far from being racist, the Black Panthers established a "Rainbow Coalition" with Puerto Rican revolutionary organization The Young Lords and The Young Patriots, a white community activist group from Chicago.

BLACK PANTHERS

ORIGIN: OAKLAND, 1960s
BLACK POWER INTELLECTUALS FIGHT THE MAN IN STYLE

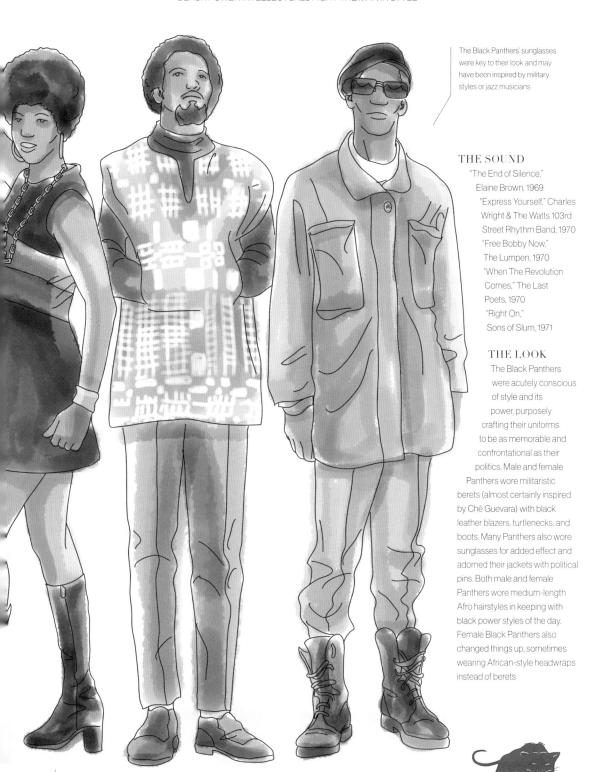

The Black Panthers' sunglasses were key to their look and may have been inspired by military styles or jazz musicians

THE SOUND

"The End of Silence,"
Elaine Brown, 1969
"Express Yourself," Charles
Wright & The Watts 103rd
Street Rhythm Band, 1970
"Free Bobby Now,"
The Lumpen, 1970
"When The Revolution
Comes," The Last
Poets, 1970
"Right On,"
Sons of Slum, 1971

THE LOOK

The Black Panthers were acutely conscious of style and its power, purposely crafting their uniforms to be as memorable and confrontational as their politics. Male and female Panthers wore militaristic berets (almost certainly inspired by Ché Guevara) with black leather blazers, turtlenecks, and boots. Many Panthers also wore sunglasses for added effect and adorned their jackets with political pins. Both male and female Panthers wore medium-length Afro hairstyles in keeping with black power styles of the day. Female Black Panthers also changed things up, sometimes wearing African-style headwraps instead of berets

THE BLACK
PANTHER PARTY LOGO

A raised right fist was the universal symbol of black power

SURF MUSIC

With swells of reverb and waves of lead guitar runs,
surf music brings the ocean's power and mystery to life

"Moon Dawg!," The Gamblers, 1960

"Panic Button," The Fireballs, 1960

"Walk, Don't Run," The Ventures, 1960

"California Sun," The Rivieras, 1961

"Carioca," The Fireballs, 1961

"Mr. Moto," The Belairs, 1961

"Misirlou," Dick Dale & The Del-Tones, 1962

"Pipeline," The Chantays, 1962

"Surfin' Safari," The Beach Boys, 1962

"Telstar," The Tornados, 1962

"Wipe Out," The Surfaris, 1962

"Body Surfin'," The Centurians, 1963

"Out of Control," The Crossfire, 1963

"Stringer," Bobby Fuller, 1963

"Surf Age," Jerry Cole, 1963

"Surf City," Jan & Dean, 1963

"Surfin' Bird," The Trashmen, 1963

"Oceanside," The Super Stocks, 1964

"Banzai Washout," The Challengers, 1965

"Mexican Party," Marty and the Monks, 1965

"Oceanside," The Super Stocks, 1964

NORTHERN SOUL

Perhaps pop's first truly nostalgic scene, Northern Soul
celebrates the unknown glories of classic soul
and R&B sides through non-stop ecstatic dancing

"Walking the Dog," Rufus Thomas, 1963

"Ain't That Peculiar," Marvin Gaye, 1965

"A Thrill a Moment," Kim Weston, 1965

"Festival Time (Single Version)," San Remo
Golden Strings, 1966

"I Don't Need No Doctor," Ray Charles, 1966

"Let's Wade in the Water," Marlena Shaw, 1966

"River of Tears," Barbara Banks, 1966

"Do I Love You," Chris Clark, 1966

"Baby Reconsider," Leon Haywood, 1967

"I Don't Want to Discuss It," Little Richard, 1967

"Moonlight Music and You," Laura Greene, 1967

"Oh Linda," Leroy Taylor, 1967

"There's a Ghost in My House," R Dean Taylor, 1967

"Baby Help Me," Percy Sledge, 1968

"Love is the Only Answer," Kelly Garrett, 1968

"Breaking Down the Walls of Heartache," Johnny Johnson &
The Band Wagon, 1968

"You Hit Me Right Where It Hurt," Alice Clark, 1968

"Backfield In Motion," Mel & Tim, 1969

"I Just Can't Live My Life (without You Babe)," Linda Jones, 1969

"Lucky To Be Loved By You," Willie Hutch, 1969

GARAGE ROCK

Discovering vintage rock and R&B
through the prism of the British Invasion, garage rock
redefines teenage alienation

"Louie Louie," The Kingsmen, 1963

"Farmer John," The Premiers, 1964

"Can't Seem To Make You Mine," The Seeds, 1965

"Have Love Will Travel," The Sonics, 1965

"Never Thought You'd Leave Me," The Pleasure Seekers, 1965

"Wooly Bully," Sam the Sham and the Pharaohs, 1965

"A Public Execution," Mouse and the Traps, 1966

"Bad Girl," The Zakary Thaks, 1966

"I Fought the Law," The Bobby Fuller Four, 1966

"I Had Too Much To Dream (Last Night)," The Electric
Prunes, 1966

"Monk Time," The Monks, 1966

"96 Tears," Question Mark and the Mysterians, 1966

"Out in the Street," Count Five, 1966

"Tobacco Road," The Blue Magoos, 1966

"You're Gonna Miss Me," 13th Floor Elevators, 1966

"Gone and Passes By," Chocolate Watchband, 1967

"Help, I'm a Rock," The West Coast Pop Art
Experimental Band, 1967

"Kick Out The Jams," MC5, 1968

EXPERIMENTAL

Avant-garde composers and rock musicians influence
each other to take music to new droning, atonal heights

"Circles," Luciano Berio, 1960

"Gesang Der Jünglinge," Karlheinz Stockahusen, 1962

"Hodograph I," Earle Brown, 1962

"Four Violins," Tony Conrad, 1964

"Day of Niagara," La Monte Young w/John Cale, Tony Conrad,
Angus Maclise, Marion Zazeela, 1965

"Come Out," Steve Reich, 1967

"Later During a Flaming Riviera Sunset," AMM, 1967

"I of IV," Pauline Oliveros, 1967

"She Was a Visitor," Robert Ashley, 1967

"Silver Apples of the Moon (Part One)," Morton Subotnick, 1967

"Mesa," Gordon Mumma, 1968

"Mort," Pierre Henry, 1968

"The Second Fortress," John Cale, 1968

"Wave Train," David Behrman, 1968

"A Rainbow in Curved Air," Terry Riley, 1969

"Cambridge 1969," John Lennon & Yoko Ono, 1969

"HPSCHD," John Cage & Lejaren Hiller, 1969

"I Am Sitting in a Room," Alvin Lucier, 1969

"Time's Encomium, Part One," Charles Wuorinen, 1969

"2eme Partie," Musica Elttronica Viva, 1970

BOSSA NOVA

Brazilian musicians combine samba and jazz to create
some of the most charming music of the 1960s

"Chega de Saudade," Elizete Cardoso, 1958

"Manhã de Carnaval," Luiz Bonfá, 1959

"O Barquinho," Paulinho Nogueira, 1960

"Samba de Uma Nota Só," Charlie Byrd/Stan Getz, 1962

"Desafinado," Antonio Carlos Jobim, 1963

"The Girl from Ipanema (feat. Astrud Gilberto),"
Stan Getz/Joao Gilberto, 1963

"Deve Ser Amor (It Must Be Love)," Herbie Mann, 1963

"Berimbau," Nara Leaõ, 1964

"Barquinho de Papel," Flora Purim, 1964

"De Manhã," Maria Bethânia, 1965

"Quiet Night (Corvocado)," Wanda Sá, 1965

"A Banda," Chico Buarque, 1966

"Mas Que Nada," Sergio Mendes and Brasil 66, 1966

"Apelo," Baden Powell, 1966

"How Insensitive," Sylvia Telles, 1966

"Beach Samba (Samba na Praia)," Walter Wanderley, 1966

"Avarandado," Gal Costa, 1967

"Summer Samba (So Nice)," Astrud Gilberto, 1967

"Alegria, Alegria," Caetano Veloso, 1967

"A Moreninha," Gilberto Gil, 1967

"Batucada," Marcos Valle, 1968

"Taj Mahal," Jorge Ben, 1972

"Aquas de Março," Elis Regina, 1972

FANIA SALSA

Latin rhythms merge with soul and rock to create the
intoxicating boogaloo sound, which soon becomes salsa

"Cabio Sile," Johnny Pacheco, 1964

"Batman´s Bugalu," Bobby Valentin, 1965

"Meta Y Guaguancó," Orchestra Harlow, 1966

"Micaela," Pete Rodríguez, 1966

"Pow Wow," Manny Corchado, 1967

"Willie Baby," Willie Colón, 1967

"Bataola Boogaloo," Bobby Quesada, 1968

"Borinquen Bella," The TNT Band, 1968

"Camel Walk," The Latinaires, 1968

"Hierba Buena," George Guzmán, 1968

"Mercy, Mercy, Baby," Ray Barreto, 1968

"Mi Guajira," Monguito Santamaría, 1968

"Montuniando," Ralph Robles, 1968

"Subway Joe," Joe Bataan, 1968

"What you mean,"Johnny Colón, 1968

"Yira Yira", Justo Betancourt, 1968

"Fuego en el 23," La Sonora Ponceña, 1969

"Latin Soul," Ralphi Pagan, 1969

"Never Learned to Dance," Harvey Averne, 1969

"Óyelo," Lenni Sesar, 1969

Surfing originated in Hawaii prior to the island's contact with Westerners and was fully developed when Captain James Cook visited the islands in 1779. After European missionaries tried to ban surfing, the sport saw a resurgence at the turn of the twentieth century when a burgeoning tourist economy in Waikiki prompted a public relations campaign highlighting surfing's uniqueness. Surfing gained popularity the world over, from Biarritz to Bondi Beach, partly due to demonstrations by legendary Hawaiian surfer and Olympic gold medalist, Duke Kahanamoku. After Duke's reign, Californian surfers were most prominent in shaping popular perceptions of surf culture, perhaps due to racism and better access to media.

As with so many cultures, surfing exploded in popularity on the crest of America's post-World War II economic boom, which attracted people to Southern California and made beachside leisure affordable to all but the poorest Americans.

Southern California's film and music industries were also instrumental in creating and marketing to the emerging teenage demographic, and surf music and films became big industries by the early '60s. Bands like The Beach Boys and films like 1959's *Gidget* introduced teenagers all over the world to an idealized life of surf, sun, and fun.

Despite California's increasing dominance of surf culture, Hawaii was still the home to many of the sport's most lasting legacies. Hawaiian tailors began making custom canvas boardshorts for surfers in the 1950s, a practice soon replicated in California by the likes of Kanvas by Katin. By the late '60s, an Australian company perfected the boardshort, adding velcro closures inspired by wetsuits. The design remains a surf staple now available in malls worldwide.

Surfing remains a massive global culture, with an industry projected to be worth as much as $13 billion by 2017.

By the 1970s, surfers wore their hair long like hippies and stoners

Boardshorts of the 1950s and '60s hit well above the knee

THE CULTURE Surfing was rough and competitive even in its original Hawaiian iteration. Today, it's still widely known for violent "localism," as surfers protect their beaches from interlopers through intimidation and violence.

SURFERS

ORIGIN: HAWAII, PREHISTORY, CALIFORNIA, EARLY 1900s
HAWAIIAN WAVE RIDERS TEACH THE WORLD THAT STYLE IS KING

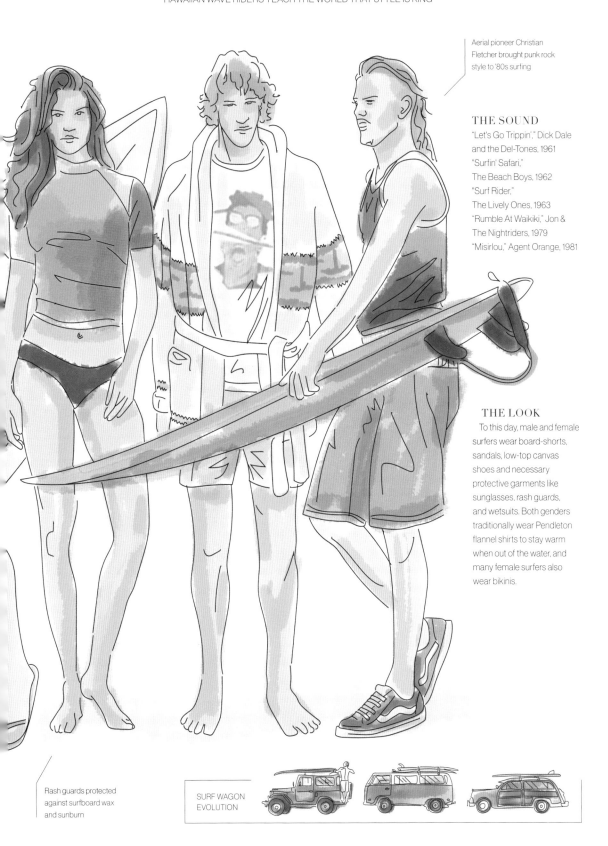

Aerial pioneer Christian
Fletcher brought punk rock
style to '80s surfing

THE SOUND

"Let's Go Trippin'," Dick Dale
and the Del-Tones, 1961
"Surfin' Safari,"
The Beach Boys, 1962
"Surf Rider,"
The Lively Ones, 1963
"Rumble At Waikiki," Jon &
The Nightriders, 1979
"Misirlou," Agent Orange, 1981

THE LOOK

To this day, male and female
surfers wear board-shorts,
sandals, low-top canvas
shoes and necessary
protective garments like
sunglasses, rash guards,
and wetsuits. Both genders
traditionally wear Pendleton
flannel shirts to stay warm
when out of the water, and
many female surfers also
wear bikinis.

Rash guards protected
against surfboard wax
and sunburn

SURF WAGON
EVOLUTION

Puerto Rico is not a country. It is, in fact, a territory of the United States, and therefore operates in a political nether region, unable to directly determine its own course nor influence American politics through voting. Puerto Ricans, are, however, US citizens, and can freely travel between the island and the mainland. In the 1950s, a huge number of Puerto Ricans immigrated to Chicago and New York in search of work. Instead, they found racism and few employment options. But many Puerto Ricans wouldn't stand for this, and in 1968, one small group in Chicago decided to stand up for their rights by founding the Young Lords Organization (YLO), a radical coalition dedicated to community activism and the liberation of their homeland.

José "Cha Cha" Jimenez, a former street gang member, founded the Young Lords Organization in Chicago, soon attracting attention from Puerto Rican activists in New York City who wanted their own chapter, which they called the Young Lords Party.

In New York, the Young Lords Party took on a life of its own, first organizing a "garbage offensive" and taking over an East Harlem church to draw attention to their cause, and later separating from the Chicago group in 1970 over political and stylistic differences.

Like the Black Panthers (with whom they'd been aligned in Chicago), the Young Lords Party also created a free breakfast program for kids and conducted their own neighborhood tests for lead poisoning.

The Young Lords in New York also published their own newspaper, *Palante*, which took its name from the organization's slogan "para adelante" which means "forward."

This radical community activism attracted FBI attention, and the Young Lords became victims of COINTELPRO surveillance and harassment, which contributed to the group's sputtering out by 1976.

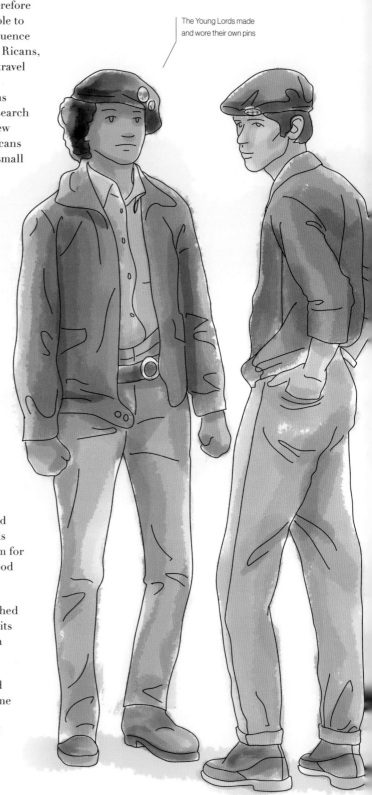

The Young Lords made and wore their own pins

THE CULTURE The Young Lords were closely aligned with salsa artists of the day, adopting "Qué Bonita Bandera" by Pepe y Flora as their official song.

YOUNG LORDS

ORIGIN: CHICAGO, LATE 1960s
PUERTO RICAN YOUTH ORGANIZE TO FIGHT THE POWER

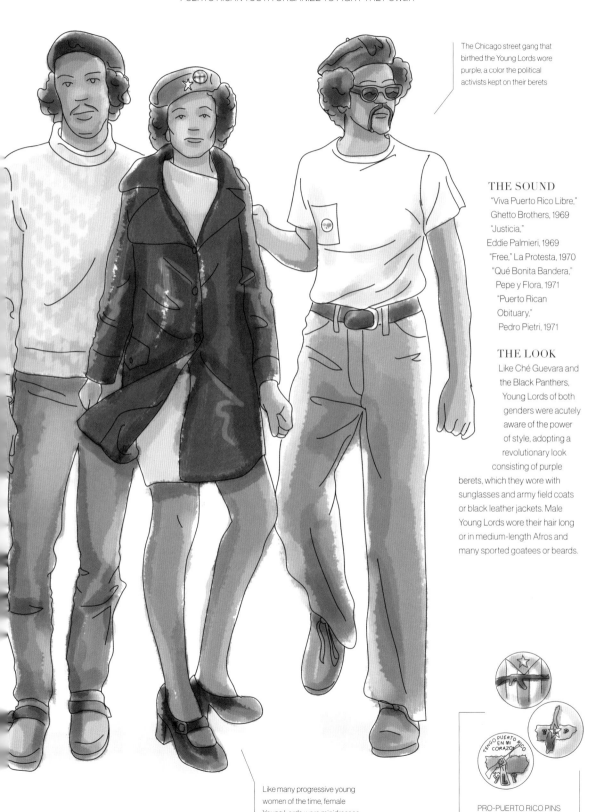

The Chicago street gang that birthed the Young Lords wore purple, a color the political activists kept on their berets

THE SOUND

"Viva Puerto Rico Libre,"
Ghetto Brothers, 1969
"Justicia,"
Eddie Palmieri, 1969
"Free," La Protesta, 1970
"Qué Bonita Bandera,"
Pepe y Flora, 1971
"Puerto Rican
Obituary,"
Pedro Pietri, 1971

THE LOOK

Like Ché Guevara and the Black Panthers, Young Lords of both genders were acutely aware of the power of style, adopting a revolutionary look consisting of purple berets, which they wore with sunglasses and army field coats or black leather jackets. Male Young Lords wore their hair long or in medium-length Afros and many sported goatees or beards.

Like many progressive young women of the time, female Young Lords wore minidresses

PRO-PUERTO RICO PINS

The late 1960s saw England's mods flirting with psychedelia, something that didn't please the tougher, working-class members of the subculture. In response, so-called hard mods shaved their heads and donned an overtly working-class uniform of boots, rolled-up jeans, braces, and button down shirts. The skinhead was born.

The original skinheads were admittedly violent and frowned upon the peace-and-love philosophy of the era. They also claimed to be apolitical and were mostly interested having a good time.

Skinheads chose Jamaican rocksteady, reggae, and American soul as their music of choice. That interest was bolstered by the waves of West Indians flooding Britain in the 1960s.

From the start, skinhead culture included black participants, a fact that supporters of the original movement point to as evidence of their anti-racist beliefs. However, most skinheads were white, and even when skinhead gangs did include black members, beating up East Indian immigrants ("Paki bashing") and gay people was a common, if abhorrent, pastime.

The skinhead craze mostly died out by the early '70s. Many former skins grew their hair out to become "suedeheads." But the punk scene and two-tone ska revival of the late '70s helped resurrect skinhead culture for a new generation.

Facing unemployment and fearing immigrants, some of these second-wave skinheads joined racist groups like the National Front in England. Oi! music, a bare bones form of punk, helped spread the skinhead revival to the United States where hardcore fans adopted the look, many of them becoming neo-Nazis and giving skinheads their current bad reputation. Throughout this, other skinheads stayed politically neutral, though some formed anti-racist groups, like the S.H.A.R.P.s (Skinheads Against Racial Prejudice).

Perhaps because of, their fearsome reputation, skinheads repeatedly pop up as influences on high fashion, street culture, and music.

Button-down collars were borrowed from mods and Ivy Leaguers

Female skins wore Chelsea cuts

THE CULTURE Skinheads were so prominent in the late 1960s that English glam band Slade briefly adopted the look, marketing themselves as a skinhead band.

SKINHEADS

ORIGIN: LONDON, LATE 1960s
WORKING CLASS MODS SHAVE THEIR HEADS AND HARDEN UP TO REGGAE TUNES

Skinheads shaved their
heads, exaggerating
working class styles

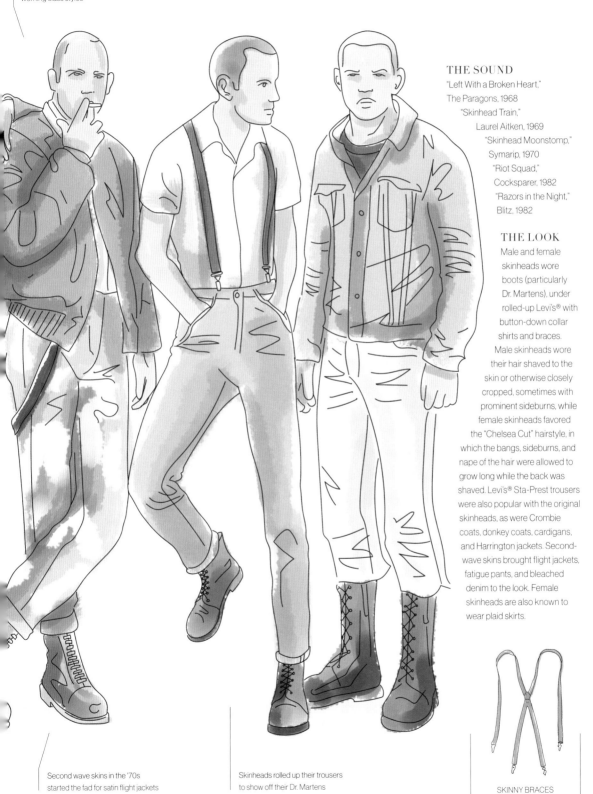

THE SOUND

"Left With a Broken Heart,"
The Paragons, 1968
"Skinhead Train,"
Laurel Aitken, 1969
"Skinhead Moonstomp,"
Symarip, 1970
"Riot Squad,"
Cocksparer, 1982
"Razors in the Night,"
Blitz, 1982

THE LOOK

Male and female
skinheads wore
boots (particularly
Dr. Martens), under
rolled-up Levi's® with
button-down collar
shirts and braces.
Male skinheads wore
their hair shaved to the
skin or otherwise closely
cropped, sometimes with
prominent sideburns, while
female skinheads favored
the "Chelsea Cut" hairstyle, in
which the bangs, sideburns, and
nape of the hair were allowed to
grow long while the back was
shaved. Levi's® Sta-Prest trousers
were also popular with the original
skinheads, as were Crombie
coats, donkey coats, cardigans,
and Harrington jackets. Second-
wave skins brought flight jackets,
fatigue pants, and bleached
denim to the look. Female
skinheads are also known to
wear plaid skirts.

Second wave skins in the '70s
started the fad for satin flight jackets

Skinheads rolled up their trousers
to show off their Dr. Martens

SKINNY BRACES

By the early '70s some British skinheads had tired of their cropped, militaristic look, yearning for a softer, more formal style that returned mod tailoring to the forefront. These skinheads grew their hair out to between an inch and a half and three inches, put on iridescent tonic suits and crombie coats, and became suedeheads.

In addition to tonic suits, suedeheads favored button-down shirts, houndstooth suits, sweater vests, shearling overcoats, and cropped trousers that showed off colored socks, with loafers, woven moccasins, or dressier brogue shoes.

Female suedeheads were called "sorts", and dressed in a conservative, modish style not entirely different from other working-class young women at the time.

With a less severe dress code and look, suedeheads also opened themselves up to new music. Many liked '60s mod bands like The Who and were also often fans of newer glam rock bands like Slade, who'd once been skinheads themselves.

Though sometimes said to be less violent than skinheads, suedeheads were still tough, and developed a reputation for hooliganism at dancehalls and on football terraces.

Like their skinhead predecessors, suedeheads weren't immune to exploitation by England's pulpy media and were chronicled in a cheap paperback by Richard Allen.

By 1972, some suedeheads grew their hair to their shoulders, becoming what were known as "smooths" or "bootboys." Some bootboys crossed over with the soulie look of Northern Soul.

Though a short-lived culture themselves, suedeheads continue to appear in pop culture, notably in Morrissey's first solo single, 1988's "Suedehead."

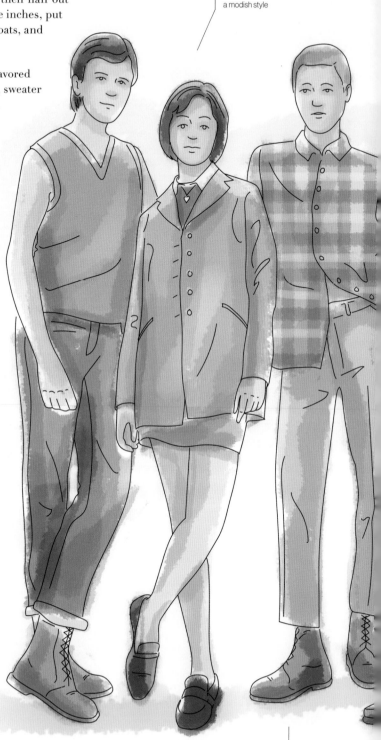

Female suedeheads were called "sorts" and favored a modish style

Wool trousers were more formal than jeans

THE CULTURE Suedeheads resurrected the mod vehicle of choice—Vespa and Lambretta scooters.

ORIGIN: LONDON, 1970s
FORMER SKINHEADS GROW THEIR HAIR BUT KEEP THE BAD ATTITUDES

Three-inch shag haircuts were less severe than the shorn skulls of skinheads

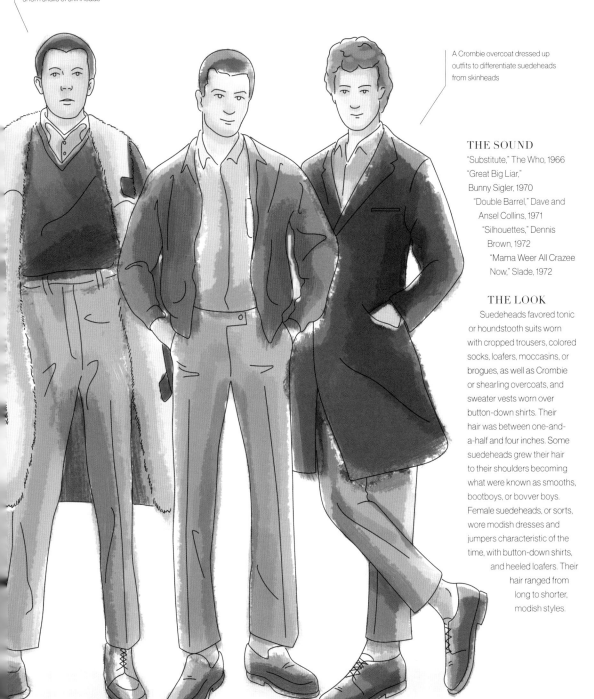

A Crombie overcoat dressed up outfits to differentiate suedeheads from skinheads

THE SOUND

"Substitute," The Who, 1966
"Great Big Liar," Bunny Sigler, 1970
"Double Barrel," Dave and Ansel Collins, 1971
"Silhouettes," Dennis Brown, 1972
"Mama Weer All Crazee Now," Slade, 1972

THE LOOK

Suedeheads favored tonic or houndstooth suits worn with cropped trousers, colored socks, loafers, moccasins, or brogues, as well as Crombie or shearling overcoats, and sweater vests worn over button-down shirts. Their hair was between one-and-a-half and four inches. Some suedeheads grew their hair to their shoulders becoming what were known as smooths, bootboys, or bovver boys. Female suedeheads, or sorts, wore modish dresses and jumpers characteristic of the time, with button-down shirts, and heeled loafers. Their hair ranged from long to shorter, modish styles.

Suedeheads called all chunky loafers "Loakes" after the company that invented them

HAIRSTYLES:
FROM SUEDEHEADS TO SMOOTHIES AND BOOTBOYS

Inspired by biker gangs and the deplorable living conditions of decaying neighborhoods like the South Bronx and Williamsburg, Brooklyn, black and Puerto Rican teenagers founded legendary outlaw gangs that quickly spread throughout the boroughs of New York City.

New York's outlaw street gangs borrowed their fashion, style, and attitude from bikers, including the heroes of the 1969 film *Easy Rider* and the city's Hells Angels chapter, who still have a clubhouse today on East Third Street in the Lower East Side.

Like "1%er" biker gangs, these New York City street gangs wore colors—denim vests emblazoned with top and bottom rockers and gang emblems.

Though groups like the Savage Skulls were violent street gangs, they were often socially conscious as well, sharing views with contemporary political groups like the Black Panthers and the Young Lords.

In 1971, when Ghetto Brothers peacekeeper Cornell "Black Benjie" Benjamin was murdered while trying to broker a truce between two warring gangs, club president Benjy Meléndez called dozens of Bronx gangs to the Hoe Avenue Boys Club to broker a fragile truce. *The Warriors*, a 1979 cult movie, showed a fictional gang peace summit inspired by the Hoe Avenue Peace Meeting.

The peace that emerged from the Hoe Avenue Boys Club meeting led gang members to range beyond their territories, eventually allowing for the massive outdoor block parties that helped birth hip-hop in the mid-'70s.

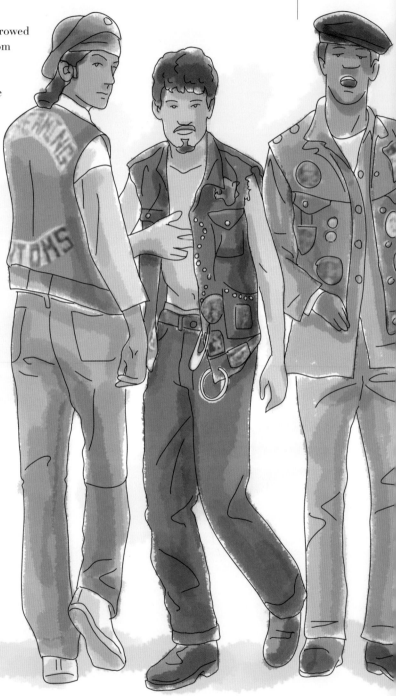

Berets inspired by the Young Lords and the Black Panthers indicated that some gangs had political ideals and did community service

THE CULTURE In the early 1970s, there were more than one hundred outlaw gangs in New York City, including the Savage Nomads, the Ghetto Brothers, the Seven Immortals, the Southside Dukes, the Black Spades, the Dirty Ones, the Sacred Lords, the Crazy Homicides, the Devil's Rebels, the Majestics, the Deadly Bachelors, the Sex Boys, the Harlem Turks, the Tomahawks, the Young Sinners, the Dirty Dozens, the Magnificent Seven, the Jolly Stompers, and the Screaming Phantoms.

ORIGIN: BROOKLYN AND THE BRONX, MID-1960s
TEENAGE OUTLAW GANGS ARISE AMONG THE RUINS OF NEW YORK CITY

Patches included iron crosses or swastikas, even though most gang members were black or Latino

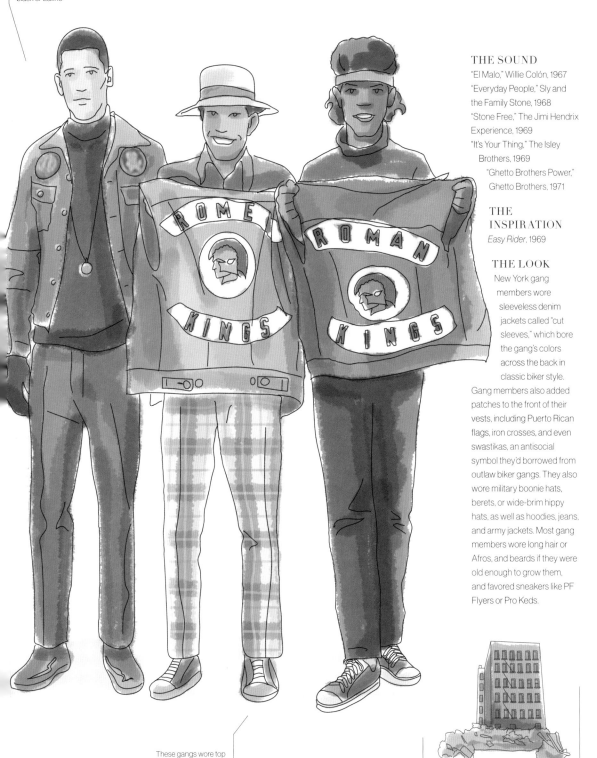

THE SOUND

"El Malo," Willie Colón, 1967

"Everyday People," Sly and the Family Stone, 1968

"Stone Free," The Jimi Hendrix Experience, 1969

"It's Your Thing," The Isley Brothers, 1969

"Ghetto Brothers Power," Ghetto Brothers, 1971

THE INSPIRATION

Easy Rider, 1969

THE LOOK

New York gang members wore sleeveless denim jackets called "cut sleeves," which bore the gang's colors across the back in classic biker style. Gang members also added patches to the front of their vests, including Puerto Rican flags, iron crosses, and even swastikas, an antisocial symbol they'd borrowed from outlaw biker gangs. They also wore military boonie hats, berets, or wide-brim hippy hats, as well as hoodies, jeans, and army jackets. Most gang members wore long hair or Afros, and beards if they were old enough to grow them, and favored sneakers like PF Flyers or Pro Keds.

These gangs wore top and bottom rockers, just like outlaw bikers

BURNT-OUT SOUTH BRONX BUILDING

In the late 1960s, northwest England and the Midlands played host to the formation of Northern Soul, a new, white working-class culture founded on a love of obscure American soul records and dance parties known as "all-nighters."

Northern Soul grew out of the mod and skinhead scenes. The Twisted Wheel, a mod nightclub in Manchester that had featured soul parties as early as 1963, was instrumental in creating the Northern Soul scene, though it closed in 1971 before the culture's peak.

Early Motown recordings were important to Northern Soul and established the basic sound enjoyed by dancers, but many of the scene's most beloved—and rarest—records came from smaller labels like Ric Tic, Backbeat, and Okeh. Many top Northern Soul DJs, like Richard Searling, traveled to the United States to buy rare records which they jealously guarded from rivals, obscuring labels or even giving them fake names.

London writer and record shop owner Dave Godin created the term Northern Soul in the late '60s to refer to the outdated records vacationing Northerners kept requesting in his shop. The Northern Soul scene adamantly held onto these early '60s records, never adopting the newer, funky, and socially conscious soul music that was popular on American record charts. Now, critics worldwide use the term to describe that genre of upbeat, danceable soul found on rare records from small labels.

Though Northern Soul featured a basic four-beat, side-to-side dance step, it's most famous for acrobatic dance moves like spins and dramatic backdrops.

Ultimately, Northern Soul floundered in the late '70s, partly because soulie diehards rejected attempts to bring contemporary recordings and white English pop into clubs.

Sweater vests (called "sleeveless jumpers" in England) were key to soulie style and a great place to sew badges and patches

THE CULTURE Northern Soul venues lubricated their dance floors with talcum powder to allow dancers to easily slide from side to side.

SOULIES

ORIGIN: NORTHERN ENGLAND, LATE 1960s
ALL NIGHT SOUL PARTIES FUEL ENGLAND'S FIRST DJ CULTURE

Soulies often wore their
hair to the shoulder like
smoothies and bootboys

Northern Soul borrowed
braces (or suspenders)
from skinheads

THE SOUND

"Tainted Love,"
Gloria Jones, 1964
"The Slow Fizz,"
The Sapphires, 1966
"I Stand Accused (Of Loving
You)," The Glories, 1967
"I Just Can't Live My Life
(Without You Babe),"
Linda Jones, 1969
"Don't It Make You Feel
Funky," Joe Hicks, 1968

THE LOOK

Male soulies wore massive,
high-waisted trousers called
"bags" and sweater vests
(called sleeveless pullovers
in the United Kingdom)
displaying patches from
various soul clubs. Bowling
shirts, Ben Sherman button-
downs, blazers, loafers or
brogues, and colored socks
were also popular. Female
soulies favored modish
elements, like short, Mary
Quant–inspired mini dresses,
but also wore long full-circle
skirts and sandals, which
were perfect for Northern
Soul's frenetic dancing.

Extra-wide flared trousers
known as bags kept dancers
cool at intense all-nighters

NORTHERN SOUL BADGES

Sharpies were an Australian youth gang culture that arose in Melbourne in the late 1960s and early 1970s, mixing their own stylistic flourishes with a love for glam rock and fashions borrowed from skinheads, mods, and soulies.

Though not well known outside their home country, sharpies lived up to the Australian reputation for carnage with a furious culture revolving around concerts, dances, gang fights, and of course, clothes.

Sharpie style incorporated aspects of glam and ultra-macho skinhead clothing into its own odd hybrid that saw closely cropped mullet hairstyles (and occasionally shags or mohawks) mixed with massive flared jeans, platform boots, cardigans, V-neck sweaters, and custom T-shirts that bore local gang names in iron-on letters.

Despite sharing some stylistic similarities with Australia's mods, sharpies considered those sharply-dressed youth mortal enemies. Local news reports of the time mention huge suburban clashes between sharpies and mods.

Australian newspaper *The Age* reported that one of these rumbles featured "vicious brawling" and "fighting youths, kicking viscously and hitting each other with clubs."

Sharpies loved glam acts like Slade and local hard rock favorites Coloured Balls and AC/DC, helping launch the latter band to international stardom.

Sharpie dancing was herky jerky and slightly resembled the "skanking" of ska fans.

Sharpies were also one of the first Western subcultures to adopt tough-looking tattoos and earrings.

Sharps' wore distinctive mullet hairstyles that were skinhead in the front, glam in the back

Jeans from Levi's® or Lee® were held up with suspenders, a nod to the Skinhead style of the UK

Baggy, flared trousers were influenced by English soulies

THE CULTURE Like many other heavily male youth subcultures, sharpies organized themselves around territories and extended families of friends and relatives, creating loose gangs for whom fighting was means to create a reputation and identity.

ORIGIN: MELBOURNE, SYDNEY, AND PERTH, LATE 1960s
AUSTRALIAN GLAM GANGS HAVE A TASTE FOR ULTRAVIOLENCE

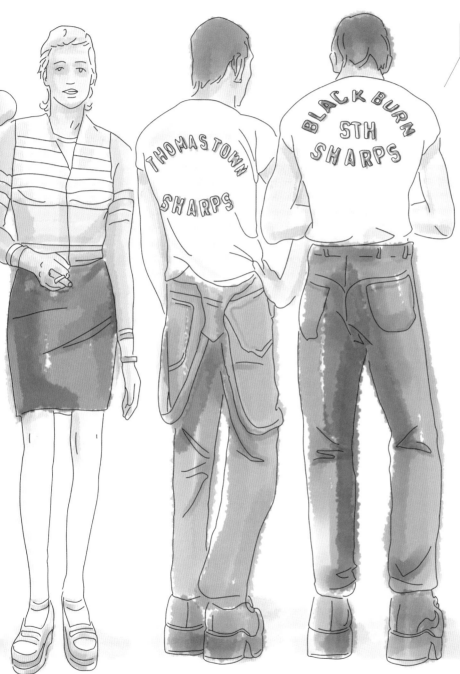

Gangs could be identified by their homemade T-shirts

THOMASTOWN SHARPS

BLACKBURN 5TH SHARPS

THE SOUND

"Cum on Feel the Noize," Slade, 1973
"Teenage Rampage," The Sweet, 1974
"Rebel Rebel," David Bowie, 1974
"Love You Babe," Coloured Balls, 1974
"It's a Long Way to the Top (If You Wanna Rock 'n' Roll)," AC/DC, 1975

THE LOOK

Sharpies wore gang cardigans, V-neck sweaters, or T-shirts with bell bottoms, and platform shoes or boots. Many added flat caps, earrings, suspenders, or tattoos to create their own unique looks. Sharpie hairstyles included short shags or mullets, shaved heads, and the occasional cropped mohawk.

DIY platform boots were painted to look two-toned

PLATFORM SHOES VARY WITH DECORATIVE STITCH AND COLOR DETAILS

Pop culture says the greaser died in the 1950s and that any appearance since was nothing but a revival. In Chicago, that wasn't the case, where groups of white boy gangsters known as stone greasers from crews like the Stoned Freaks and the Gaylords kept the culture alive into the '70s. In doing so, they added gang cardigans, baggy work pants, and even long hair to the culture, creating a unique, forgotten style.

"Stone" was '60s slang meaning "completely" or "thoroughly." Thus a "stone greaser" was a committed, diehard greaser.

Aside from long hair, gang sweaters were the most interesting element of stone greaser style. Though other Chicago gangs like the Latin Kings wore gang sweaters too, the stone greaser cardigans that became popular in the late '60s were notable for bright colors and elaborate emblems that proclaimed gang membership, territory, and the even the wearer's nickname and rank.

Many stone greaser gangs professed at least some "pride" in their heritage, which ranged from relatively innocuous statements like "Italian and proud," to the more aggressive and pernicious use of swastikas and KKK imagery. However, some stone greaser gangs opened their membership to Native Americans. Others, like the Gaylords, formed alliances with Latino gangs. Though not stone greasers, certain Hispanic gangs in northwest Chicago had diverse membership that included black and white members.

As whites moved out of inner-city Chicago in the '80s and '90s, stone greaser gangs died out. Nevertheless, some gangs like the Gaylords continue to meet up for barbecues and gatherings, even if their aging members no longer actively engage in criminal activity.

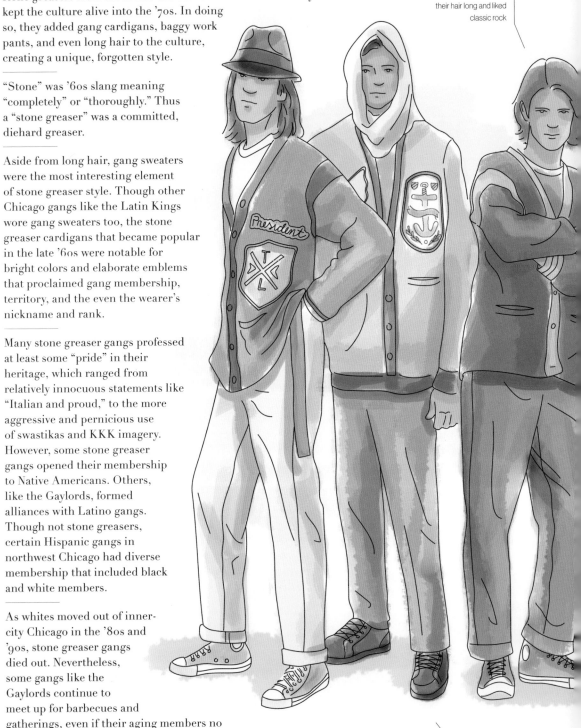

Stone greasers wore their hair long and liked classic rock

Gray or green work pants earned stone greasers the nickname "grayboys" from rival gangs

THE CULTURE In addition to their elaborate gang sweaters, stone greaser gangs carried "compliment cards," which they gave out as warnings, or left on beating victims like criminal business cards. These cards listed the gang's name, as well as members' names, gang symbols, and sometimes a roll call of enemies.

STONE GREASERS

ORIGIN: CHICAGO, LATE 1960s
LONG-HAIRED GANGSTERS KEEP GREASER CULTURE ALIVE IN CHICAGO

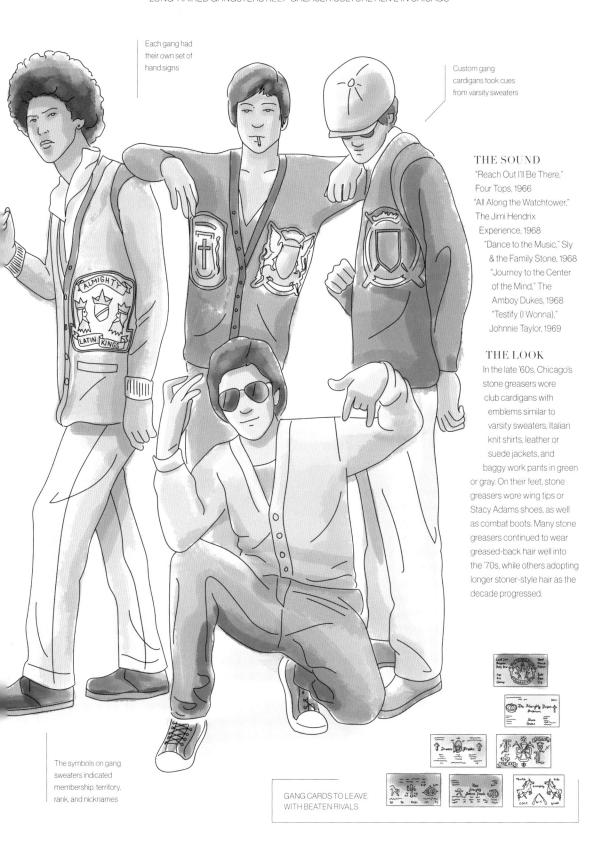

Each gang had their own set of hand signs

Custom gang cardigans took cues from varsity sweaters

THE SOUND

"Reach Out I'll Be There,"
Four Tops, 1966
"All Along the Watchtower,"
The Jimi Hendrix
Experience, 1968
"Dance to the Music," Sly
& the Family Stone, 1968
"Journey to the Center
of the Mind," The
Amboy Dukes, 1968
"Testify (I Wonna),"
Johnnie Taylor, 1969

THE LOOK

In the late '60s, Chicago's
stone greasers wore
club cardigans with
emblems similar to
varsity sweaters, Italian
knit shirts, leather or
suede jackets, and
baggy work pants in green
or gray. On their feet, stone
greasers wore wing tips or
Stacy Adams shoes, as well
as combat boots. Many stone
greasers continued to wear
greased-back hair well into
the '70s, while others adopting
longer stoner-style hair as the
decade progressed.

The symbols on gang sweaters indicated membership, territory, rank, and nicknames

GANG CARDS TO LEAVE
WITH BEATEN RIVALS

By the mid-'60s, amid social unrest and an emergent Chicano rights movement, the old pachuco style no longer made sense to Mexican American youth across California and the Southwest. So young Chicanos replaced the zoot suits of their fathers with a harder street style featuring workwear, denim, white T-shirts, and tattoos that alluded to both pride in their immigrant ancestors and friends who found themselves in prison. These were the cholos and their clean, rugged style would prove to be both influential and controversial.

Cholo is a South American colonial term for people of mixed indigenous and European heritage that has had negative connotations throughout history. Starting in the mid-'60s, Mexican Americans flipped it as their own to describe their emerging street culture.

Cholo culture still exists and is closely linked with lowrider car culture, as well as the deeply-ingrained street gangs of California and the Southwest. Though not all cholos are gangsters, some are members of gangs like the Texan Barrio Azteca Gang and the Sureño, Norteño, and Clanton 14 gangs from California, the latter of which dates back to 1921.

In addition to style and slang, cholos also communicate with a visual language of black and gray tattoos, graffiti, and folk art—all things featured in the independent cult magazine *Teen Angels*, founded by artist Dennis "Teen Angel" Holland in 1981.

Romantic depictions of Aztec heritage, beautiful cholas, "smile now, cry later" masks, clown makeup, and Catholic imagery make up the visual lexicon of cholo culture.

Cholo culture cherishes "cruisin' oldies"—1960s doo-wop, soul, and girl group music that's perfect for driving low and slow in custom lowriders. Certain cholos also love Anglo-Irish rocker Morrissey, whose romantic lyrics also suit the lowrider lifestyle.

"Smile now, cry later" clown tattoos were a reminder to cherish the good times

Cholo style was extra sharp, with chinos and shorts creased, ironed, and starched

THE CULTURE In addition to continuing to use pachuco caló slang like *firme* for cool and *hyna* for girl, cholos created terms like *ése* and *vato* meaning dude, and *ranfla* for lowrider. In Texas, cholos are still sometimes called "chucs," which is short for pachuco.

CHOLOS

ORIGIN: CALIFORNIA, NEW MEXICO, TEXAS, 1960s

CHICANOS BUILD A NEW STREET CULTURE ON THE FOUNDATIONS OF THEIR PACHUCO FOREBEARERS

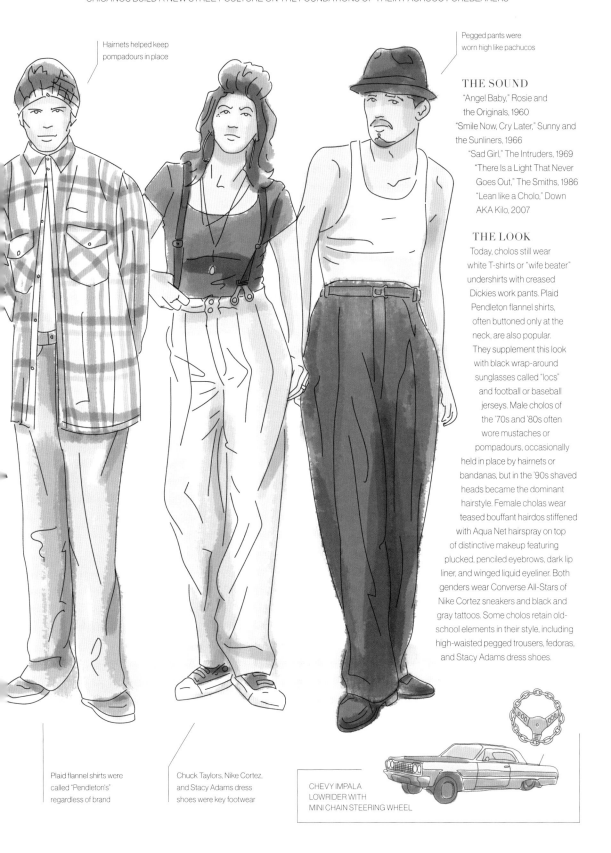

Hairnets helped keep pompadours in place

Pegged pants were worn high like pachucos

THE SOUND

"Angel Baby," Rosie and the Originals, 1960

"Smile Now, Cry Later," Sunny and the Sunliners, 1966

"Sad Girl," The Intruders, 1969

"There Is a Light That Never Goes Out," The Smiths, 1986

"Lean like a Cholo," Down AKA Kilo, 2007

THE LOOK

Today, cholos still wear white T-shirts or "wife beater" undershirts with creased Dickies work pants. Plaid Pendleton flannel shirts, often buttoned only at the neck, are also popular. They supplement this look with black wrap-around sunglasses called "locs" and football or baseball jerseys. Male cholos of the '70s and '80s often wore mustaches or pompadours, occasionally held in place by hairnets or bandanas, but in the '90s shaved heads became the dominant hairstyle. Female cholas wear teased bouffant hairdos stiffened with Aqua Net hairspray on top of distinctive makeup featuring plucked, penciled eyebrows, dark lip liner, and winged liquid eyeliner. Both genders wear Converse All-Stars of Nike Cortez sneakers and black and gray tattoos. Some cholos retain old-school elements in their style, including high-waisted pegged trousers, fedoras, and Stacy Adams dress shoes.

Plaid flannel shirts were called "Pendleton's" regardless of brand

Chuck Taylors, Nike Cortez, and Stacy Adams dress shoes were key footwear

CHEVY IMPALA LOWRIDER WITH MINI CHAIN STEERING WHEEL

PETER SAVILLE'S GLAM ROCK TOP FIVE

"Bang a Gong (Get It On)," T. Rex, 1972

"Starman," David Bowie, 1972

"Make Me Smile (Come Up and See Me)," Steve Harley
& Cockney Rebel, 1975

"Virginia Plain," Roxy Music, 1972

"Vicious," Lou Reed, 1972

HARD ROCK

Stripped down and amped up, hard rock is a faded denim jacket brought to musical life

"All Right Now," Free, 1970

"Black Dog," Led Zeppelin, 1971

"Easy Livin'," Uriah Heap, 1972

"Gimme Three Steps," Lynyrd Skynyrd, 1973

"La Grange," ZZ Top, 1973

"Sheer Heart Attack," Queen, 1973

"Rock Candy," Montrose, 1973

"Bad Company," Bad Company, 1974

"Fly By Night," Rush, 1975

"Slow Ride," Foghat, 1975

"Sweet Emotion," Aerosmith, 1975

"Carry On My Wayward Son," Kansas, 1976

"More Than A Feeling," Boston, 1976

"The Boys are Back in Town," Thin Lizzy, 1976

"Tie Your Mother Down," Queen, 1976

"(Don't Fear) The Reaper," Blue Öyster Cult, 1976

"Ain't Gonna Eat Out My Heart Anymore," Angel, 1977

"Barracuda," Heart, 1977

"Cat Scratch Fever," Ted Nugent, 1977

"Love Gun," KISS, 1977

"Rockin' All Over the World," Status Quo, 1977

"Runnin' With the Devil," Van Halen, 1978

"Highway to Hell," AC/DC, 1979

"I Live for the Weekend," Triumph, 1980

GLAM ROCK

Arch, sexy, and unapologetically decadent, glam rock brings a new sense of showbizzy fun to the post-hippie rock scene

"All the Young Dudes," Mott The Hoople, 1972

"School's Out," Alice Cooper, 1972

"Ballroom Blitz," Sweet, 1973

"Do You Wanna Touch Me? (Oh Yeah)," Gary Glitter, 1973

"Personality Crisis," New York Dolls, 1973

"Rock On," David Essex, 1973

"Saturday Night," Bay City Rollers, 1973

"Sebastian," Cockney Rebel, 1973

"See My Baby Jive," Wizzard, 1973

"Angel Face," The Glitter Band, 1974

"Deuce," Kiss, 1974

"Devil Gate Drive," Suzi Quatro, 1974

"Killer Queen," Queen, 1974

"Slaughter on Tenth Avenue," Mick Ronson, 1974

"The Cat Crept In," Mud, 1974

"The 'In' Crowd," Bryan Ferry, 1974

"This Town Ain't Big Enough for the Both of Us," Sparks, 1974

"Whizz Kid," David Werner, 1974

"Let's Get the Party Going," Warwick, 1975

"Sweet Lady," Queen, 1975

"White Punks on Dope," The Tubes, 1975

"Roxy Roller," Nick Gilder, 1976

"Coz I Luv You," Slade, 1976

"Star Machine," Woody Woodmansey's U-Boat, 1977

"And I Never Dreamed," Kaptain Kool and the Kongs, 1978

"New York Groove," Ace Frehley, 1978

FUNK

Sweatier and earthier than disco, funk builds community on the dance floor, expanding minds and moving behinds

"It's Your Thing," The Isley Brothers, 1969

"Get Up (I Feel Like Being a) Sex Machine, Pt. 1,"
James Brown, 1970

"Chicken Strut," The Meters, 1970

"Clean Up Woman," Betty Wright, 1971

"Do Your Thing," Isaac Hayes, 1971

"Move On Up," Curtis Mayfield, 1971

"Mr. Big Stuff," Jean Knight, 1971

"Respect Yourself," The Staple Singers, 1971

"Bra," Cymande, 1972

"Slippin' Into Darkness," War, 1972

"If You Want Me to Stay," Sly & The Family Stone, 1973

"Jungle Boogie," Kool & The Gang, 1973

"DO IT (Til' You're Satisfied)," B.T. Express, 1974

"Pick Up the Pieces," Average White Band, 1974

"Tell Me Something Good (feat. Chaka Khan)," Rufus, 1974

"The Same Love That Made Me Laugh," Bill Withers, 1974

"Play That Funky Music," Wild Cherry, 1976

"Tear the Roof Off the Sucker (Give Up the Funk)," Parliament, 1976

"Brick House," Commodores, 1977

"Slide," Slave, 1977

"Bootzilla," Bootsy Collins, 1978

"One Nation Under a Groove," Funkadelic, 1978

KRAUTROCK/EUROPEAN PROG

Coming at music from a uniquely Teutonic perspective, krautrock's improvisation ranged from polyrhythmic grooves to minimal synth pulsess

"Der LSD-Marsch," Guru Guru, 1970

"Babylon 1 Adantino," Deuter, 1971

"Hocus Pocus," Focus, 1971

"Watchin' You," Brainticket, 1971

"Hallgallo," Neu!, 1972

"Mother Universe," Wallenstein, 1972

"Vitamin C," CAN, 1972

"You Play For Us Today," Agitation Free, 1972

"Are You Receiving Me," Golden Earring, 1973

"Earth Calling," Hawkwind, 1973

"Inside," Eloy, 1973

"Krautrock," Faust, 1973

"Cosmic Mind Affair," Acqua Fragile, 1974

"Dino," Harmonia, 1974

"Mysterious Semblance at the Strand of Nightmares," Tangerine Dream, 1974

"Celebration (Including When the World Became the World)," PFM, 1975

"Echo Waves," Manuel Göttsching, 1975

"Letzte Tage - Letzte Nächte," Popol Vuh, 1976

"Karussell," Michael Rother, 1977

"Rockpommel's Land," Grobschnitt, 1977

"Ork Alarm," Magma, 1978

"Shuttle Cock," Ashra, 1978

"The Model," Kraftwerk, 1978

"Breitengrad 20," Cluster, 1979

 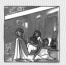

DISCO

When soulful R&B meets sleek futurism, dance floors come alive

"Kung Fu Fighting," Biddu, 1974

"Can't Get Enough of Your Love, Babe," Barry White, 1974

"That's the Way (I Like It)," KC & The Sunshine Band, 1975

"The Hustle (Original Mix)," Van McCoy, 1975

"Dancing Queen," ABBA, 1976

"Disco Inferno," The Trammps, 1976

"Love Hangover," Diana Ross, 1976

"More, More, More," Andrea True Connection, 1976

"Salsoul Hustle," The Salsoul Invention, 1976

"From Here to Eternity," Giorgio, 1977

"I Feel Love (12" Version)," Donna Summer, 1977

"In Hollywood (Everyone Is a Star)," Village People, 1977

"Ma Baker," Boney M., 1977

"Music Inspired By Star Wars," Meco, 1977

"Stayin' Alive," Bee Gees, 1977

"Boogie Oogie Oogie," A Taste of Honey, 1978

"Born to Be Alive," Patrick Hernandez, 1978

"I'm Every Woman," Chaka Khan, 1978

"I Will Survive," Gloria Gaynor, 1978

"Heart of Glass (12" Version)," Blondie, 1978

"Knock on Wood," Amii Stewart, 1978

"Le Freak," Chic, 1978

"Don't Stop 'Til You Get Enough," Michael Jackson, 1979

"Found a Cure," Ashford & Simpson, 1979

"Funky Town," Lipps Inc., 1979

"Ladies Night," Kool & The Gang, 1979

"We Are Family," Sister Sledge, 1979

In the early 1970s, musicians like Alice Cooper and David Bowie rebelled against self-serious psychedelic hippie rock, creating music with a newfound sense of pageantry and pop appeal known as glam rock. The glam rockers celebrated image and theatricality above authenticity, and gleefully pushed the envelope of performance, persona, and pop songwriting.

Alice Cooper was arguably the first true glam rock group, introducing horror-influenced stage props and makeup as early as the late-'60s. However, it wasn't until a glitter-dusted, metallic-suit-clad Marc Bolan and his band T.Rex performed "Hot Love" on the BBC's *Top of the Pops* in 1971 that glam rock crystallized as a musical genre and a distinct style of dress.

By this time, David Bowie had moved into his glam rock phase, adopting the bisexual, alien Ziggy Stardust persona for certain songs and performances in 1971, before releasing his *The Rise and Fall of Ziggy Stardust and the Spiders from Mars* concept album the following summer of 1972. Bowie's touring stage show in support of the album changed rock and roll and fully cemented glam rock as an artistic force.

Glam rock was the first rock culture to openly celebrate androgyny and cross-dressing while even hinting at homosexuality and bisexuality. As such, its performative gender aspects—not to mention showbiz props—owe a debt to drag queens and drag culture, perhaps including the glitter-drenched Cockettes theater troupe from San Francisco.

Though critics derided glam rock as vacant and narcissistic even as teenage fans flocked to it, it influenced punk rock in its frank transgression of gender norms, embrace of wild clothing, and obsession with high-octane reboots of '50s rock and roll. A teenage Sid Vicious, then known as Simon Ritchie, was a massive David Bowie fan before going punk. Glam rock also influenced the hair metal scene centered around LA's Sunset Strip in the '80s.

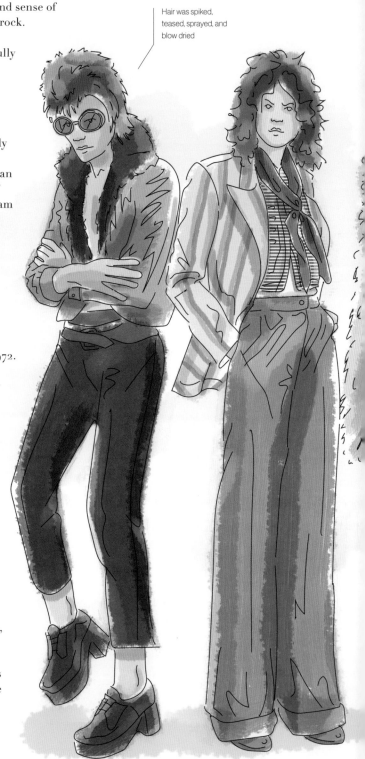

Hair was spiked, teased, sprayed, and blow dried

THE CULTURE Despite boasting influential acts like Alice Cooper and the New York Dolls, first-generation glam rock never had an impact on America quite like it did the United Kingdom, where glam acts like Slade, Sweet, and even Detroit's own Suzi Quatro regularly sold out shows and appeared on TV.

ORIGIN: DETROIT, NEW YORK, AND LONDON, EARLY 1970s
HARD ROCK FANS GO GLITZ

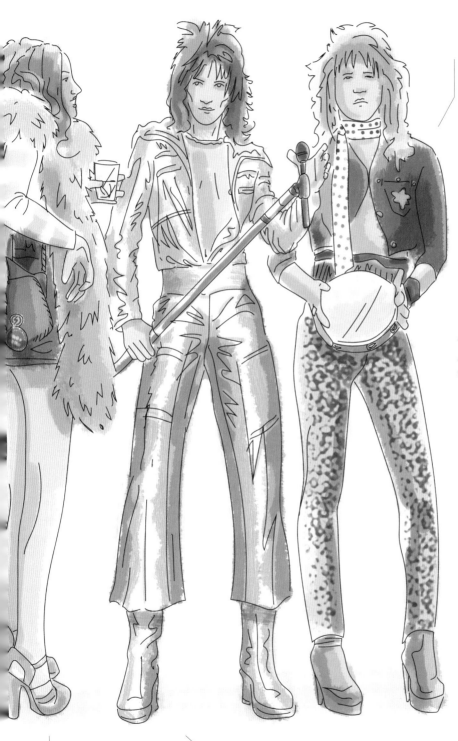

Glam was one of the
first pop movements to
play with gender

THE SOUND

"I'm Eighteen,"
Alice Cooper, 1970
"Hot Love," T. Rex, 1971
"Moonage Daydream,"
David Bowie, 1972
"48 Crash,"
Suzi Quatro, 1973
"AC-DC," Sweet, 1974

THE LOOK

As a primarily performative genre,
glam rock style was varied, but
included metallic fabrics, leather,
and glitter and makeup on both
male and female rockers.
Towering platform boots,
scarves, feather boas, leopard
print, and other patterns like
stripes were also popular,
as was long feathered hair
or shorter "mullet" style
haircuts on both genders.

Metallic materials
gave glam its
signature glitz

Glam was one of the first
subcultures to pull styles from
science fiction movies

CUSTOM-MADE PLATFORM BOOTS

A new menace arose in peaceful Japan in the early 1970s: all-girl gangs, intent on smoking cigarettes, shoplifting, sniffing glue, and defending their territory, all while wearing long skirts and chaste school uniforms. These were the sukeban, and they continue to influence Japanese subcultures and popular media today.

Sukeban style consisted of classic sailor *fuku* school girl uniforms, worn with the skirts extra-long, and set off by delinquent details like permed hair, baggy, colorful socks, and slip-on school shoes. In a show of solidarity, sukeban who'd already graduated high school continued to wear their sailor uniforms, often customizing them, cutting the tops short with scissors or embroidering roses or kanji characters on them.

Sukeban is a combination of the Japanese words for "female" (*suke*) and "boss" (*ban*), and roughly translates to "girl boss."

Though the sukeban's primary hustles were pickpocketing and shoplifting, they were also down to rumble, packing razors, chains, and bamboo kendo swords called *shinai*.

Sukeban gangs were strictly female affairs. Deviating from this rule, especially by hooking up with boys, was punishable by being burned with cigarettes, a practice they called "lynching."

At the peak of sukeban culture in the late-'70s, gangs reached massive sizes. The Kanto Women Delinquent Alliance boasted twenty thousand members, and was run like a corporation with a president and an account. Smaller gangs, like the United Shoplifters Group from Tokyo, numbered about eighty girls.

Though the sukeban faded away by the late-'80s, they'd made their mark on Japanese culture, influencing other subcultures like the takenoko-zoku, as well as a subgenre of female-focused "Pinky Violence" films, like Norifumi Suzuki's 1972 *Girl Boss Guerilla*, which in turn influenced actual sukeban style and culture.

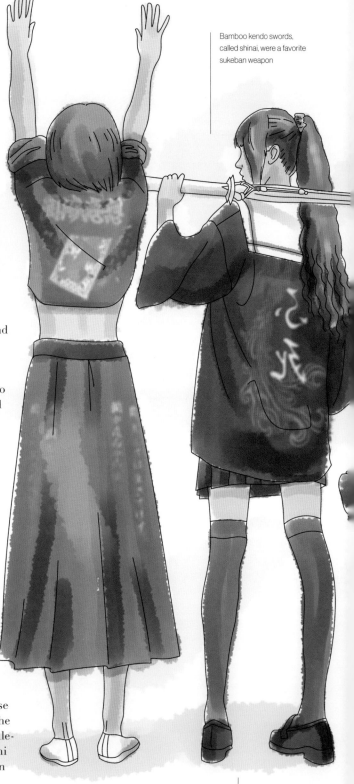

Bamboo kendo swords, called shinai, were a favorite sukeban weapon

School uniforms were customized with embroidered dragons, roses, or sayings in kanji characters

THE CULTURE Sukeban gangs may have originated with groups of girls slinking off to sneak cigarettes together, and smoking remained a key aspect of sukeban culture. Their favorite cigarette brands were Hope and Lark.

SUKEBAN

ORIGIN: JAPAN, 1970s

JAPAN'S ORIGINAL BAD GIRLS HAVE A TASTE FOR CIGARETTES AND RAZOR FIGHTS

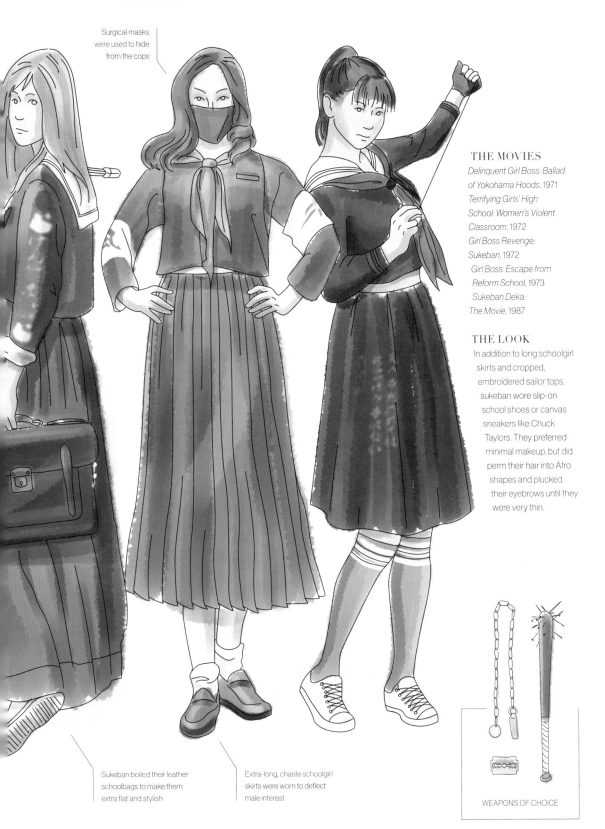

Surgical masks were used to hide from the cops

THE MOVIES

Delinquent Girl Boss: Ballad of Yokohama Hoods, 1971
Terrifying Girls' High School: Women's Violent Classroom, 1972
Girl Boss Revenge: Sukeban, 1972
Girl Boss: Escape from Reform School, 1973
Sukeban Deka: The Movie, 1987

THE LOOK

In addition to long schoolgirl skirts and cropped, embroidered sailor tops, sukeban wore slip-on school shoes or canvas sneakers like Chuck Taylors. They preferred minimal makeup, but did perm their hair into Afro shapes and plucked their eyebrows until they were very thin.

Sukeban boiled their leather schoolbags to make them extra flat and stylish

Extra-long, chaste schoolgirl skirts were worn to deflect male interest

WEAPONS OF CHOICE

In the early 1970s, New York DJ Francis Gross of gay nightclub The Sanctuary perfected a new way to play records live. He used two turntables, headphones, and slip-cueing to "beatmatch" songs, creating an unbroken loop of music that kept patrons on the dance floor all night. When this technique met the jazzy, psychedelic soul bubbling up from Philadelphia, New York, and Detroit, it created disco culture. This new lifestyle dominated dance floors in the mid-'70s and introduced gay and black culture to Middle America, before sparking a bitter backlash.

Prior to Gross's innovation, disco had three main influences: elite, big city, European-style discotheques like New York City's Le Club; psychedelic counterculture ballrooms like Bill Graham's Fillmore East; and massive black and Latino clubs and underground parties like The Loft, thrown by DJ David Mancuso.

Since the Euro-discos and counterculture movements were relatively racist and homophobic, these black and Latino clubs and underground parties profoundly influenced the disco scene with its eventual mix of gay men, Latinos, and African Americans.

Disco owned the record industry by the end of the '70s, forcing many radio stations to ditch rock music and fire DJs. Steve Dahl, a Chicago DJ, started an anti-disco campaign that culminated in "Disco Demolition Night" at a Chicago White Sox game in 1979, a near riot that saw seventy thousand disco haters converge on Comiskey Park to smash records. Dahl's campaign and thinly veiled homophobia were ultimately successful, forcing disco back into underground clubs like New York's Paradise Garage.

Female designers used spandex bodywear to challenge notions that feminists couldn't be feminine

THE CULTURE Black-owned and independent record labels like Philadelphia International Records and Salsoul were key in creating and spreading the disco sound, but established companies like Motown also played a part. Salsoul was the first company to sell commercially available 12-inch singles, a format formerly available only as a promotional item sent to DJs.

DISCO

ORIGIN: NEW YORK, 1970s
DJS TURN AMERICA'S BEAT AROUND

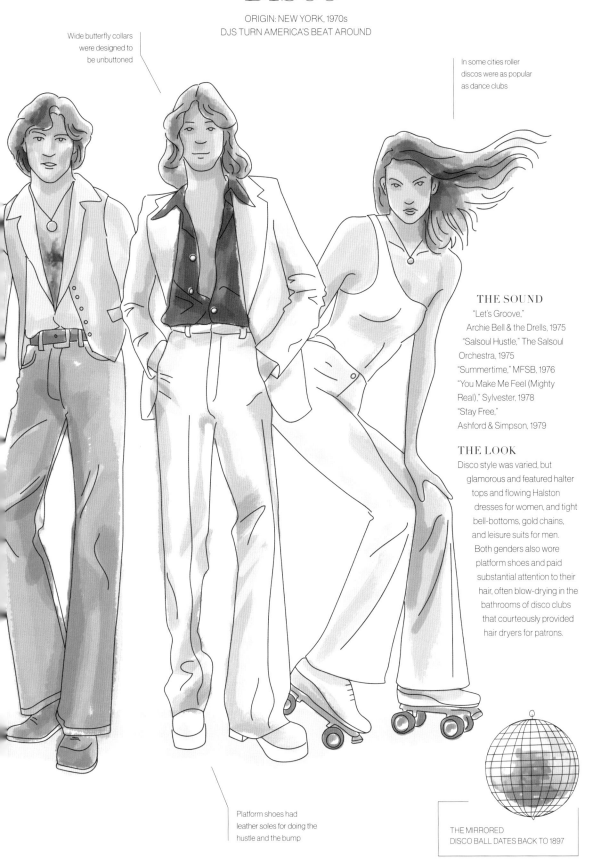

Wide butterfly collars were designed to be unbuttoned

In some cities roller discos were as popular as dance clubs

THE SOUND

"Let's Groove,"
Archie Bell & the Drells, 1975
"Salsoul Hustle," The Salsoul Orchestra, 1975
"Summertime," MFSB, 1976
"You Make Me Feel (Mighty Real)," Sylvester, 1978
"Stay Free,"
Ashford & Simpson, 1979

THE LOOK

Disco style was varied, but glamorous and featured halter tops and flowing Halston dresses for women, and tight bell-bottoms, gold chains, and leisure suits for men. Both genders also wore platform shoes and paid substantial attention to their hair, often blow-drying in the bathrooms of disco clubs that courteously provided hair dryers for patrons.

Platform shoes had leather soles for doing the hustle and the bump

THE MIRRORED
DISCO BALL DATES BACK TO 1897

In December 1971, *Village Voice* music critic Robert Christgau was the first writer to notice something unique about Grateful Dead fans, observing that at the band's New York City show, "regulars greeted other regulars, remembered from previous boogies, and compared this event with a downer in Boston or a fabulous night in Arizona." By then, the Grateful Dead had observed the same phenomenon and coined the term Deadhead to describe these superfans who traveled to every show.

The Grateful Dead began their career as the house band to Ken Kesey's Electric Kool-Aid Acid Test parties, free-form psychedelic freak-outs that let the band develop a unique style that relied heavily on live experimentation and improvisation.

Because the band always improvised, every Dead concert was unique and fans clamored for recordings of each show. Luckily, Grateful Dead sound engineer and sometime LSD-maker Owsley Stanley had begun recording the band from his soundboard as early as the Acid Test days, a practice fans soon picked up. The Grateful Dead realized the value of these recordings in maintaining and attracting fans, allowing Deadheads to continue the practice and even opening a tapers section at every show in the early 1980s.

By the mid-to-late '70s, dedicated Grateful Dead fans found it was possible to fund their band-trailing caravans by selling wares in the parking lot outside of shows. Fans named this traveling, open-air bazaar where one could buy tie-dye shirts, veggie burritos, and other less-legal substances "Shakedown Street" after the Dead's 1978 song.

Though the Deadhead phenomenon technically ended when the Grateful Dead split following lead guitarist Jerry Garcia's death in 1995, it still persists in some form to this day, as fans continue to follow offshoots of the band like The Dead and Co. and RatDog.

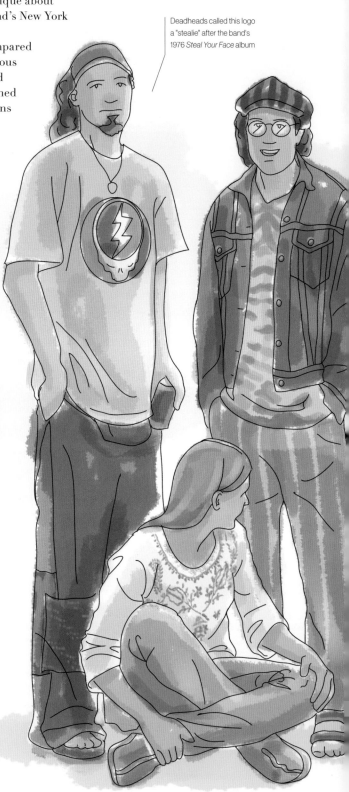

Deadheads called this logo a "stealie" after the band's 1976 *Steal Your Face* album

THE CULTURE Writers like Joshua Green of *The Atlantic* credit the Grateful Dead and its taping policy with anticipating social networking and the post-Internet musical economy, which devalues record sales and privileges word-of-mouth buzz as it translates into ticket and merchandize sales.

DEADHEADS

ORIGIN: UNITED STATES, 1970s
GRATEFUL DEAD FANS HIT THE ROAD FOR ONE LONG, STRANGE, TRIP

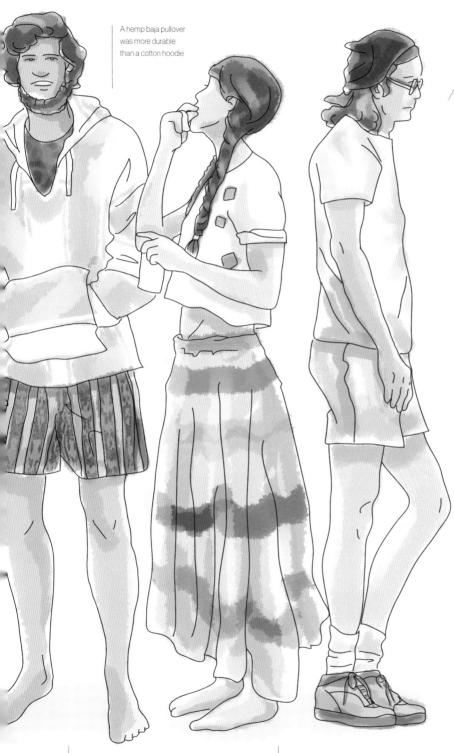

A hemp baja pullover
was more durable
than a cotton hoodie

Fans wore daisy dukes,
just like Bob Weir, the
Dead's rhythm guitarist

THE SOUND

"Dark Star," Grateful Dead, Old
Renaissance Faire Grounds,
Veneta, OR, August 27, 1972
"Terrapin Station," Grateful
Dead, Swing Auditorium, San
Bernardino, CA, February 26, 1977
"Scarlet Begonias > Fire On The
Mountain," Grateful Dead, Barton
Hall, Cornell University, Ithaca,
NY, May 8, 1977
"Shakedown Street," Grateful
Dead, New Haven Coliseum,
New Haven, CT, October 25, 1979
"Drums > Space," Grateful Dead,
Baltimore Civic Center, Baltimore,
MD, April 19, 1982

THE LOOK

Deadheads were known for
the homemade tie-dyed shirts,
shorts, and long hair worn
by both genders. Female
Deadheads also popularized
long, flowing hippie dresses,
and both genders favored
Birkenstock or Teva
sandals. In the late '80s,
white Deadheads also began
wearing their hair in dreadlocks.

Shorts were made
from hand-woven
Guatemalan fabric

Long, straight hippie hair
and braids were kept alive
well into the '90s

FAN-MADE BOOTLEG CONCERT TAPES

To create punk, downtown New York rockers combined '60s garage rock with the swagger of Warhol's Superstars, and a touch of glam to create an image and music that was bold, rough, and instantly recognizable.

Heavy psychedelic bands like The Stooges and rough glam bands like the New York Dolls deeply influenced punk with their Chuck Berry licks, unconventional style, and transgressive attitudes.

Prior to the '70s, punk was slang for hoodlum—often with homosexual undertones that hinted at gay prostitution and passive prison homosexuality. Music critics like Lester Bangs first used punk to describe '60s garage rock bands, but the 1975 publication of *Punk* magazine cemented its meaning, documenting the downtown bands and culture coalescing around Bowery club CBGB.

The Ramones of Forest Hills, Queens, were the first true punk band, writing energetic two-minute songs that combined garage fury with girl-group pop, all presented in a costume of leather biker jackets, tight Levi's®, Keds, and bowl cuts inspired by the male hustlers who plied their trade on New York streets in search of a fix.

After selling retro Teddy Boy and rocker gear at his King's Road store Let It Rock with his girlfriend Vivienne Westwood, Englishman Malcolm McLaren came to New York to sell clothes and manage the New York Dolls. There he met early punks like Richard Hell of Television, whose torn T-shirt and shorn hair McLaren repackaged to clothe his band The Sex Pistols, whom he'd recruited from his London shop, now called SEX.

Following McLaren's influence and UK tours by The Ramones, punk exploded in England, where its political conscious and extreme fashion flourished.

Punk bands like The Ramones, The Sex Pistols, Blondie, The Clash, and The Damned proved massively influential, spawning offshoots like hardcore, street punk, and Oi!

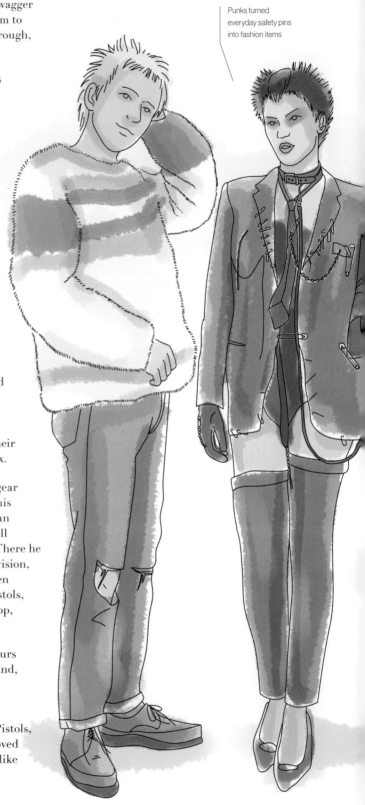

Punks turned everyday safety pins into fashion items

THE CULTURE Punk culture reveled in degradation; many early punks like Dee Dee Ramone and Sid Vicious were addicted to heroin and audiences would praise bands by spitting on them, a practice that came to be called "gobbing" in England.

PUNK

ORIGIN: NEW YORK AND LONDON, 1970s
A BLANK GENERATION RISES

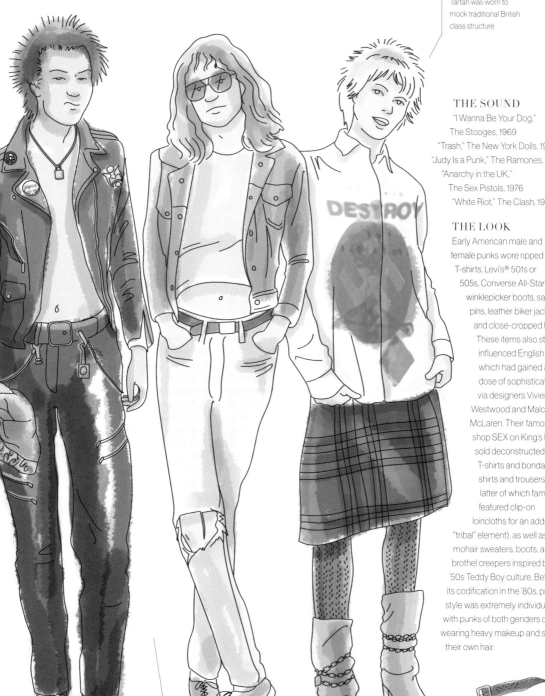

Tartan was worn to mock traditional British class structure

THE SOUND

"I Wanna Be Your Dog,"
The Stooges, 1969
"Trash," The New York Dolls, 1973
"Judy Is a Punk," The Ramones, 1976
"Anarchy in the UK,"
The Sex Pistols, 1976
"White Riot," The Clash, 1977

THE LOOK

Early American male and female punks wore ripped T-shirts, Levi's® 501s or 505s, Converse All-Stars or winklepicker boots, safety pins, leather biker jackets, and close-cropped hair. These items also strongly influenced English punk, which had gained a dose of sophistication via designers Vivienne Westwood and Malcolm McLaren. Their famous shop SEX on King's Road sold deconstructed T-shirts and bondage shirts and trousers (the latter of which famously featured clip-on loincloths for an added "tribal" element), as well as fuzzy mohair sweaters, boots, and brothel creepers inspired by '50s Teddy Boy culture. Before its codification in the '80s, punk style was extremely individualistic, with punks of both genders often wearing heavy makeup and styling their own hair.

The first lock-and-chain necklaces were bought at hardware stores

Deedee Ramone wore a leather jacket when he was a male hustler on 53rd Street and 3rd Avenue in New York

STUDDED COLLAR AND BONDAGE BELT

In 1973, Bronx DJ Kool Herc discovered he could extend a song's drum break indefinitely using two copies of the same record and a mixer. He called this "The Merry-Go-Round," but it later became known as hip-hop. Alongside this new music, black and Latino youth from the Bronx created b-boy culture, and its signature dance "breaking," with two imperatives: looking fresh and dominating any and all challengers in dance battles that sometimes substituted for the gang warfare that had ravaged the Bronx and New York City during the late '60s and early '70s.

Though origin of the term b-boy is obscure, Kool Herc claims he called the kids dancing to his percussive new music "break boys" and "break girls." Thus, "breaking" became the name for this new dance.

Breaking was purposely combative, with individuals or crews challenging each other to see who had the most style and the best moves. "Uprocking" (originally just "rocking") is breaking's most basic move, and features complicated footwork inspired by James Brown's "Good Foot" dancing, as well as stylized hand gestures known as "burns" intended to mock opponents.

B-boy crews, like the Rock Steady Crew or the Dynamic Rockers, were integral to early hip-hop and often sported matching crewneck sweatshirts or T-shirts with their names in iron-on old English lettering.

Innovators from these crews, like Rock Steady's Richard "Crazy Legs" Colón and Wayne "Frosty Freeze" Frost, added acrobatics to breaking with new moves like the backspin, headspin, windmill, and "freezes," which meant the dancer would freeze in place on a particularly stylish move.

Former gang members were integral to the b-boy scene, and helped push kids from destructive gang warfare towards breaking or one of hip-hop's other three arts: DJing, MCing, and graffiti.

THE CULTURE In addition to helping propel hip-hop into the mainstream, b-boys' most lasting cultural gift might be the fetishization of the sneaker as a key element of fashion, something they emphasized by customizing their sneakers with "fat" laces and matching them to tracksuits and other outfits.

DIY crew shirts were made with gothic iron on letters

Crossed arms became known as the b-boy stance

ORIGIN: THE BRONX, MID-1970S
HIP-HOP'S FIRST FANS CREATE A NEW DANCE THAT PROVES STYLE IS KING

Breakers wore nylon
tracksuits to spin
on cardboard

German-made Cazal
glasses were a b-boy
status symbol

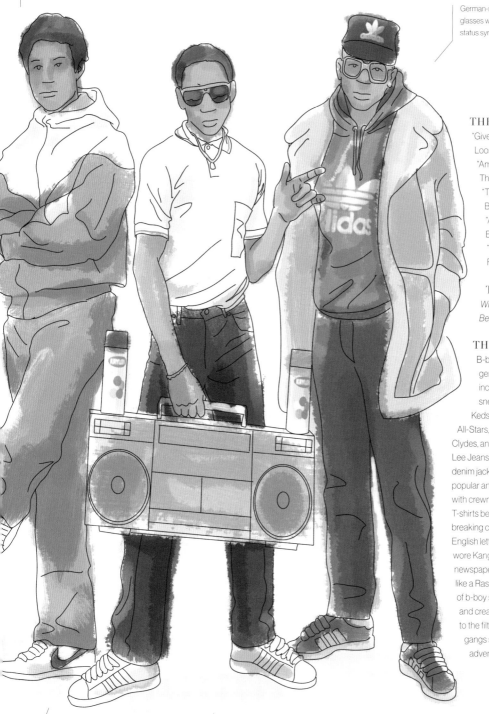

THE SOUND

"Give It Up Or Turnit a
Loose," James Brown, 1969
"Amen Brother,"
The Winstons, 1969
"The Mexican,"
Babe Ruth, 1972
"Apache," Incredible
Bongo Band, 1973
"That's the Joint,"
Funky 4+1, 1980

THE FILMS

Wild Style, 1983
Beat Street, 1984

THE LOOK

B-boy styles for both
genders were similar and
included tracksuits and
sneakers (especially Pro
Keds, PF Flyers, Converse
All-Stars, Puma Suedes or
Clydes, and adidas Superstars).
Lee Jeans and custom-painted
denim jackets were also
popular and were often worn
with crewneck sweatshirts or
T-shirts bearing the names of
breaking crews in iron-on Old
English lettering. Many b-boys
wore Kangol hats stuffed with
newspaper so they looked "puffy"
like a Rastafarian tam. The point
of b-boy style was looking "fresh"
and creating a clean alternative
to the filthy biker look NYC
gangs sported just prior to the
advent of hip-hop.

Fat laces added extra
swagger to sneakers

B-boys carried
boomboxes
everywhere

NEW YORK CITY
SUBWAY CAR BURNER

If the sukeban were Japan's first female rebels, the takenoko-zoku were the next generation, something Tokyo officials never expected to manifest when they opened a *hokoten* (a pedestrian paradise where people could walk and hang out on Sundays) near Yoyogi Park in Harajuku in 1977. Takenoko-zoku, energetic, disaffected youth who just wanted to dance, soon overran this paradise claiming the streets as their own.

The takenoko-zoku drew their name from Harajuku's Boutique Takenoko where they bought their costumes, called Haremu-sutsu (Harem suits). Takenoko means "bamboo shoot," while zoku is a Japanese suffix meaning "tribe." Thus, the takenoko-zoku were the "bamboo shoot tribe."

Traditional Japanese and Chinese clothes inspired the takenoko-zuku's outfits, which was remarkable considering past Japanese subcultures like the Miyuki-zoku only wore Western clothing.

Female takenoko-zuku also wore inexpensive accessories, like plush toys and plastic beads or whistles, a pastiche that influenced decora style of the late '90s.

Takenoko-zuku groups were mainly female, but often had one or two male dance leaders.

Takenoko-zuku dances were coordinated and highly choreographed, consisting mainly of simple hand movements and turning in circles. Dancers played music on boom boxes, but were not particularly concerned with any certain style of music, settling for pop hits from the United States, Europe, and Japan.

By the early '80s, most takenoko-zuku had turned to other trends, and the Harajuku hokoten near Yoyogi Park was overtaken by rival crews of rockabilly-loving street dancers.

Plastic whistles and knickknacks were bought in nearby

Harem suits were some of the first Japanese street styles based on traditional Asian designs

THE CULTURE Takenoko-zuku crews had names like Rainbow, Angels, Utopia, or Elegance, and differentiated themselves from other groups with large, colorful banners.

TAKENOKO-ZOKU

ORIGIN: TOKYO, LATE 1970s
JAPANESE TEENS JUST WANT TO DANCE

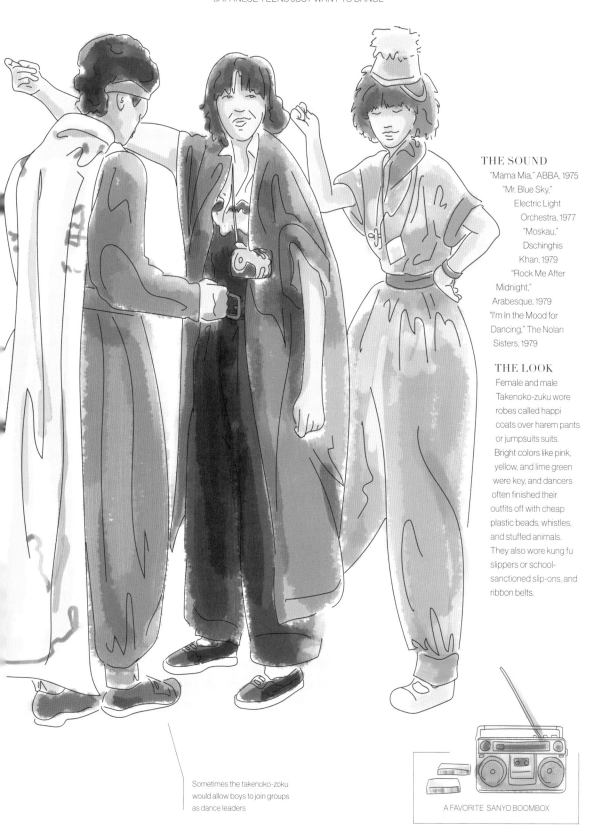

THE SOUND

"Mama Mia," ABBA, 1975
"Mr. Blue Sky,"
Electric Light
Orchestra, 1977
"Moskau,"
Dschinghis
Khan, 1979
"Rock Me After
Midnight,"
Arabesque, 1979
"I'm In the Mood for
Dancing," The Nolan
Sisters, 1979

THE LOOK

Female and male
Takenoko-zuku wore
robes called happi
coats over harem pants
or jumpsuits suits.
Bright colors like pink,
yellow, and lime green
were key, and dancers
often finished their
outfits off with cheap
plastic beads, whistles,
and stuffed animals.
They also wore kung fu
slippers or school-
sanctioned slip-ons, and
ribbon belts.

Sometimes the takenoko-zoku
would allow boys to join groups
as dance leaders

A FAVORITE SANYO BOOMBOX

MARKY RAMONE'S PUNK TOP FIVE

"Personality Crisis," New York Dolls, 1973
"Chinese Rocks," Johnny Thunders
and the Heartbreakers, 1977
"Blank Generation," Richard and the Voidiods, 1977
"My Way," Sid Vicious, 1979
"I Wanna Be Sedated," The Ramones, 1980

PUNK

Punk rewrites the rock rulebook,
bringing DIY urgency to the people

"(I Live For) Cars and Girls," The Dictators, 1975
"Anarchy in the UK," The Sex Pistols, 1976
"Born to Lose," The Heartbreakers, 1977
"See No Evil," Television, 1977
"Sonic Reducer," Dead Boys, 1977
"We Are the One," The Avengers, 1977
"White Riot," The Clash, 1977
"Oh Bondage Up Yours!" X-Ray Spex, 1978
"Teenage Kicks," The Undertones, 1978
"What Do I Get?," Buzzcocks, 1978
"She's Not There," U.K. Subs, 1979
"Where Did His Eye Go?," The Dickies, 1979

JAZZ FUSION

Electric instruments and funk rhythms
get improvisational

"Big Nick," Tony Williams Lifetime, 1970
"Bitches Brew," Miles Davis, 1970
"Devil Lady," Dreams, 1970
"Slightly All the Time," Soft Machine, 1970

"Don't You Know the Future's In Space?," Eddie Harris, 1970
"A Love Supreme (feat. John Coltrane)," Carlos Santana
& John McLaughlin, 1973
"Bass Folk Song," Stanley Clarke, 1973
"Boogie Woogie Waltz," Weather Report, 1973
"Stratus," Billy Cobham, 1973
"Feel," George Duke, 1974
"Hang Up Your Hang Ups," Herbie Hancock, 1975
"Illusion," Isotope, 1975
"Take Me to the Mardi Gras," Bob James, 1975
"Born Ugly," Brand X, 1976
"Midwestern Nights Dream," Pat Metheny, 1976
"Oh Yeah," Jan Hammer, 1976
"The Sun is Dancing," Narada Michael Walden, 1976
"Take It Off the Top," Dixie Dregs, 1978
"Codona," Codona, 1979

OUTLAW COUNTRY

Country music rebels forgo slick production
and pop lyrics to sing about the wild side of life
over raw arrangements

"The Silver-Tongued Devil and I," Kris Kristofferson, 1971
"To Live Is to Fly," Townes Van Zandt, 1971
"Dallas," The Flatlanders, 1972
"Seven Bridges Road," Steve Young, 1972
"Bad, Bad Cowboy," Tompall Glaser, 1973
"I Been to Georgia on a Fast Train," Billy Joe Shaver, 1973
"Rosalie's Good Eats Cafe," Bobby Bare, 1973
"Shotgun Willie," Willie Nelson, 1973
"Up Against the Wall, Redneck Mother," Jerry Jeff Walker, 1973
"Are You Sure Hank Done It This Way," Waylon Jennings, 1975
"L.A. Freeway," Guy Clark, 1975
"Longhaired Redneck," David Allen Coe, 1975
"Ohoopee River Bottomland," Larry Jon Wilson, 1975
"There Oughta Be a Law Against Sunny Southern California,"
Terry Allen, 1975
"You Ain't Never Been Loved (Like I'm Gonna Love You),"
Jessi Colter, 1975
"She Never Spoke Spanish to Me," Joe Ely, 1977
"Take This Job and Shove It," Johnny Paycheck, 1977
"I Ain't Living Long Like This," Rodney Crowell, 1978

STEFAN SAGMEISTER'S PROG ROCK TOP FIVE

"I Talk to the Wind," King Crimson, 1969

"Us and Them," Pink Floyd, 1973

"Station to Station," David Bowie, 1976

"Yours Is No Disgrace" Yes, 1971

"Solsbury Hill," Peter Gabriel, 1977

PROG ROCK

Building on psychedelia's most experimental excursions, prog and art rock brought new sounds and philosophical lyrics to modern music

"Why Are We Sleeping?", The Soft Machine, 1968

"Question," Moody Blues, 1970

"To Cry You a Song," Jethro Tull, 1970

"Song From the Bottom of a Well," Kevin Ayers, 1971

"The Advent of Panurge," Gentle Giant, 1972

"Trilogy," Emerson, Lake & Palmer, 1972

"10538 Overture," Electric Light Orchestra, 1972

"For Calvin (And His Next Two Hitch-Hikers)," Frank Zappa, 1972

"Watcher of the Skies," Genesis, 1973

"The Thrill of it All," Roxy Music, 1974

"Third Uncle," Brian Eno, 1974

"Fitter Stoke Has a Bath," Hatfield and the North, 1975

"In the Dead of Night," U.K., 1978

REGGAE, ROOTS & DUB

Spirituality, justice, and bass create a warm, enveloping sound / Stripping out the vocals and boosting the bottom end, dub is the secret history of modern music

"Marcus Garvey," Burning Spear, 1974

"Roots of Dub," King Tubby, 1975

"Curly Dub," The Upsetters, 1976

"King Tubby Meets Rockers Uptown," Augustus Pablo, 1976

"Natty Cultural Dread," Big Youth, 1976

"Police and Thieves," Junior Murvin, 1976

"Positive Vibration," Bob Marley & The Wailers, 1976

"Rock Vibration," Yabby U, 1976

"Rastaman," Bunny Wailer, 1976

"War Ina Babylon," Max Romeo, 1976

"Fever," Horace Andy, 1977

"Fisherman," The Congos, 1977

"National Anthem Dub 2," Keith Hudson, 1977

"Two Sevens Clash," Culture, 1977

"Dance A Dub," Junior Delgado, 1978

"Don't Shoot the Youth," Tapper Zukie, 1978

"I'm the Toughest," Peter Tosh, 1978

"Guess Who is Coming to Dinner," Black Uhuru, 1979

"Mr. Brown," Gregory Isaacs, 1979

"Saturday Night Style," Mikey Dread, 1979

HEAVY METAL

Throwing devil horns instead of peace signs, heavy metal strips the psychedelic improvisation out of late '60s acid blues

"Big Teaser," Saxon, 1970

"Paranoid," Black Sabbath, 1970

"Child in Time," Deep Purple, 1972

"Supernaut," Black Sabbath, 1972

"Doctor Doctor," UFO, 1974

"In Trance," Scorpions, 1975

"Man on the Silver Mountain," Rainbow, 1975

"Earthshaker," Y&T, 1976

"Street Fighter," Triumph, 1976

"Exciter," Judas Priest, 1978

"Expect No Mercy," Nazareth, 1977

"Pleasure Seekers," Quartz, 1977

"Susie," Krokus, 1978

"Back in the Streets," Dokken, 1979

"Invasion," Iron Maiden, 1979

"Koz," Samson, 1979

"Lady Lou" Accept, 1979

"Livin' in a Ram's Head," Pentagram, 1979

"Overkill," Motörhead, 1979

"You're a Woman Now," Helix, 1979

By 1979, bands like Iron Maiden and Saxon had completely changed heavy music, destroying any remaining trace of hippie psychedelia. In its place came speed, soaring vocals, technical guitar solos, and an interest in Satan. A youthful fan base emerged alongside this new music, which writers called the "New Wave of British Heavy Metal." These were the first true metalheads, and like the music, they were louder, meaner, younger, and more aggressive than the hard rock fans who came before them.

Though the New Wave of British Heavy Metal is now viewed as a departure from the first generation of hard rock, one group in particular bridged this gap. Judas Priest, formed in Birmingham, England, in 1969, started out in the heavy blues mold of bands like Deep Purple, but changed their tune on the 1978 album *Killing Machine*. This faster, more complex sound used Les Binks's double-bass drumming to showcase the twofold lead guitar attack of Glenn Tipton and K. K. Downing, just as lead singer Rob Halford pushed his vocals to ever more operatic heights.

DJ Neal Kay was instrumental in creating the metalhead subculture. At his London parties, where acts like Angel Witch regularly played while he spun records between sets, denim and leather-clad kids began showing up with cardboard guitars, which they used as props for "headbanging" and "air guitar," raucous dances that defined metal forevermore.

As the New Wave of British Heavy Metal died down in the early '80s, American bands like Metallica and Slayer created thrash metal, an even faster, harder sound that attracted legions of new metalheads to the scene.

With innumerable genres of metal— including death metal, power metal, and black metal—still enormously popular, metalheads exist today, perhaps in greater numbers than ever before.

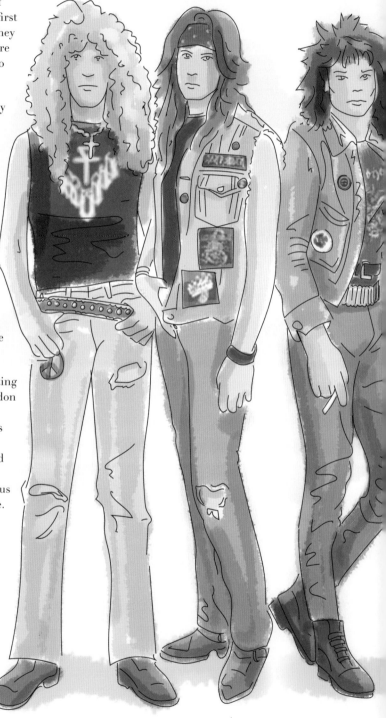

Metalheads perfected a technique for ripping their jeans by shaving the top layer of denim off with a pocketknife so the holes would look natural

THE CULTURE In the '80s, American metalheads were famous for lurking around video game arcades and convenience store parking lots, where they smoked cigarettes and bullied younger kids.

METALHEADS

ORIGIN: UNITED KINGDOM, LATE 1970s
BAD KIDS BANG THEIR HEADS

Band patches were
meticulously sewn onto
vests after every concert

Spiked leather gauntlets were
inspired by Judas Priest singer
Rob Halford, who nicked them
from gay leatherman style

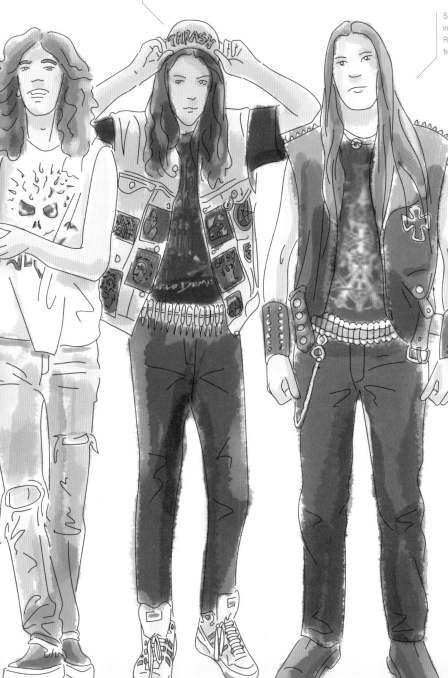

THE SOUND

"Hell Bent for Leather,"
Judas Priest, 1978
"Baphomet,"
Angel Witch, 1980
"Demolition Boys,"
Girlschool, 1980
"747 (Strangers in the
Night)," Saxon, 1980
"The Number
of the Beast,"
Iron Maiden, 1982

THE LOOK

Metalheads of both
genders adopted a
"leather and studs"
look inspired by bands
like Judas Priest who
notoriously borrowed
the style from the gay
leatherman culture, which
consisted of motorcycle
jackets worn with tight black
or blue jeans, denim vests or
jackets, and boots or high-top
sneakers. Metalheads wore
their hair long, religiously
collected band T-shirts, and
adorned their jackets with
studs, band patches, and pins.
They sometimes wore spiked
bracelets or belts, leather
gloves, and bullet-shell belts.

Dirty white high-tops with
puffy tongues were the mark
of a true 1980s hesher

EVOLUTION
OF THE
METAL MOUSTACHE: FROM DIRT STACHE TO MUTTON CHOPS

Like the United States, Japan experienced a 1950s rockabilly revival during the '70s, which happened to coincide with the opening of the *Harajuku hokoten* (pedestrian paradise) near Yoyogi Park. Starting in 1977, this car-free walkway was open only on Sundays, and had already attracted groups of teenage dancers known as *takenoko-zoku*. When the takenoko-zoku began attracting huge crowds, putting on a show became irresistible. Soon Japan's rockabilly fans, the street rockers (sometimes called the *Rokkun-rora-zoku*, a Japanese transliteration of "rock and rollers" with the suffix *zoku* tacked on, meaning tribe) flocked to Yoyogi Park too, intent on showcasing their hip swivels, leather pants, and outsize pompadours.

The history of rockabilly in Japan predates the Yoyogi Park street rockers by more than twenty years. In 1955, Japanese rockabilly artist Chiemi Eri released a hit cover of Bill Haley's "Rock Around the Clock." At the same time, Japanese biker gangs known as the kaminari-zoku were riding rough over the country, with rebel attitudes borrowed from music and movies like *The Wild One*. Artists like Mickey Curtis, Masaaki Hiraou, and Keijiro Yamashita, known as "The Three Rockabilly Men," soon followed, racking up hit covers of American songs and performing at the Nichigeki Western Carnival, an ongoing event that attracted as many as 45,000 fans until its closure in 1977.

Just before the street rockers began their weekly dance parties, a new generation of Japanese rockabilly bands sprang up to inspire the dancers with new songs and help push Japanese rockabilly fashion forward. Carol, founded in 1972, released a number of hit albums, while also bringing all-leather outfits to the forefront of Japanese rockabilly style.

Though the takenoko-zoku phenomenon died in the early '80s, groups like the Tokyo Rockabilly Club have kept the street rocker culture going strong to this day.

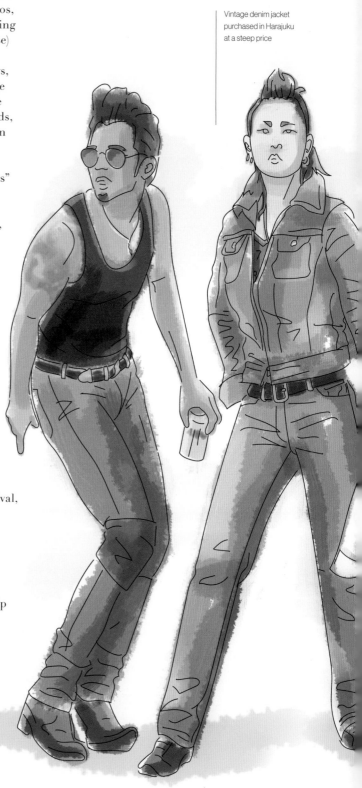

Vintage denim jacket purchased in Harajuku at a steep price

Street rockers favored pointy winklepicker boots

THE CULTURE In a country where tattoos are associated with yakuza gangsters, street rockers are among the only citizens to proudly display their ink in public despite having no criminal ties.

ORIGIN: TOKYO, LATE 1970s
TOKYO TEENS JUST WANT TO ROCK AND ROLL

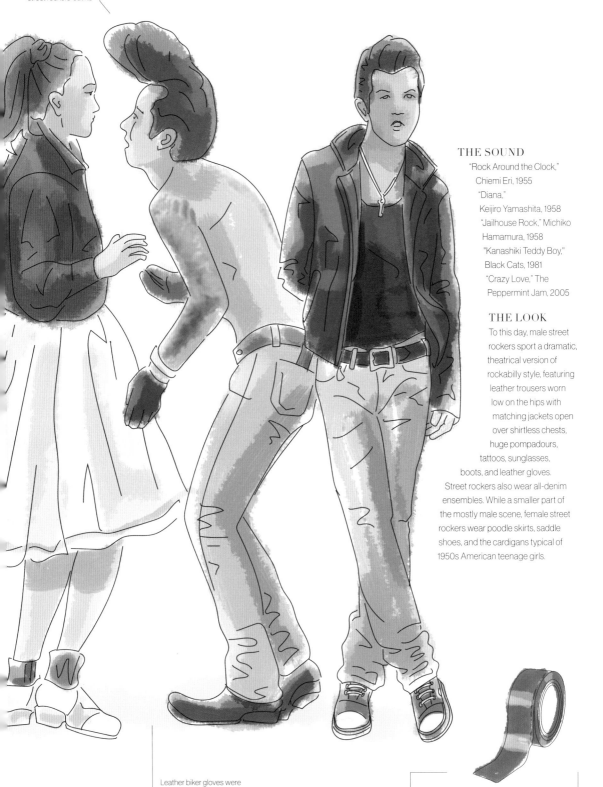

Oversized pompadours added theatrical drama to street rockers' outfits

THE SOUND

"Rock Around the Clock,"
Chiemi Eri, 1955
"Diana,"
Keijiro Yamashita, 1958
"Jailhouse Rock," Michiko
Hamamura, 1958
"Kanashiki Teddy Boy,"
Black Cats, 1981
"Crazy Love," The
Peppermint Jam, 2005

THE LOOK

To this day, male street rockers sport a dramatic, theatrical version of rockabilly style, featuring leather trousers worn low on the hips with matching jackets open over shirtless chests, huge pompadours, tattoos, sunglasses, boots, and leather gloves. Street rockers also wear all-denim ensembles. While a smaller part of the mostly male scene, female street rockers wear poodle skirts, saddle shoes, and the cardigans typical of 1950s American teenage girls.

Leather biker gloves were picked out to match boots

BLACK TAPE FOR DANCE-WORN BOOTS

After America embraced Ivy League style in the late 1950s, the country's elite youth created a new look to differentiate themselves from the masses. This look was sportier, more rebellious, less attainable, and a bit more rumpled than before. It was prep and it would eventually take over America and then the world.

The history of American collegiate style has been a race to see who could be the most subversive while still meeting the demands of elite society. In the '20s, college kids began to wear varsity sweaters and button-down shirts on the streets, which was revolutionary at the time. The Ivy Leaguers of the '50s kept these items, but added two-button cuff jackets, chinos, and sneakers.

For preppies, who emerged in the '70s, this wasn't enough. Where Ivy Leaguers rebelled in sporty sneakers, preppies went all out, adding ski sweaters and L.L. Bean boots to the mix. Where Ivy Leaguers' wore khakis, preppies favored bright "Nantucket reds" trousers. Where Ivy Leaguers vacationed in colorful madras shorts, preppies sported pink "go-to-hell" pants embroidered with tiny pheasants.

Neckties and the alligator logo on Lacoste shirts had inspired these embroidered trouser motifs. Fitting, since the next iteration of prep started with neckties and ended with polo shirts. Ralph Lauren first launched Polo with wide, colorful ties. Later he'd place his polo player logo on the knit tennis shirts made famous by Lacoste. Lauren's version was so popular the style became known simply as "polo shirts" by the '80s.

Polo took prep—previously something so outlandish and insular that non-preppies were never expected to understand it— and made it accessible. And the masses, desirous of what they didn't have, wanted to dress like preps. Lauren had cracked the code and transformed prep from an elite American cult into a global fashion culture.

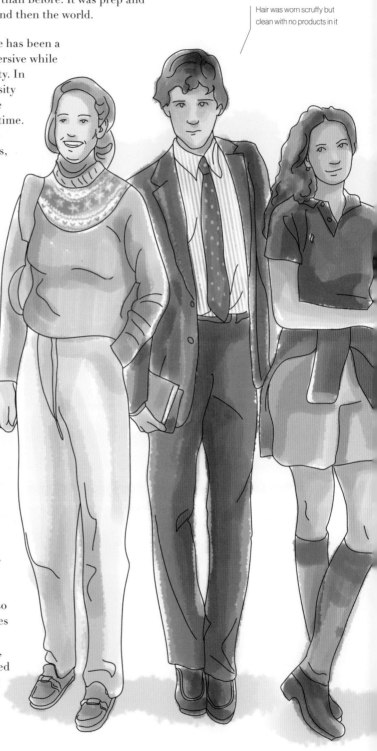

Hair was worn scruffy but clean with no products in it

THE CULTURE Tom Wolfe first applied the term "go-to-hell" to pants when describing the trousers of "checks and plaids of the loudest possible sort, madras plaids, yellow-on-orange windowpane checks, crazy-quilt plaids" worn by vacationing Boston Brahmins on Martha's Vineyard in his 1975 *Esquire* essay, "Mauve Gloves and Madmen, Clutter and Vine."

PREPPY

ORIGIN: NORTHEAST UNITED STATES, 1970s
IVY LEAGUE LOOKS GO SPORTY, BRIGHT, AND BOLD

Repp stripe tie
was purchased at
campus bookstore

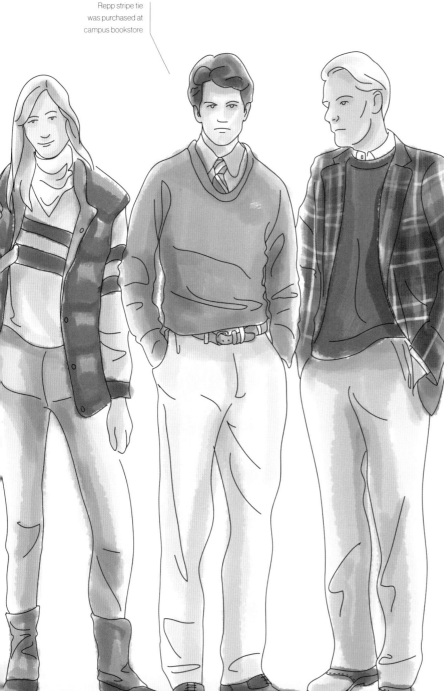

THE SOUND

"She Loved Me,"
The Rising Storm, 1967
"Sugar Magnolia,"
Grateful Dead, 1970
"Fee," Phish, 1989
"Crash," Dave
Matthews Band, 1996
"Oxford Comma,"
Vampire Weekend,
2008

THE LOOK

Prep style still thrives today, with male preppies wearing blue three-roll-two blazers, Oxford cloth button-downs, striped club ties, Nantucket reds trousers, embroidered or checked "go-to-hell" pants, canvas belts, and boat shoes. In the colder months, male preps turn to corduroys, tweed blazers, fisherman sweaters, and polar fleece vests. Shoes are often worn without socks. Female prep style is similar to male prep style, but includes A-line skirts, plaid kilts, knee socks, or tennis skirts, and often pearls for more formal occasions. Female preps also favor loafers or ballet flats. Prep clothing is almost always made from natural materials and should be worn and repaired until it falls apart.

Bean duck boots were
worn and resoled until
they fell apart

Saddle shoes were still
worn in the '70s

CLASSIC EMBROIDERED MONOGRAMS

For some late '70s New York artists punk wasn't quite punk enough. After all, punk still privileged Chuck Berry riffs above all else. Some people didn't think riffs even made sense any more, especially in a deteriorating New York abandoned by the Feds and full of crime and dereliction. Renaming punk New Wave in an attempt to sell Blondie records also wasn't relatable for these outcasts. So they made their own wave: No Wave, full of transgressive art tunes from groups like Suicide with a side of cinematography that blew away all previous rock clichés.

No Wave bands like Mars, James Chance & the Contortions, and Teenage Jesus and the Jerks shared an interest in transcending rock and roll to create music that revealed the pain and vacuousness, freedom and fun, that a decaying New York City had to offer. They created raw, atonal music favoring texture over melody, while drawing on sources like free jazz and avant garde composer La Monte Young to inform their sonic experiments.

Uniquely, No Wave lacked any defining fashion style, with each participating artist perfecting their own look. Some wore suits and sunglasses, others blazers and dress shirts buttoned to the top. Sunglasses were popular. And Lydia Lunch, perhaps No Wave's most famous artist, created an ultra-sexual, decadent look, with fishnet stockings, kohl-dark eyes, dyed black hair, and bold lipstick worn on top of black tank tops or satin vintage dresses. This look proved influential, ultimately morphing into Courtney Love's "kinderwhore" look of the '90s.

No Wave was short-lived, dying out by the early '80s. But it did spawn a few famous recordings, notably the *No New York* compilation produced by Brian Eno and had lasting effect on pop culture, inspiring acts like Sonic Youth and Swans.

Plain T-shirts and jeans created a studied anti-style

Crop tops and leggings showed some overlap with New Wave style

THE CULTURE While it's remembered as a musical movement, No Wave also encompassed filmmaking and visual arts, launching the careers of directors like Jim Jarmusch and Richard Kern, as well as photographer Nan Goldin and conceptual artist Jenny Holzer.

NO WAVE

ORIGIN: NEW YORK, LATE 1970s
ART PUNKS EXPLODE ROCK AND ROLL

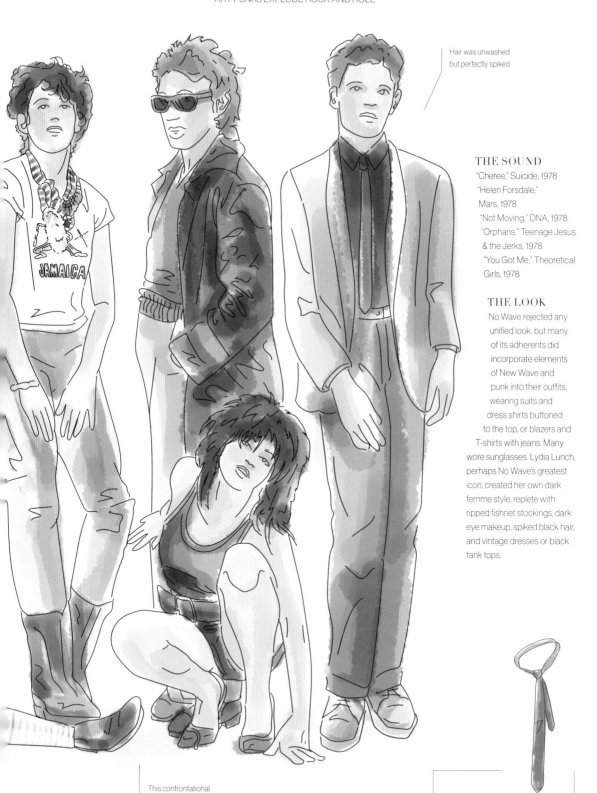

Hair was unwashed
but perfectly spiked

THE SOUND

"Cheree," Suicide, 1978
"Helen Forsdale,"
Mars, 1978
"Not Moving," DNA, 1978
"Orphans," Teenage Jesus
& the Jerks, 1978
"You Got Me," Theoretical
Girls, 1978

THE LOOK

No Wave rejected any
unified look, but many
of its adherents did
incorporate elements
of New Wave and
punk into their outfits,
wearing suits and
dress shirts buttoned
to the top, or blazers and
T-shirts with jeans. Many
wore sunglasses. Lydia Lunch,
perhaps No Wave's greatest
icon, created her own dark
femme style, replete with
ripped fishnet stockings, dark
eye makeup, spiked black hair,
and vintage dresses or black
tank tops.

This confrontational
feminist style was pioneered
by No Waver Lydia Lunch

NO WAVERS
RESURRECTED '50s RAZOR TIES

There's a long tradition of motorcycle riding in Japan. In the 1950s, the country had the *kaminari-zoku* (thunder tribe) who were similar to American bikers and British rockers. By the '70s, it had the *bosozoku*, its own brand of completely Japanese bad boy bike riders. Even though the bosozoku were only petty criminals, they'd spark a moral panic in Japan while also creating a techno-punk look that still seems futurist today.

Bosozoku were gangs of young people aged seventeen to twenty, mostly boys but also some girls, who rode custom motorcycles and occasionally drove cars. Though not true criminals, their reckless riding and massive, 100-vehicle road rallies made them truly dangerous and earned them their name, which means "out-of-control tribe" or "speed tribe."

To be a true bosozoku, a person must have owned a motorcycle by their late teens, with some groups requiring members to have moved on to custom cars by age eighteen. Bosozoku cliques drew members from groups of younger "Yankii" teens, a catch-all term that refers to disaffected youth, whose style and attitude overlapped with many other Japanese subcultures, including the sukeban.

Despite their outsider status, most bosozoku were conservative nationalists who saw themselves as preserving Japan's heritage, living by the abandoned Bushido code of the samurai.

These sentiments were reflected in bosozoku clothing, with most members donning kamikaze pilot coats called *tokko-fuku*, which they adorned with Chinese or Japanese characters and the rising sun symbol of the Imperial Japanese navy. Many bosozoku also wore headbands bearing the rising sun and surgical masks to avoid recognition by police.

Bosozoku numbers have steadily declined since peaking at 42,510 in 1982, falling to 36,500 by 1991, and reaching fewer than 10,000 by 2011.

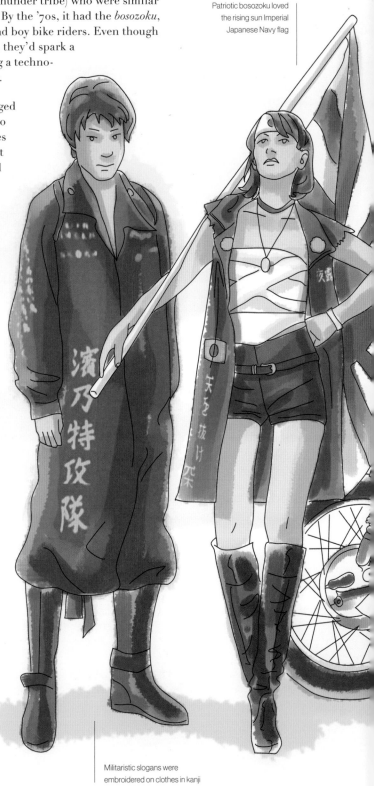

Patriotic bosozoku loved the rising sun Imperial Japanese Navy flag

Militaristic slogans were embroidered on clothes in kanji

THE CULTURE Bosozoku favored small Japanese Hondas and Suzuki motorcycles, which they would adorn with huge windscreens, extra-tall rear seats, and flashy paint jobs, sometimes including flames of the Japanese rising-sun motif.

ORIGIN: JAPAN, LATE 1970s
FUTURISTIC SPEED TRIBES RIDE WILD IN THE STREETS

Tasuki sash could be tied in an X around the torso like Japanese WWII fighter pilot

Bosozoku favored the Marushin W116 motorcycle helmet

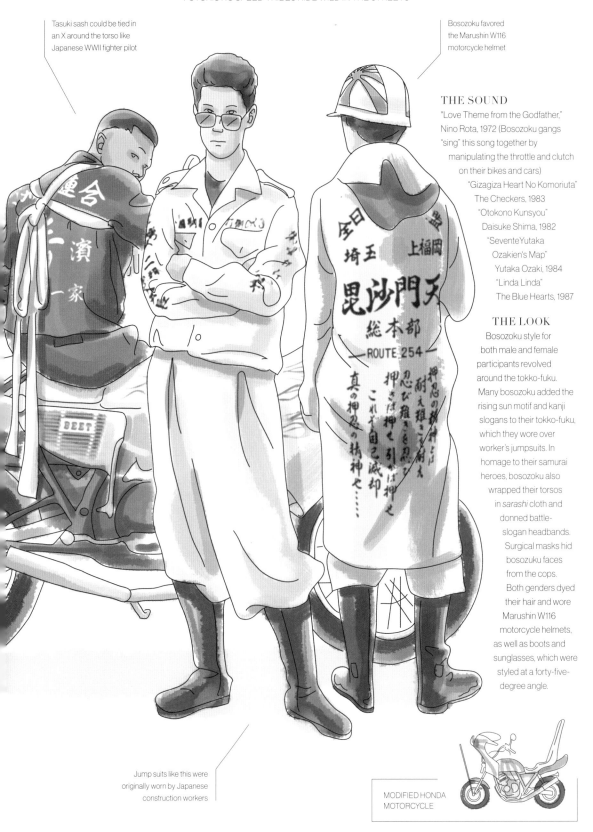

THE SOUND

"Love Theme from the Godfather,"
Nino Rota, 1972 (Bosozoku gangs
"sing" this song together by
manipulating the throttle and clutch
on their bikes and cars)
"Gizagiza Heart No Komoriuta"
The Checkers, 1983
"Otokono Kunsyou"
Daisuke Shima, 1982
"SeventeYutaka
Ozakien's Map"
Yutaka Ozaki, 1984
"Linda Linda"
The Blue Hearts, 1987

THE LOOK

Bosozoku style for
both male and female
participants revolved
around the tokko-fuku.
Many bosozoku added the
rising sun motif and kanji
slogans to their tokko-fuku,
which they wore over
worker's jumpsuits. In
homage to their samurai
heroes, bosozoku also
wrapped their torsos
in *sarashi* cloth and
donned battle-
slogan headbands.
Surgical masks hid
bosozuku faces
from the cops.
Both genders dyed
their hair and wore
Marushin W116
motorcycle helmets,
as well as boots and
sunglasses, which were
styled at a forty-five-
degree angle.

Jump suits like this were originally worn by Japanese construction workers

MODIFIED HONDA MOTORCYCLE

In 1970 it dawned on Frank Nasworthy that soft urethane wheels might give skateboards a smoother, more controlled ride. He was right—and, by the time he was manufacturing urethane wheels under the name Cadillac, his insights had changed skateboarding from a kiddie fad to an all-out subculture with its own style, lingo, and attitude.

Frank Nasworthy may have been the first to recognize the value of urethane wheels, but the aggressive young team of skaters sponsored by Jeff Ho's Zephyr Productions surf shop in Venice Beach—known as the Z-Boys—were the first to realize the new material was grippy enough to bomb hills and ride the vertical walls of the swimming pools that lay abandoned due to a 1976 drought in Southern California.

Pool skating prompted the opening of concrete skate parks, leading to an explosion in the popularity of skateboarding in the late 1970s. Because many of these parks were improperly conceived and dangerous, this phenomenon was short-lived, and skaters began to build their own wooden ramps to satisfy their vertical fix by the early 1980s.

Skaters of the 1980s loved punk and hardcore, and this music, along with the demands of the sport, influenced their style. Many skate companies pumped out board graphics rich in skulls and gore, an aesthetic that also worked well on T-shirts. Skaters also turned to Chuck Taylors or basketball shoes for ankle support, and added bright, New Wave–influenced colors like pink or lime green to their wardrobes.

Vert ramps were spectacular, but were out of reach for many skaters. So, when Mark Gonzales and Natas Kaupas brought the flatground ollie to the sidewalks of Southern California, street skating overtook vert in popularity and the industry crashed again as companies struggled to understand this new market.

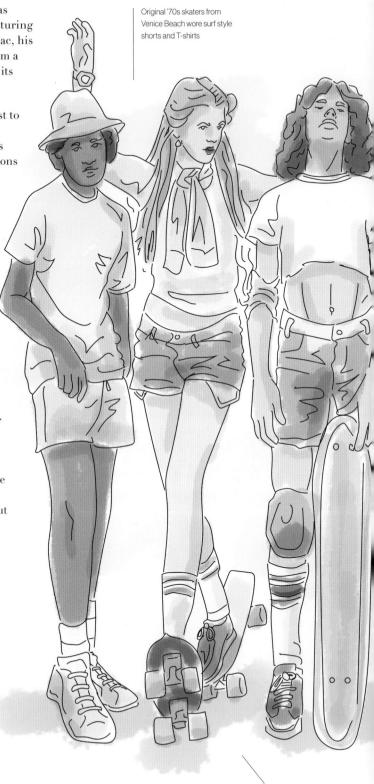

Original '70s skaters from Venice Beach wore surf style shorts and T-shirts

Grippy urethane wheels allowed early skaters to do tricks like the daffy

THE CULTURE Skateboarders of the '70s established their sport as an outlaw activity, since it was necessary to trespass on private property to skate abandoned pools.

ORIGIN: CALIFORNIA, 1970s–1980s
SOCAL'S MISFIT CHILDREN FIND FREEDOM IN POOLS AND RAMPS

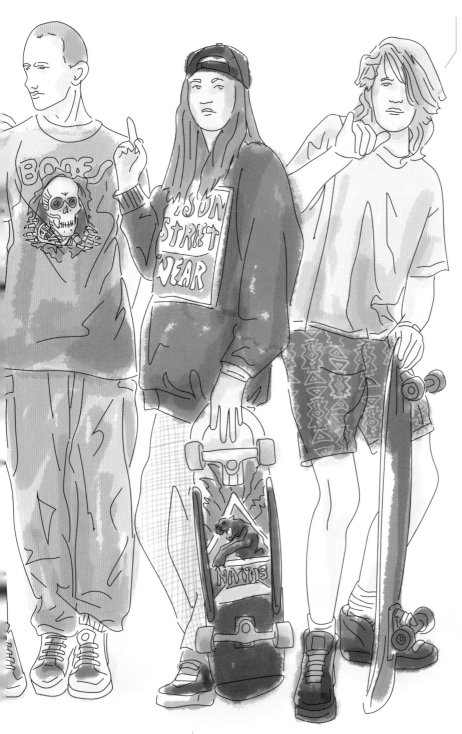

The famous '80s hang-bang skater cut was called the "McSqueeb"

THE SOUND

"Kashmir," Led Zeppelin, 1975
"Yellow Pills," 20/20, 1979
"Gates of Steel," Devo, 1980
"Out of School," JFA, 1981
"Possessed to Skate," Suicidal Tendencies, 1987

THE LOOK

Skaters of the 1970s wore long hair, short surf trunks or dolphin shorts, striped tube socks, Vans or high-top Nikes, jeans, and graphic T-shirts. By the 1980s, skateboarding had its own clothes, including shorts with slots for inserting hip pads and shoes specifically made to skate in from companies like Airwalk and Vision streetwear. These '80s skaters wore longer, boardshort-style shorts known as jams, and graphic skate company T-shirts, which they sometimes cut up and restyled to their own liking. In the early part of the decade, punk and New Wave elements like leather jackets, zipper-covered pants, asymmetrical haircuts, and shaved heads were also popular.

Vision was the first company to use the term streetwear on clothes

POOL COPING:
LADYFINGER, BULNOSE, AND SLAB

GLENN O'BRIEN'S
NO WAVE TOP FIVE

"Mars," Helen Forsdale, 1978
"Contort Yourself," James White & The Blacks, 1979
"Atomic Bongos," Lydia Lynch, 1980
"New Fast," DNA 1981
"Sally Go Round the Roses," Del-Byzanteens, 1982

I think the first time I heard No Wave it was hovering around the 1978 *No New York* collection LP compiled by Brian Eno that featured the Contortions, Mars, Teenage Jesus and the Jerks, and DNA. No Wave was generally defined more by what it wasn't than what it was. It wasn't about R&B or blues but it touched the edge of jazz. It wasn't melodic, romantic or lyrical; it was noisy. The term New Wave, lifted from the French cinema, was applied to music—as I recall by the advertising of Sire Records. They wanted to explain that there was more than one kind of new music. The Ramones were punk, but they were so different from another different band like Talking Heads. Why, then Talking Heads could be New Wave, accommodating new music fans who liked art and didn't wear leather jackets. Recently I was in a discussion at MoMA after showing *Downtown 81* which featured several No Wave bands and an audience member became quite animated, even heated in finding a strict definition for No Wave. I objected in general to defining and categorizing music but especially No Wave. That's the charm of No Wave as a genre. Essentially it means music that sounds like itself and not part of a trend or a movement—it is music by and for individuals. Here I have selected atypical examples of the atypical genre. New Wave and No Wave were seen as anti-disco but August "Kid Creole" Darnell melded the stinging funk riff with the most typical disco thump, creating a satirical triumph you can dance to. Del-Byzanteens (Jim Jarmusch's old band) remade The Jaynetts' haunting and mysterious 1963 hit single "Sally Go Round the Roses" (Andy Warhol's favorite song to paint to.) None of these tracks conform to an aesthetic, each is as unique as a fingerprint, and that's what all music should aspire to.

NO WAVE
This Lower Manhatten scene deconstructs punk into a furious blast of lurching rhythms and bursts of skronky noise.

"Animal Instincts," Model Citizens, 1979
"Diamonds, Fur Coat, Champagne," Suicide, 1980
"Atomic Bongos," Lydia Lunch, 1980
"Off the Hook," Y Pants, 1980
"Lying on the Sofa of Life," DNA, 1981
"Harlem Nocturne," The Lounge Lizards, 1981
"Dog Save My Sole," Blurt, 1982
"Mystic Mints," Jody Harris, 1982
"Obvious," Y Pants, 1982
"Kill Yr Idols," Sonic Youth, 1983
"I'll Meet You in Poland Baby," Foetus, 1984
"Phoenix," UT, 1985
"My Funny Valentine," Lizzy Mercier Descloux, 1986

GOTH
Brooding, but not without a certain black humor, goth explores the darker side of post-punk

"All Cats Are Grey," The Cure, 1981
"The Passion of Lovers," Bauhaus, 1981
"Deathwish," Christian Death, 1982
"My Heart," The Danse Society, 1982
"Fatman," The Southern Death Cult, 1982
"Slowdive," Siouxsie and the Banshees, 1982
"Frenzy," Killing Joke, 1983
"Temple of Love," The Sisters of Mercy, 1983
"The Killing Moon," Echo and the Bunnymen, 1983
"Dead and Buried," Alien Sex Fiend, 1984
"83rd Dream," The Cult, 1984
"Hollow Eyes," Red Lorry Yellow Lorry, 1984
"Holocaust," This Mortal Coil, 1984
"Mondlicht," X Mal Deutschland, 1984

"Musica Eternal," Dead Can Dance, 1984

"Performance," Tones On Tail, 1984

"A Day," Clan of Xymox, 1985

"Always A Flame," Gene Loves Jezebel, 1985

"Grimly Fiendish," The Damned, 1985

"Wasteland," The Mission, 1986

"Whip It," Treacherous Three, 1982

"Weekend," Cold Crush Brothers, 1982

"Beat Bop," Rammellzee, 1983

"8 Million Stories," Kurtis Blow, 1984

"Friends," Whodini, 1984

"Sucker M.C.'s (Krush-Groove 1)," Run-DMC, 1984

"Roxanne, Roxanne," UTFO, 1984

"Jam On It," Newcleus, 1984

"Home of Hip Hop," Grandmixer D. ST., 1985

"I Can't Live Without My Radio," LL Cool J, 1985

"King Of Rock," Run D.M.C., 1985

"The Show," Doug E. Fresh and The Get Fresh Crew, 1985

NEW ROMANTICS

*Mocking the gloom of Margaret Thatcher's Britain
by updating glam rock for the post-punk era,
the New Romantics looked as good as they sounded*

"Framework," Berlin Blondes, 1980

"Fade to Grey," Visage, 1980

"To Cut a Long Story Short," Spandau Ballet, 1980

"Vienna," Ultravox, 1980

"Europe After the Rain," John Foxx, 1981

"Guilty," Classix Nouveaux, 1981

"New Life," Depeche Mode, 1981

"Planet Earth," Duran Duran, 1981

"The Sound of the Crowd," Human League, 1981

"Images of Heaven," Peter Godwin, 1982

"Poison Arrow," ABC, 1982

"Something in Your Picture," Fashion, 1982

"Forever Young," Alphaville, 1984

ELECTRO

*Electro's funk-driven 808 beats have pulsated
through hip-hop since the early '80s*

"Don't Try To Stop Me," Kano, 1981

"Body Mechanic," Quadrant Six, 1982

"Dance Floor," Zapp, 1982

"Magic's Wand," Whodini, 1982

"Pack Jam," The Jonzun Crew, 1982

"Planet Rock," Afrika Bambaataa & The Soul Sonic Force, 1982

"The Smurf," Tyrone Brunson, 1982

"Walking on Sunshine," Rockers Revenge, 1982

"Al-Naafiysh (The Soul)," Hashim, 1983

"Beat Box," Art of Noise, 1983

"Danger Zone," Planet Control, 1983

"Electric Kingdom," Twilight 22, 1983

"Rockit," Herbie Hancock, 1983

"Beat Street Breakdown," Grandmaster Melle Mel &
The Furious Five, 1984

"Captain Rock," Cosmic Blast, 1984

"Egypt, Egypt," The Egyptian Lover, 1984

"Hip Hop Be Bop (Don't Stop)," Man Parrish, 1984

"In the Mix," Roger, 1984

"Jam On It," Newcleus, 1984

"One For the Treble," Davy DMX, 1984

"Push the Button," Newcleus, 1984

"Don't Stop the Rock," Freestyle, 1985

"King of the Beats," Mantronix, 1988

OLD SCHOOL RAP

From the five boroughs, the birth of a nation

"Freedom," Grandmaster Flash & The Furious Five, 1980

"Monster Jam," Spoonie Gee Meet The Sequence, 1980

"Catch The Beat," T-Ski Valley, 1981

"Genius Rap," Dr. Jeckyll & Mr. Hyde, 1981

"Busy Bee at the Amphitheater," Busy Bee, 1982

"Change the Beat," Fab 5 Freddy, 1982

"Smerphie's Dance," Spyder-D, 1982

The first stirrings of the New Romantic movement occurred in 1978 at Billy's in Soho, London, where promoter Steve Strange teemed with DJ Rusty Egan to throw a "Bowie Night" party every Tuesday. It attracted art school kids who were fed up with punk rock violence and searching for a more expressive scene.

By 1980, the party moved to Blitz, a run-down wine bar in Covent Garden, where attendees' Bowie-inspired looks gave way to sumptuous outfits unlike anything that came before them. Denizens of this scene—known as Blitz kids—still turned to Bowie for inspiration, but also combined bits of a partially imagined past with post-punk futurism. At Blitz, attendees like performance artist Leigh Bowery fused the pansexual romanticism of Weimar Berlin with a severe but theatrical post-punk future, combining frilly shirts and velvet suits with cutting-edge asymmetrical haircuts and goth makeup. With their aesthetic established, people began calling the Blitz kids "New Romantics."

At these parties, DJ Steve Egan played electro from Kraftwerk and Giorgio Moroder mixed with New York No Wave and Bowie, a blend that eventually gave way to futuristic synthpop, often made by Blitz kids themselves. Spandau Ballet bassist Martin Kemp was a key member of the scene, as was Boy George, who worked the coat check room at Blitz before Culture Club made it big.

And make it big they did. Culture Club's "Karma Chameleon" and its omnipresent music video was a worldwide number-one hit by 1983, proving the importance of the New Romantics as their style and amazing hair came to influence nearly all of '80s music and fashion, particularly on MTV, where VJs lumped them in with American New Wave.

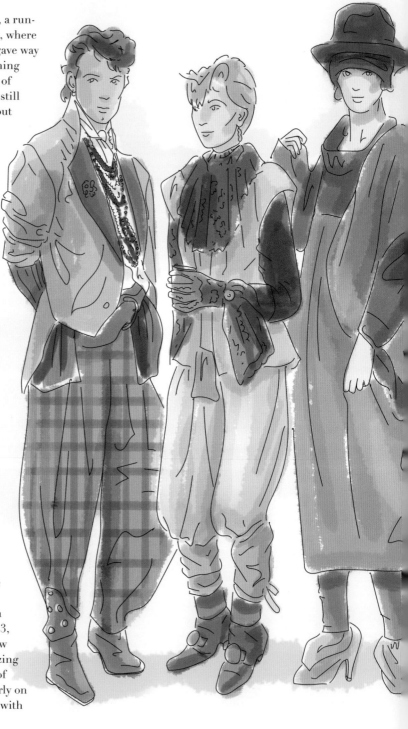

New Romantics used vintage clothing to help build their outfits

THE CULTURE Blitz club host Steve Strange once turned Mick Jagger away at the door, but Michael Jackson and David Bowie were welcomed when they visited. Bowie even picked Strange to appear in his "Ashes to Ashes" video.

ORIGIN: LONDON, 1980s
ART SCHOOL KIDS IMAGINE AN OPULENT FUTURE BECAUSE PUNK IS DEAD

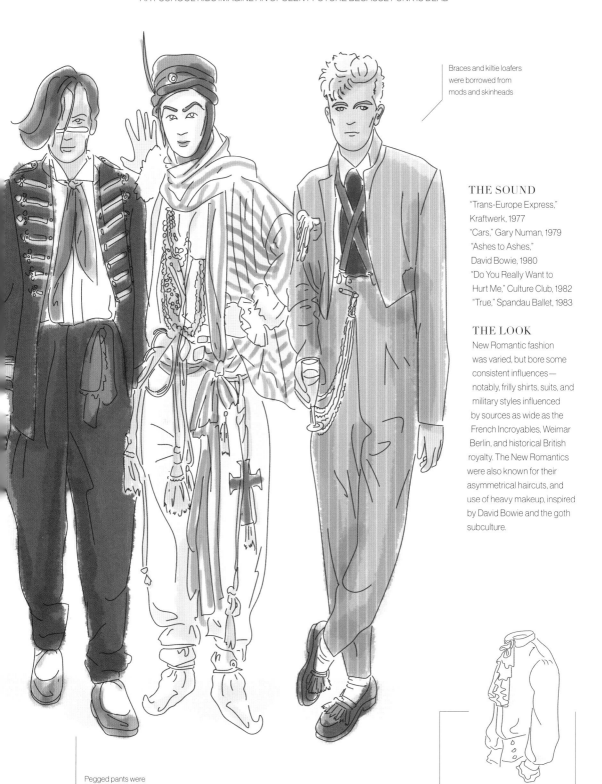

Braces and kiltie loafers
were borrowed from
mods and skinheads

THE SOUND

"Trans-Europe Express,"
Kraftwerk, 1977
"Cars," Gary Numan, 1979
"Ashes to Ashes,"
David Bowie, 1980
"Do You Really Want to
Hurt Me," Culture Club, 1982
"True," Spandau Ballet, 1983

THE LOOK

New Romantic fashion
was varied, but bore some
consistent influences—
notably, frilly shirts, suits, and
military styles influenced
by sources as wide as the
French Incroyables, Weimar
Berlin, and historical British
royalty. The New Romantics
were also known for their
asymmetrical haircuts, and
use of heavy makeup, inspired
by David Bowie and the goth
subculture.

Pegged pants were
inspired by American
zoot suits of the '30s

SHIRT WITH RUFFLED COLLAR
AND CUFFS

Starting in the late 1970s, goths were mopey English kids on the fringes of the punk scene in cities like London and Manchester, who shared an interest in black clothes, moody post-punk music, and mortality.

London rocker Siouxsie Sioux and her band the Banshees were an early influence on the goth scene, giving it a dark, romantic sound and an aesthetic to be emulated. Her dark eye makeup, spiky black hair, black lace, and flowing layers were the blueprint for goth fashion.

Joy Division, a grim post-punk act from the Manchester suburbs, were another early influence, giving goths a soundtrack with the band's debut album *Unknown Pleasures* in 1979. A year later lead singer Ian Curtis killed himself, cementing his legend as the lost prince of goths around the world.

Taking cues from the aforementioned Sioux and Bauhaus lead singer Peter Murphy, goths developed an intentionally morbid style featuring black clothing, the pallid skin of sun-shy weirdos, dark eyes, dyed black hair, silver jewelry, and black nail polish.

Goths also liked Victorian ephemera, incorporating petticoats, long dresses, corsets, velvet, lace, and round spectacles into their outfits.

In the early 1980s, new goth sounds emerged, when Throbbing Gristle and Skinny Puppy incorporated industrial noise into the subculture's music, innovations that would come to fruition in the 1990s, when Nine Inch Nails and Marilyn Manson became icons of goth culture.

In the 1990s, goth culture became increasingly commercialized and mainstream, appearing in "mall stores" like Hot Topic, a one stop shop where teenage rebels could get band T-shirts, Dr. Martens, and bondage belts.

Goth subculture still exists, continuing to attract sensitive, ostracized youth with an eye for colorless clothing, dark music, and black humor.

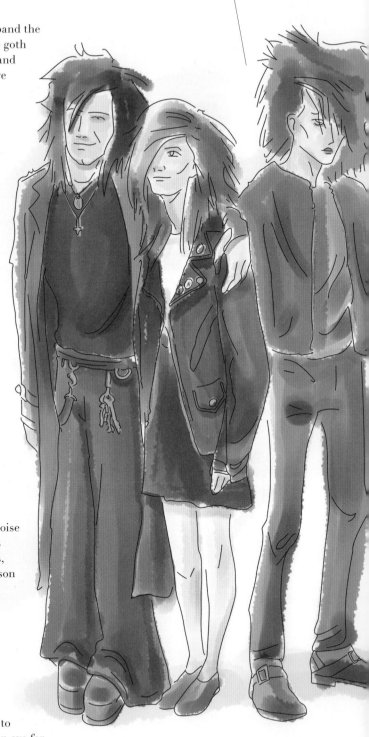

Goths of both genders wore copious black eye makeup

THE CULTURE Goth also drew heavily on horror culture, gothic romance, and camp, idolizing movie monsters like Dracula, as well as Count Orlok of *Nosferatu* (1922) and alien transvestite Dr. Frank-N-Furter of *The Rocky Horror Picture Show* (1975).

GOTH

ORIGIN: UNITED KINGDOM, LATE 1970s
UNDYING MOPE ROCKERS EMBODY TEEN ANGST

Hair was dyed black with Stargazer
Hair Colour from the Great Gear
Market stall on Kings Road

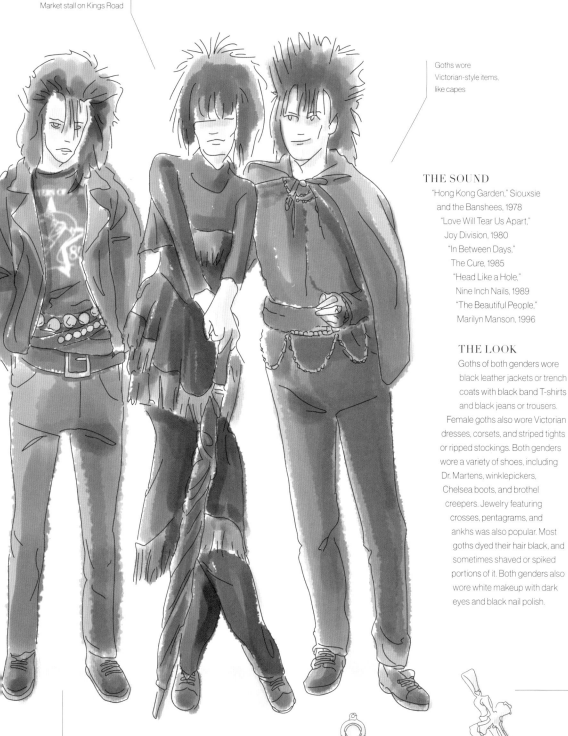

Goths wore
Victorian-style items,
like capes

THE SOUND

"Hong Kong Garden," Siouxsie
and the Banshees, 1978
"Love Will Tear Us Apart,"
Joy Division, 1980
"In Between Days,"
The Cure, 1985
"Head Like a Hole,"
Nine Inch Nails, 1989
"The Beautiful People,"
Marilyn Manson, 1996

THE LOOK

Goths of both genders wore
black leather jackets or trench
coats with black band T-shirts
and black jeans or trousers.
Female goths also wore Victorian
dresses, corsets, and striped tights
or ripped stockings. Both genders
wore a variety of shoes, including
Dr. Martens, winklepickers,
Chelsea boots, and brothel
creepers. Jewelry featuring
crosses, pentagrams, and
ankhs was also popular. Most
goths dyed their hair black, and
sometimes shaved or spiked
portions of it. Both genders also
wore white makeup with dark
eyes and black nail polish.

Leather jackets and
studded belts were carried
over from punk rock style

POPULAR ACCESSORIES:
SAFETY PINS, ANKHS, CROSSES

By the 1980s, football hooliganism was a major pastime for working-class youth in the United Kingdom. But English cops had by then zeroed in on young men wearing team colors or skinhead gear as troublemakers. In response, football fans changed their style, going "casual" in Italian sportswear from Sergio Tacchini and Stone Island and upscale homegrown brands like Burberry and Aquascutum.

The United Kingdom has a history of organized football hooliganism dating back to the 1970s, when gangs—known as "firms"—emerged in support of clubs both large and small. However, writers like Phil Thornton trace the casuals phenomenon back even further to the mods, skinheads, and soulboys of the '60s and '70s, pointing to Fred Perry tennis shirts as an item valued by these youth cults and casuals alike.

While one early hooligan firm, Manchester United's Perry Boys, even named themselves after a shirt, football lore holds that the casuals trend got a style boost when Liverpool Football Club fans traveled to Italy for an early-'80s European Cup game. Here, they became enamored of fine continental sportswear from brands like Sergio Tacchini and Lacoste, looting it from retailers to sell back in the United Kingdom, where it wasn't available.

In the late 1980s, football casuals added weatherproof Italian sportswear from Stone Island and C.P. Company to their wardrobes, elevating the latter's Mille Miglia jacket to icon status, partly because its built-in hood and goggles shrouded their faces from police during brawls and riots.

Manchester bands like the Stone Roses and Oasis brought the modish haircuts, fine parkas, and adidas trainers favored by football casuals to the masses in the late '80s and early '90s.

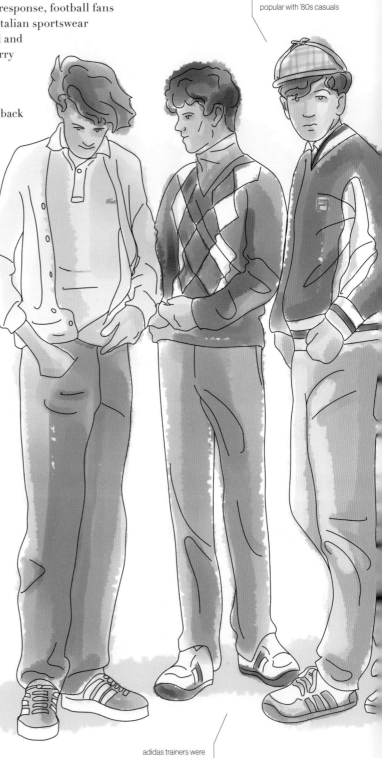

Sherlock Holmes-style deerstalker caps were popular with '80s casuals

adidas trainers were casual favorites

THE CULTURE Casuals never referred to themselves as such, instead preferring the terms "scallies," "trendies," or "dressers."

ORIGIN: UNITED KINGDOM, 1980s
FOOTBALL HOOLIGANS DRESS THEIR THUGGERY UP IN FANCY ITALIAN SPORTSWEAR

Casuals favored
Sergio Tacchini
tracksuits

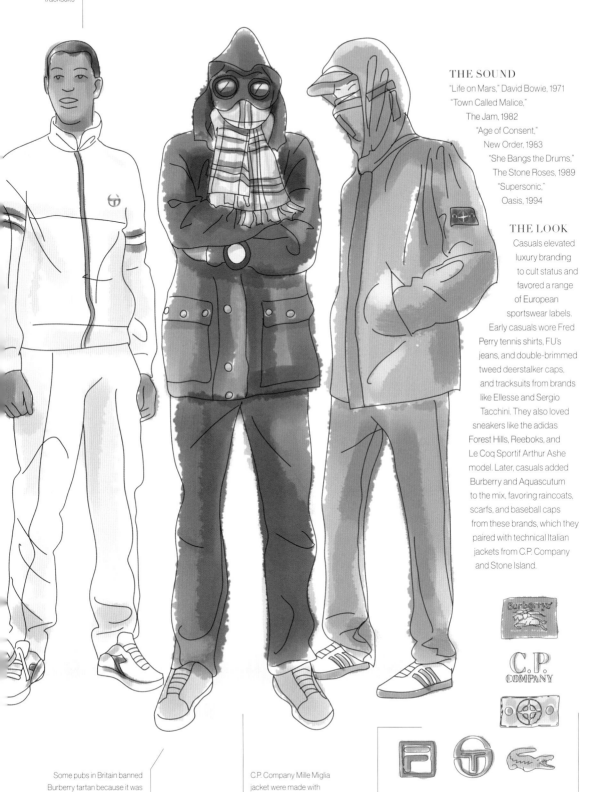

THE SOUND

"Life on Mars," David Bowie, 1971
"Town Called Malice,"
The Jam, 1982
"Age of Consent,"
New Order, 1983
"She Bangs the Drums,"
The Stone Roses, 1989
"Supersonic,"
Oasis, 1994

THE LOOK

Casuals elevated luxury branding to cult status and favored a range of European sportswear labels. Early casuals wore Fred Perry tennis shirts, FU's jeans, and double-brimmed tweed deerstalker caps, and tracksuits from brands like Ellesse and Sergio Tacchini. They also loved sneakers like the adidas Forest Hills, Reeboks, and Le Coq Sportif Arthur Ashe model. Later, casuals added Burberry and Aquascutum to the mix, favoring raincoats, scarfs, and baseball caps from these brands, which they paired with technical Italian jackets from C.P. Company and Stone Island.

Some pubs in Britain banned
Burberry tartan because it was
associated with football violence

C.P. Company Mille Miglia
jacket were made with
googles built into the hood

CASUALS' FAVORITE EUROPEAN LUXURY LABELS

By 1979, the Sex Pistols had broken up and Margaret Thatcher was prime minister of Great Britain. Punk seemed dead—but it wasn't. A mix of bands, some new, and some long-established, stepped to the fore to push punk rock into the 1980s with an assemblage of increasingly intricate fashion statements and radical politics. From this surge, two main wings of punk rock emerged: the political anarcho-punk of bands like Crass and Conflict and the colorful working-class UK82 punk of bands like The Exploited and Charged GBH.

Crass started out as a group of anarchist artists living on a commune called Dial House near Epping Forest between London and Essex. By 1977, they'd formed a band to broadcast their radical message to the masses. Though not typical punks in music or style, they drew on their anarchist politics and the Situationist International influences of band art director Gee Vaucher to create an image of all-black clothes and strong, collage-style visuals that inspired other anarchist bands like Amebix and Flux of Pink Indians.

At the same time, bands like The Exploited from Scotland and Chaos UK from Bristol were creating an aggressive new form of punk rock, inspired by the outlandish style of bands like the Sex Pistols, Sham '69, and hard-driving, no-frills Oi! music. This music became known as "UK82" after an Exploited song of the same name. When these influences combined, an entirely new punk fashion was born. Extreme and brightly dyed hairstyles proliferated, like the iconic mohawk haircut that Exploited singer Wattie Buchan borrowed from Native Americans.

The dark, political anarcho-punk style is still prevalent among so-called crusty and gutter punks, while bands like Rancid and The Casualties have carried the colorful UK82 style forward to the future.

Mohawks (also called a Mohican by British punks) were appropriated from Native Americans

Liberty spikes hairdo was named after the Statue of Liberty and her crown

THE CULTURE Both anarcho-punk bands and UK82 punk bands were preoccupied with the threat of nuclear war, a theme reflected in songs like Crass's "Nagasaki Nightmare" and the UK Subs's "Warhead."

Royal Stewart tartan bondage pants were designed to mock Queen Victoria with her own family's heritage plaid

STREET PUNK

ORIGIN: UNITED KINGDOM, 1980s
OUTRAGEOUS PUNK STYLE MEETS POLITICS IN THE STREETS

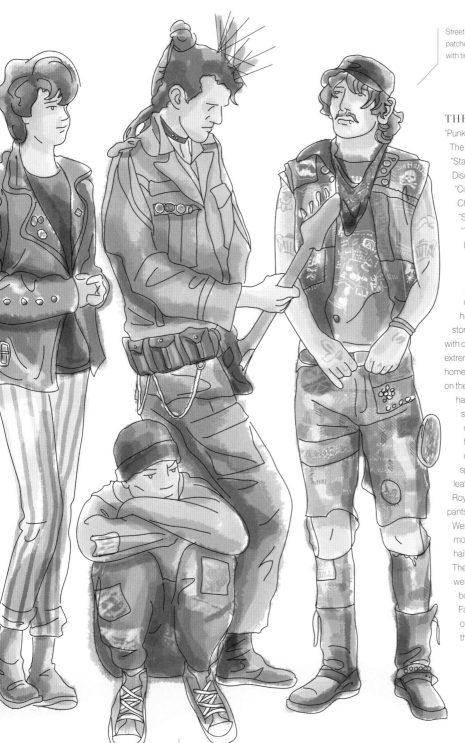

Street punks sewed patches on their clothes with time and care

THE SOUND

"Punks Not Dead,"
The Exploited, 1981
"State Violence State Control,"
Discharge, 1982
"City Baby Attacked by Rats,"
Charged GBH, 1982
"Systematic Death," Crass, 1981
"Tube Disaster," Flux of Pink
Indians, 1981

THE LOOK

Anarcho-punks wore dark, militaristic looks often harvested from Army Surplus stores. They paired these styles with combat boots, and the more extreme political punks sewed homemade screen-printed patches on their clothes. Most wore their hair short, but some wore spiked hair or a mohawk with dreadlocks. UK82 style was far more colorful, featuring dyed mohawks and liberty spikes, hand-painted, studded leather motorcycle jackets, and Royal Stewart tartan bondage pants, which designer Vivienne Westwood originally invented to mock Queen Elizabeth II who hailed from the House of Stewart. They also wore studded belts, as well as chain necklaces, combat boots, and studded cuffs. Facial piercings were common, often consisting of a safety pin through the cheek.

PHOTO'S 1 POUND
£ 1£1

PUNKS CHARGED FOR PHOTOS

Black bondage pants with patches were more popular with fans of bands like Discharge or GBH

Clothes sing, records talk, style is language, and genre is affinity. In a moment where digital communication is imperiled, the kids are, all of them, right. Fashion and music are the morse code of young people, providing a system of both signification and organization that is habitually turned into a commercial system of class emblems. In 2017, their original signals will be needed more than ever. Clothes and songs are analog, even if the source is digital; they both move through physical space before they are captured.

Since the industrial age, teenagers, often of color, have defined whatever cool is and isn't. Sapeurs in the Congo borrowed the pleats of their colonial bosses and turned them into hometown slang that echoed the American jazz age without replicating it. New York b-boys took elemental jeans (Lee®), demanded a snug fit, threaded unusually wide laces into very usual sneakers and, with folded arms, gave a nation a uniform. The music that goes with clothes can be replicated and sold as easily as the outfits, but by the time any outfit is on sale as an outfit, or a genre is listed somewhere, the kids are three operating systems ahead of you.

Teens use the cheapest tools at hand and subvert their intended use. Guaracheros had only to slim their jean legs and sharpen their boot toes to create a new subset. These changes don't read to outsiders until it's too late. The way a star reaches us eons after its death, fashion reaches the page after it's finished transmitting. Commercial fashion is, in many ways, the documentary of activity that has already reached its end point, the recorded signal of a dead planet.

Or, commercial fashion is inverted and simply confuses the system into a state of involuntary success. The hair metal scene of Los Angeles in the eighties injected pop forms into existing hard rock forms, added hairspray to push the needle on gender norms, futzed about with jeans, and firmly refused to take any of it seriously. Straight male fans everywhere were baffled by a music they were coded to like only half of and looks they were taught to reject. (Secretly, the Poison cassettes played.) The genre confounded, in plain sight.

Jamaican rude boys played another kind of inversion. Tough guys, or those who didn't mind being identified as such, adopted a crisp,

clean look that was equally parts New York jazz and LA cool. Suits are inherently authoritative, so rude boys shorten the pant leg as a signal: Too natty to be dismissed, with music too cheerful to be decoded on a single listen. Rude boys used the power of locality — any outsider would have thought them church-going A-students. Rude boys used class as camouflage.

New York's Lo Lifes were as local as a style could be. Ralph Lauren's Polo gear is an all-American staple, so a teen of color wearing all Polo isn't all that surprising for a native New Yorker. But in the late 1980s, a pack of kids wearing all Polo were possibly Lo Lifes, where the fashion was inextricable from its extraction: shoplifting. The Lo Life outfit wouldn't be the same, bought off the rack. The Lo Lifes wore the symbols of aspirational WASP culture as a receipt of that culture, literally appropriated and taken on as an informal gang colors (though the gang's main activity was simply boosting those colors).

Sometimes style is a matter of tiny details and intentional near misses. The roadman look of South London is something any jock could stumble on: track suits and hoodies with curved brim caps, all in black and white. But add one wrong logo, or the wrong trainers, and the look is off. President Obama happened to wear a classic roadman outfit for a basketball game in 2016 and the memes sprouted. Grime artists like Skepta, after a decade of work, went mainstream, meaning the sound and the roadman outfit would have to change, and it probably is right now.

The point of all these styles is they begin on the street as expressions of resistance and definitions of a cohort. The moment the monied want their boutique version of that style, cool is gone and the style ends its organic phase. The number of iterations recorded here is a testament to how quickly and how often the youth can multiply and generate new disguises. There is no need to feel intimidated by cool; you wouldn't likely feel intimidated by a plant that has changed the color of its blossom to blend into a new environment. Cool is this kind of work, the contextual change, an intervention that protects those who have been given no other choices. Celebrate this resilience and fabulousness. Cool is evidence that people can still create their own optimism, and their own weather.

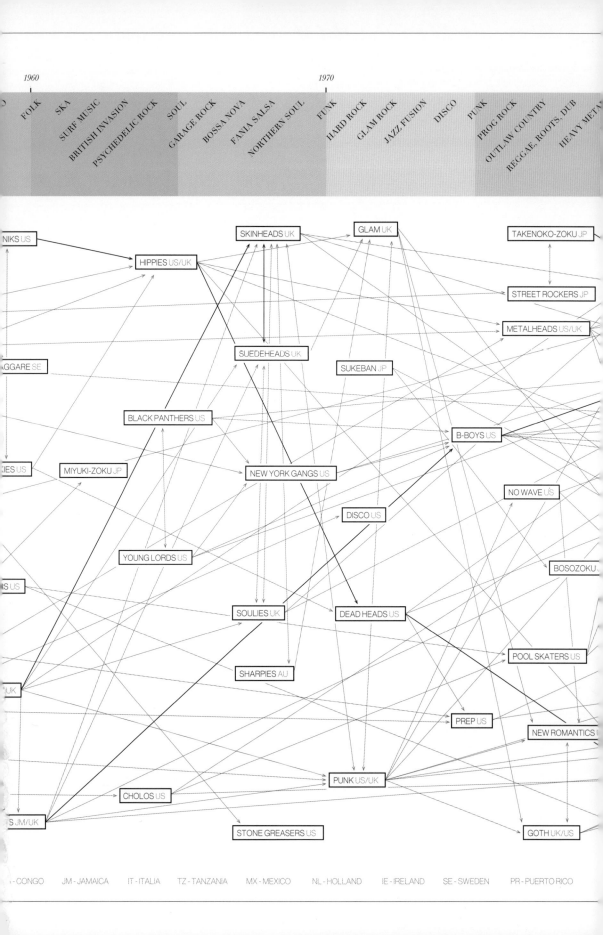

FOLK · SKA · SURF MUSIC · BRITISH INVASION · PSYCHEDELIC ROCK · SOUL · GARAGE ROCK · BOSSA NOVA · FANIA SALSA · NORTHERN SOUL · FUNK · HARD ROCK · GLAM ROCK · JAZZ FUSION · DISCO · PUNK · PROG ROCK · OUTLAW COUNTRY · REGGAE, ROOTS, DUB · HEAVY METAL

NIKS US
HIPPIES US/UK
SKINHEADS UK
GLAM UK
TAKENOKO-ZOKU JP
STREET ROCKERS JP
METALHEADS US/UK
GGARE SE
SUEDEHEADS UK
SUKEBAN JP
BLACK PANTHERS US
IES US
MIYUKI-ZOKU JP
NEW YORK GANGS US
B-BOYS US
NO WAVE US
DISCO US
YOUNG LORDS US
BOSOZOKU
S US
SOULIES UK
DEAD HEADS US
POOL SKATERS US
UK
SHARPIES AU
PREP US
NEW ROMANTICS
PUNK US/UK
CHOLOS US
S JM/UK
STONE GREASERS US
GOTH UK/US

CHRONOLOGY 1920–1980

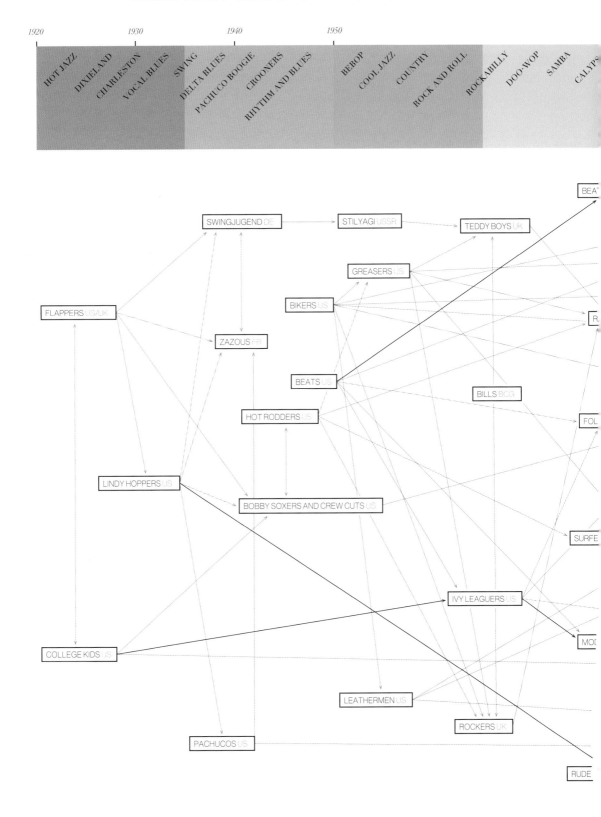

1920 1930 1940 1950

HOT JAZZ
DIXIELAND
CHARLESTON
VOCAL BLUES
SWING
DELTA BLUES
PACHUCO BOOGIE
CROONERS
RHYTHM AND BLUES
BEBOP
COOL JAZZ
COUNTRY
ROCK AND ROLL
ROCKABILLY
DOO-WOP
SAMBA
CALYPS

BEA⁻

SWINGJUGEND DE ——▸ STILYAGI USSR ——▸ TEDDY BOYS UK

GREASERS US

BIKERS US

FLAPPERS US/UK

ZAZOUS FR

BEATS US

BILLS BCG

R.

HOT RODDERS US

FOL

LINDY HOPPERS US

BOBBY SOXERS AND CREW CUTS US

SURFE

IVY LEAGUERS US

COLLEGE KIDS US

MOD

LEATHERMEN US

ROCKERS UK

PACHUCOS US

RUDE

NATIONS KEY US - UNITED STATES OF AMERICA UK - UNITED KINGDOM JP - JAPAN AU - AUSTRALIA FR - FRANCE DE - GERMANY

Style, Sound, *and* Subversion

Greg Foley | Andrew Luecke

CHRONOLOGY 1980–2020

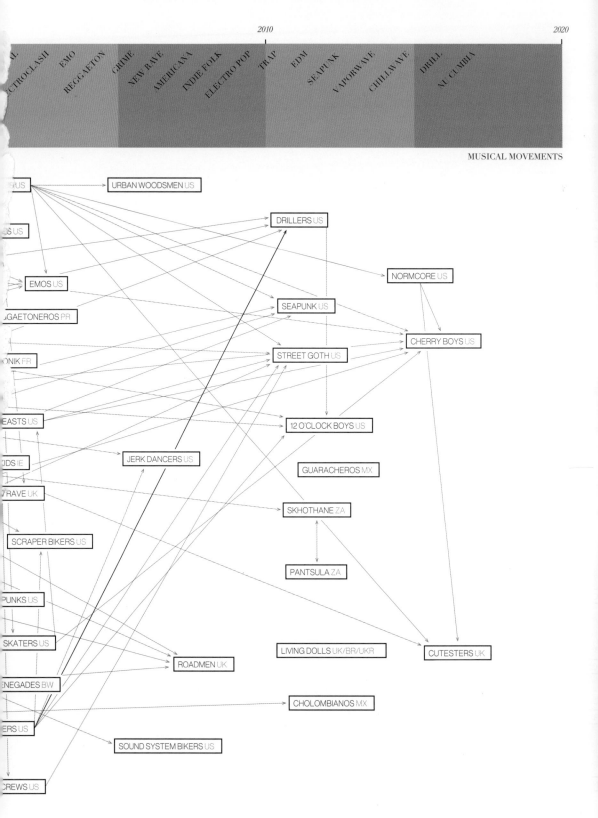

2010

2020

MUSICAL MOVEMENTS

ELECTROCLASH
EMO
REGGAETON
GRIME
NEW RAVE
AMERICANA
INDIE FOLK
ELECTRO POP
TRAP
EDM
SEAPUNK
VAPORWAVE
CHILLWAVE
DRILL
NU CUMBIA

URBAN WOODSMEN US

DRILLERS US

EMOS US

NORMCORE US

GGAETONEROS PR

SEAPUNK US

ONIK FR

STREET GOTH US

CHERRY BOYS US

EASTS US

12 O'CLOCK BOYS US

JERK DANCERS US

GUARACHEROS MX

KIDS IE

RAVE UK

SKHOTHANE ZA

SCRAPER BIKERS US

PANTSULA ZA

PUNKS US

SKATERS US

LIVING DOLLS UK/BR/UKR

CUTESTERS UK

ROADMEN UK

ENEGADES BW

CHOLOMBIANOS MX

ERS US

SOUND SYSTEM BIKERS US

CREWS US

SUBCULTURES

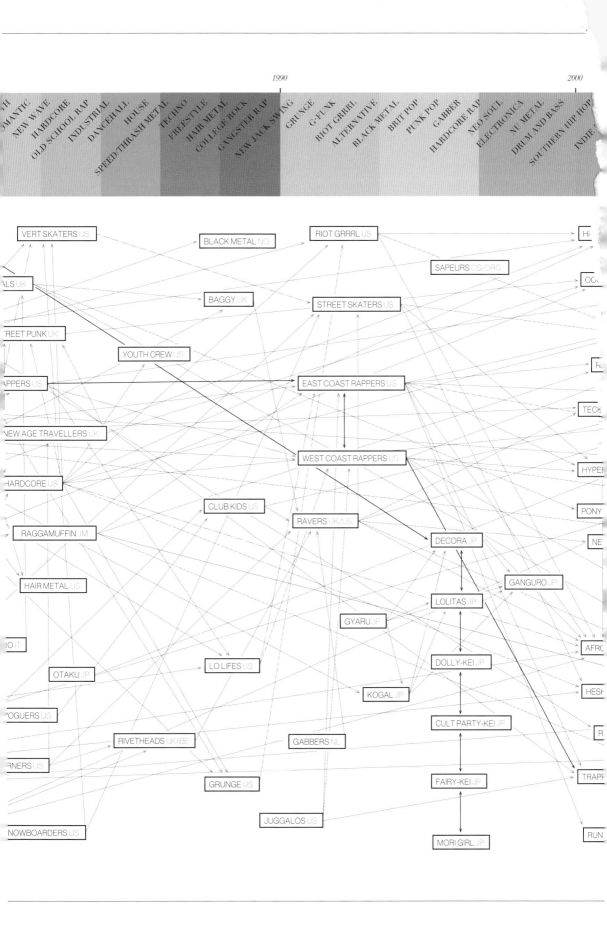

...TH

NEW WAVE

...OMANTIC

HARDCORE

OLD SCHOOL RAP

INDUSTRIAL

DANCEHALL

HOUSE

SPEED/THRASH METAL

TECHNO

FREESTYLE

HAIR METAL

COLLEGE ROCK

GANGSTER RAP

NEW JACK SWING

GRUNGE

G-FUNK

RIOT GRRRL

ALTERNATIVE

BLACK METAL

BRIT POP

PUNK POP

GABBER

HARDCORE RAP

NEO SOUL

ELECTRONICA

NU METAL

DRUM AND BASS

SOUTHERN HIP HOP

INDIE...

VERT SKATERS US

BLACK METAL NO

RIOT GRRRL US

Hi...

SAPEURS CG/DRC

OC...

...ALS UK

BAGGY UK

STREET SKATERS US

...REET PUNK UK

YOUTH CREW US

R...

...APPERS US

EAST COAST RAPPERS US

TECK...

NEW AGE TRAVELLERS UK

WEST COAST RAPPERS US

HYPE...

...HARDCORE US

CLUB KIDS US

RAVERS UK/US

DECORA JP

PONY

NE...

RAGGAMUFFIN JM

HAIR METAL US

GANGURO JP

LOLITAS JP

GYARU JP

AFRO...

...O IT

OTAKU JP

LO LIFES US

DOLLY-KEI JP

HESH...

KOGAL JP

...OGUERS US

CULT PARTY-KEI JP

R...

RIVETHEADS UK/BE

GABBERS NL

...RNERS US

TRAPP...

GRUNGE US

FAIRY-KEI JP

...NOWBOARDERS US

JUGGALOS US

RUN...

MORI GIRL JP

SUBVERSION

Just after the First World War, a new type of young woman emerged in the big cities of the United States. She wore what she wanted, which was often a too-short shift dress and a kohl-dark eye. She drank, smoked, and danced all night. She was the flapper, and she and her sisters made up the first youth subculture of the twentieth-century media age. Many more would follow. Pachucos. Teddy Boys. And even pothead, African cowboys who idolized the heroes of American Westerns.

For many of these young people—women, African Americans, Latinxs, homosexuals, and working class whites—style and slang were ways to resist power structures and show the world they owned their own bodies, sometimes even in death. Many, like the pachucos who fought American servicemen and the Los Angeles Police Department during the infamous Zoot Suit Riots, paid in blood to protect their rights to wear what they wanted and to act how they pleased.

And even though some subcultures—like skinheads or outlaw bikers—bonded over extreme ideologies, their impact on style and high fashion has been undeniable. Just recently, Givenchy designer Riccardo Tisci told *Vogue* that his 2017 resort collection for the label was "skinhead romantic." Powerful stuff that proves no matter how rough, youth subcultures have infiltrated the most exclusive arenas of world culture. But before they could do so, they needed a little help and a push.

That push first came from the demands of an increasingly industrial and militarized world that required teenagers to work grim, alienating jobs, or funneled them into the military. This drive towards modernization exploded in the horror of World War I, which shook imperial Europe, killed 17 million young people and civilians, and brought America out of isolation into a globalizing world. After this international tragedy, many people, particularly the young, found it difficult to trust authority.

Almost immediately following the war, the emergence of commercial radio and recording industries proved that technology wouldn't only be used to kill. This was the help. Though newspapers and magazines had been around for more than a century, recorded music and radio were the first true mass media of the modern era, broadcasting new music, ideas, and current events into the living rooms of people around the world. This was particularly true in the United States, whose economy boomed during the 1920s, while Europe's markets faltered. These factors, plus a cultural mix of African Americans, Anglo-Americans, and European immigrants, meant that the United States would emerge as the original home of the teenager and the first youth subcultures, including the notorious flappers and college kids of the 1920s.

In the 1940s, World War II would repeat many of the horrors of World War I on an even greater scale. This time, the United States

would emerge as the dominant world power, with a massive economy and cultural reach unprecedented in history. Extra income meant more freedom for young people, who were able to eschew premature adulthood for a life of school days, cars, and records. New media—television—and music—rock and roll—fueled this emergent teenage lifestyle and would help it explode into a plethora of subgenres that still influence culture today, including beatniks, greasers, mods, and hippies. These legendary subcultures all used the lexicon of hip style and music to define themselves in opposition to the mainstream—attributes that birthed an ever-growing variety of such groups, including skinheads, punks, goths, skaters, metalheads, and ravers, many of whom had to fight for their right to dress how they wanted.

Along the way, a number of developments injected new life into teenage subcultures. Psychedelic drugs in the 1960s. Electronic music and DJ culture in the 1970s, 1980s, and 1990s. And of course, the Internet in the 2000s, which dramatically changed issues of access, space, and time for young people. With the Internet, subcultures could connect instantly and persist ad infinitum.

Contemporary hipsters, with their pick-and-choose musical tastes and scrapbook style, were an early product of this mass connectivity. Normcore, seapunk, and cutesters were—and are—among the first true Internet subcultures, created online, without a need for physical space or a unified musical identity. All of these youth subcultures, from the flappers on, were simultaneously of and apart from the dominant cultures of the time, with blurry borders that show the two were often inextricable. Each subculture is, in fact, a culture. But it's also part of a larger economic machine, in which creation and ownership are bought and sold by both young people and corporations. Since its inception, teenage cool has been part of the capitalist market, with eager buyers everywhere. The Internet has only sped up these crossovers. Today's trends become tomorrow's fast fashion in an instantaneous feedback loop that threatens to swallow itself.

It's currently popular to say that subcultures are dead, but we're not so sure. Whether this Internet-driven trend ouroboros will homogenize subcultures into oblivion, obscure them under infinite layers of remixed signifiers, or eventually start spawning new ones is unclear, but in giving everyone from corporate giants to the youth of Soweto access to all information imaginable, it has destabilized the relationship between the young and the powerful, putting the production, meaning, and ownership of resistance into question. No one knows what will happen next, but it's worth exploring the future of subculture in a Wi-Fi–blanketed world and, in the meantime, paying tribute to the young rebels who've given the world so much excitement while creating their own systems of meaning to subvert oppression.

New Age travellers originated in England in the 1970s in relation to free festivals, which had themselves emerged from the rock and pop music festivals first popularized in the 1960s. Free festivals emulated these experiences while creating a communal living situation in which land, food, and goods were shared. Glastonbury began as a free music festival, while other free festivals, like those at Stonehenge, were related to Britain's Celtic past and the emergent neo-pagan scene of the 1970s and 1980s. Some festivalgoers decided they preferred a communal, traveling lifestyle, and the New Age travellers were born.

Unlike most other subcultures, which are based on youth, minority status, or sexuality, New Age travellers come mainly from the white English population, and live in families that pass the lifestyle and tradition down to their children.

In addition to viewing themselves as the heirs to a semi-mythical Celtic past, many New Age travellers believe they are continuing the gypsy traditions of British minorities like the Romanichals and Irish travellers.

New Age travellers often wear loose, brightly colored clothes inspired by circus performers, Asian robes and trousers, and the costumes of Romanichal gypsies. Many also grow dreadlocks.

While not part of every New Age traveller's lifestyle, drugs and the psychedelic culture of the 1960s were an important part of this culture at its outset.

New Age traveller encampments have occasionally faced harassment by English police. In "The Battle of the Beanfield" police blocked a group of New Age travellers from setting up the Stonehenge Festival in 1985, resulting in over four hundred arrests in a single day.

Despite such incidents, the New Age traveller culture still exists in the UK, and some families now boast three generations of travellers.

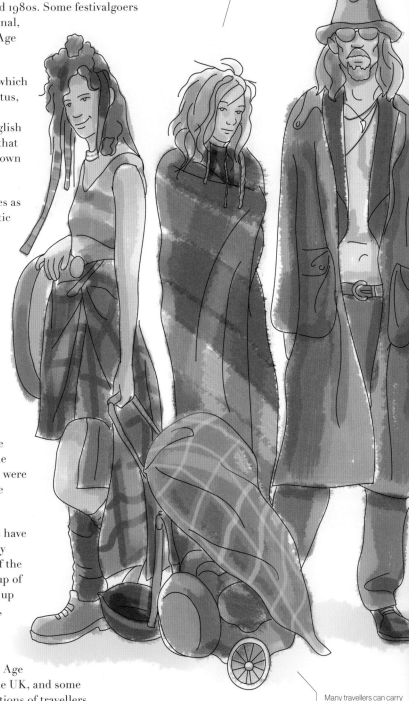

Like Deadheads, their fellow hippie offshoots, many New Age travellers wear dreadlocks

Many travellers can carry all of their possessions in a single rolling pack

THE CULTURE Though some New Age travellers refer to themselves as such, others favored specific names for their personal groups. The Yellow Tepee and The Tibetan Ukranian Mountain Troupe were New Age traveller groups in the 1980s.

ORIGIN: UNITED KINGDOM, 1970s
NEO-PAGAN HIPPIES HIT THE ROAD IN SEARCH OF FREEDOM AND COMMUNITY

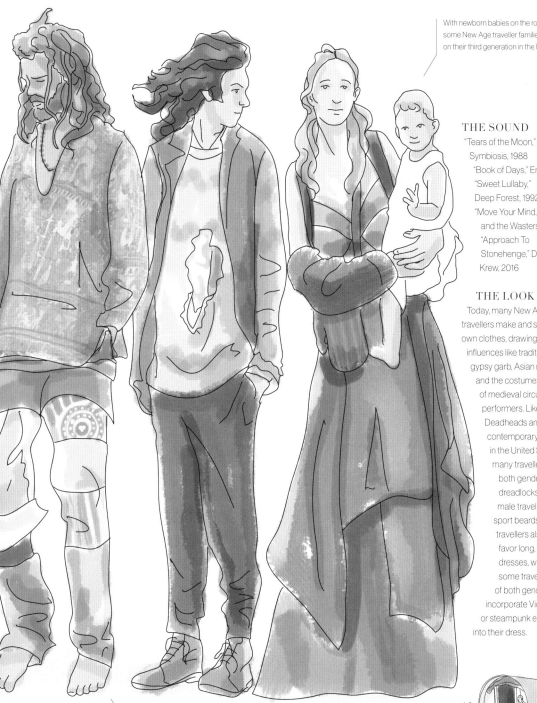

With newborn babies on the road, some New Age traveller families are on their third generation in the life

THE SOUND

"Tears of the Moon,"
Symbiosis, 1988
"Book of Days," Enya, 1992
"Sweet Lullaby,"
Deep Forest, 1992
"Move Your Mind," Will Tun
and the Wasters, 2015
"Approach To
Stonehenge," DMX
Krew, 2016

THE LOOK

Today, many New Age
travellers make and sell their
own clothes, drawing on
influences like traditional
gypsy garb, Asian robes,
and the costumes
of medieval circus
performers. Like
Deadheads and
contemporary hippies
in the United States,
many travellers of
both genders wear
dreadlocks, while
male travellers often
sport beards. Female
travellers also
favor long, flowing
dresses, while
some travellers
of both genders
incorporate Victorian
or steampunk elements
into their dress.

New Age travellers make the most of what they have, patching clothes with scrap material

HORSE-DRIVEN TRAVELLER'S CARAVAN

By the early 1980s, dedicated b-boys, DJs, and MCs had proved hip-hop was no mere fad, and outsiders had taken notice. Graffiti legends like Futura 2000 were getting downtown gallery shows and new independent record labels like Tommy Boy and Def Jam were springing up to release cutting-edge music from young artists like LL Cool J. New technology like drum machines and samplers were increasingly affordable, providing youth the means to create a hard, techy version of hip-hop that shifted the focus from the DJ to the MC. At the close of the decade, hip-hop had changed the worlds of style and media beyond anyone's wildest imagination.

Run-DMC, a group from Hollis, Queens (far outside b-boy territories like the South Bronx), released their first single, "It's Like That" in 1983. The sound was revolutionary, as was the group's style, which seamlessly melded b-boy staples like adidas track jackets and matching sneakers with raw Lee® jeans, Kangol bell hats, and huge, gold "dookie" rope chains—a look both of its time, and totally progressive.

Harlem tailor Dapper Dan was acutely aware of the shift in hip-hop taste, outfitting rappers like Eric B. & Rakim and drug dealers like Alberto "Alpo" Martinez in custom-made outfits that illegally borrowed the Louis Vuitton logo. Eventually lawsuits from multiple luxury labels shut this operation down.

Toward the end of the decade, hip-hop turned towards Afrocentrism and sample-heavy music, as groups as diverse as Public Enemy and De La Soul combined b-boy wordplay with black power rhetoric. At the same time, MTV (long prejudiced against black artists) finally acknowledged hip-hop and began airing *Yo! MTV Raps* featuring veteran graffiti artist Fab 5 Freddy as host.

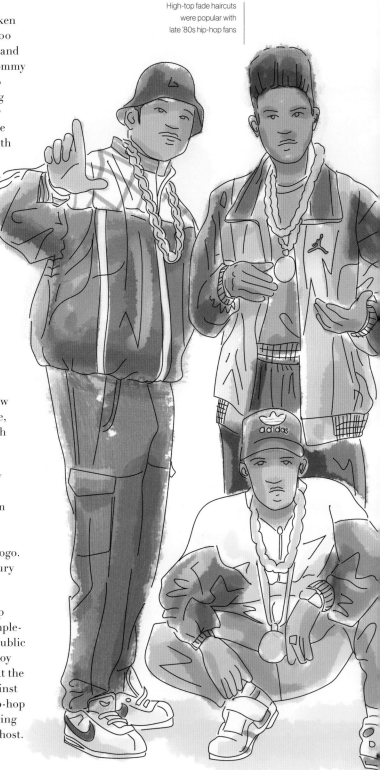

High-top fade haircuts were popular with late '80s hip-hop fans

THE CULTURE B-boys elevated sneakers to must-have status, but hip-hop artists were some of the first non-athletes a to capitalize on this new craze. Under the management of Russell Simmons, founder of Def Jam records and brother of group member Joseph Simmons, Run-DMC went on to record "My adidas," simultaneously signing an endorsement deal with the label, forever changing the way music interacted with athletic brands.

ORIGIN: NEW YORK, 1980s

RAPPERS, DRUM MACHINES, AND SAMPLERS TAKE HIP-HOP TO THE NEXT LEVEL

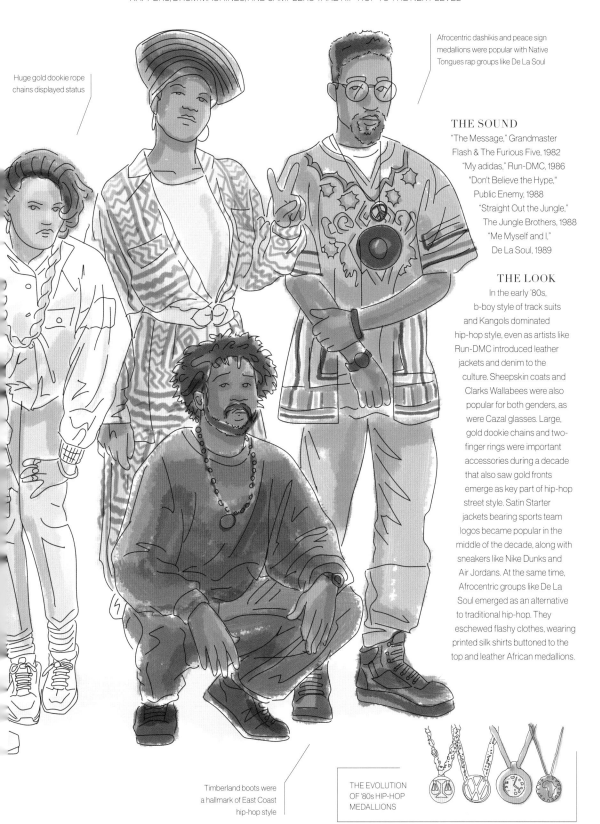

Huge gold dookie rope chains displayed status

Afrocentric dashikis and peace sign medallions were popular with Native Tongues rap groups like De La Soul

THE SOUND

"The Message," Grandmaster Flash & The Furious Five, 1982

"My adidas," Run-DMC, 1986

"Don't Believe the Hype," Public Enemy, 1988

"Straight Out the Jungle," The Jungle Brothers, 1988

"Me Myself and I," De La Soul, 1989

THE LOOK

In the early '80s, b-boy style of track suits and Kangols dominated hip-hop style, even as artists like Run-DMC introduced leather jackets and denim to the culture. Sheepskin coats and Clarks Wallabees were also popular for both genders, as were Cazal glasses. Large, gold dookie chains and two-finger rings were important accessories during a decade that also saw gold fronts emerge as key part of hip-hop street style. Satin Starter jackets bearing sports team logos became popular in the middle of the decade, along with sneakers like Nike Dunks and Air Jordans. At the same time, Afrocentric groups like De La Soul emerged as an alternative to traditional hip-hop. They eschewed flashy clothes, wearing printed silk shirts buttoned to the top and leather African medallions.

Timberland boots were a hallmark of East Coast hip-hop style

THE EVOLUTION OF '80s HIP-HOP MEDALLIONS

SHEPARD FAIREY'S
HARDCORE TOP FIVE

"Skateboarding and punk rock / hardcore saved my life.
I grew up in the South, and skate, and hardcore culture was an oasis in a conservative desert. They were an outlet that was both creative and visceral and at that time hardcore music was basically the only soundtrack to skateboarding, which was all I cared about from middle school on. The hardcore music was an aggressive companion to the aggressive frustrations I felt, but it also ignited an interest in politics and social commentary on a more intellectual level."

"Bloodstains," Agent Orange, 1981

The day I bought my first real skateboard, February 15, 1984, (my birthday) the skate shop had just that day gotten a shipment of the skateboard video "Skate Visions." Agent Orange did the soundtrack for that video. They were the first hardcore band I sought out and "Bloodstains" was one of my favorite songs from their *Living in Darkness* album.

"Nazi Punks Fuck Off," Dead Kennedys, 1981

"Nazi Punks Fuck Off" was on the *Let Them Eat Jellybeans*, a hardcore comp put out by the Dead Kennedy's label Alternative Tentacles. That comp included songs by Flipper, DOA, Black Flag, the Circle Jerks, the Subhumans, Bad Brains, etc. That was an important gateway for me to finding music by all those bands that would be important to me in my life. The song "Nazi Punks Fuck Off" is fantastic lyrically in both a fourteen-year-old with a bad attitude way, and a college professor dropping sociological knowledge way. The lyric —"Punk ain't no religious cult, punk means thinking for yourself / You ain't hardcore 'cuz you spike your hair if a jock still lives inside your head"—made me realize that action NOT image is what counts.

"Institutionalized," Suidical Tendencies, 1983

I also got this record in 1984 when the BMXer neighbor of a friend of mine decided he didn't want it because he thought it was going to be a metal record by the cover and he "hated that punk shit." Ironically, a lot of people from the hardcore scene thought this record was a little too metal-tinged and the song "Institutionalized" is a slower dirge with an almost rap-style spoken-word lyrical delivery, except in the chorus which is screamed in double-time, potentially salvaging some hardcore cred. The amazing thing about this song is that it perfectly captures teenage feelings of frustration and alienation. It has a sense of humor, but it also connects with a fairly universal truth about disaffected youth.

"Betray," Minor Threat, 1983

I love Minor Threat's entire discography, and they have great songs on their first EP, but their sound got much more muscular on the *Out of Step* album when they added bassist Steve Hansgen and moved Brian Baker who was formerly on bass to rhythm guitar giving the album an amazing guitar punch. The song "Betray" is great musically, but also lyrically in its analysis of a deteriorating relationship. Ian MacKaye always made the personal political in a powerful way.

"I Against I," Bad Brains, 1986

I absolutely loved Bad Brains ROIR cassette, with its amazing cover of the Capitol being struck by lightning, so I was excited when "I Against I" came out when I was a sophomore in high school. The song "I Against I" itself is the perfect bridge between the faster hardcore Bad Brains was known for and the funk-metal and New Wave grooves that they would expand their sound with. The "I Against I" video was shot at the Living Room in Providence, Rhode Island, where I would later see many hardcore bands including Bad Brains. I would try to catch "120 Minutes" on MTV in hopes they would air "I Against I." It may seem hard to believe now when the term "sellout" is thrown around so casually, but at the time, I was very excited for Bad Brains to be validated by something as mainstream as MTV, simply because the entire hardcore genre seemed to be so looked down upon. On the one hand, I loved being an outsider, but on the other hand, I wanted people to recognize the merits of the genre.

HARDCORE

*Distilling punk into minimalist blasts
of pure sonic aggression, hardcore is an exclusive,
tribal scene*

"World Up My Ass," Circle Jerks, 1980

"Revenge," Black Flag, 1980

"Anarchy Is Dead," Government Issue, 1981

"Bloodstains," Agent Orange, 1981

"Code Blue," T.S.O.L., 1981

"God Is Dead," Heart Attack, 1981

"John Wayne Was a Nazi," MDC, 1981

"Making Room for Youth," Social Unrest, 1981

"Nazi Punks Fuck Off," Dead Kennedys, 1981

"Bikeage," Descendents, 1982

"Hey, Ronnie," Government Issue, 1982

"1945.0 (13th Floor Version)," Social Distortion, 1982

"Selfish," Gang Green, 1982

"Suburban Home," Descendants, 1982

"Betray," Minor Threat, 1983

"Diane," Hüsker Dü, 1983

"I Don't Need Society," D.R.I., 1983

"Institutionalized," Suicidal Tendencies, 1983

"No One Rules," Agnostic Front, 1983

"Degenerated," Reagan Youth, 1984

"Surf Combat," Naked Raygun, 1984

"Hard Times," Cro-Mags, 1985

"Positive Outlook," Youth Of Today, 1985

"I Against I," Bad Brains, 1986

NEW WAVE

*With an ironic wink and a fondness for kitsch, New Wave
brings back the fun after punk's fury*

"Baby Talks Dirty," The Knack, 1980

"Crosseyed and Painless," Talking Heads, 1980

"Don't Stand So Close to Me," The Police, 1980

"If I Didn't Love You," Squeeze, 1980

"I Know What Boys Like," The Waitresses, 1980

"Love For Tender," Elvis Costello & The Attractions, 1980

"Pretty Boys," Joe Jackson, 1980

"Walk Like Me," Blondie, 1980

"Whip It," Devo, 1980

"Metro," Berlin, 1981

"Never Say Never," Romeo Void, 1981

"Tainted Love," Soft Cell, 1981

"Up All Night," Boomtown Rats, 1981

"We Got the Beat," Go-Go's, 1981

"Who Can It Be Now?," Men At Work, 1981

"Destination Unknown," Missing Persons, 1982

"Grey Matter," Oingo Boingo, 1982

"I Ran," A Flock Of Seagulls, 1982

"Love My Way," The Psychedelic Furs, 1982

"Mexican Radio," Wall of Voodoo, 1982

GOLDEN ERA HIP-HOP

*Reporting direct from the streets of the five boroughs,
first-generation hip-hop crews changed both the sound
and the look of music*

"Ego Tripping," Ultra Magnetic M.C.'s, 1986

"Make the Music With Your Mouth, Biz," Biz Markie, 1986

"I'm Bad," LL Cool J, 1987

"Paid in Full," Eric B. & Rakim, 1987

"Push It," Salt-N-Pepa, 1987

"The Bridge Is Over," Boogie Down Productions, 1987

"It Takes Two," Rob Base & DJ E-Z Rock, 1988

"The Symphony," Marley Marl, 1988

"Straight Outta Compton," N.W.A, 1988

"Talkin' All That Jazz," Stetsasonic, 1988

"Turn This Mutha Out," MC Hammer, 1988

"You Gots to Chill," EPMD, 1988

"Cha Cha Cha," MC Lyte, 1989

"Fight The Power," Public Enemy, 1989

"Hey Ladies," Beastie Boys, 1989

"I Come Off," Young MC, 1989

"I Get The Job Done," Big Daddy Kane, 1989

"Me So Horny," 2 Live Crew, 1989

"Words I Manifest," Gang Starr, 1989

"The Humpty Dance," Digital Underground, 1989

As in the United Kingdom, the second wave of American punks created music that was leaner, faster, and more aggressive than anything that had come before it. They called it hardcore, and bands like Minor Threat, Bad Brains, and Black Flag pushed it forward with raw tenacity and rage. But, where UK punk bands like The Exploited added mohawks and embellished leather jackets to the punk style canon, Americans stripped things down, wearing shaved heads, flannel shirts, khakis, jeans, and Vans, creating a stark look that was all the more menacing for its simplicity.

Bands like the Germs from Los Angeles (formed in 1977 and broken up by 1980) provided a bridge between the first wave of '70s punk and the hardcore that dominated '80s America.

In addition to Southern California, where bands like Black Flag and Fear formed in the wake of The Germs, New York, Washington, DC, and Boston were key incubators of hardcore punk.

Washington, DC, in particular produced influential bands, including straight edge progenitors Minor Threat and the musically advanced Rastafarian band Bad Brains.

Through the influence of British Oi! music, skinhead style became part of the American hardcore landscape, a development that included all the violence, and some of the racism, of second-generation UK skins.

Hardcore was less interested in political theory than anarcho-punk or UK82, instead concerning itself with personal freedom, self-discipline, and police oppression.

This emphasis on personal discipline famously produced the drug-free straight edge movement, which began with Minor Threat's song "Straight Edge."

Hardcore morphed and changed throughout the 1980s, splitting off into subgenres like New York's Youth Crew movement and emo (originally called "emo-core"), while also influencing alternative bands like Dinosaur Jr. and Nirvana.

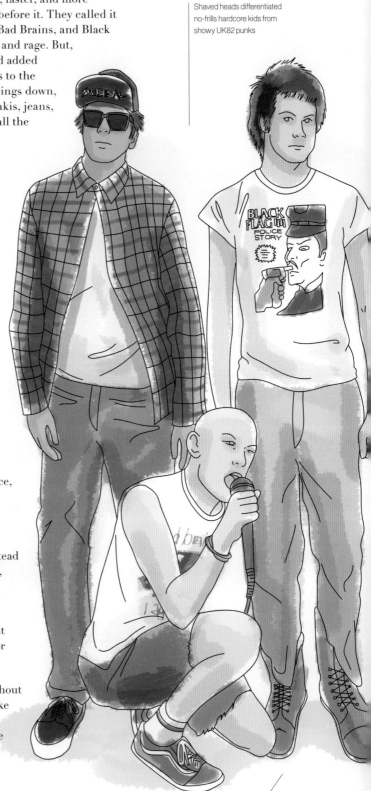

Shaved heads differentiated no-frills hardcore kids from showy UK82 punks

Vans or combat boots were the hardcore footwear of choice

THE CULTURE The LA hardcore scene mixed with the city's gang culture, producing crews like Circle One.

HARDCORE

ORIGIN: UNITED STATES, 1980s
AMERICAN TEENS STRIP PUNK ROCK TO ITS BRUTAL CORE

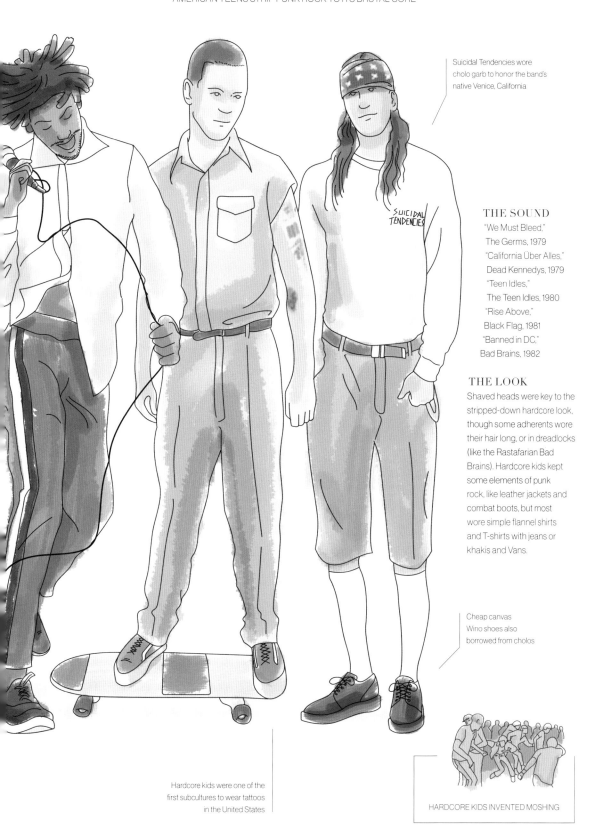

Suicidal Tendencies wore cholo garb to honor the band's native Venice, California

THE SOUND

"We Must Bleed,"
The Germs, 1979
"California Über Alles,"
Dead Kennedys, 1979
"Teen Idles,"
The Teen Idles, 1980
"Rise Above,"
Black Flag, 1981
"Banned in DC,"
Bad Brains, 1982

THE LOOK

Shaved heads were key to the stripped-down hardcore look, though some adherents wore their hair long, or in dreadlocks (like the Rastafarian Bad Brains). Hardcore kids kept some elements of punk rock, like leather jackets and combat boots, but most wore simple flannel shirts and T-shirts with jeans or khakis and Vans.

Cheap canvas Wino shoes also borrowed from cholos

Hardcore kids were one of the first subcultures to wear tattoos in the United States

HARDCORE KIDS INVENTED MOSHING

In the five years leading up the 1980 election, Jamaica experienced a wave of bloodshed as the populist People's National Party and the conservative Jamaica Labour Party used violent Kingston gangs to help secure votes. In West and South Kingston, the JLP-backed Phoenix gang murdered rivals with an impunity past generations of Rude Boys could only imagine, just as PNP gangs like the Skulls did the same in Eastern and Central Kingston. Edward Seaga, the JLP leader with ties to the CIA, won the 1980 election and became prime minister. At the same time, gangsters from both sides were becoming increasingly involved in the cocaine trade, exporting it to the United States, Canada, and the United Kingdom.

The money and guns cocaine dealing brought to Jamaica instigated a shift in an already violent nation, as musicians left the Afrocentric messages of Rastafarianism behind to create dancehall music focused on "gun talk" and "slackness," which celebrated violence and raw sexuality.

By the early '80s, synthesizers had become more affordable, and Jamaican producers switched from live musicians to digital song-making, creating a style of reggae known as raggamuffin, which dominated Jamaican music by 1985.

This new music also created a shift in fashion, as silk suits, gangster gold, and American hip-hop influences rose in importance among dancehall artists and fans. Many also wore the classic Jamaican net tank top known as a mesh marina.

During the '80s, Clarks were the shoe of choice among Jamaican musicians and gangsters alike. the brand's split-toe model, the Desert Trek, were known as "bankrobbers." Jamaican immigrants brought Clarks to New York City, where they became part of early hip-hop fashion.

As ragga continued on into the '90s, it became ever-more electronic sounding, while the fashion fell under the influence of gangster rap, as baggy denim, hi-top fades, and bandanas became popular among raggamuffins.

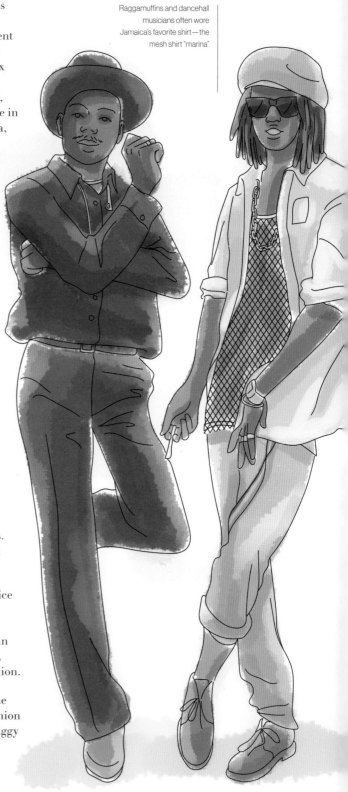

Raggamuffins and dancehall musicians often wore Jamaica's favorite shirt—the mesh shirt "marina"

THE CULTURE The mobile DJ sound system culture that helped influence DJ Kool Herc to create hip-hop in the Bronx during the 1970s remained crucial to '80s raggamuffin music in Jamaica, with crews like Jammy's Super Power and Kilimanjaro pitting their massive speakers and best DJs against one another in live competitions called "sound clashes."

RAGGAMUFFIN

ORIGIN: KINGSTON, 1980s
JAMAICANS UPDATE RUDE BOY STYLE FOR THE CRACK ERA

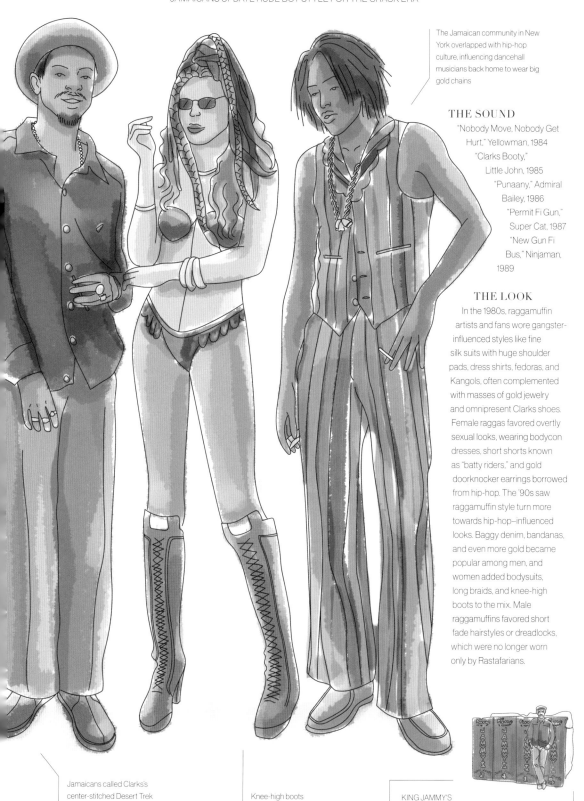

The Jamaican community in New York overlapped with hip-hop culture, influencing dancehall musicians back home to wear big gold chains

THE SOUND

"Nobody Move, Nobody Get Hurt," Yellowman, 1984
"Clarks Booty,"
Little John, 1985
"Punaany," Admiral
Bailey, 1986
"Permit Fi Gun,"
Super Cat, 1987
"New Gun Fi
Bus," Ninjaman,
1989

THE LOOK

In the 1980s, raggamuffin artists and fans wore gangster-influenced styles like fine silk suits with huge shoulder pads, dress shirts, fedoras, and Kangols, often complemented with masses of gold jewelry and omnipresent Clarks shoes. Female raggas favored overtly sexual looks, wearing bodycon dresses, short shorts known as "batty riders," and gold doorknocker earrings borrowed from hip-hop. The '90s saw raggamuffin style turn more towards hip-hop–influenced looks. Baggy denim, bandanas, and even more gold became popular among men, and women added bodysuits, long braids, and knee-high boots to the mix. Male raggamuffins favored short fade hairstyles or dreadlocks, which were no longer worn only by Rastafarians.

Jamaicans called Clarks's center-stitched Desert Trek model "Bankrobbers," because gunmen loved them

Knee-high boots were perfect for doing the butterfly

KING JAMMY'S
SUPER POWER SOUND SYSTEM

Clubs like Rodney's English Disco ensured that Los Angeles' Sunset Strip was the home of glam rock in America. But even as the scene faded by the mid-1970s, new homegrown hard rock bands like Van Halen and Quiet Riot were forming, taking the hard edge off of glam rock and replacing it with a sunny, good-time California pop. While Van Halen wasn't necessarily hair metal, Quiet Riot was, and their massive success on radio and a nascent MTV set the stage for the costumed fun of true hair bands like Mötley Crüe and Poison, who would come to overshadow harder metal bands and dominate the 1980s with their catchy riffs and hairspray-enhanced coifs.

Though they claim to have formed in rebellion against all the other bands in LA at the time, Mötley Crüe's massive, hairsprayed coifs, incredible stage costumes, and pop-metal sound made them the hair metal heirs to Quiet Riot. "Looks That Kill," the first single off Crüe's second album, *Shout at the Devil*, was a minor chart hit, but its spandex-filled video became a sensation on MTV, setting the template for the hair metal bands that would follow.

Mötley Crüe's success on MTV opened the hair metal floodgates, as Midwestern bands like Poison from Mechanicsburg, Pennsylvania, flooded LA to hit the Sunset Strip in hopes of finding a record deal.

Labels rushed to push out MTV-ready hair metal bands in the late 1980s and early 1990s, eventually flooding the market, and setting the stage for a massive backlash. That backlash came in 1991, when little-known band Nirvana hit number one on the *Billboard* charts with their debut album *Nevermind*, a record that lead singer Kurt Cobain derided for sounding too much like a Mötley Crüe record.

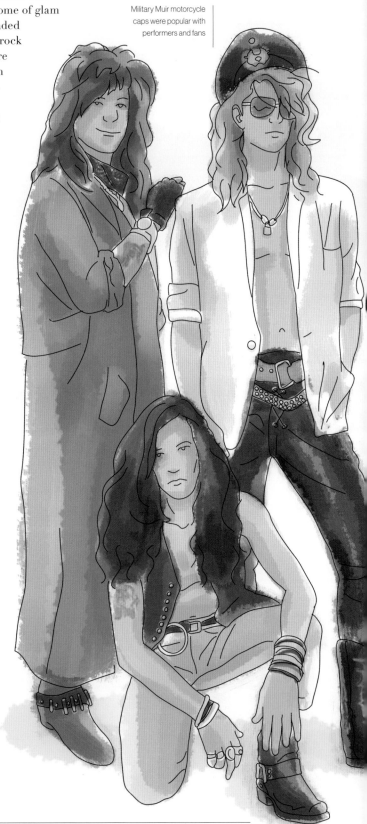

Military Muir motorcycle caps were popular with performers and fans

THE CULTURE Despite great female artists like Lita Ford and Vixen, hair metal was mostly a male domain where women were relegated to groupie status. It's famous for bringing macho rock culture into the AIDS era and for its general sexism.

HAIR METAL

ORIGIN: LOS ANGELES, 1980s
SOCAL METAL FANS TAKE GLAM TO BEAUTIFUL NEW HEIGHTS

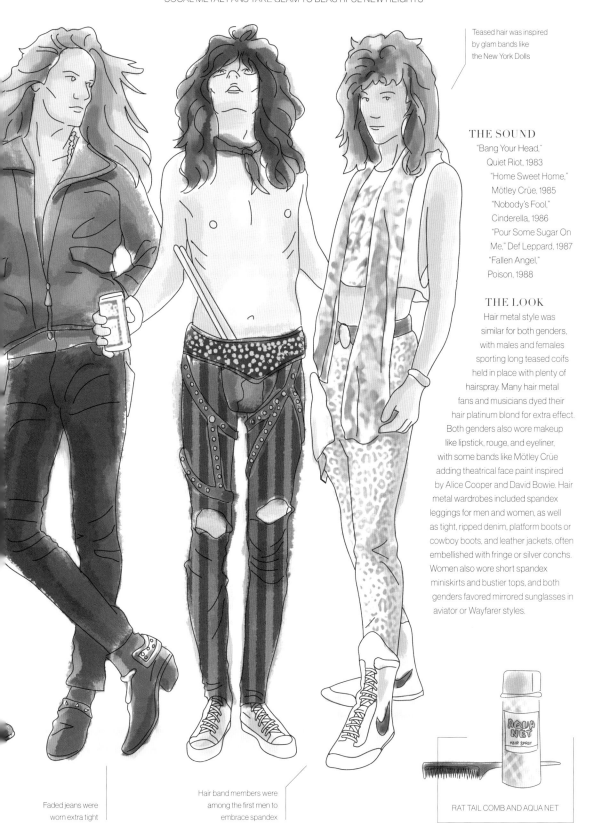

Teased hair was inspired
by glam bands like
the New York Dolls

THE SOUND

"Bang Your Head,"
Quiet Riot, 1983
"Home Sweet Home,"
Mötley Crüe, 1985
"Nobody's Fool,"
Cinderella, 1986
"Pour Some Sugar On
Me," Def Leppard, 1987
"Fallen Angel,"
Poison, 1988

THE LOOK

Hair metal style was
similar for both genders,
with males and females
sporting long teased coifs
held in place with plenty of
hairspray. Many hair metal
fans and musicians dyed their
hair platinum blond for extra effect.
Both genders also wore makeup
like lipstick, rouge, and eyeliner,
with some bands like Mötley Crüe
adding theatrical face paint inspired
by Alice Cooper and David Bowie. Hair
metal wardrobes included spandex
leggings for men and women, as well
as tight, ripped denim, platform boots or
cowboy boots, and leather jackets, often
embellished with fringe or silver conchs.
Women also wore short spandex
miniskirts and bustier tops, and both
genders favored mirrored sunglasses in
aviator or Wayfarer styles.

Faded jeans were
worn extra tight

Hair band members were
among the first men to
embrace spandex

RAT TAIL COMB AND AQUA NET

The Paninaro were a group of well-off teenagers who began hanging out Milan's Al Panino sandwich shop, where they gathered to gulp down burgers and show off their latest duds. These teens favored expensive continental labels filtered through an American sensibility, often paring puffy down Moncler jackets or vests with embroidered Best Company sweatshirts, Levi's® 501s, large cowboy belt buckles, and Timberland boots, boat shoes, or Vans. The clique included both boys and girls, and eventually spread from Milan to the rest of Italy and even England, where it influenced the high-end style of 1980s football casuals.

The Paninaro were an instant hit with Italian media. *La Stampa* newspaper named them after the Al Panino sandwich shop where they first gathered, and at one point in the 1980s, there were at least three magazines dedicated to Paninaro, including *Wild Boys*, *Preppie*, and *Paninaro*.

After Al Panino, the Paninaro's back up hang out spot was the Piazza San Babila location of Burghy, an Italian fast food chain that shuttered in the '90s after being purchased by McDonald's.

The Paninaro insisted on hemming or rolling their jeans above their ankles in order to show off their colorful Burlington socks.

Paninaro were fond of scooters, riding both Vespas and the larger, more powerful Aprilia Scarabeo models. As a complement to their scooters, Paninaro also wore bright, colorful backpacks that could be seen from anywhere on the road.

In addition to foreign labels like Moncler and Levi's®, the Paninaro loved Italian luxury goods like Valentino jeans and outerwear from C.P. Company jackets.

Unlike many youth subcultures, the Paninaro were largely apolitical, offering up American-influenced optimism and brand fetishism as an antidote to the political terrorism that wracked Italy during the "Years of Lead" in the 1960s and 1970s.

Paninaro loved to mix American icons like fleece Schott bomber jackets with cowboy belts

Embroidered crewnecks from Best Company were designed as an Italian spin on prep

THE CULTURE The informal leader of a Paninaro clique was called *el gallo*, which means "the cock."

PANINARO

ORIGIN: MILAN, 1980s
WEALTHY ITALIAN TEENS FLAUNT THEIR STATUS THROUGH FANCY BRANDS

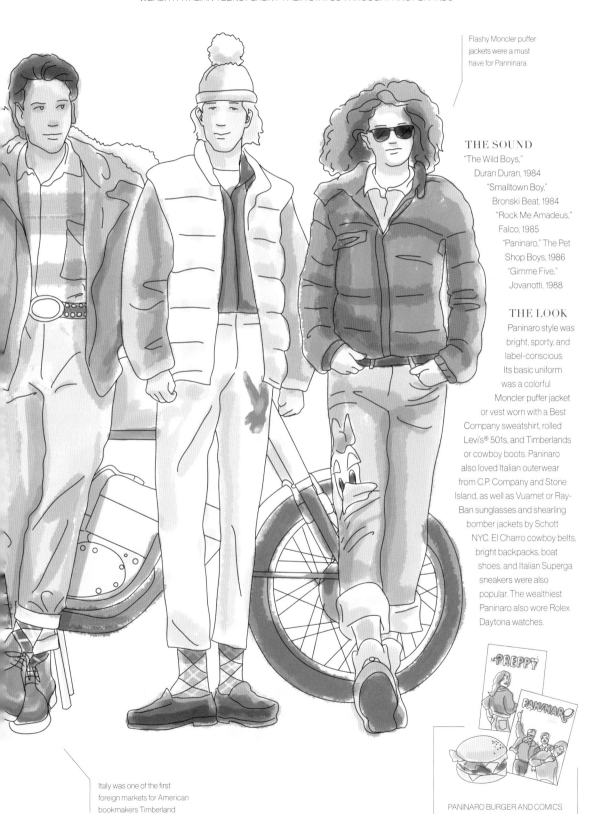

Flashy Moncler puffer
jackets were a must
have for Panninara

THE SOUND
"The Wild Boys,"
Duran Duran, 1984
"Smalltown Boy,"
Bronski Beat, 1984
"Rock Me Amadeus,"
Falco, 1985
"Paninaro," The Pet
Shop Boys, 1986
"Gimme Five,"
Jovanotti, 1988

THE LOOK
Paninaro style was
bright, sporty, and
label-conscious.
Its basic uniform
was a colorful
Moncler puffer jacket
or vest worn with a Best
Company sweatshirt, rolled
Levi's® 501s, and Timberlands
or cowboy boots. Paninaro
also loved Italian outerwear
from C.P. Company and Stone
Island, as well as Vuarnet or Ray-
Ban sunglasses and shearling
bomber jackets by Schott
NYC. El Charro cowboy belts,
bright backpacks, boat
shoes, and Italian Superga
sneakers were also
popular. The wealthiest
Paninaro also wore Rolex
Daytona watches.

Italy was one of the first
foreign markets for American
bookmakers Timberland

PANINARO BURGER AND COMICS

ANDREW W.K.'S PROTO-INDUSTRIAL SELECTS

"Hamburger Lady," Throbbing Gristle, 1978

"Havoc," Cabaret Voltaire, 1978

"Drag Racing," Big Stick, 1986

"The Inmost Light," Current 93, 1996

"A Million Years," Wolf Eyes, 2006

INDUSTRIAL

Industrial music uses samplers and other electronics to create a dystopian soundscape for the modern age

"United," Throbbing Gristle, 1979

"Der Mussolini," D.A.F., 1982

"Compulsion," Test Dept., 1983

"Sensoria," Cabaret Votaire, 1984

"Dead Eyes Opened," Severed Heads, 1984

"What's My Mission Now?," Tackhead, 1985

"Murderous," Nitzer Ebb, 1986

"The Anal Staircase," Coil, 1986

"Did You Miss Me?," The Young Gods, 1987

"Life Is Life," Laibach, 1987

"Body Count," Front Line Assembly, 1988

"Stigmata," Ministry, 1988

"Down In It," Nine Inch Nails. 1989

"Kooler Than Jesus," My Life With The Thrill Kill Kult, 1989

 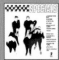 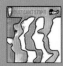 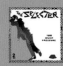

TWO TONE SKA

Bridging racial divides after the right-wing National Front infiltrated the punk scene, the ska revival brings the Rude Boys together

"Baggy Trousers," Madness, 1980

"Do Nothing," The Specials, 1980

"Enjoy Yourself (It's Later Than You Think)," The Specials, 1980

"Hey, Little Rich Girl," The Specials, 1980

"Let's Do Rocksteady," The Bodysnatchers, 1980

"Lip Up Fatty," Bad Manners, 1980

"Mantovani," The Swinging Cats, 1980

"Mirror in the Bathroom," The Beat, 1980

"Romance," The Members, 1980

"Sea Cruise," Rico, 1980

"Three Minute Hero," The Selecter, 1980

"Tom Hark," The Piranhas, 1980

"Too Experienced," The Bodysnatchers, 1980

"Too Much Pressure," The Selecter, 1980

"Twist and Crawl," The Beat, 1980

"House of Fun," Madness, 1982

"Jungle Music," Rico & The Special AKA, 1982

"The Boiler," Rhoda, 1982

"Nelson Mandela," The Special AKA, 1984

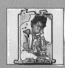

DANCEHALL

A slack attitude and a cool electronic beat sets dancehall apart from its reggae precursors

"Entertainment," Triston Palmer, 1981

"Love Bump," Lone Ranger, 1981

"Trodding Through the Jungle," Carlton Livingston, 1981

"Mi God Mi King," Papa Levi, 1982

"Spar With Me," Toyan, 1982

"Sugar Ray," Captain Sinbad, 1982

"Zungguzunggzungguzung," Yellowman, 1983

"Billie Jean," Shinehead, 1984

"Lick Shot," Michael Palmer, 1984

"Pass the Tu-Sheng-Peng," Frankie Paul 1984

"Under Mi Sleng Teng," Wayne Smith, 1984

"Cool and Loving," Barrington Levy, 1985

"I Lost My Sonia," Cocoa Tea, 1985

"Original Foreign Mind," Junior Reid, 1985

"Ring the Alarm," Tenor Saw, 1985

"Boops," Super Cat, 1986

"Greetings," Half Pint, 1986

"Nah Follow Nuh Fashion," Sugar Minott, 1986

"No Wanga Gut," Tiger, 1986

"Lady In Red," Sanchez, 1987

"More Reality," Ninja Man, 1987

"Wear Yu Size," Lieutenant Stitchie, 1987

"Gimme No Crack," Shinehead, 1988

"Telephone Love," J.C. Lodge, 1988

"V.I.P.," Shabba Ranks, 1988

SPEED/THRASH METAL
*Thrash brings hardcore speed and intensity
to metal's lumbering wallop*

"Hallowed Be Thy Name," Iron Maiden, 1982

"Into the Crypts of Rays," Celtic Frost, 1984

"Merciless Onslaught," Metal Church, 1984

"Agents of Steel," Agent Steel, 1985

"Rotten to the Core," Overkill, 1985

"Strike of the Beast," Exodus, 1985

"Hang the Pope," Nuclear Assault, 1986

"Master of Puppets," Metallica, 1986

"Peace Sells," Megadeth, 1986

"Reign in Blood," Slayer, 1986

"Caught in a Mosh," Anthrax, 1987

"Death By Hanging," Heathen, 1987

"First Strike Is Deadly," Testament, 1987

"U.S.A. For U.S.A.," Carnivore, 1987

"Alison Hell," Annihilator, 1988

"Americanized," Gwar, 1988

"Kill On Command," Vio-Lence, 1988

"Bored," Death Angel, 1988

"Saturday Night's Alright for Fighting," Flotsam & Jetsam, 1988

"Inner Self," Sepultura, 1989

HAIR METAL
*Hair metal leavens old school headbanging
with pop hooks and glam attitude*

"Cum On Feel the Noize" Quiet Riot, 1983

"Photograph," Def Leppard, 1983

"Shout at the Devil," Mötley Crüe, 1983

"L.O.V.E. Machine," W.A.S.P., 1984

"Reason for the Season," Stryper, 1984

"Round and Round," Ratt, 1984

"Turn Up the Radio," Autograph, 1984

"We're Not Gonna Take It," Twisted Sister, 1984

"In My Dreams," Dokken, 1985

"Livin' on a Prayer," Bon Jovi, 1986

"Somebody Save Me," Cinderella, 1986

"Don't Change That Song," Faster Pussycat, 1987

"Here I Go Again," Whitesnake, 1987

"Modern Day Cowboy," Tesla, 1987

"Rock Me," Great White, 1987

"Every Rose Has Its Thorn," Poison, 1988

"Girlschool," Britny Fox, 1988

"Seventeen," Winger, 1988

"18 and Life," Skid Row, 1989

OI!, STREET PUNK, AND ANARCHO-PUNK
*Loud, fast, and political, street punk and Oi!
unite the kids and they won't step back*

"Fight Back," Discharge, 1980

"Join the Rejects," Cockney Rejects, 1980

"Shotgun Solution," Angelic Upstarts, 1980

"Unite and Win," Sham 69, 1980

"Big A Little a," Crass, 1981

"One Law For Them," 4 Skins, 1981

"Race Against Time," G.B.H., 1981

"Alternative," The Exploited, 1982

"Emergency," Infa Riot, 1982

"I'm Gonna Get a Gun," The Ejected, 1982

"No U Turns," The Partisans, 1983

"Viva la Revolution," The Adicts, 1982

"Voice of a Generation," Blitz, 1982

"When the Punks Go Marching In," Abrasive Wheels, 1982

"Mesrine," The Blood, 1983

"Reason Why," Angelic Upstarts, 1983

"Riot Squad," Cock Sparrer, 1983

"September Part 2," Peter And The Test Tube Babies, 1983

"Surburan Reels," The Business, 1983

"We're The Oppressed," The Oppressed, 1983

Industrial music arose in the late 1970s on the heels of English band Throbbing Gristle and their record label Industrial Records. In addition to being performance artists and pioneers of noisy synthesizer and tape-sample based industrial music, Throbbing Gristle adopted a pseudo-fascist style, consisting of black, gray, or camouflage military uniforms decorated with punk-inspired studs and the band's sigil, a white lightning bolt on a red and black field that recalled the Nazi swastika flag and the SS rune sign. Though Throbbing Gristle broke up by 1981, their music and fashion set the course for later groups, like Belgian Front 242, to develop industrial dance music and spread the rivethead style.

Like Throbbing Gristle, Front 242 wore dark military uniforms, adding a hard technological edge to the look that included flak jackets, combat boots, body piercings, and sunglasses.

The rivethead subculture began as other—mostly male—industrial dance music artists and fans adopted Front 242's style.

As the rivethead culture grew, and members of other industrial dance groups like Nitzer Ebb added their spin on the look, it came to include shaved heads and dreadlocked mohawks, as well as goggles and hardware-coated platform boots from companies like Transmuter.

Towards the end of the 1980s, women also experimented with rivethead style, as designers like Southern California's Lip Service popped up to add skirts and fetish-inspired vinyl to the mix.

Though Front 242 abandoned hardcore rivethead style for a softer, all-black look in the early 1990s, the subculture only increased in popularity, especially as groups like Nine Inch Nails expanded industrial music, and a burgeoning Internet culture added cyberpunk elements to it.

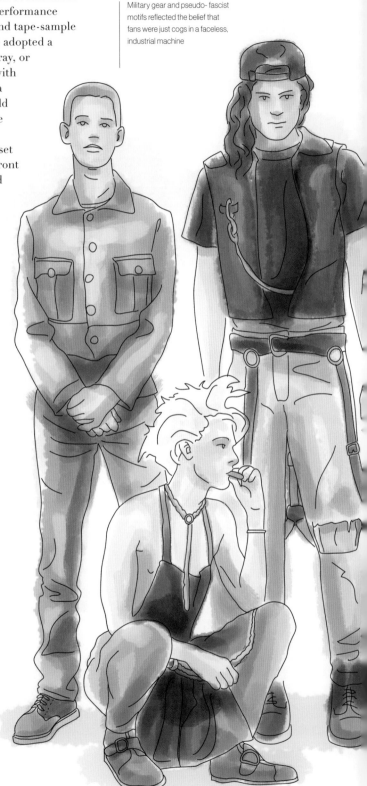

Military gear and pseudo-fascist motifs reflected the belief that fans were just cogs in a faceless, industrial machine

THE CULTURE Rivethead progenitors Throbbing Gristle evolved from COUM Transmissions, an English performance art collective that had featured band members Genesis P-Orridge and Cosey Fanni Tutti. COUM Transmissions performances featured bloodletting and bodily mortification with the objective of reaching spiritual transcendence through near-death experiences.

ORIGIN: UNITED KINGDOM AND BELGIUM, 1980s
INDUSTRIAL DANCE MUSIC FANS PARODY TECHNO-FASCISM THROUGH FASHION

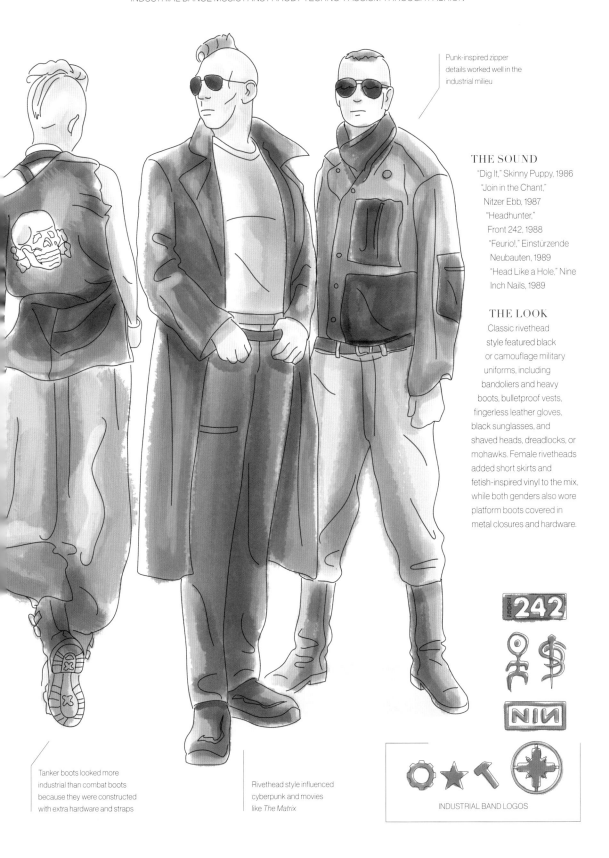

Punk-inspired zipper details worked well in the industrial milieu

THE SOUND

"Dig It," Skinny Puppy, 1986
"Join in the Chant,"
Nitzer Ebb, 1987
"Headhunter,"
Front 242, 1988
"Feurio!," Einstürzende
Neubauten, 1989
"Head Like a Hole," Nine
Inch Nails, 1989

THE LOOK

Classic rivethead style featured black or camouflage military uniforms, including bandoliers and heavy boots, bulletproof vests, fingerless leather gloves, black sunglasses, and shaved heads, dreadlocks, or mohawks. Female riveteheads added short skirts and fetish-inspired vinyl to the mix, while both genders also wore platform boots covered in metal closures and hardware.

INDUSTRIAL BAND LOGOS

Tanker boots looked more industrial than combat boots because they were constructed with extra hardware and straps

Rivethead style influenced cyberpunk and movies like The Matrix

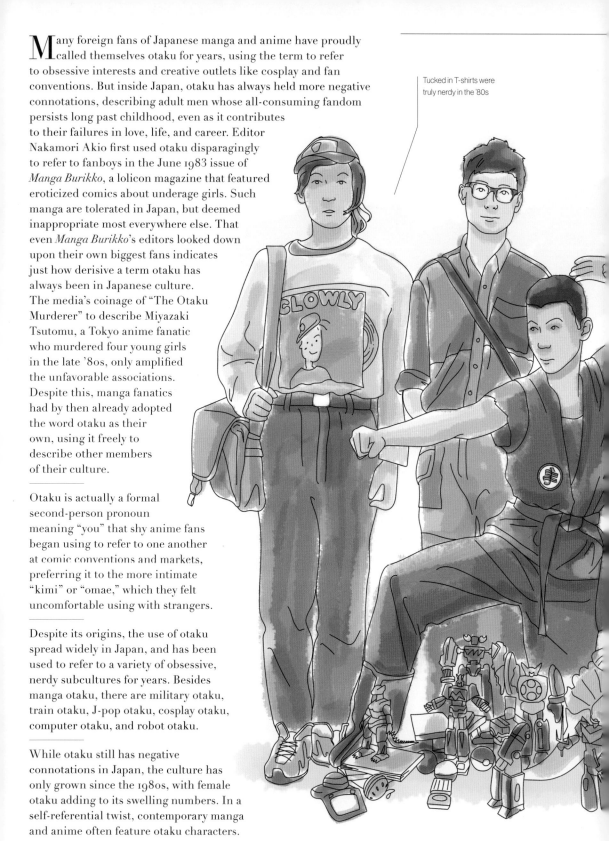

Many foreign fans of Japanese manga and anime have proudly called themselves otaku for years, using the term to refer to obsessive interests and creative outlets like cosplay and fan conventions. But inside Japan, otaku has always held more negative connotations, describing adult men whose all-consuming fandom persists long past childhood, even as it contributes to their failures in love, life, and career. Editor Nakamori Akio first used otaku disparagingly to refer to fanboys in the June 1983 issue of *Manga Burikko*, a lolicon magazine that featured eroticized comics about underage girls. Such manga are tolerated in Japan, but deemed inappropriate most everywhere else. That even *Manga Burikko*'s editors looked down upon their own biggest fans indicates just how derisive a term otaku has always been in Japanese culture. The media's coinage of "The Otaku Murderer" to describe Miyazaki Tsutomu, a Tokyo anime fanatic who murdered four young girls in the late '80s, only amplified the unfavorable associations. Despite this, manga fanatics had by then already adopted the word otaku as their own, using it freely to describe other members of their culture.

Otaku is actually a formal second-person pronoun meaning "you" that shy anime fans began using to refer to one another at comic conventions and markets, preferring it to the more intimate "kimi" or "omae," which they felt uncomfortable using with strangers.

Despite its origins, the use of otaku spread widely in Japan, and has been used to refer to a variety of obsessive, nerdy subcultures for years. Besides manga otaku, there are military otaku, train otaku, J-pop otaku, cosplay otaku, computer otaku, and robot otaku.

While otaku still has negative connotations in Japan, the culture has only grown since the 1980s, with female otaku adding to its swelling numbers. In a self-referential twist, contemporary manga and anime often feature otaku characters.

Tucked in T-shirts were truly nerdy in the '80s

THE CULTURE In the most extreme cases of obsessive fandom, some otaku choose to "marry" collectable pillows that bear the images of their favorite anime characters.

OTAKU

ORIGIN: JAPAN, 1980s
SHY NERDS CREATE THEIR OWN WORLDS OF MANGA AND ANIME

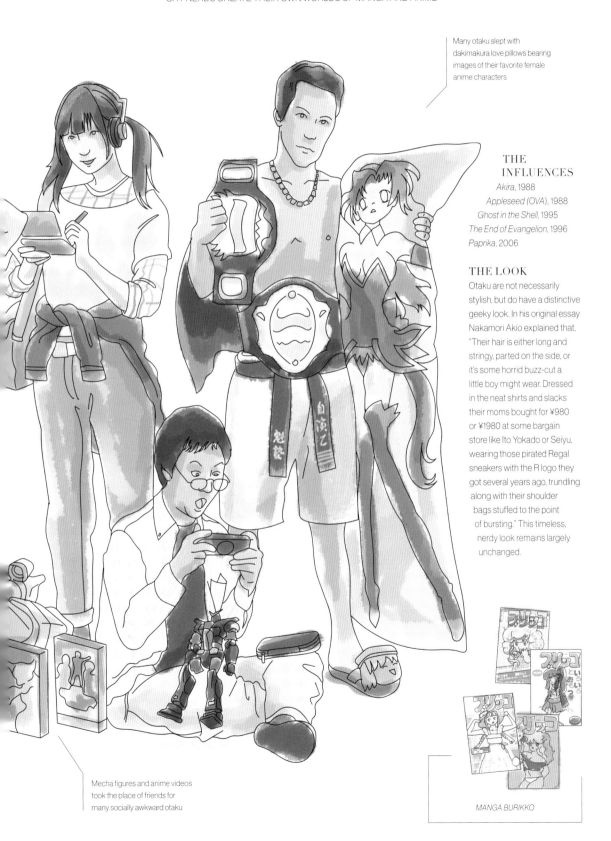

Many otaku slept with dakimakura love pillows bearing images of their favorite female anime characters

THE INFLUENCES

Akira, 1988
Appleseed (OVA), 1988
Ghost in the Shell, 1995
The End of Evangelion, 1996
Paprika, 2006

THE LOOK

Otaku are not necessarily stylish, but do have a distinctive geeky look. In his original essay Nakamori Akio explained that, "Their hair is either long and stringy, parted on the side, or it's some horrid buzz-cut a little boy might wear. Dressed in the neat shirts and slacks their moms bought for ¥980 or ¥1980 at some bargain store like Ito Yokado or Seiyu, wearing those pirated Regal sneakers with the R logo they got several years ago, trundling along with their shoulder bags stuffed to the point of bursting." This timeless, nerdy look remains largely unchanged.

Mecha figures and anime videos took the place of friends for many socially awkward otaku

MANGA BURIKKO

When Minor Threat's Ian Mackaye wrote "Straight Edge" in 1981, he never thought he'd start a movement. But his ode to drug-free living inspired a whole generation of fans to dedicate themselves to sobriety, vegetarianism, and positivity. New York Hardcore band Youth of Today were among those kids, and with other influences from Boston bands like SSD and DYS, they created the Youth Crew movement, spreading the straight edge message around the world with an athletic intensity.

John Porcelly, known as Porcell, was a high school football player from Danbury, Connecticut, when he formed Youth of Today with his friend and singer Ray Cappo in the early 1980s. The band moved to New York City shortly thereafter and coined the term "Youth Crew" to describe their friends. With a new athletic look and a straight edge message, "Youth Crew" defined the second generation of East Coast Hardcore.

Porcelly's athletic background informed every aspect of this new movement. In contrast to the skinhead style that dominated hardcore music at the time, Youth of Today wore collegiate Champion hoodies, track pants, and Nike high-tops.

Youth Crew's hardline version of straight edge bore heavy jock influences, demanding adherents maintain an athletic, active lifestyle that often included lifting weights, while shunning meaningless sex and intoxicants.

In 1988 Cappo founded Revelation Records with Jordan Cooper, first releasing Warzone's Lower East Side Crew EP in 1988. Revelation Records proved a home for a number of other Youth Crew bands, including Gorilla Biscuits, Chain of Strength, and Judge.

In the late '80s, Cappo found a spiritual home for his straight edge beliefs among the Hare Krishna and their bhakti-yoga practice, influences he would transfer to his new band Shelter, whose 1990 debut album spawned the krishnacore style of hardcore music.

Punk rock jocks wore varsity jackets with letters they actually earned playing high school football

Levi's® were rolled to reveal basketball shoes not combat boots

THE CULTURE Youth Crew devotees signified their dedication to straight edge by marking large "Xs" on their hands, a symbol inspired by the mark drawn on the kids still too young to drink at all ages shows.

YOUTH CREW

ORIGIN: CONNECTICUT AND NEW YORK, MID-1980s
SUBURBAN HARDCORE JOCKS TAKE STRAIGHT EDGE TO THE NEXT LEVEL

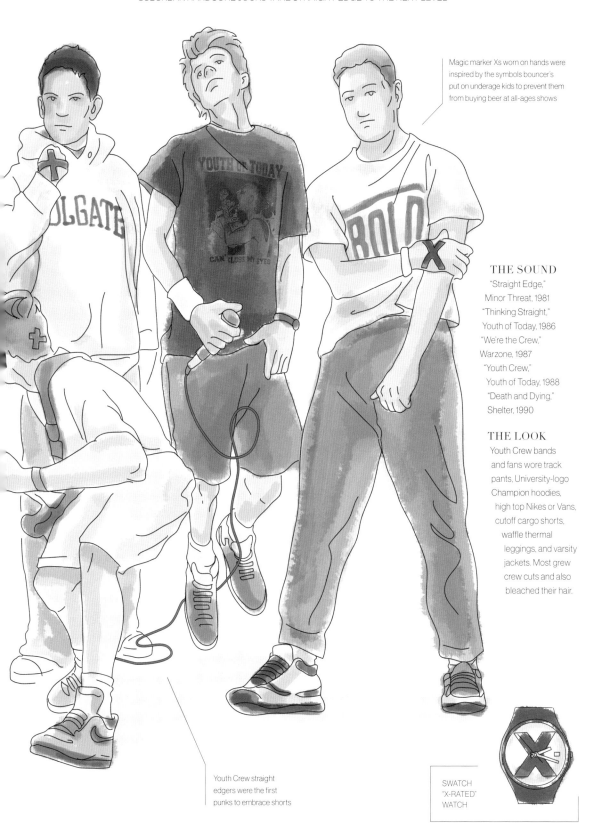

Magic marker Xs worn on hands were inspired by the symbols bouncer's put on underage kids to prevent them from buying beer at all-ages shows

THE SOUND

"Straight Edge,"
Minor Threat, 1981
"Thinking Straight,"
Youth of Today, 1986
"We're the Crew,"
Warzone, 1987
"Youth Crew,"
Youth of Today, 1988
"Death and Dying,"
Shelter, 1990

THE LOOK

Youth Crew bands and fans wore track pants, University-logo Champion hoodies, high top Nikes or Vans, cutoff cargo shorts, waffle thermal leggings, and varsity jackets. Most grew crew cuts and also bleached their hair.

Youth Crew straight edgers were the first punks to embrace shorts

SWATCH
"X-RATED"
WATCH

Queer black and Latino youth are among the most vulnerable populations in the world, not only facing violence and discrimination from the outside world, but also from their own communities, where homosexuality or non-binary gender identities are often hated and even attacked. In response, many queer blacks and Latinos found it necessary to "pass" for straight or cisgender to protect their own lives. In the 1960s, queer communities in Harlem began hosting drag balls to experiment with aspects of gender, sexuality, and "passing" in a safe space, while also celebrating these skills.

These earliest drag balls featured a mix of queer participants with a variety of gender identities and sexual preferences walking against each other on runways in categories like "femme queen realness" or "business executive realness." Success in these battles depended on how "real" participants could appear. This successful mimicry was both the measure of a competitor's success and a potential matter of survival outside the ballroom.

In the 1980s, "houses" ran ballroom culture. These groups recruited members, organized balls, and acted as de facto families for queer black and Latino youth. Famous '80s houses included the House of Pendavis, the House of Ninja, and the House of LaBeija. Members would adopt the surname of their house.

Voguing, a dance in which people mimic the poses of a fashion model being shot for *Vogue* magazine, originated in ballroom battles.

Before the documentary *Paris Is Burning* and Madonna's hit song "Vogue" (both of which were released in 1990) made "voguing" famous, fashion insiders like Susanne Bartsch and Patricia Field became interested in the scene, helping bring it from uptown halls to downtown clubs.

Ballroom houses and their drag balls are more popular today than ever, with a presence in every large American city.

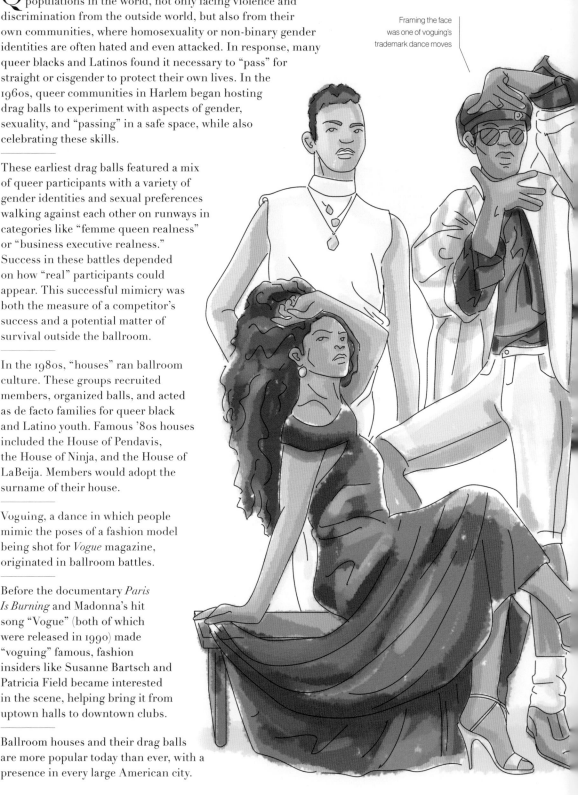

Framing the face was one of voguing's trademark dance moves

THE CULTURE Though still marginalized, ballroom culture had a massive influence on mainstream fashion, with designers like Pat Field and Jean Paul Gaultier finding inspiration in the culture and casting voguers like Willi Ninja in runway shows.

ORIGIN: NEW YORK, 1980s
QUEER HARLEM YOUTH BATTLE TO BE THE REALEST

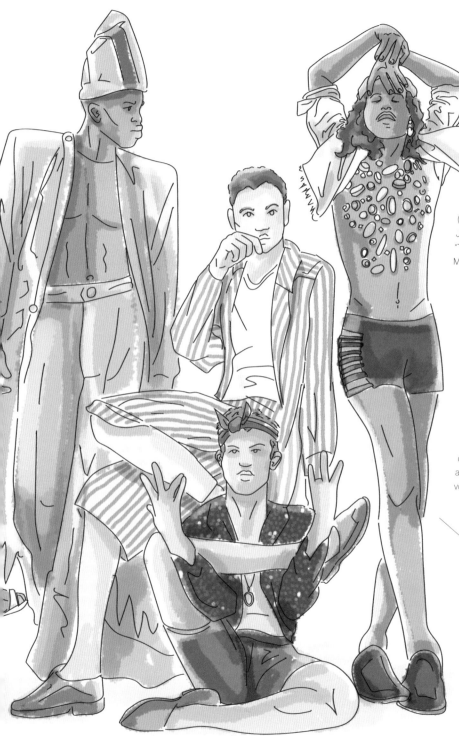

THE SOUND

"Got to Be Real,"
Cheryl Lynn, 1978
"Love Is the Message
(Larry Levan Remix),"
MFSB, 1979
"Is It All Over My Face
(Female Vocal),"
Loose Joints, 1980
"Work This Pussy
(Hurt Me Mix),"
Junior Vasquez, 1989
"The Ha Dance,"
Masters at Work, 1991

THE LOOK

In '80s ballroom culture, looks were limited by competition categories. For example, a "butch queen" participating in a "thug realness" competition would have worn the same sneakers and jeans as an actual drug dealer, while one competing in "executive realness" would have donned a business suit, and "butch queen in drag" might have worn a ball gown while competing in a vogue battle.

There are three styles of voguing: New Way ('90s), Old Way ('60s–'80s), and Vogue Fem ('95–present). Though all styles are still practiced, New Way voguing is the most widely known thanks to Madonna's "Vogue" video

A masculine-identifying gay man would have worn a ball gown to compete in the "butch queen in drag" ball competition

MCs RULED THE BALLS

MICHAEL STIPE'S POST-PUNK TOP FIVE

"At Home He's a Tourist," Gang Of Four, 1979

"Once in a Lifetime," Talking Heads, 1980

"Poptones," Public Image Ltd., 1980

"How I Wrote Elastic Man," The Fall, 1980

"Golden Brown," The Stranglers, 1981

COLLEGE ROCK

*When punk and new wave loses their "1977 as Year Zero"
attitude, a new generation discovers and reinterprets
the entire history of rock*

"Private Idaho,"The B-52's, 1979

"Academy Fight Song," Mission Of Burma, 1980

"Pretty in Pink," The Psychedelic Furs, 1981

"Blister in the Sun," Violent Femmes, 1983

"Uncertain Smile," The The, 1983

"I Will Dare," The Replacements, 1984

"Bitchin' Camaro," The Dead Milkmen, 1985

"Ask," The Smiths, 1986

"Blood and Roses," The Smithereens, 1986

"Dear God," XTC, 1986

"Fall on Me," R.E.M., 1986

"Happy Hour," The Housemartins, 1986

"Could You Be the One?," Hüsker Dü, 1987

"Don't Let's Start," They Might Be Giants, 1987

"In a Jar," Dinosaur Jr., 1987

"Hey Jack Kerouac," 10,000 Maniacs, 1987

"Just Like Heaven," The Cure, 1987

"No New Tale To Tell," Love and Rockets, 1987

"The Real Sheila," Game Theory, 1987

"Under the Milky Way," The Church, 1987

"What's My Scene," Hoodoo Gurus, 1987

"Suedehead," Morrissey, 1988

"Teen Age Riot," Sonic Youth, 1988

"Waiting for the Great Leap Forwards," Billy Bragg, 1988

"Nothing to Be Done," The Pastels, 1989

"Cuts You Up," Peter Murphy, 1989

POST-PUNK

*Freed from punk's self-imposed restrictions,
elements of dub, psychedelia, funk, and electronic
music pointed the way into the '80s*

"Ambition," Subway Sect, 1978

"I Am the Fly," Wire, 1978

"Let's Build a Car," Swell Maps, 1979

"Reasons To Be Cheerful (Part Three)," Ian Dury and the Blockheads, 1979

"She Is Beyond Good and Evil," The Pop Group, 1979

"Do the Du," A Certain Ratio, 1980

"In the Beginning, There Was Rhythm," The Slits, 1980

"In the Congo," The Bongos, 1980

"Just Keep Walking," INXS, 1980

"Love Will Tear Us Apart," Joy Division, 1980

"Sorry For Laughing," Josef K, 1980

"A New Kind of Water," This Heat, 1981

"About the Weather," Magazine, 1981

"Charlotte Sometimes," The Cure, 1981

"Goodbye To That Jazz," Girls At Our Best!, 1981

"Hungry So Angry," Medium Medium, 1981

"Over the Wall," Echo And The Bunnymen, 1981

"Release the Bats," The Birthday Party, 1981

"That's When I Reach For My Revolver," Mission of Burma, 1981

"The Sweetest Girl," Scritti Politti, 1981

"This Sporting Life," The Mekons, 1981

"We're So Cool," The Au Pairs, 1981

"Rip It Up," Orange Juice, 1982

"Thoughts That Go By Steam," Pere Ubu, 1982

"Pilgrimage," R.E.M., 1983

"Up the Down Escalator," The Chameleons, 1983

HOUSE MUSIC

House strips disco down to a pulsating electronic throb

"Funk-U-Up (Original 12" Vocal)," Jesse Saunders, 1984

"Like This," Chip E., 1985

"House Nation," The House Master Boyz, 1986

"I've Lost Control," Sleezy D., 1986

"It's Over," Fingers, Inc., 1986

"It's You," E.S.P., 1986

"Jack Your Body," Steve 'Silk' Hurley, 1986

"Love Can't Turn Around (Original Mix)," Farley
'Jackmaster' Funk, 1986

"You Can't Hide," Frankie Knuckles, 1986

"Move Your Body," Marshall Jefferson, 1986

"No Way Back," Adonis, 1986

"The Jungle (Edit) (12" Club Mix)," Jungle Wonz, 1986

"Washing Machine," Mr. Fingers, 1986

"Bring Down the Walls," Robert Owens, 1987

"Can't Get Enough," Liz Torres, 1987

"Jack It All Night Long," Bad Boy Bill, 1987

"Devotion (Extended Version)," Ten City, 1987

"Face It," Master C&J, 1987

"Let the Music (Use You)," The Night Writers, 1987

"Promised Land (Club Remix)," Joe Smooth, 1987

"This is Acid (A New Dance Craze)," Maurice, 1988

"Good Life (Original 12" Mix)," Inner City, 1988

"French Kiss (The Original Underground Mix)," Lil Louis, 1989

C86

A new generation of British kids discover
the Byrds and the Buzzcocks

"Strawberries Are Growing in My Garden (And It's Wintertime),"
The Dentists, 1985

"Every Conversation," The June Brides, 1985

"Never Understand," The Jesus and Mary Chain, 1985

"Up the Hill and Down the Slope," The Loft, 1985

"Well Well Well," The Woodentops, 1985

"Safety Net," The Shop Assistants, 1986

"Firestation Towers," Close Lobsters, 1986

"Thru the Flowers," The Primitives, 1986

"The Trumpton Riots," Half Man Half Biscuit, 1986

"Whole Wide World," The Soup Dragons, 1986

"Almost Prayed," The Weather Prophets, 1986

"Cold Heart," The Jasmine Minks, 1986

"The Other Side of You," The Mighty Lemon Drops, 1986

"Velocity Girl," Primal Scream, 1987

"Happy All the Time," The Flatmates, 1987

"Talulah Gosh," Talulah Gosh, 1987

"Everyone Thinks He Looks Daft," The Wedding Present, 1987

"Emma's House," The Field Mice, 1988

"Hit the Ground," The Darling Buds, 1988

"I Know Someone Who Knows Someone Who Knows Alan
McGee Quite Well," The Pooh Sticks, 1988

"I'm Not a Patriot But," McCarthy, 1989

FREESTYLE

Freestyle's Latin rhythms and sweet pop hooks
are as irresistible as its electronic dance beats

"I.O.U.," Freeez, 1982

"Play At Your Own Risk," Planet Patrol, 1982

"Looking For The Perfect Beat," Afrika Bambaataa
& The Soulsonic Force, 1983

"When I Hear Music," Debbie Deb, 1983

"Lookout Weekend," Debbie Deb, 1984

"Lovergirl," Teena Marie, 1984

"My Heart's Divided," Shannon, 1984

"Point Of No Return," Exposé, 1984

"Yo, Little Brother," Nolan Thomas, 1984

"Can You Feel the Beat," Lisa Lisa & Cult Jam, 1985

"I Can't Wait," Nu Shooz, 1985

"In My House," Mary Jane Girls, 1985

"Diamond Girl," Nice & Wild, 1986

"Second Chance For Love," Nayobe, 1986

"Show Me," The Cover Girls, 1986

"(You Are My) All and All," Joyce Sims, 1986

"Come Into My Arms," Judy Torres, 1987

"Girlfriend," Pebbles, 1987

"Naughty Girls," Samantha Fox, 1987

"Scars of Love," TKA, 1987

"Silent Morning," Noel, 1987

"Tell It To My Heart," Taylor Dayne, 1987

"Why You Wanna Go," Fascination, 1987

"Boy I've Been Told," Sa-Fire, 1988

"What's on Your Mind (Pure Energy)," Information Society, 1988

"Fantasy Girl," Johnny O, 1988

"Spring Love," Stevie B., 1988

"Take It While It's Hot," Sweet Sensation, 1988

Baggy emerged in Manchester, England, as a style of dress and music in the late 1980s. It was based on a mix of overlapping influences, most notably the acid house rave scene and the Madchester dance-rock scene.

Manchester and Northwest England have a long history of dance music culture dating back to the Twisted Wheel, a '60s mod nightclub that was influential in establishing the Northern Soul scene. Northern Soul, perhaps the first DJ-based culture in the United Kingdom, was an obvious precursor to baggy. It also produced the huge, distinctive trousers known as "bags," which predated the massive flared jeans that gave baggy its name by almost twenty years.

In addition to Northern Soul, Manchester was also home to danceable post-punk acts like The Smiths and New Order, the latter of whom found a home on the city's Factory Records owned by Tony Wilson.

Wilson was also influential in the creation of baggy. He signed iconic baggy group Happy Mondays to Factory records and also owned the Haçienda nightclub in Manchester, which began hosting acid house nights in the summer of 1988. By providing a home for acid house, which had traveled from Chicago to London and then Manchester on the back of its definitive "squelching" Roland TR-303 drum-machine sound, Wilson helped kick-start the ecstasy-fueled months known as the "Second Summer of Love" in England. Baggy drew much of its loose psychedelic style from these parties.

This danceable, chemically enhanced bliss proved irresistible to rock bands. The Stone Roses released their acid house-influenced eponymous first album in the spring of 1989, followed by the Happy Mondays who dropped their *Madchester Rave On EP* that fall, giving a name to the emerging psychedelic dance rock scene that would define baggy style and culture.

Baggy was influential but short-lived. By the mid-'90s, baggy-influenced Britpop bands like Oasis and Blur eclipsed the scene in popularity. Nevertheless, its wide trousers and rave-all-night enthusiasm helped lay the groundwork for the American raver style and attitude in the 1990s.

The yellow smiley face was the unofficial symbol of baggy and acid house

THE CULTURE Legend holds that baggy culture, its love of ecstasy, and its participation in 1988's "Second Summer of Love" helped reduce Saturday afternoon football violence across the United Kingdom.

BAGGY

ORIGIN: MANCHESTER, 1980s
ACID HOUSE-LOVING ENGLISH ROCKERS EXPAND THEIR MINDS AND THEIR TROUSERS

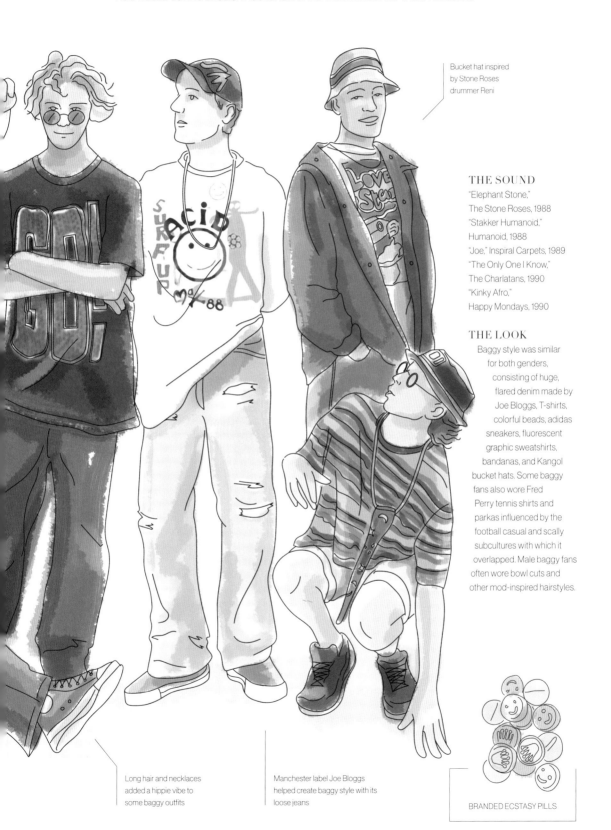

Bucket hat inspired
by Stone Roses
drummer Reni

THE SOUND

"Elephant Stone,"
The Stone Roses, 1988
"Stakker Humanoid,"
Humanoid, 1988
"Joe," Inspiral Carpets, 1989
"The Only One I Know,"
The Charlatans, 1990
"Kinky Afro,"
Happy Mondays, 1990

THE LOOK

Baggy style was similar
for both genders,
consisting of huge,
flared denim made by
Joe Bloggs, T-shirts,
colorful beads, adidas
sneakers, fluorescent
graphic sweatshirts,
bandanas, and Kangol
bucket hats. Some baggy
fans also wore Fred
Perry tennis shirts and
parkas influenced by the
football casual and scally
subcultures with which it
overlapped. Male baggy fans
often wore bowl cuts and
other mod-inspired hairstyles.

Long hair and necklaces
added a hippie vibe to
some baggy outfits

Manchester label Joe Bloggs
helped create baggy style with its
loose jeans

BRANDED ECSTASY PILLS

No music fans transgressed the bounds of good taste and legality quite like those dedicated to black metal. This hardcore offshoot of the new wave of British heavy metal originally used satanic imagery for shock value, but later morphed into a murderous, suicidal, church-burning clique of true believers at the urging of a few young Norwegian outcasts.

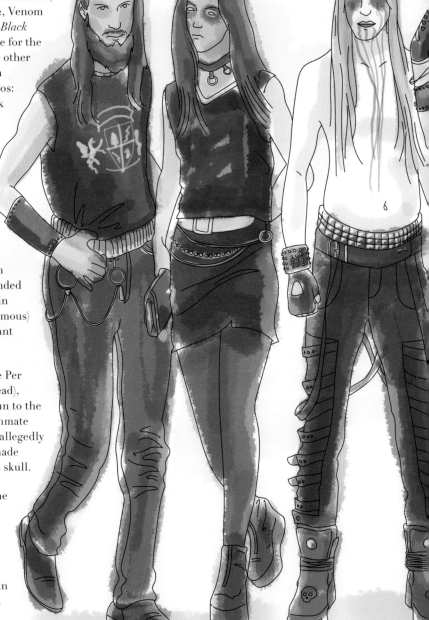

Many black metal fans seemed to be totally humorless

Black metal has its roots in the music of Venom, an early-'80s English metal group who made their name with outlandish satanic stage performances, costumes, and lyrics. In 1982, Venom released their second album *Black Metal*, which provided a name for the scene that would follow. Two other important bands emerged on Venom's heels in the early '80s: Mercyful Fate from Denmark and Bathory from Sweden. These bands continued Venom's tradition of satanic imagery and lyrics, while creating a solid Scandinavian milieu for the genre.

Black metal finally flourished in Norway, where a number of bands formed in the late 1980s. Mayhem, founded by record shop owner Øystein Aarseth (stage name Euronymous) was among the most important and notorious.

Mayhem's first singer, Swede Per Yngve Ohlin (stage name Dead), committed suicide by shotgun to the head in 1991. When his roommate Euronymous found him, he allegedly ate some of his brains and made necklaces from shards of his skull.

A couple years later, one-time Mayhem bass player, Varg Vikernes (stage name Count Grishnackh) murdered Euronymous.

These crimes gave Norwegian black metal global notoriety, and the scene continues to thrive with fans worldwide.

THE CULTURE In addition to the various murders and suicides linked to black metal, adherents of the culture are reputed to have burned as many as fifty churches, including the Fantoft Stave Church, a priceless eleventh century masterpiece of early Norse Christian woodworking.

Black leather boots were sometimes embellished with extra hardware and straps

BLACK METAL

ORIGIN: UK, SWEDEN, NORWAY, 1980s–1990s
EXTREME METAL MOVES FROM MAYHEM TO MURDER

Many bands incorporated inverted crosses into logos to make them more satanic

Corpse paint makeup was inspired King Diamond of Mercyful Fate

THE SOUND

"Black Metal," Venom, 1982
"Equimanthorn," Bathory, 1987
"Freezing Moon,"
Mayhem, 1991
"Det Som Engang Var,"
Burzum, 1994
"Blashyrkh (Mighty
Ravendark)," Immortal, 1995

THE LOOK

Black metal style has remained relatively consistent over the years, with fans favoring long, black hair and the distinctive black and white makeup called corpse paint. Casually, black metal fans have also worn black jeans, boots, band T-shirts, and leather jackets, sometimes switching to gauntlets studded with six-inch nails and other homemade leather gear for shows and performances. Posing with medieval weapons for promo photos is also a long-running black metal tradition that remains popular today.

HOMEMADE SPIKED GAUNTLET

Bullet belts and spikes came to black metal from punk rock and earlier metal artists like Rob Halford of Judas Priest

After the death of Andy Warhol, a new group of young party people stepped up to revitalize New York nightlife with their outlandish costumes, fluid takes on gender, and indulgent drug habits.

There were a few different groups of club kids that shared a taste for nightlife and theatrical costumes, but they didn't necessarily overlap, and generational differences and drugs were a major factor in dividing the scenes. On the earlier, less druggy side of things, club kids like Mykul Tronn and Magenta hosted parties at Tunnel, while Larry Tee and Lahoma Van Zant held parties at other places throughout the city. Many of these original club kids, like Astro Erle, the first person to make custom 24-inch platform shoes, and Zaldy, were talented fashion designers, creative skills party promoter Susanne Bartsch emphasized when she introduced them to fashion luminaries like Jean Paul Gaultier and a Marc Jacobs at her gatherings at Copacabana.

Michael Alig and his crew were on the younger, druggier spectrum of the club kid scene. Alig in particular was inseparable from his patron, Peter Gatien, the influential New York club owner, who hired Alig to promote parties at his Chelsea club, The Limelight, in the late '80s.

In addition to massive parties with sardonic names like Disco 2000, Special K, and the ominous Bloodfeast, Alig and the club kids threw illegal "outlaw parties" in fast food restaurants and subway cars.

Alas, all the drugs and fabulosity couldn't last, and the club kid scene came to a grinding halt when Michael Alig pleaded guilty to manslaughter charges that he and a friend murdered and dismembered fellow club kid Andre "Angel" Melendez over a drug debt. Shortly thereafter, the Feds convicted Peter Gatien on drug and tax charges, effectively ending the club kid scene.

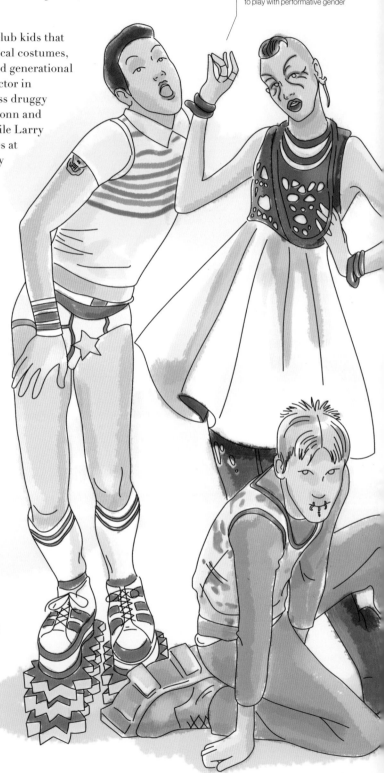

New York City's well-established drag scene inspired the club kids to play with performative gender

THE CULTURE Through appearances on television talk shows, club kids like Michael Alig, James Saint James, and a young RuPaul deeply impacted the '90s rave scene, introducing body piercing, huge platform shoes, and fluid versions of sexuality and gender to the mainstream.

ORIGIN: NEW YORK, 1980s
BIG LOOKS AND BIGGER PERSONALITIES OWN NYC NIGHTS

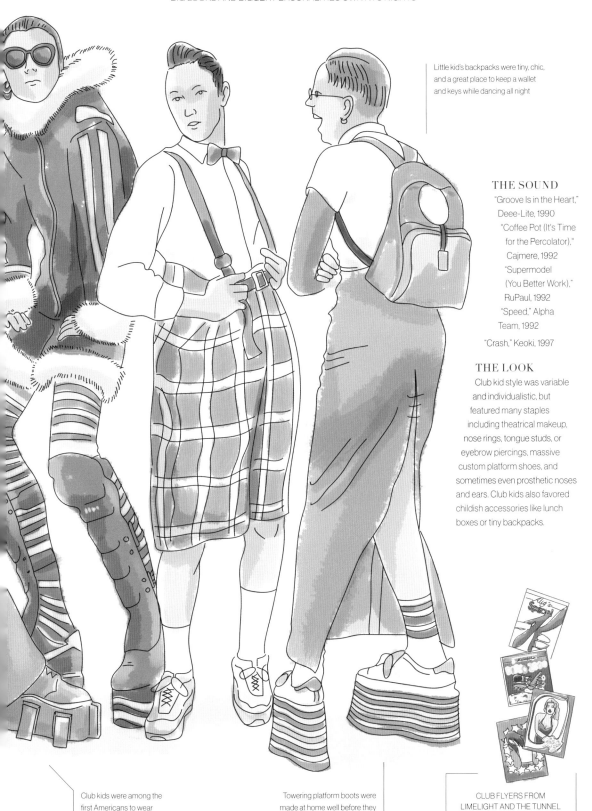

Little kid's backpacks were tiny, chic, and a great place to keep a wallet and keys while dancing all night

THE SOUND

"Groove Is in the Heart," Deee-Lite, 1990

"Coffee Pot (It's Time for the Percolator)," Cajmere, 1992

"Supermodel (You Better Work)," RuPaul, 1992

"Speed," Alpha Team, 1992

"Crash," Keoki, 1997

THE LOOK

Club kid style was variable and individualistic, but featured many staples including theatrical makeup, nose rings, tongue studs, or eyebrow piercings, massive custom platform shoes, and sometimes even prosthetic noses and ears. Club kids also favored childish accessories like lunch boxes or tiny backpacks.

Club kids were among the first Americans to wear facial piercings

Towering platform boots were made at home well before they were commercially available

CLUB FLYERS FROM LIMELIGHT AND THE TUNNEL

In the late 1980s, New York City was highly segregated. Few areas were as marginalized as Brooklyn neighborhoods Brownsville and Crown Heights, where African Americans, West Indians, and Latinos were left out in the cold by Reaganomics. But some teenagers from these neighborhoods refused to believe the American dream couldn't be theirs, creating it for themselves on their own terms. They did this by collecting and wearing the freshest Polo Ralph Lauren gear they could find, acquiring the goods by any means necessary. These were the Lo Lifes, and they changed street style and high fashion forever.

The Lo Lifes formed by chance when Ralphie's Kids from Crown Heights met Brownsville's Polo U.S.A. (United Shoplifters Association) crew one night in Times Square, uniting the two independent, Polo-obsessed boosting crews into the best-dressed clique in New York City.

Like graffiti writers racking spray paint, the Lo Lifes viewed stealing as the honorable way to obtain their Polo garments. It was a sport to them, one they undertook on both a personal scale, with foil-lined shopping bags designed to block store sensors, and on a large scale, occasionally rolling thirty-deep in department stores to grab Polo en masse.

Not unlike the self-made Lauren himself, who was born Ralph Lifshitz to a Bronx house painter, the Lo Lifes saw that they could reinvent themselves through clothing. By wearing Polo, they acquired a piece of the American dream that wasn't meant to make it to Brownsville, subverting the structural racism designed to keep them in their place, far from the white and wealthy.

The Lo Life movement never died out, and original members like Rack Lo and Thirstin Howl III are still active, hosting meetups and putting out hip-hop albums and books about the lifestyle.

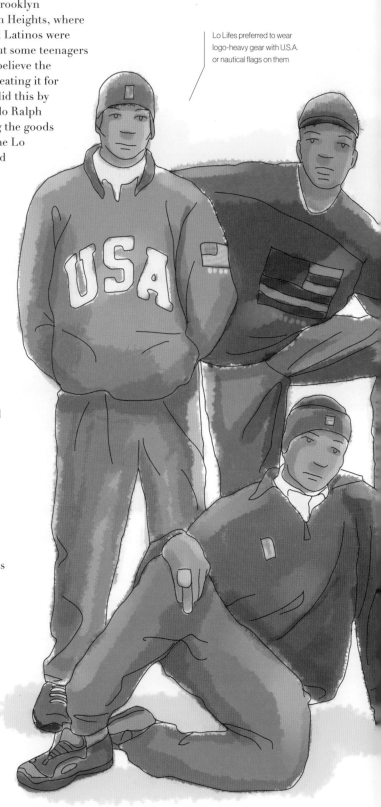

Lo Lifes preferred to wear logo-heavy gear with U.S.A. or nautical flags on them

THE CULTURE Many Lo Lifes took their love of Polo beyond apparel, outfitting their homes with Polo towels, sheets, wallpaper, and teddy bears.

ORIGIN: BROOKLYN, 1980s
BROOKLYN KIDS BOOST A PIECE OF THE AMERICAN DREAM

The sit-down bear was one of the most-coveted Polo sweaters ever

The silk crest shirt was another Lo Life favorite

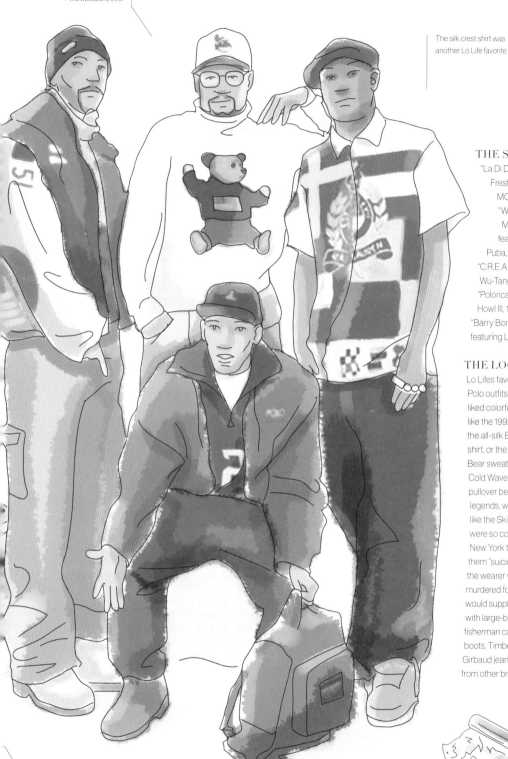

THE SOUND

"La Di Da Di," Doug E. Fresh and MC Ricky D, 1985
"What's the 411?," Mary J. Blige featuring Grand Puba, 1992
"C.R.E.A.M.," Wu-Tang Clan, 1993
"Polorican," Thirstin Howl III, 1999
"Barry Bonds," Kanye West featuring Lil Wayne, 2007

THE LOOK

Lo Lifes favored head-to-toe Polo outfits and particularly liked colorful, graphic pieces like the 1992 Alpine Rugby, the all-silk Barber Shop polo shirt, or the "Sit-Down" Polo Bear sweater. Items like the Cold Wave Snow Beach pullover became instant legends, while other pieces, like the Ski '92 Polo jacket, were so covetable that New York teenagers called them "suicides," because the wearer was likely to be murdered for them. Lo Lifes would supplement their outfits with large-brimmed Polo fisherman caps, Polo Ranger boots, Timberlands, Nikes, Girbaud jeans, and activewear from other brands like Fila.

Other items like Fila headbands and Timberland work boots were used to augment mostly-Polo outfits

TINFOIL LINING
FOR A BOOSTER BAG

In 1986, Larry Harvey and Jerry James invited a small group of friends to burn a wooden sculpture of a man on San Francisco's Baker Beach. Each year after that, Harvey and James attracted more people to their event and were eventually forced to move things to Nevada's Black Rock desert. There, they held Burning Man in a dry lakebed known as the Playa. With more space, the event attracted more attendees, who built their own wooden art and sculptures and developed their own camps and subcultures within the event that now hosts around 50,000 attendees each year.

Since growing in size in the early 1990s, Burning Man has been run by the San Francisco company Black Rock LLC, a for-profit company with the mission of establishing community and fostering radical self-expression.

Burning Man attendees, known as burners, are allowed to build art and dictate much of what goes on at the event, organizing themselves into camps with colorful names like Kamp Suckie Fuckaye and Rat Trap. Some camps, like Camp Charlie and White Ocean, bill themselves as "sound camps" and attract world-class DJs like Paul Oakenfold, Tiësto, and Rob Garza of Thievery Corporation.

Burning Man is associated with psychedelic drugs, and though not all burners partake, many attendees freely mix LSD, Psilocybin, and MDMA throughout their time on the playa.

Burners overlap with hippies and other freewheeling subcultures like rave and cyberpunk, often adding elements like dreadlocks and glowing gas masks to their looks. Burning Man and burners have also been instrumental in creating the steampunk aesthetic, with artists like Kinetic Steam Works bringing working steam engines to the event.

Every Burning Man still culminates with the burning of a forty-five foot tall wooden structure, now known as The Man.

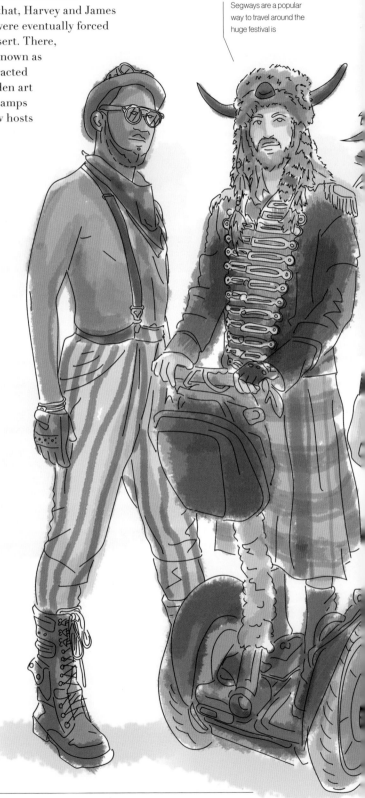

Segways are a popular way to travel around the huge festival is

THE CULTURE As Burning Man has become more popular within Northern California's tech industry, disputes have arisen among burners about the true nature of the event. Many claim that wealthy camps, often hosted by Silicon Valley billionaires who stay in RVs with their own personal chefs, are not living within the anarchistic Burning Man's founders intended.

ORIGIN: SAN FRANCISCO AND BLACK ROCK DESERT, 1980s
NEW BOHEMIANS CREATE A PSYCHEDELIC COMMUNITY IN THE DESERT

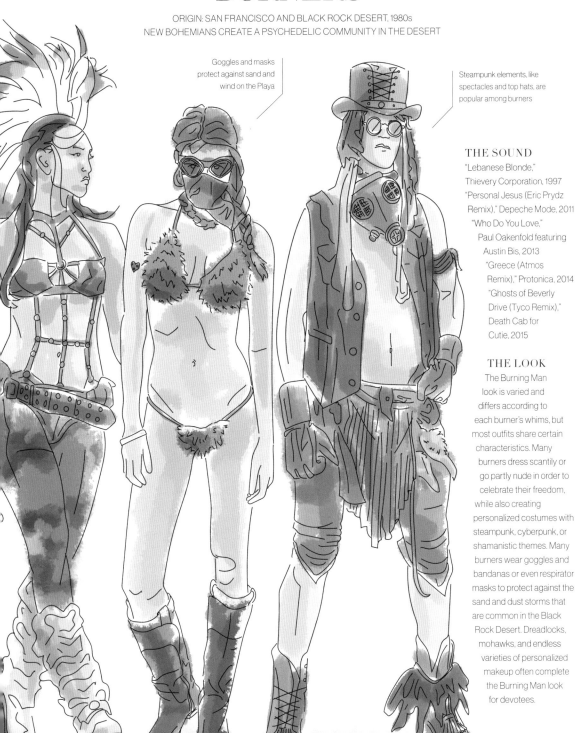

Goggles and masks
protect against sand and
wind on the Playa

Steampunk elements, like
spectacles and top hats, are
popular among burners

THE SOUND

"Lebanese Blonde,"
Thievery Corporation, 1997
"Personal Jesus (Eric Prydz
Remix)," Depeche Mode, 2011
"Who Do You Love,"
Paul Oakenfold featuring
Austin Bis, 2013
"Greece (Atmos
Remix)," Protonica, 2014
"Ghosts of Beverly
Drive (Tyco Remix),"
Death Cab for
Cutie, 2015

THE LOOK

The Burning Man
look is varied and
differs according to
each burner's whims, but
most outfits share certain
characteristics. Many
burners dress scantily or
go partly nude in order to
celebrate their freedom,
while also creating
personalized costumes with
steampunk, cyberpunk, or
shamanistic themes. Many
burners wear goggles and
bandanas or even respirator
masks to protect against the
sand and dust storms that
are common in the Black
Rock Desert. Dreadlocks,
mohawks, and endless
varieties of personalized
makeup often complete
the Burning Man look
for devotees.

Many Burning Man
attendees have been criticized
for cultural appropriation

FIRE DANCING GEAR

ICE-T'S
GANGSTER RAP TOP FIVE

*"True gangster rap is apolitical . . . From the perspective
of the criminal."*

"P.S.K. What Does It Mean?," Schoolly D, 1985
"Colors," Ice-T, 1988
"Straight Outta Compton," N.W.A., 1988
"Shook Ones, Pt. 1," Mobb Deep, 1994
"Ante Up," MOP, 2000

NATIVE TONGUES
*Conscious rap's multicultural sensibility
is as earnest as its look is colorful*

"Jimbrowski," Jungle Brothers, 1987
"Freedom of Speech," De La Soul, 1988
"I Can Do This," Monie Love, 1988
"Plug Tunin'," De La Soul, 1988
"Black Is Black (feat. Jungle Brothers)," Q-Tip, 1989
"Brand Nubian," Brand Nubian, 1989
"Buddy (Native Tongues Remix) (feat. Jungle Brothers, Monie
 Love, Queen Latifah, Q-Tip)," De La Soul, 1989
"Description Of A Fool," A Tribe Called Quest, 1989
"Eye Know," De La Soul, 1989
"Grandpa's Party," Monie Love, 1989
"Ladies First (feat. Monie Love)," Queen Latifah, 1989
"Mama Gave Birth To The Soul Children (feat. De La Soul),"
 Queen Latifah, 1989
"Promo No. 2 (feat. Tribe Called Quest)," Jungle Brothers, 1989
"Doin' Our Own Dang (feat. Q-Tip, De La Soul, Monie Love),"
 Jungle Brothers, 1990
"Monie In The Middle," Monie Love, 1990
"Case Of The P.T.A." Leaders of The New School, 1991
"Flavor Of The Month," Black Sheep, 1991
"La Schmoove (Remix)," Fu-Schnickens, 1992
 360 (What Goes Around)" Grand Puba, 1992
"Reign Of The Tec," The Beatnuts, 1993

GANGSTER RAP
*Gangster rap dispatches its lyrical flow
from the violence and desperation of the inner city*

"Gangster of Hip Hop," Just Ice, 1986
"I'm A Trip," Sir Mix-A-Lot, 1986
"Boyz-n-the-Hood," Eazy-E, 1987
"Criminal Minded," Boogie Down Productions, 1987
"Act A Fool," King Tee, 1988
"Gangsta Gangsta," N.W.A, 1988
"Hey Young World," Slick Rick, 1988
"I Don't Care," Audio Two, 1988
"My Posse," C.I.A., 1988
"Bald Headed Hoes," Willie Dee, 1989
"Mind Blowin'," D.O.C., 1989
"Oakland," Too $hort, 1989
"Trigga Happy Nigga," Geto Boys, 1989
"Trilogy of Terror," Kool G Rap & DJ Polo, 1989
"Murder Rap," Above The Law, 1990
"One Time Gaffled 'Em Up," Compton's Most Wanted, 1990
"Born And Raised In Compton," DJ Quik, 1991
"187 Proof," Spice 1, 1991
"Trapped (feat. Shock G)," 2Pac, 1991
"Hand on the Pump," Cypress Hill, 1991
"Guerillas in tha Mist," Da Lench Mob, 1992
"Now I Gotta Wet 'Cha," Ice Cube, 1992
"Cocaine in the Back of the Ride," UGK, 1992
"Back to the Hotel," N2Deep, 1992
"Shoot to Kill," Tommy Wright III, 1992

PUNK FUNK
*From the Lower East Side to Manchester
and beyond, your spine is the bassline*

"In the Beginning There Was Rhythm," The Slits, 1980
"Thermonuclear Sweat," Defunkt, 1980
"Shake (The Foundations)," Glaxo Babies, 1980
"Search," Minutemen, 1981
"Outside the Trains Don't Run on Time," Gang of Four, 1981

"Drunk WIth Funk," The Brainiacs, 1981

"Hungry So Angry," Medium Medium, 1981

"Can't Be Funky," The Bush Tetras, 1981

"Papa's Got a Brand New Pigbag," Pigbag, 1981

"Shoot You Down," APB, 1981

"Stretch," Maximum Joy, 1981

"Vegas El Bandito," 23 Skidoo, 1982

"We Got Soul," Big Boys, 1982

"Knife Slits Water," A Certain Ratio, 1982

"Moody," ESG, 1982

"Sax Maniac," James White & The Blacks, 1982

"Konk Party," Konk, 1982

"Put the Punk Back Into Funk," The Higsons, 1983

"Optimo," Liquid Liquid, 1983

"Funky Hayride," The Stickmen, 1983

"Genius of Love," Tom Tom Club, 1981

SYNTH POP

*Completely eschewing guitars in favor of electronics
and drum machines, synth pop drove post-punk
to ever more digital sounds*

"Messages," Orchestral Manoeuvres in the Dark, 1980

"Sleepwalk," Ultravox, 1980

"Nice Age," Yellow Magic Orchestra, 1980

"Dreaming of Me," Depeche Mode, 1981

"Pocket Calculator," Kraftwerk, 1981

"Bedsitter," Soft Cell, 1981

"Don't You Want Me," Human League, 1981

"Metro," Berlin, 1981

"Jerkin' Back & Forth," Devo, 1981

"(We Don't Need This) Fascist Groove Thang," Heaven 17, 1981

"Living on the Ceiling," Blancmange, 1982

"One of Our Submarines," Thomas Dolby, 1982

"Situation," Yazoo, 1982

"Sweet Dreams (Are Made of This)," Eurythmics, 1982

"Never Never," The Assembly, 1983

TECHNO

*Born in Detroit, techno is dance music at its
most minimalist and propulsive*

"Clear," Cybotron, 1983

"No UFO's," Model 500, 1985

"Let's Go," X-Ray, 1986

"Acid Tracks," Phuture, 1987

"Break 4 Love," Raze, 1987

"Beat Dis," Bomb The Bass, 1987

"Strings Of Life," Strings of Life, 1987

"When We Used To Play," Blake Baxter, 1987

"Big Fun," Inner City, 1988

"Can You Party," Royal House, 1988

"Oochy Koochy," Baby Ford, 1988

"Theme From S-Express," S'Express, 1988

"We Call It Acieed," D Mob, 1988

"What Time Is Love?," KLF, 1988

"All for Lee-Sah," K-Alexi, 1989

"Call It Techno," Frankie Bones, 1989

"Pacific," 808 State, 1989

"Voodoo Ray," A Guy Called Gerald, 1989

"Work That Mutha Fucker," Steve Poindexter, 1989

"Aftermath," Nightmares On Wax, 1990

"LFO," LFO, 1990

MADCHESTER/BAGGY

*English Madchester and baggy bands combine
psychedelic '60s rock with dance beats and acid house*

"I Wrote For Luck," Happy Mondays, 1988

"I'm Losing More Than I'll Ever Have," Primal Scream, 1989

"She Bangs the Drums," The Stone Roses, 1989

"Move," Inspiral Carpets, 1989

"Box Set Go," The High, 1990

"Strawberry Fields Forever," Candy Flip, 1990

"Perfume," Paris Angels, 1990

"It's On," Flowered Up, 1990

"I'm Free (ft. Junior Reid)," The Soup Dragons, 1990

"The Only One I Know," The Charlatans, 1990

"Groovy Train," The Farm, 1991

In 1985, a new strain of hip-hop emerged on the streets of Philadelphia where a young Schoolly D boasted about "towing on a J" and toting a pistol on gangster rap blueprint "P.S.K. What Does It Mean?" Soon California MCs Ice-T and Eazy-E would expand the genre, only to be followed by New York City rappers like The Notorious B.I.G. and Mobb Deep. These artists, and their tales of crack dealing, transformed hip-hop into a commercial behemoth before real-life gunplay silenced some of them forever.

Following early West Coast gangster rap hits like 1986's "6 in the Mornin'" by Ice-T, N.W.A emerged as kings of the genre, releasing *Straight Outta Compton* in 1988, proving that the more outrageous a rap record was, the more popular it would be.

After leaving N.W.A, Dr. Dre perfected this recipe, selling huge numbers of *The Chronic* on Death Row Records in 1992.

On the East Coast, MCs like Kool G. Rap had also been dabbling in gangster themes, but it took a group of younger rappers to articulate the realities of New York hustlers. Wu-Tang Clan's 1993 album *Enter the Wu-Tang (36 Chambers)* was a good start, but the player lifestyle and paranoia of New York City drug dealers weren't truly revealed until Nas dropped his *Illmatic* album in the spring of 1994, a feat The Notorious B.I.G. equaled that fall when he released *Ready to Die*.

Shortly after that, the East and West Coast gangster rap scenes began to beef when Tupac Shakur was shot outside a New York City recording studio in 1994, a crime he accused Bad Boy Records mainstays Notorious B.I.G. and Sean "Puffy" Combs of setting up. This led Tupac to sign with Bad Boy rival Death Row Records, where label head Marion "Suge" Knight fanned the flames of the East Coast-West Coast rivalry. Eventually, unknown assailants gunned Tupac down in 1996 and shot and killed Notorious B.I.G. in 1997. The crimes have never been solved, but did end the halcyon days of '90s gangster rap.

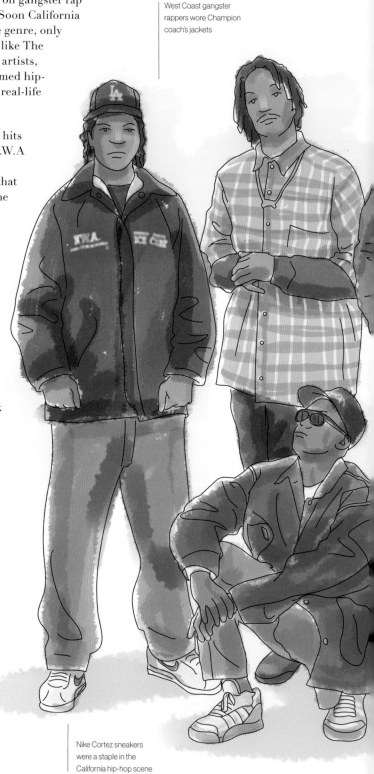

West Coast gangster rappers wore Champion coach's jackets

Nike Cortez sneakers were a staple in the California hip-hop scene

THE CULTURE From Schoolly D's mention of "Js" and "cheeba" in "P.S.K. What Does It Mean" to the title of Dr. Dre's *The Chronic* and Wu-Tang and Biggie's beloved blunts, marijuana was a key cultural signifier of gangster and hardcore rap.

ORIGIN: NEW YORK AND CALIFORNIA, 1990s
DANGEROUS HIP-HOP GOES MAINSTREAM

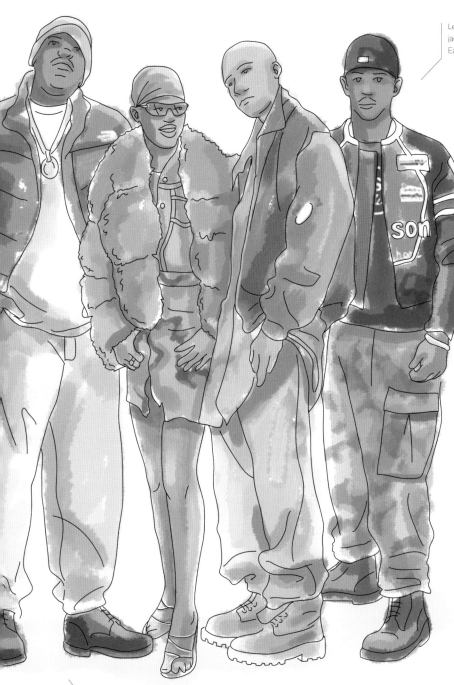

Leather Vanson motorcycle jackets were popular on the East Coast in the late '90s

THE SOUND

"6 'N the Mornin'," Ice-T, 1986

"Fuck Tha Police," N.W.A 1988

"Ill Street Blues," Kool G. Rap

"N.Y. State of Mind," Nas, 1994

"What's Beef?," Notorious B.I.G., 1997

THE LOOK

West Coast rappers and East Coast MCs both had their unique styles, with the former wearing street gang-influenced black jeans and Raiders gear, along with Air Jordans, Chuck Taylors, Pendleton flannels, and khakis. The latter favored down North Face Jackets, Coogi sweaters, baggy Girbaud jeans, Polo Ralph Lauren, Timberland boots, and designer labels like Gucci.

North Face puffer jackets kept East Coast hip-hop fans warm all winter

Timberland work boots were worn untied

TUPAC ALMOST WORE A BULLETPROOF VEST THE NIGHT HE WAS SHOT

Grunge was a style and music that arose in the late 1980s rock scene in Seattle among bands like Green River, the Melvins, and Mother Love Bone. It was largely fostered by the Sub Pop label which put out records by Mudhoney and Nirvana and adamantly, if somewhat sarcastically, pushed the grunge moniker to market its preferred brand of loud, fuzzy indie rock. By the early '90s, major labels took notice of the grunge movement, signing Seattle bands like Soundgarden, Alice In Chains, and Nirvana, the latter of which broke through in 1991, kicking Michael Jackson out of the number one spot on the *Billboard* charts with their second album, *Nevermind*. Music and fashion would never be the same.

In 1986, CZ Records released the *Deep Six* compilation album, which contained tracks from Washington bands The Melvins, Green River, and Soundgarden, first alerting people to the common heavy rock sounds growing in the Seattle music scene.

By 1988, Green River broke up, sending some members to Mother Love Bone (and later to Pearl Jam) and others to Mudhoney, who released their hit single "Touch Me I'm Sick" on Sub Pop in 1988, a song which might be considered the first true grunge song.

On the wave of this success, Sub Pop put out *Bleach*, the first album from Aberdeen, Washington, product Nirvana, who would later break through as grunge figureheads in 1991.

In 1992, Marc Jacobs showed his "grunge" fashion collection for Perry Ellis. It was panned by critics, and label heads fired Jacobs for it, but it proved incredibly influential, effectively propelling the designer to stardom.

Bands like Bush and Days of the New emerged in the mid-'90s to dampen grunge's authenticity with their watered-down sound, leading to the genre's demise.

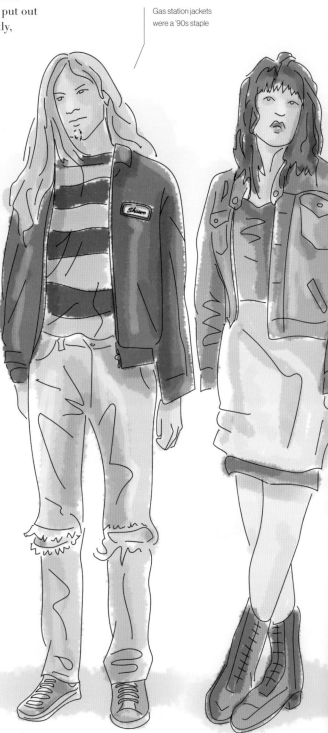

Gas station jackets were a '90s staple

Boots worn with skirts created a juxtaposition between traditional femininity and aggressive punk style

THE CULTURE Legendary rock critic Lester Bangs first used "grunge" to refer to a Seattle rock band in a 1971 issue of *Creem*, where he noted The Count Five's "grungy spunk." Grunge's first usage in relation to distorted rock from the Pacific Northwest came in 1981 when Mark Arm, later of Green River and Mudhoney, wrote local fanzine *Desperate Times* to satirically describe his own band, Mr. Epp & the Calculations as "pure grunge."

ORIGIN: SEATTLE, 1990s
SEATTLE ROCKERS BECOME A MEDIA SENSATION WHEN THEY COMBINE PUNK WITH CLASSIC ROCK

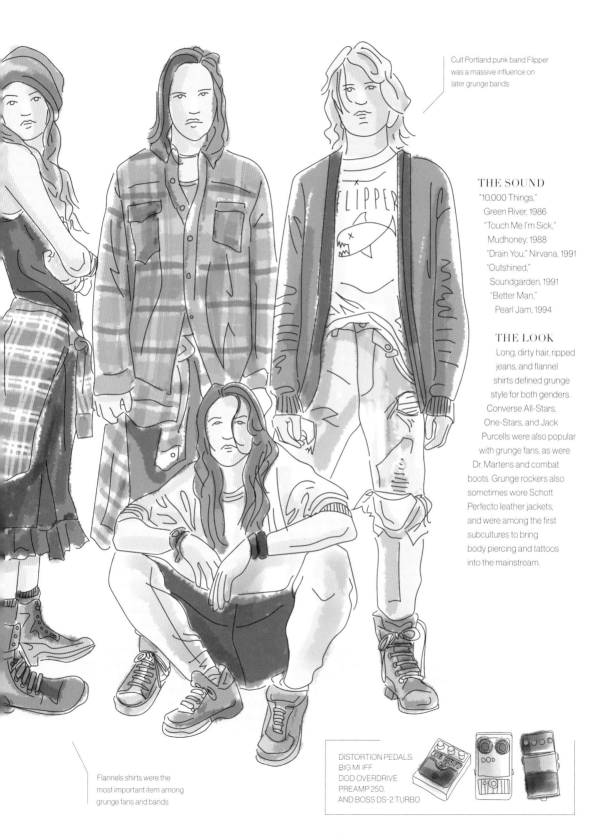

Cult Portland punk band Flipper was a massive influence on later grunge bands

THE SOUND

"10,000 Things,"
Green River, 1986
"Touch Me I'm Sick,"
Mudhoney, 1988
"Drain You," Nirvana, 1991
"Outshined,"
Soundgarden, 1991
"Better Man,"
Pearl Jam, 1994

THE LOOK

Long, dirty hair, ripped jeans, and flannel shirts defined grunge style for both genders. Converse All-Stars, One-Stars, and Jack Purcells were also popular with grunge fans, as were Dr. Martens and combat boots. Grunge rockers also sometimes wore Schott Perfecto leather jackets, and were among the first subcultures to bring body piercing and tattoos into the mainstream.

DISTORTION PEDALS:
BIG MI IFF
DOD OVERDRIVE
PREAMP 250,
AND BOSS DS-2 TURBO

Flannels shirts were the most important item among grunge fans and bands

S nowboarding is older than you think. In 1965, Michigan engineer Sherman Poppen conjoined two skis and began "surfing" the hill behind his house. When he saw his kids enjoyed it too, he upgraded the product, adding a rope handle for control and naming it the "Snurfer," a conjunction of "snow" and "surfer." Though only a toy, the Snurfer proved influential, and helped future snowboarding pioneers like Tom Sims and Jake Burton foster their interest in the sport.

Though modern snowboarding is often traced to pioneers like Tom Sims and Jake Burton, Cornell dropout Dimitrije Milovich actually founded the first high-performance snowboard company, Winterstick, in 1974.

Perhaps because it was ahead of its time, Winterstick only lasted three years, but it proved a point and inspired Jake Burton to found his eponymous snowboard company out of his Londonderry, Vermont, garage in 1977.

A year later, avid skier and skateboard pioneer Tom Sims founded his own snowboard company in California, which quickly caught on with surfers and skaters. The Burton-Sims rivalry would help push the industry forward, earning it increased attention throughout the '80s and '90s.

Like its predecessor skateboarding, snowboarding developed a bit of an outlaw reputation, with many ski areas and resorts banning the sport up through the 1990s.

By 1998, snowboarding gained the world's respect, earning a spot in the Nagano Winter Olympics, a platform that would later help make millionaires of gold medalists like Shaun White.

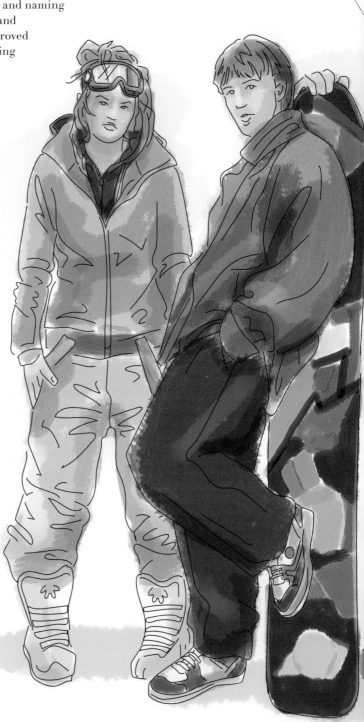

Late '80s snowboarders loved fluorescent colors

THE CULTURE Despite its mainstream popularity, many outsiders still view snowboarders as potheads and burnouts, a reputation partly born out of Canadian gold medalist Ross Rebagliati's positive marijuana test following the 1998 Winter Olympics.

SNOWBOARDERS

ORIGIN: MICHIGAN, NEW JERSEY, UTAH, VERMONT, CALIFORNIA, 1970s–1990s
OUTCASTS ARE DETERMINED TO SURF ON SNOW

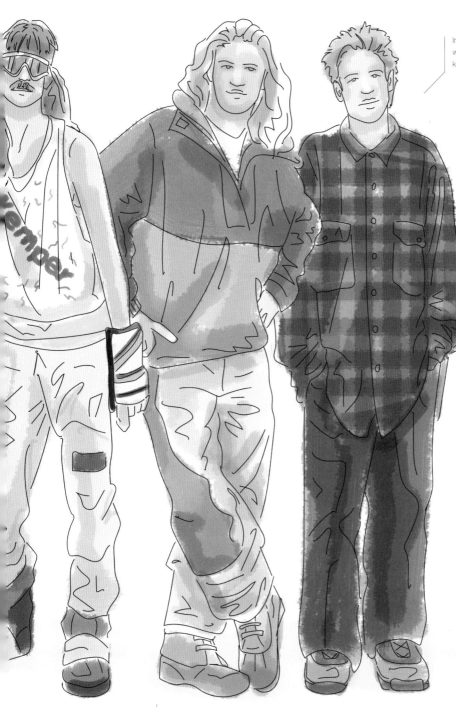

In California, flannel shirts were often enough to keep riders warm

THE SOUND

"Mother," Danzig, 1988
"Bro Hymn," Pennywise, 1991
"Bulls on Parade," Rage Against the Machine
"Seeing Double at the Triple Rock," NOFX, 2006
"1,000 Winters in a Row," Valient Thorr, 2008

THE LOOK

Snowboarders in the 1970s made do with cast-off ski gear and clothes, but during the 1980s they began to develop their own ultra-bright fluorescent style. By the 1990s, the tides turned and earth tones became popular. Influences like skateboarding made baggy jackets and snow pants de rigueur amongst snowboarders, and that loose, earthy look remained popular through the 2000s, when stars like Shaun White also started wearing bandanas and helmets for protection and style on the slopes.

By the 2000s, snowboarding companies turned to technical materials like Gore-Tex for jackets

SHERMAN POPPEN INVENTED THE SNURFER IN 1965 TO ENTERTAIN HIS KIDS

Riot grrrl grew out of the late 1980s hardcore and indie scenes, particularly in Washington, DC, and Olympia, Washington. Local record labels like Dischord and K Records and colleges like Evergreen State helped foster aggressively feminist, mostly female bands like Bikini Kill, Bratmobile, and Sleater-Kinney.

Homemade zines with names like "Girl Germs" and "Bikini Kill," as well as all aspects of DIY subculture were crucial to riot grrrl. Riot grrrl is at least as responsible as punk for bringing DIY culture to mass attention, with adherents even making their own clothes and cassette-based record labels.

Riot grrrl style wasn't markedly distinct from the indie and college rock fashions of the time, but it did include hallmark items like Mary Janes, cardigans, thick glasses, childlike hair barrettes, and other "cute" elements that coyly played with themes of gender, power, age, and independence.

Participants sought to challenge mainstream media and male dominance within indie rock.

This style and "cute punk" ethos also influenced the greater culture of the time. Riot grrrl icons like Kathleen Hanna popped up on MTV in Sonic Youth's "Bull in the Heather" video in 1994 before founding the electro supergroup Le Tigre in the late '90s.

Though riot grrrl bands shared some of the same ideals as female grunge bands, they are not to be confused with Hole, Babes in Toyland, or the notorious "kinderwhore" look. In fact, Courtney Love infamously punched Bikini Kill singer Kathleen Hanna for unknown reasons after a Lollapalooza concert in 1995.

Riot grrrl was relatively small in commercial terms, but hugely influential in style and culture.

Many riot grrrls displayed their commitment to feminism with ungroomed hair and a refusal to shave their armpits and legs

Body graffiti scrawled in felt pen or lipstick was used to reclaim misogynist words

Dr. Martens Mary Janes and schoolgirl skirts were used to play with notions feminine innocence and power

THE CULTURE DIY culture and homemade zines like "Jigsaw," "Runty," and "Snarla," acted as feminist manifestos and namesakes for bands, all while exploring punk rock, patriarchy and even incest and rape.

RIOT GRRRL

ORIGIN: OLYMPIA AND WASHINGTON, DC, 1990s
THIRD WAVE FEMINISTS CLAIM PUNK ON THEIR OWN TERMS

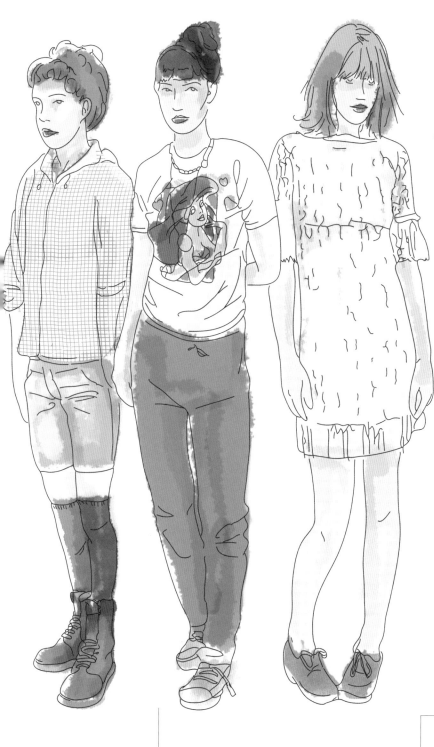

THE SOUND

"Girl Germs," Bratmobile, 1991
"Nothing Can Stop Me,"
Heavens to Betsy, 1991
"New Radio," Bikini Kill, 1993
"Her Jazz," Huggy Bear, 1993
"Her Again,"
Sleater-Kinney, 1995

THE LOOK

"Riot grrrls wore track
jackets, ringer T-shirts and
band T-shirts, as well as
shift dresses, baby-tees,
cardigans, and miniskirts.
They also wore Dr. Martens,
Mary Janes or platforms
shoes and accessorized
with headbands and
headscarves, choker
necklaces, band pins, and
wrap-around sunglasses.
Riot grrls often wore their hair
short, bleached or dyed, or
long with bangs.

Chuck Taylors were a
riot grrrl staple

ZINE COVERS:
RIOT GRRRL, JIGSAW, GIRL POWER

LARRY JACKSON'S
G-FUNK TOP FIVE

"Nuthin' But a 'G' Thang (feat. Snoop Dogg)," Dr. Dre, 1992

"California Love (feat. Dr. Dre and Roger Troutman)," 2Pac, 1995

"Captain Save A Hoe," E-40, 1994

"Ain't No Future in Yo Frontin'," MC Breed, 1991

"Playa Fo Real," Dru Down, 1996

G-FUNK

G-Funk's chill, cheeba-driven sound looks back
to the sweaty funk of the '70s

"Alwayz Into Somethin'," N.W.A., 1991

"Call It What U Want," Above The Law, 1992

"Getto Jam," Domino, 1993

"I'm A Player," Too $hort, 1993

"Real Muthaphuckkin G´s (feat. Gangsta Dresta
 and BG Knocc Out)," Eazy-E, 1993

"Who Am I (What's My Name)?," Snoop Dogg, 1993

"You Know How We Do It," Ice Cube, 1993

"All for the Money (feat. CMW)," MC Eiht, 1994

"Funkdafied," Da Brat, 1994

"Regulate," Warren G, 1994

"Thuggish Ruggish Bone," Bone Thugs-N-Harmony, 1994

"What Am I Supposed To Do," Celly Cel, 1994

"Big Pimpin 2" Tha Dogg Pound, 1995

"We Be Puttin' It Down (Feat. Snoop Dog)," Bad Azz, 1998

GRUNGE

When punks discover weed and Black Sabbath,
it's time to fly the flannel

"Touch Me I'm Sick," Mudhoney, 1988

"Jack Pepsi," TAD, 1990

"Stardog Champion," Mother Love Bone, 1990

"Swallow My Pride," Green River, 1990

"Hunger Strike," Temple Of The Dog, 1991

"Jeremy," Pearl Jam, 1991

"Lithium," Nirvana, 1991

"Out of Focus," Love Battery, 1992

"Nearly Lost You," Screaming Trees, 1992

"Pretend We're Dead," L7, 1992

"Would," Alice in Chains, 1992

"Backwater," Meat Puppets, 1993

"Going Blind," Melvins, 1993

"Black Hole Sun," Soundgarden, 1994

"Doll Parts," Hole, 1994

"Interstate Love Song," Stone Temple Pilots, 1994

"Machinehead," Bush, 1994

"Seether," Veruca Salt, 1994

"The Scratch," 7 Year Bitch, 1994

"I'll Stick Around," Foo Fighters, 1995

"River of Deceit," Mad Season, 1995

RIOT GRRRL

Putting a new feminist spin on punk orthodoxy,
riot grrrls reclaim the music as their own

"Shove," L7, 1990

"Kiss & Ride," Bratmobile, 1992

"Magnet," Bikini Kill, 1992

"Kenuwee Head," Voodoo Queens, 1993

"Calculated," Heavens to Betsy, 1994

"Facedown," Huggy Bear, 1994

"It's Too Late," 7 Year Bitch, 1994

"Pussycat Trash Vs. Jarvis Cocker," Pussycat Trash, 1994

"Butch in the Streets," Tribe 8, 1995

"Other People Would Be Suspicious of You,"
 Emily's Sassy Lime, 1995

"She's Amazing," Team Dresch, 1995

"This is Not Your Wedding Song," Excuse 17, 1995

"Crazy Glue," The Third Sex, 1996

"Be Good," Frumpies, 1997

"Crown," The Need, 1997

"Dad," Lucid Nation, 1997

"Everything's Brown," Jack Off Jill, 1997

"Go Far," Autoclave, 1997

"Little Babies," Sleater-Kinney, 1997

"Firetrap," Cadallaca, 1998

"Fuck Kitty," Frumpies, 1998

ALTERNATIVE

If grunge is punk, then alternative is New Wave

"Tomorrow, Wendy," Concrete Blonde, 1990

"Been Caught Stealing," Jane's Addiction, 1990

"Kool Thing," Sonic Youth, 1990

"Smells Like Teen Spirit," Nirvana, 1991

"Creep," Radiohead, 1992

"Killing in the Name," Rage Against The Machine, 1992

"No Rain," Blind Melon, 1992

"Teen Angst (What the World Needs Now)," Cracker, 1992

"Cannonball," The Breeders, 1993

"She Don't Use Jelly," The Flaming Lips, 1993

"Girl, You'll Be a Woman Soon," Urge Overkill, 1994

"Liar," Rollins Band, 1994

"Loser," Beck, 1994

"Red Right Hand," Nick Cave & The Bad Seeds, 1994

"What's the Frequency, Kenneth?," R.E.M., 1994

"Down by the Water," PJ Harvey, 1995

"Queer," Garbage, 1995

"1979," The Smashing Pumpkins, 1995

"The Beautiful People," Marilyn Manson, 1996

"Pepper," Butthole Surfers, 1996

"Scar Tissue," Red Hot Chili Peppers, 1999

BRIT POP

Britpop updates the mod sound and look
for the post-grunge, go-go '90s

"There She Goes," The La's, 1990

"Blue Deep Ocean," Ocean Colour Scene, 1992

"Does This Hurt?," The Boo Radleys, 1992

"Metal Mickey," Suede, 1993

"Sometimes (Lester Pigott)," James 1993

"Common People," Pulp, 1995

"Sale of the Century," Sleeper, 1995

"Sleeping In," Menswear, 1995

"Stereotypes," Blur, 1995

"Strange Ones," Supergrass, 1995

"Stutter," Elastica, 1995

"Wonderwall," Oasis, 1995

"A Design For Life," Manic Street Preachers, 1996

"Getting Better," Shed Seven, 1996

"Slight Return," The Bluetones, 1996

"Bitter Sweet Symphony," The Verve, 1997

"More Life In A Tramps Vest," Stereophonics, 1997

"North Country Boy," The Charlatans, 1997

"She Makes My Nose Bleed," Mansun, 1997

BLACK METAL

Metal distilled to its darkest essence,
both lyrically and musically

"Pad Modly," Master's Hammer, 1991

"Skyggedans," Satyricon, 1993

"Stemmen Fra Tårnet," Burzum, 1993

"The Horny And The Horned," Impaled Nazarene, 1993

"Unsilent Storms in the North Abyss," Immortal, 1993

"Velvet Thorns (Of Drynwhyl)," Katatonia, 1993

"Freezing Moon," Mayhem, 1994

"Inn I Evighetens Mørke (Part I)," Dimmu Borgir, 1994

"The Burning Shadows of Silence," Emperor, 1994

"Een Stemme Locker," Ulver, 1995

"The Hordes of Nebulah," Darkthrone, 1995

"Where Dead Angels Lie," Dissection, 1995

"A Dynasty From the Ice," Rotting Christ, 1996

"Opium," Moonspell, 1996

"793 (Slaget Om Lindisfarne)," Enslaved, 1997

"Willothewisp," Ancient, 1997

"A Forest," Carpathian Forest, 1998

"Dying in a Moment of Splendour," Ancient Rites, 1998

"The Twisted Nails of Faith," Cradle of Filth, 1998

"Decade of Therion," Behemoth, 1999

By the late 1980s, skateboarding's vert superstars were making big money selling boards and doing demos worldwide, but that was soon to change. Not everyone had access to massive vert ramps. Enter street skating. Any kid could step out of their house and skate a curb. Though street skating had been building throughout the '80s, spurred on by innovators like Natas Kaupas, Mark Gonzales, and Matt Hensley, it reached critical mass in the early '90s. The switch from vert skating to street skating shook the skateboarding industry to its core, unseating past masters and established companies, and putting upstarts like World Industries and its gaggle of teenage tech wizards in charge of the decade.

Steve Rocco, former freestyle skater and all-around firebrand, founded World Industries Skateboards with Rodney Mullen in 1987, adding companies like 101 and Blind to his empire by the early 1990s. Blind in particular would prove influential as its co-owner Mark Gonzales teamed with filmmaker Spike Jonze to make *Video Days*, skateboarding's first great street opus.

That video inspired young skaters in Los Angeles and San Francisco's Embarcadero plaza to embrace technical street skating and enormous, saggy trousers, ultimately influencing hip-hop and ravers and establishing the dominant trouser silhouette of the 1990s.

As mainstream culture caught on to huge pants, skaters changed things up. They downsized and adopted a fresh, hip-hop–influenced look. This trend ultimately culminated in the huge puffy shoes and infamous "swishy pants" of late-'90s skateboarding.

Towards the end to the decade, television coverage from ESPN's X Games put skateboarding back in the spotlight. This set the stage for a new generation of punk-influenced rippers to come in and upend '90s trends just as the new millennium dawned.

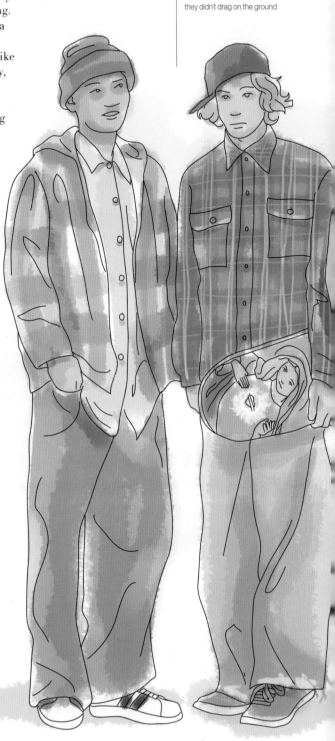

Massive, size 40 Blind jeans were cut off at the bottom so they didn't drag on the ground

Retro sneakers, like adidas Superstars were popular with skaters in the early '90s

THE CULTURE The early 1990s were skateboarding's last underground era, a pre-Internet time when teenage pioneers stayed out all night inventing new tricks, smoking blunts, and drinking 40s in spots like San Francisco's Embarcadero Plaza and Philadelphia's Love Park.

ORIGIN: SAN FRANCISCO, LOS ANGELES, PHILADELPHIA, NEW YORK, WASHINGTON, DC, 1990s
TEEN TECHNICIANS TAKE THE STREETS AS THE SKATE INDUSTRY BOTTOMS OUT

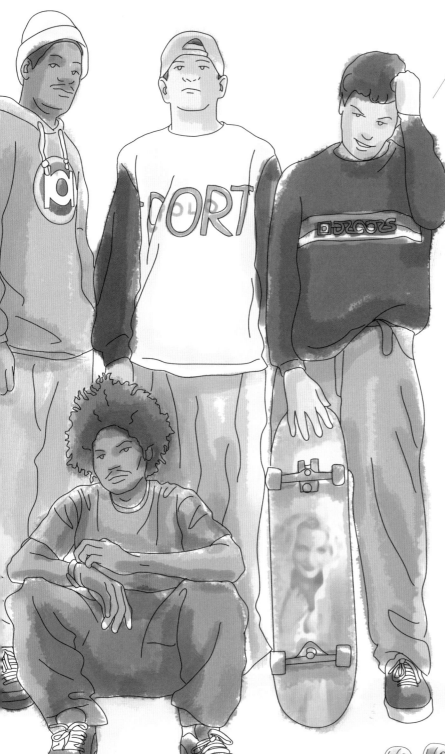

By the mid '90s, skaters had moved on to slightly less baggy light wash denim

THE SOUND

"The Knife Song," Milk, 1991
"Just to Get a Rep," Gang Starr, 1991
"93 'Till Infinity," Souls of Mischief, 1993
"Diary of a Madman," Gravediggaz, 1994
"Publicity (Instrumental)," GZA, 1999

THE LOOK

Skaters of the early '90s wore huge, earth-toned Blind jeans, which they cut ragged at the bottoms. On top, striped T-shirts were popular among skaters, as were hoodies and flannel shirts. Early '90s skaters wore shoes from skate brands like Airwalk and Etnies, but also liked throwback kicks like Puma Suedes and adidas Superstars. By 1994, skaters cleaned up, opting for less baggy jeans in light washes and a fresh hip-hop aesthetic. Crewneck sweatshirts became popular around this time, and infamous skate brand Supreme first opened up shop in New York City. As the decade closed, puffy, technical skate shoes from companies like DC and Emerica became the norm, usually paired with cargo pants or "swishy" warm-up bottoms.

SKATEBOARD WHEELS 1993–1996: 38MM, 42MM, 57MM, AND 63MM

The original raves were illegal underground events hosted by DJs and party promoters in rural fields and urban warehouses. Raves, and their devotees, ravers, had a few notable influences, including Chicago house music, Detroit techno, the post-disco parties DJ'ed by Larry Levan at New York's Paradise Garage, and the mood-enhancing drug ecstasy (MDMA), which was legal in the US until 1985, but had been banned in the UK since 1977. When these elements crossed the Atlantic, they found fertile homes, first in Ibiza and later in the acid house scenes of London and Manchester. When these elements merged in England in 1988, they produced "The Second Summer of Love," a few months of ecstasy, acid house, and clubbing that decreased violence across the country. All this fun (and a couple of ecstasy-related deaths) attracted the authorities, whose unfriendly attention quashed the UK acid house scene. In response, many party promoters moved things to New York, where the rave scene flourished, first on the East Coast and then nationwide.

After DJing an Energy rave in the UK in 1989, New York producer Frankie Bones proved crucial in moving the scene from England to the United States. He hosted the first true American raves in abandoned Brooklyn buildings under the STORMRave banner.

Guerilla advertising and subterfuge were key features of early raves. Fliers often gave would-be attendees a phone number to call to get directions to a secrete party site.

The rave scene mixed heavily with New York City's club kids, before spreading out across the rest of the country and Canada.

Though illegal raves no longer exist, the popularity of electronic dance music and large outdoor electronic music festivals are at an all-time high, proving rave's lasting influence.

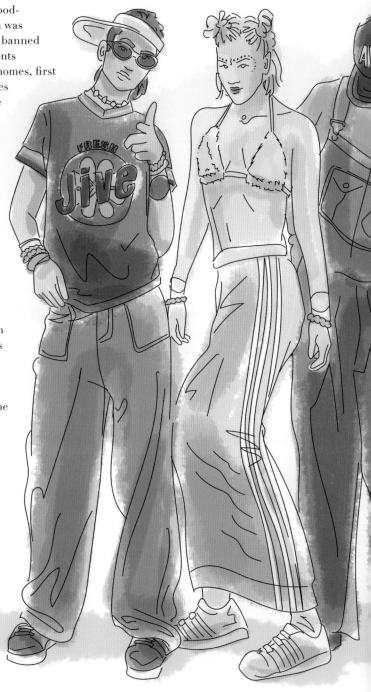

Retro adidas gear brought an '80s b-boy vibe to rave style

THE CULTURE Many ravers loved to mix Vicks® VapoRub® with their MDMA, carrying small containers to raves and smearing it under their noses to accentuate their high.

ORIGIN: LONDON AND NEW YORK, 1990s
DANCERS BECOME OUTLAWS WHEN ECSTASY IS CRIMINALIZED

Pacifiers were used to help sooth ecstasy-fueled teeth grinding

Baby T-shirt were a female raver staple in the '90s

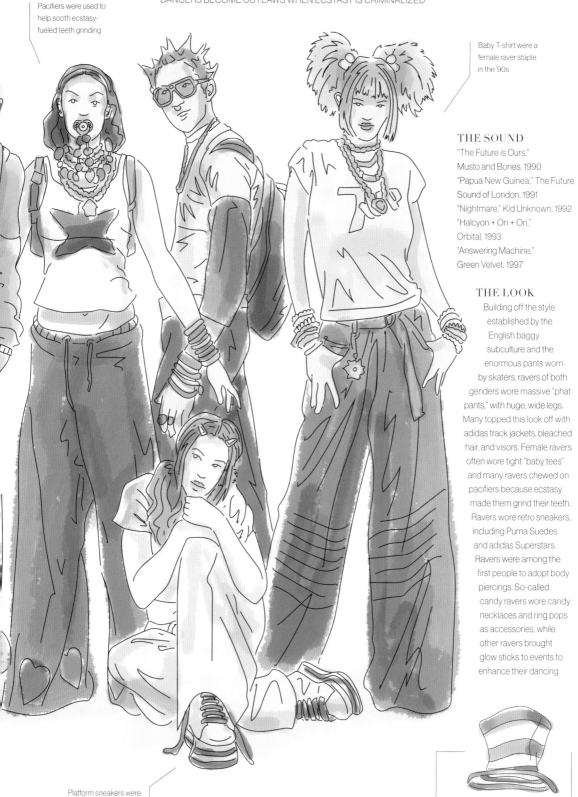

THE SOUND

"The Future is Ours,"
Musto and Bones, 1990
"Papua New Guinea," The Future
Sound of London, 1991
"Nightmare," Kid Unknown, 1992
"Halcyon + On + On,"
Orbital, 1993
"Answering Machine,"
Green Velvet, 1997

THE LOOK

Building off the style established by the English baggy subculture and the enormous pants worn by skaters, ravers of both genders wore massive "phat pants," with huge, wide legs. Many topped this look off with adidas track jackets, bleached hair, and visors. Female ravers often wore tight "baby tees" and many ravers chewed on pacifiers because ecstasy made them grind their teeth. Ravers wore retro sneakers, including Puma Suedes and adidas Superstars. Ravers were among the first people to adopt body piercings. So-called candy ravers wore candy necklaces and ring pops as accessories, while other ravers brought glow sticks to events to enhance their dancing.

Platform sneakers were inspired by club kids

OVERSIZED DR. SEUSS CAT HAT

Gyaru is the phonetic spelling of the Japanese pronunciation of the word "girl," and refers to a subculture of young women devoted to fashion and luxury. The name comes from "Gals," a line of Wrangler jeans marketed in Japan in the 1970s. Dyed hair, fake tans, artificial fingernails, false eyelashes, and circle contact lenses are gyaru trademarks. Many also enlarge their eyes using glue, tape, or surgery. Shibuya and its 109 luxury department store are home to the gyaru phenomenon. Gyaru listen to Eurobeat music from Konamai's Para Para Paradise video game franchise. Since its peak around the millennium, gyaru culture has spawned many offshoots, including the infamous *ganguro*, teenage *kogal*, and the male *gyaruo*.

Ganguro, which means "black-face" in Japanese, are a subset of gyaru that arose in the late 1990s, pushing the look to extremes by darkening their skin with artificial tans while outlining their eyes and lips in white makeup, wearing leis, platform boots, and face stickers and bleaching their hair silver. Perhaps predictably, the look (along with tanning salons with names like Blacky) proved controversial, and the ganguro transitioned into the yamanba style, which drew its name from the mountain witches of Japanese folklore.

The teenage kogal subset of the gyaru phenomenon proved equally controversia for their mix of youth and overt sexuality. Teenage kogal (a contraction of *ko-gyaru*, meaning "child of gyaru") adopted schoolgirl uniforms as their style of choice. They purposely evoked a sexual naiveté: shortening their skirts, wearing loose socks, and dyeing their hair brown. Kogal style was most prominent in the late '90s, but has recently seen a resurgence. Some kogal dated sugar daddies to fund their lifestyles.

Gyaruo are the male version of gyaru. They also favor deep tans, bleached hair, expensive clothes, and hanging around Shibuya.

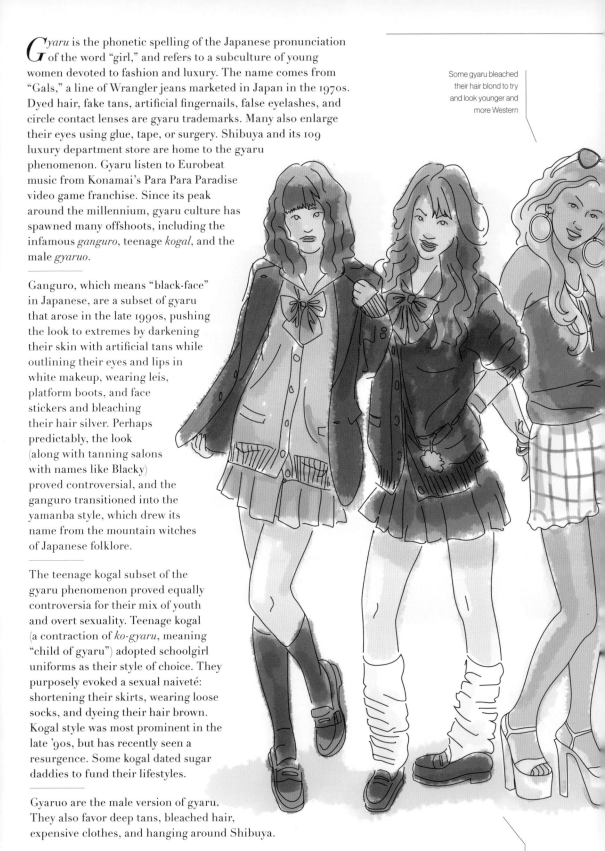

Some gyaru bleached their hair blond to try and look younger and more Western

Baggy white socks were the mark of a teenage kogal

THE CULTURE The most extreme version of gyaru were the *ogals*, a play on words, with "o" coming from the Japanese character for dirty, but also being the sound of an honorific prefix. Thus, the ogals were considered "honorable dirty girls," who, having spent all their money on looking cute and having fun, were forced to drop out from society and live on the streets.

GYARU / KOGAL

ORIGIN: TOKYO, 1990s
EXTREME GIRL CULTURE, SHIBUYA STYLE

Eyelids were often glued open to create an anime-style expression and show off colored contacts

Ganguro created their unique look through a combination of tanning and makeup

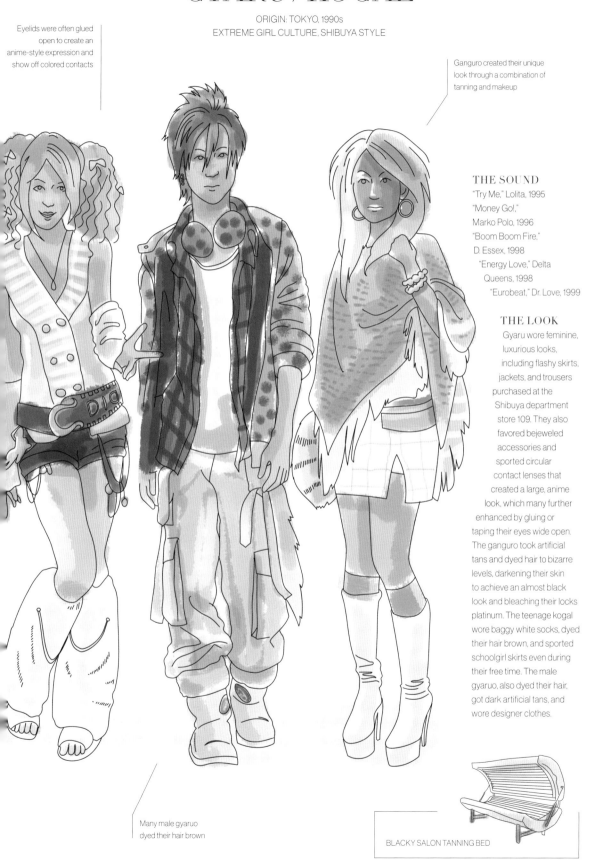

THE SOUND

"Try Me," Lolita, 1995
"Money Go!,"
Marko Polo, 1996
"Boom Boom Fire,"
D. Essex, 1998
"Energy Love," Delta
Queens, 1998
"Eurobeat," Dr. Love, 1999

THE LOOK

Gyaru wore feminine, luxurious looks, including flashy skirts, jackets, and trousers purchased at the Shibuya department store 109. They also favored bejeweled accessories and sported circular contact lenses that created a large, anime look, which many further enhanced by gluing or taping their eyes wide open. The ganguro took artificial tans and dyed hair to bizarre levels, darkening their skin to achieve an almost black look and bleaching their locks platinum. The teenage kogal wore baggy white socks, dyed their hair brown, and sported schoolgirl skirts even during their free time. The male gyaruo, also dyed their hair, got dark artificial tans, and wore designer clothes.

Many male gyaruo dyed their hair brown

BLACKY SALON TANNING BED

No subculture better represents the transformative, rebellious, life-affirming value of clothes quite like the urbane sapeur dandies of Kinshasa and Brazzaville. These are the capital cities of the two Congos—the Democratic Republic of the Congo (formerly Zaire, and before that the Belgian Congo) and the Republic of the Congo (once a part of the French Congo)—and they are home to the SAPE, an acronym for the Société des Ambianceurs et des Personnes Élégantes, roughly translated as the "Society of Ambience-Makers and Elegant People." SAPE is not only an acronym, but also a play on words, as "la sape" is French slang for elegant clothing.

Sapeurs trace their history first to twentieth century colonial houseboys who spent their wages on fine clothes and to Brazzaville social clubs of the 1920s, whose members collected European and Cuban records and wore expensive clothing and outlandish accessories.

As with many other subcultures, pop music was important in the creation of sapeurs. In the '20s and '30s, many migrant workers moved from the west coast of Africa to the Congos, bringing their own music with them, which inspired local musicians. In turn, more recent musicians like Papa Wemba have become among the most well-known sapeurs worldwide.

Both Congos have experienced multiple civil wars and face extreme poverty. According to the World Bank, the 2015 gross national income per capita in the Republic of the Congo was $2,540 and only a mere $410 in the Democratic Republic of the Congo. Thus paying between $1,300 and $3,900 for a pair of crocodile shoes, as some sapeurs do, is an extreme statement of commitment to style.

Sapeur culture is still going strong in both Congos and in immigrant communities in France.

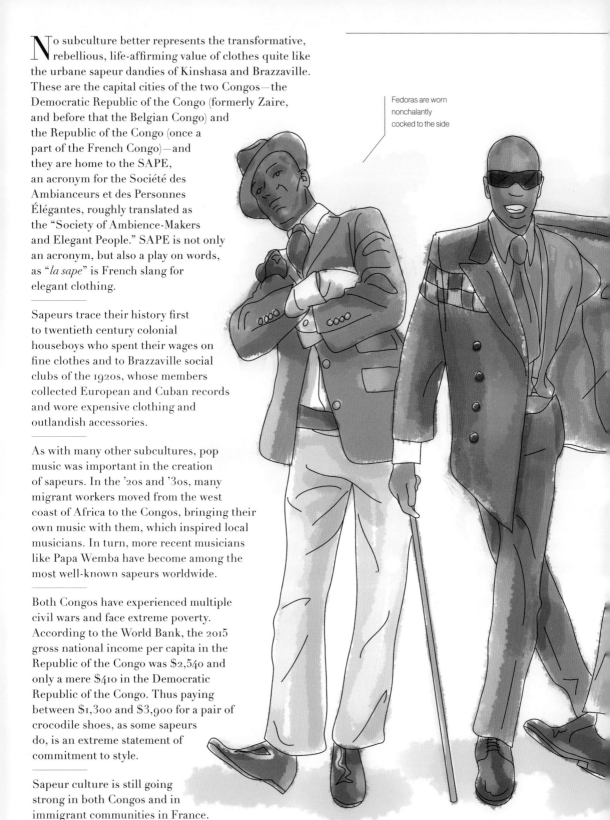

Fedoras are worn nonchalantly cocked to the side

THE CULTURE Because sapeurs wear European clothes, they have been accused of perpetuating colonial repression. Sapeur supporters, however, argue that they are actually undermining European control over both luxury goods and their own African bodies, making colonial-style classification and repression impossible.

SAPEURS

ORIGIN: BRAZZAVILLE AND KINSHASA, 1970s
THE EVERYDAY DANDIES OF THE TWO CONGOS

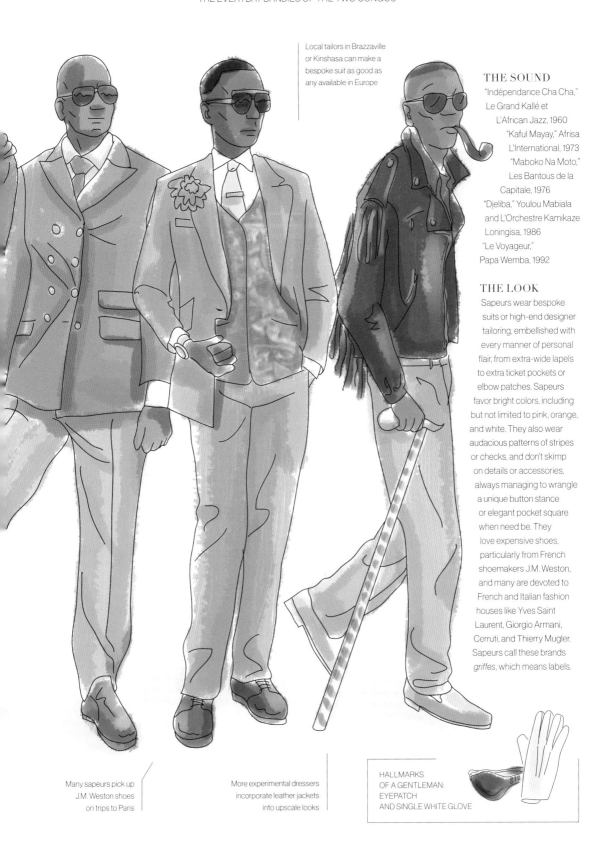

Local tailors in Brazzaville or Kinshasa can make a bespoke suit as good as any available in Europe

THE SOUND

"Indépendance Cha Cha,"
Le Grand Kallé et
L'African Jazz, 1960
"Kaful Mayay," Afrisa
L'International, 1973
"Maboko Na Moto,"
Les Bantous de la
Capitale, 1976
"Djeliba," Youlou Mabiala
and L'Orchestre Kamikaze
Loningisa, 1986
"Le Voyageur,"
Papa Wemba, 1992

THE LOOK

Sapeurs wear bespoke suits or high-end designer tailoring, embellished with every manner of personal flair, from extra-wide lapels to extra ticket pockets or elbow patches. Sapeurs favor bright colors, including but not limited to pink, orange, and white. They also wear audacious patterns of stripes or checks, and don't skimp on details or accessories, always managing to wrangle a unique button stance or elegant pocket square when need be. They love expensive shoes, particularly from French shoemakers J.M. Weston, and many are devoted to French and Italian fashion houses like Yves Saint Laurent, Giorgio Armani, Cerruti, and Thierry Mugler. Sapeurs call these brands *griffes*, which means labels.

Many sapeurs pick up J.M. Weston shoes on trips to Paris

More experimental dressers incorporate leather jackets into upscale looks

HALLMARKS
OF A GENTLEMAN:
EYEPATCH
AND SINGLE WHITE GLOVE

KELIS'S
NEO-SOUL SELECTS

"Brown Sugar," D'Angelo, 1995

"On & On," Erykah Badu, 1997

"Nothing Even Matters (feat. D'Angelo)," Lauryn Hill, 1998

"Good Stuff," Kelis, 1999

"A Long Walk" Jill Scott, 2000

"Just Friends (Sunny)," Musiq Soulchild, 2000

"Say Yes," Floetry, 2003

NEO SOUL

The sound and social message of the
civil rights era for the hip-hop generation

"Reality," Adriana Evans, 1995

"Ascension (Don't Ever Wonder)," Maxwell, 1996

"Nobody Else," Anthony Hamilton, 1996

"Where You Are," Rahsaan Patterson, 1997

"Baby I'm Scared Of You," Syleena Johnson, 1998

"Makeda," Les Nubians, 1998

"Breakthrough," Jazzyfatnastees, 1999

"Fool of Me," Me'shell Ndegéocello, 1999

"Get Involved," Raphael Saadiq, 1999

"No More Rain," Angie Stone, 1999

"I Try," Macy Gray, 1999

"Brown Skin," India.Arie, 2001

HARDCORE RAP

As tough as the West Coast gangsters, the East Coast's
hardcore rappers broke the music down to streetwise
lyrics and no-nonsense production

"King of New York," Schoolly D, 1990

"Hardcore," EPMD, 1990

"Protect Ya Neck," Wu-Tang Clan, 1993

"Code Of The Streets," Gang Starr, 1994

"Da Graveyard," Big L, 1994

"Diary Of A Madman," Gravediggaz, 1994

"Gimme The Loot," The Notorious B.I.G., 1994

"I Got Cha Opin'," Black Moon, 1994

"Brooklyn Zoo," Ol' Dirty Bastard, 1995

"4th Chamber (feat. RZA, Ghostface Killah, Killah Preist),"
GZA, 1995

"It's A Shame," Kool G Rap, 1995

"Last Dayz," Onyx, 1995

"Shook Ones, Pt. II," Mobb Deep, 1995

"Sound Bwoy Burreill, Smiff-n-Wessun, 1995

"Keep It Real," MC Ren, 1996

"Leflaur Leflah Eshkoshka," Heltah Skeltah, 1996

"Stick to Ya Gunz," M.O.P., 1996

"You Ain't a Killer (feat. Tony Smalios)," Big Pun, 1998

"Da Rockwilder," Method Man & Redman, 1999

"New York (Ya Out There)," Rakim, 1999

GABBER

Electronic music at its hardest, fastest, and grimiest

"Alles naar de klote," Euromasters, 1992

"Brain Confusion," Lenny Dee & Ralphie Dee, 1993

"Chosen Anthem (Against Racism)" Chosen Few, 1993

"Mother Fucker New York," DX-13, 1993

"The World of the LSD User," Juggernaut, 1993

"AEIOU," DJ Buby feat. The Stunned Guys, 1994

"Bang The Drums," The Scotchman, 1994

"Fuck Paris!," DJ Davyd, 1994

"My Salvation, " Knight Vision, 1994

"Phuture Piano," Magnetic Two, 1994

"Riot in N.Y.," Rob Gee, Repete & MC Romeo, 1994

"Six million ways 2 die," Turbulence, 1994

"We Need Things That Make Us Go (Senna's Drive Mix),"
3 Steps Ahead, 1994

"Are You With Me," Masters of Rave, 1995

"Energy Boost," DJ Dano & Liza 'n' Elias, 1995

"French Connection," French Connection, 1995

"Hardcore M.F.," Semtex, 1995

"Hardcore Muthafucka!!!," Nasty Django, 1995

"Luv U More (DJ Paul's Forze Mix)," DJ Paul Elstak, 1995

"Tough Guy," Delta 9, 1995

"Wizard of Oh!," Omar Santana, 1995

ELECTRONICA

*From big beat to trip hop, electronica grew out
of the house and techno movements in the '80s*

"Blue Room," The Orb, 1992

"Born Slippy (Nuxx)," Underworld, 1995

"Children," Robert Miles, 1995

"Clipper," Autechre, 1995

"Lifeforms (Path 1)," Future Sound of London, 1995

"Insomnia," Faithless, 1995

"Release the Pressure," Leftfield, 1995

"Smokebelch II (Beatless Mix)," The Sabres Of Paradise, 1995

"Atomic Moog 2000," Coldcut, 1996

"Da Funk," Daft Punk, 1996

"Firestarter," The Prodigy, 1996

"Girl/Boy Song," Aphex Twin, 1996

"My Mate Paul," David Holmes, 1996

"Rocco," Death in Vegas, 1996

"Santa Cruz," Fatboy Slim, 1996

"Take California," Propellerheads, 1996

"The Box," Orbital, 1996

"There's Gonna Be a Riot (Original Mix)," Dub Pistols, 1996

"Block Rockin' Beats," The Chemical Brothers, 1997

"Sexy Boy," Air, 1998

"Turquoise Hexagon Sun," Boards of Canada 1998

"Porcelain," Moby, 1999

SHOEGAZE

A rush of beautiful noise

"Afterglow," Loop, 1990

"De-Luxe," Lush, 1990

"Drive That Fast," Kitchens of Distinction, 1990

"Heaven or Las Vegas," Cocteau Twins, 1990

"Sight of You," Pale Saints, 1990

"Vapour Trail," Ride, 1990

"Breather," Chapterhouse, 1991

"Fait Accompli," Curve, 1991

"When You Sleep," My Bloody Valentine, 1991

"Black Metallic," Catherine Wheel, 1992

"Ice Cream Star," The Ecstasy of St. Theresa, 1992

"Winona," Drop Nineteens, 1992

"Alison," Slowdive, 1993

"Duel," Swervedriver, 1993

"Fade Into You," Mazzy Star, 1993

"Into the Ether," Secret Shine, 1993

"Never Click," Medicine, 1993

"Park the Car by the Side of the Road," Swirlies, 1993

"Your Guest and Host," Lilys, 1994

NEW JACK SWING

Bringing hip-hop swagger to a pop tip

"Feels Good," Tony! Toni! Toné!, 1990

"I Wanna Get With U" Guy, 1990

"Poison," Bell Biv Devoe, 1990

"Rub You the Right Way," Johnny Gill, 1990

"Sensitivity," Ralph Tresvant, 1990

"She's Got That Vibe," R. Kelly & Public Announcement, 1990

"Treat Them Like They Want To Be Treated," Father MC, 1990

"Iesha," Another Bad Creation, 1991

"I Love Your Smile," Shanice, 1991

"I'm Dreamin'," Christoper Williams, 1991

"I Wanna Sex You Up," Color Me Badd, 1991

"Motown Philly," Boyz II Men, 1991

"Keep It Coming," Keith Sweat, 1991

"Don't Walk Away," Jade, 1992

"Hat 2 Da Back," TLC, 1992

"I'm So Into You," SWV, 1992

"Live and Learn," Joe Public, 1992

"Rumpshaker," Wreck-N-Effect, 1992

"She's Playing Hard to Get," Hi-Five, 1992

"Cherish," Jodeci, 1992

"The Floor," Johnny Gill, 1993

Gabber is subgenre of hardcore techno that originated in Rotterdam during the early 1990s. It's ultra-fast, featuring a tempo between 160 and 220 beats per minute. In addition to its fast tempo, gabber tracks utilize a "hoover" sound effect produced using a Roland Alpha Juno-1 Synthesizer, creating a frenzied, distorted sound. The lyrics of gabber songs are equally hardcore, and often discus violence, sex, and partying. Gabber fans, also called gabbers, have their own style consisting of shaved heads, nylon track suits, Nike Air Max sneakers, and bomber jackets, with occasional skinhead touches like Fred Perry polo shirts.

Gabber was seen as a response to the mellower, more positive tone of house and techno genres which many gabbers hate.

Gabber was almost an entirely Dutch phenomenon, but did make some inroads in Germany and Italy.

The name gabber reputedly came from the Yiddish word *khaver* meaning "friend," and possibly originated when a bouncer at an Amsterdam club denied someone at the door, saying, "No khaver, you can't come in here."

Like other techno fans, gabbers' drug of choice was ecstasy.

In the early '90s, a small group gabber fans became involved with fascist politics and racism in the Netherlands and Germany. In response, many artists put out records with anti-racist messages, like Chosen Few's 1993 "Chosen Anthem (Against Racism)," while anti-racist fans wore patches that said "United Gabbers Against Racism & Fascism."

There were two forms of gabber music: old school, which features faster tempos and new school, which features slower tempos around 150 bpm and longer songs.

Possibly due to mockery from other techno fans, the term gabber began to fall out of favor in the 2000s, to be replaced by simply by hardcore.

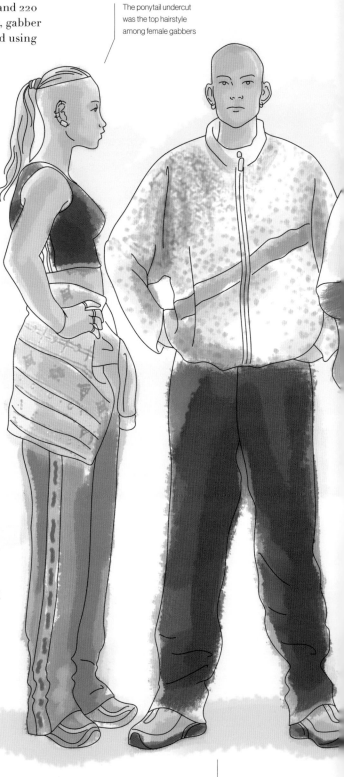

The ponytail undercut was the top hairstyle among female gabbers

Australian L'Alpina tracksuits were a scene favorite

THE CULTURE In the early 1990s, gabbers and other hardcore techno fans gained a reputation for racism and hardcore nationalism in the Netherlands and Germany. Since then, many gabbers have worked to shake this association.

ORIGIN: ROTTERDAM, 1990s
TECHNO-HEADS CREATE ULTRA-FAST MUSIC FOR ULTRA-FAST TIMES

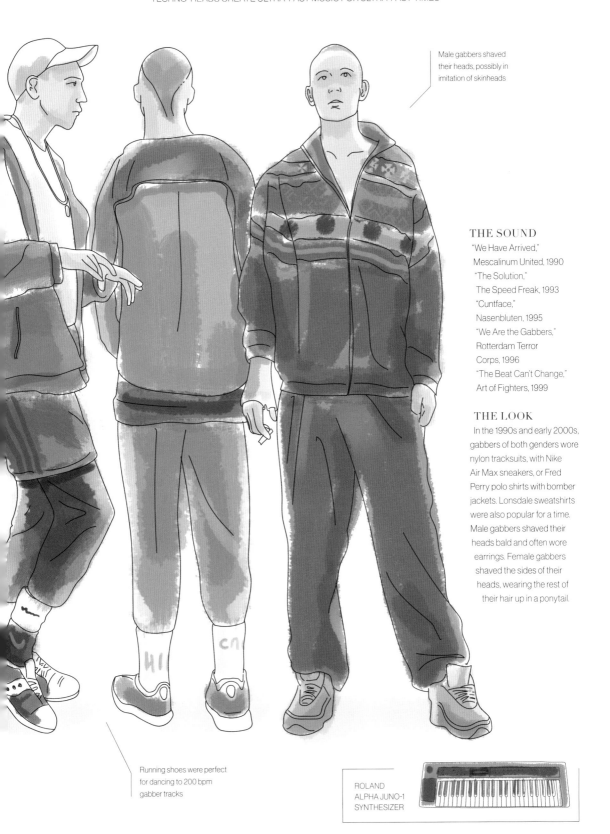

Male gabbers shaved their heads, possibly in imitation of skinheads

THE SOUND

"We Have Arrived,"
Mescalinum United, 1990
"The Solution,"
The Speed Freak, 1993
"Cuntface,"
Nasenbluten, 1995
"We Are the Gabbers,"
Rotterdam Terror
Corps, 1996
"The Beat Can't Change,"
Art of Fighters, 1999

THE LOOK

In the 1990s and early 2000s, gabbers of both genders wore nylon tracksuits, with Nike Air Max sneakers, or Fred Perry polo shirts with bomber jackets. Lonsdale sweatshirts were also popular for a time. Male gabbers shaved their heads bald and often wore earrings. Female gabbers shaved the sides of their heads, wearing the rest of their hair up in a ponytail.

Running shoes were perfect for dancing to 200 bpm gabber tracks

ROLAND
ALPHA JUNO-1
SYNTHESIZER

Juggalos (feminine: Juggalettes) are fans of Michigan horrorcore rap duo Insane Clown Posse. According to group member Violent J, the term Juggalo originated during a live performance of the song "The Juggla," during which he spontaneously called fans "my Juggalos." As white rappers performing outlandish, comedic horrorcore on their own record label, Insane Clown Posse appeared as true hip-hop outsiders, doing things for themselves and their fans. This authenticity proved irresistible to fans who felt similarly outcast, and Insane Clown Posse slowly built a rabid following, first in the Midwest and then worldwide—a fanbase they honored with the track "What Is a Juggalo?" from their 1997 album *The Great Milenko*.

Like Insane Clown Posse, Juggalos wear makeup and often take on clown names.

Though Insane Clown Posse claims the inspiration to wear clown makeup came from one of Violent J's dreams, it likely also tracks back to any number of "evil clowns" from pop culture, including The Joker from DC's Batman comics, the evil-clown imagery favored by cholos, and violent clowns from film and TV, like those in *Killer Klowns From Outer Space* and Stephen King's *It*.

In 2000, Insane Clown Posse hosted the first Gathering of the Juggalos festival, a now annual event that's attracted top talent like Ol' Dirty Bastard, George Clinton and Parliament, and Oscar winners Three 6 Mafia to its stages.

Juggalos have developed their own slang and traditions, including the ceremonial spraying of Detroit-area soda pop brand Faygo at concerts.

Juggalos are also devoted followers of friends of Insane Clown Posse, like horrorcore artists Esham and Tech N9ne.

Juggalo style has remained relatively stable and resistant to change since the late 1990s, and still consists of baggy, zipper-laden bondage pants from stores like Hot Topic, wallet chains, puffy skate shoes, Insane Clown Posse T-shirts, and of course clown makeup.

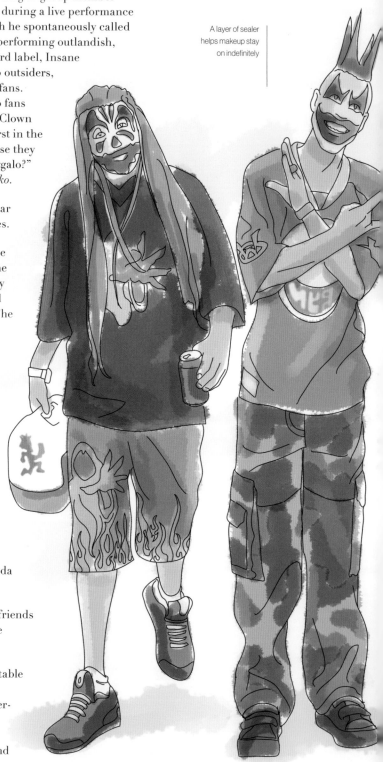

A layer of sealer helps makeup stay on indefinitely

THE CULTURE In 2011, the FBI's National Gang Intelligence Center added Juggalos to their list of street gangs. Insane Clown Posse responded to these allegations with a lawsuit, aided in part by the American Civil Liberties Union of Michigan. A court date for the lawsuit has yet to be set.

JUGGALOS

ORIGIN: DETROIT, 1990s
OBSESSED FANS CREATE A CULT AROUND RAPPING CLOWNS

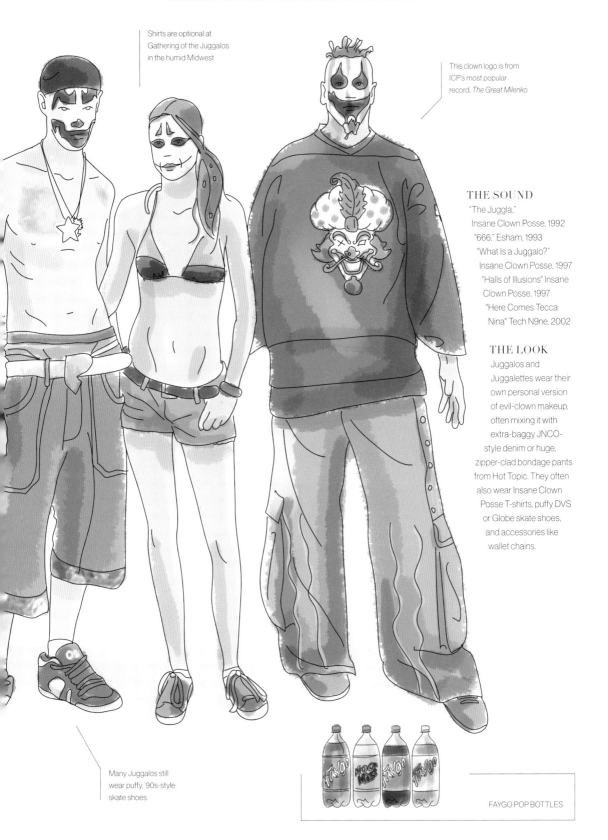

Shirts are optional at
Gathering of the Juggalos
in the humid Midwest

This clown logo is from
ICP's most popular
record, *The Great Milenko*

THE SOUND

"The Juggla,"
Insane Clown Posse, 1992
"666," Esham, 1993
"What Is a Juggalo?"
Insane Clown Posse, 1997
"Halls of Illusions" Insane
Clown Posse, 1997
"Here Comes Tecca
Nina" Tech N9ne, 2002

THE LOOK

Juggalos and
Juggalettes wear their
own personal version
of evil-clown makeup,
often mixing it with
extra-baggy JNCO-
style denim or huge,
zipper-clad bondage pants
from Hot Topic. They often
also wear Insane Clown
Posse T-shirts, puffy DVS
or Globe skate shoes,
and accessories like
wallet chains.

Many Juggalos still
wear puffy, '90s-style
skate shoes

FAYGO POP BOTTLES

Crowded Tokyo has a tradition of shutting down streets on Sundays to create *hokoten* (pedestrian paradises), where people can gather and shop. In the mid-'90s, Tokyo opened a hokoten in the commercial Harajuku district, allowing teenagers to congregate and socialize. Here the Decora subculture emerged, creating a new Japanese street fashion full of bright colors, infinite accessories, and a mix of Asian and Western clothing.

Photographer Shoichi Aoki, one of the first adults to recognize this trend, started the magazine *Fruits*, which brought worldwide attention to Decora and other Japanese street fashion. Despite this attention, Decora preferred *Kera* magazine, because it celebrated their look while also featuring street fashion photos from cities like New York, London, and Berlin.

Decora got its name from the hundreds of small accessories adherents wore in their bangs and on their clothes, piling them on until the hair and garments below were barely visible. Decora style also featured leg warmers, knee socks, and arm warmers, along with massive platform shoes and patterned surgical masks, all of which could be purchased at shops like Wego, Paris Kid's, and ACDC Rag on Takeshita street in Harajuku.

Decora favorites like singer Tomoe Shinohara and model Haruka Kurebayashi became icons because their pioneering styles embodied *kawaii*, the distinctly Japanese notion of cuteness.

Decora were notable for effortlessly mixing traditional Japanese kimonos with Western dress, a combination bordering on taboo at the time.

Though visually arresting, Decora weren't overtly political. Instead, they emphasized playfulness and freedom from established norms.

Decora and the other styles captured in *Fruits* were myriad; some were completely unique, starting and ending with the wearer, but many initiated new trends, even spawning new subcultures like Lolita and Fairy-kei, which replaced Decora in Japan by the late 2000s.

Piles of barrettes were worn in the hair

Stuffed animals were worn on shoes, pinned to clothes, or in the form of bags

THE CULTURE Decora, like their dance-oriented Harajuku predecessors the takenoko-zoku, were all about being seen in public, which is why they needed the Harajuku hokoten to flourish. In this sense, it was true street fashion.

DECORA

ORIGIN: TOKYO, 1990s

HARAJUKU YOUTH PILE ON ACCESSORIES TO CREATE JAPANESE STREET FASHION

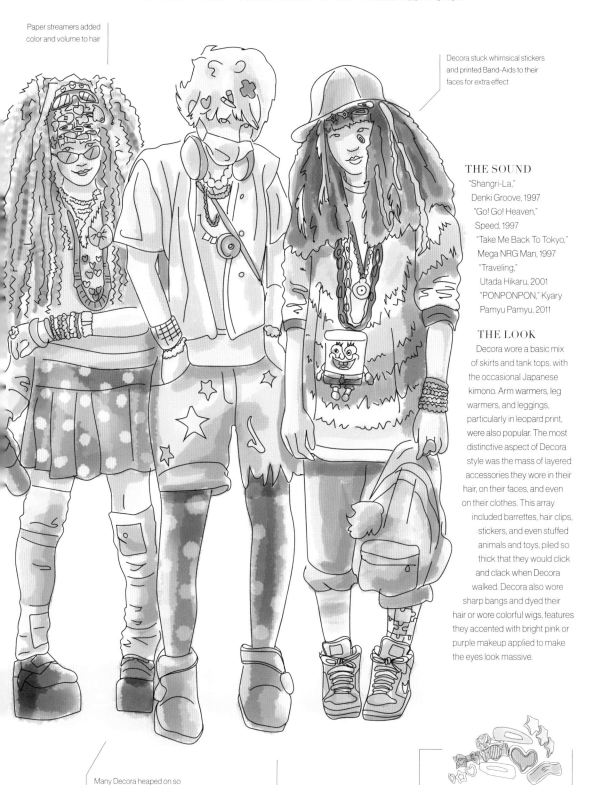

Paper streamers added color and volume to hair

Decora stuck whimsical stickers and printed Band-Aids to their faces for extra effect

THE SOUND

"Shangri-La,"
Denki Groove, 1997
"Go! Go! Heaven,"
Speed, 1997
"Take Me Back To Tokyo,"
Mega NRG Man, 1997
"Traveling,"
Utada Hikaru, 2001
"PONPONPON," Kyary
Pamyu Pamyu, 2011

THE LOOK

Decora wore a basic mix of skirts and tank tops, with the occasional Japanese kimono. Arm warmers, leg warmers, and leggings, particularly in leopard print, were also popular. The most distinctive aspect of Decora style was the mass of layered accessories they wore in their hair, on their faces, and even on their clothes. This array included barrettes, hair clips, stickers, and even stuffed animals and toys, piled so thick that they would click and clack when Decora walked. Decora also wore sharp bangs and dyed their hair or wore colorful wigs, features they accented with bright pink or purple makeup applied to make the eyes look massive.

Many Decora heaped on so many accessories that they clicked when they walked

SpongeBob SquarePants was a scene favorite

POPULAR ACCESSORIES: STICKERS, BAND-AIDS, AND BARRETTES

CULT PARTY-KEI

Cult Party-kei is named after the Koenji-area shop that inspired its look. It features layers of soft, white fabric and lace, with cream accents, accessories, and minimal makeup. Today, the Cult Party shop has changed its name to the Virgin Mary.

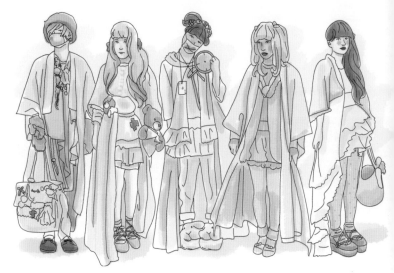

DOLLY-KEI

Dolly-kei is inspired by the Victorian era, Grimm's fairy tales, and antique dolls. It features layers of draped tapestries, lace, and floral prints in earth tones, as well as doll-like makeup and chemically lightened hair. In 2012, *Larme* magazine emerged as champion of Dolly-kei.

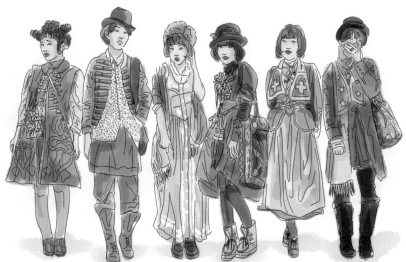

FAIRY-KEI

Fairy-kei emphasizes the more childlike aspects of Decora while toning down the style's cluttered layering and playing up pastel colors like pink and lavender. Adherents of Fairy-kei often dye their hair pink or blond and wear tutus or sheer skirts, items they embellish with accessories inspired by vintage American toys like Barbie, the Care Bears, and Strawberry Shortcake. Models like Amo and Kimura Yu are leading icons of Fairy-kei.

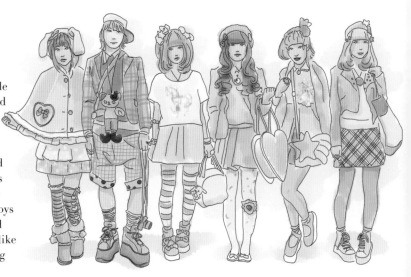

Decora wasn't the only notable style to emerge from Harajuku and its pedestrian hokoten walkway. Magazines like *Fruits* and *Kera* featured a mix of Decora and other, more personal styles, which conveyed a sense of self-expression and fun that additional Japanese youth would pick up on to create their own, over-the-top street styles. But more than simple fun, Decora pushed the limits of what was possible in terms of dress and transgression, proving that conservative Japan would at least tolerate youth in very strange outfits. Further, these publications showed that dressing up could garner the average Japanese teenager not only attention at home, but also interest from abroad. Foreign tourists who had long flocked to Yoyogi park to photograph the Japanese rockabilly dancers, were now moving further into Harajuku's commercial center to photograph Decora too, and they didn't even have to dance. Such domestic and foreign attention proved irresistible to Japanese teenagers who were already prone to fashionable self-expression, and Harajuku spawned many more incredible street-style tribes like Lolita, Dolly-kei, Fairy-kei, Cult Party-kei, and Mori Girls.

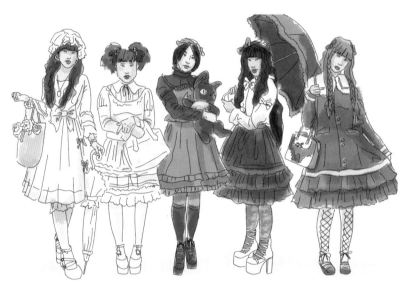

LOLITA

With roots dating back forty-five years to Milk, a shop that still operates in its original location on Takeshita Street in Harajuku, Lolita style peaked in the late 2000s. It's still popular in Harajuku today, where Lolitas wear A-line skirts, petticoats, and hair bows. This original Lolita style has spawned uncountable offshoots, including *hime* (princess), gothic, sweet, and *kuro/shiro* (black/white) Lolita styles, which have all but replaced Decora in Japan.

MORI GIRL

Mori Girl style is a departure from the bright colors of Decora and subsequent kei. It features vintage floral prints, long skirts, cardigans, and leggings in dusty, subdued palettes of cream, avocado, and pink. Magazines like *Seda* and model Masumi Kodama are leading proponents and icons of the Mori Girl life.

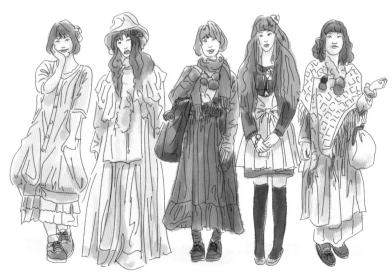

INDIE

The genuine alternative to alternative rock,
with a DIY attitude and a musically inclusive mindset

"Dig For Fire," Pixies, 1990

"Fourth of July," Galaxie 500, 1990

"Our Love Is Heavenly," Heavenly, 1990

"Slack Motherfucker," Superchunk, 1990

"Only Shallow," My Bloody Valentine, 1991

"The Concept," Teenage Fanclub, 1991

"The Freed Pig," Sebadoh, 1991

"Summer Babe (Winter Version)," Pavement, 1992

"Cath Carroll," Unrest, 1993

"I Wish I Was Him," Noise Addict, 1993

"Katy Song," Red House Painters, 1993

"Never Said," Liz Phair, 1993

"Echoes Myron," Guided By Voices, 1994

"West Palm Beach," Palace, 1994

"Needle In The Hay," Elliot Smith, 1995

"Tom Courtenay," Yo La Tengo, 1995

"Interstate 8," Modest Mouse, 1996

"Stars of Track and Field," Belle and Sebastian, 1996

"You've Passed," Neutral Milk Hotel, 1996

"Dig Me Out," Sleater-Kinney, 1997

"Shine A Light," Apples In Stereo, 1997

"Virginia Reel Around The Fountain," The Halo Benders, 1998

ACID JAZZ

Acid jazz old-school soul-jazz for a new
generation of cratediggers

"Apparently Nothin'," Young Disciples, 1990

"Never Stop," The Brand New Heavies, 1990

"Wash Your Face In My Sink," Dream Warriors, 1990

"Get Busy," Courtney Pine, 1992

"Get to Grips," Ronny Jordan, 1992

"Girl Overboard," Snowboy, 1992

"Loaded," Night Trains, 1992

"Prince of Peace," Galliano, 1992

"Apple Green," Mother Earth, 1993

"Cantaloop (Flip Fantasia)," Us3, 1993

"Loungin'," Guru, 1993

"Magnetic Ocean," Incognito, 1993

"Now Is The Time," D*Note, 1993

"Too Young To Die," Jamiroquai, 1993

"Uptight," Shara Nelson, 1993

"Where I'm From," Digable Planets, 1993

"Rentstrike," Groove Collective, 1993

"Stolen Moments," United Future Organization, 1994

"Take the L Train," Brooklyn Funk Essentials, 1994

"Free Your Mind," James Taylor Quartet, 1995

"Street Scene (4 Shazz), St. Germain, 1995

"Sweet Luis," Count Basic, 1996

TRIP-HOP

Cinematic cool meets electronic beats
for the '90s' most stylish sound

"Dead By Dawn," Depth Charge, 1990

"Deep Shit Pt. 1 & Pt. 2," Kruder & Dorfmeister, 1993

"Karmacoma," Massive Attack, 1994

"Sour Times," Portishead, 1994

"Chocolate Elvis," Tosca, 1995

"Clubbed To Death," Clubbed To Death, 1995

"Harmonicas Are Shite," Fila Brazillia, 1995

"Hell Is Round The Corner," Tricky, 1995

"Nights Introlude," Nightmares on Wax, 1995

"Portobello Cafe," The Ballistic Brothers, 1995

"Trigger Hippie," Morcheeba, 1995

"Berry Meditation (Original Mix)," U.N.K.L.E., 1996

"Dark Lady," DJ Food, 1996

"Midnight In A Perfect World," DJ Shadow, 1996

"Spin Spin Sugar," Sneaker Pimps, 1996

"2Wicky," Hooverphonic, 1996

"Busy Child," The Crystal Method, 1997

"Hopscotch," Howie B., 1997

"La La La," Tranquility Bass, 1997

"Midlander (There Can Only Be One...),"
Bentley Rhythm Ace, 1997

 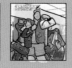

POP PUNK

A streamlined revival of first-wave
'70s punk, with the clean sound and big hooks
of alternative rock

"Disconnected," Face to Face, 1992

"Anti-Manifesto," Propagandhi, 1993

"Hyena," Rancid, 1993

"Touch My Joe Camel," Pansy Division, 1993

"Basket Case," Green Day, 1994

"Linoleum," NOFX, 1994

"Need You Around," Smoking Popes, 1994

"Stranger Than Fiction," Bad Religion, 1994

"Chick Magnet," MxPx, 1996

"Here In Your Bedroom," Goldfinger, 1996

"Dammit," blink-182, 1997

"Flagpole Sitta," Harvey Danger, 1997

"History of a Boring Town," Less Than Jake, 1997

"With My Looks and Your Brains," The Mr. T Experience, 1997

"Enjoy Your Day," Alkaline Trio, 1998

"My Girlfriend's Dead," The Vandals, 1998

"San Dimas High School Football Rules," The Ataris, 1998

"Suckerpunch," Bowling For Soup, 1998

"The Kids Aren't Alright," The Offspring, 1998

"All My Fault," Fenix TX, 1999

"Hit Or Miss," New Found Glory, 1999

DRUM AND BASS

Perhaps the most descriptively named genre ever,
D'n'B ratchets up both the tempo and the bottom end

"Hooligan 69," The Ragga Twins, 1991

"Outer Limits," Andy C, 1992

"Renegade Snares, (Original Mix)" Omni Trio, 1993

"Valley of the Shadows," Origin Unknown, 1993

"Dub Plate Style," Marvellous Cain, 1994

"Roll The Beats (Inject The Bass Mix)," DJ Hype, 1994

"Circles," Adam F, 1995

"Horizons," LTJ Bukem, 1995

"Inner City Life," Goldie, 1995

"Arabian Nights," J Majik, 1995

"Feel The Sunshine (feat. Deborah Anderson),"
Alex Reece, 1996

"Stonekiller," Source Direct, 1996

"Bank of America," Spring Heel Jack, 1997

"Can We Talk," Code Red, 1997

"EKG," Kid Loops, 1997

"Heroes," Roni Size/Reprazent, 1997

"The Hidden Camera," Photek, 1997

"Miles From Home," Peshay, 1998

"Rainbows of Colour," Grooverider, 1998

"Universal Reprise," 4hero, 1998

"Wormhole" Ed Rush & Optical, 1998

"BM Funkster," Aphrodite, 1999

NU METAL

Updated metal for the 1990s combines heavy riffs
with hip-hop vocals and DJ flourishes

"Bring The Noise," Anthrax, 1991

"I Love It Loud (Injected Mix)," Phunk Junkeez, 1995

"Fire Water Burn," The Bloodhound Gang, 1996

"A.D.I.D.A.S.," Korn, 1996

"Black," Sevendust, 1997

"Ground, (Hed) P.E., 1997

"Loco," Coal Chamber, 1997

"My Own Summer (Shove It)," Deftones, 1997

"Nookie," Limp Bizkit, 1999

"Bawitdaba," Kid Rock, 1998

"Check," Zebrahead, 1998

"Eye For An Eye," Soulfly, 1998

"New Skin," Incubus, 1998

"Southern Pride," Stuck Mojo, 1998

"Sugar," System of a Down, 1998

"Guerrilla Radio," Rage Againt The Machine, 1999

"Mudshovel," Staind, 1999

"Southtown," P.O.D., 1999

"Wait and Bleed," Slipknot, 1999

"Last Resort," Papa Roach, 2000

The contemporary usage of hipster dates to the turn of the millennium and refers to mostly middle-class, mostly white young creatives in big cities. It's frequently tied to the gentrification of Williamsburg, Brooklyn, which began in earnest around 2000 when artists and baristas moved to the neighborhood from downtown Manhattan. The term itself, however, dates to the 1940s, when it described a similar phenomenon of white, middle-class youths who attempted to live like black jazz musicians. Today, the term is amorphous, taking on a range of meanings so wide as to sometimes appear meaningless. Further complicating things, hipster fashion has always been broad and dynamic, but generally encompasses things like tight jeans, Converse All-Stars, vintage T-shirts, traditional American tattoos, and thick framed glasses.

In 2003, Williamsburg writer Rob Lanham published *The Hipster Handbook*, a satirical take on hipster culture that helped popularize the term and subculture.

Around 2005, skinny jeans became widely available, rapidly turning into a hipster trademark. This early adoption proved influential as rappers like Lil Wayne began to wear the style, making it the standard silhouette of the 2000s. Simultaneously, male hipsters began growing beards (which remain a symbol of hipsterism to this day).

By 2010, hipster fashion had spread far beyond Brooklyn, London, and Los Angeles. That year, New York Magazine published an article asking "What Was the Hipster?" but hipsters continued to proliferate and mutate, eventually becoming media shorthand for any pretentious young urbanite. Even in 2016, it's still possible to find headlines like "How Hipsters Are Spreading Zika in Miami" on reputable news sites like The Daily Beast, perhaps proving that hipsters are one subculture that will never die.

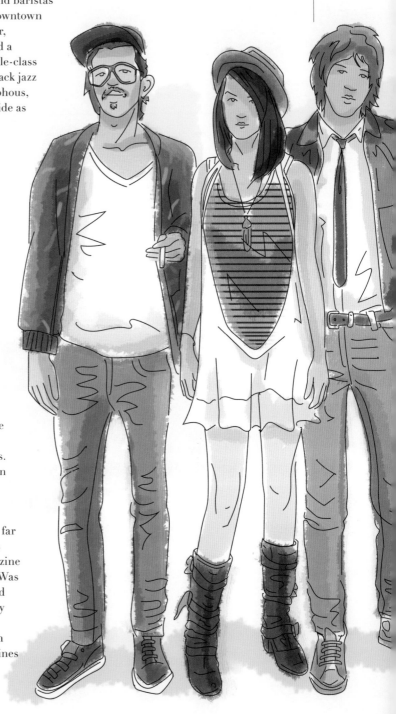

Razor tie inspired by No Wave artists from the '80s

THE CULTURE Hipsters were long accused by outsiders of only liking things ironically. Whether true or not, one thing they did like in earnest was drugs, favoring cocaine, cheap canned beer, and American Spirit cigarettes to keep the party going.

HIPSTERS

ORIGIN: NEW YORK, 2000s
URBAN COOL KIDS RULE THE 2000s

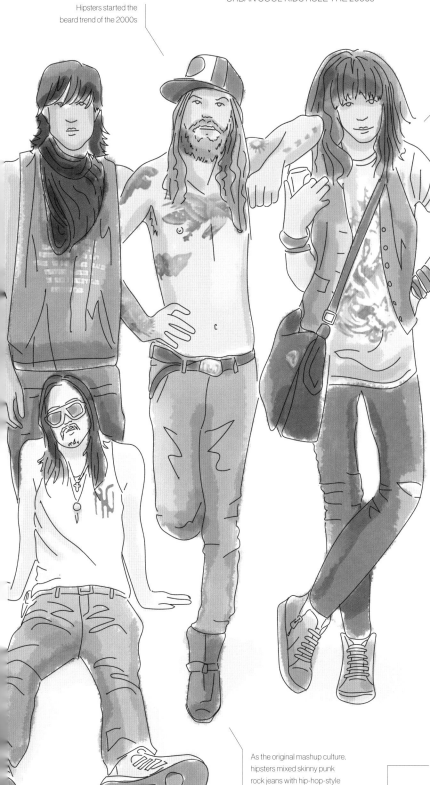

Hipsters started the beard trend of the 2000s

Skinny jeans were worn until ripped and shredded

As the original mashup culture, hipsters mixed skinny punk rock jeans with hip-hop-style New Era fitted caps

THE SOUND

"Last Nite,"
The Strokes, 2001
"House of Jealous Lovers,"
The Rapture, 2002
"Maps," Yeah Yeah Yeahs, 2003
"Time to Pretend," MGMT, 2005
"All My Friends," LCD Soundsystem, 2007

THE LOOK

Hipster style has always been vast and variable, with some hipsters sticking strictly to indie and punk influenced looks, and others adopting aspects of hip-hop or rave culture. However, some items always transcended these cultural variations and are found in every pocket of hipsterdom, on both men and women. Skinny jeans fit into this category, as do thick, chunky glasses, traditional American tattoos, vintage T-shirts, and canvas sneakers like Vans or Converse All-Stars.

NYC HIPSTER BAR DON HILL'S NOW CLOSED

Oogles are a twenty-first century subculture that combine elements of crust punk fashion and lifestyle with the rail-riding freedom and romance of Depression-era hobos. They travel by freight train and make a living panhandling or playing music for spare change. Oogles can be found all over the country, but cluster in college towns like Berkeley, California, and Austin, Texas, also favoring Pacific Northwestern cities like Portland, Oregon, and rough, warm weather spots like New Orleans, Louisiana. Though often accused of being "rich kids" playing at being bums by outsiders, oogles come from all walks of life, and many have been kicked out by their parents or hit the streets to escape abusive households.

Oogle began as insult but has come to take on an affectionate, if somewhat humorous, meaning.

In addition to their hybrid fashion style, oogles are also responsible for helping create the folk-punk musical genre, which combines punk themes and vocal styles with traditional folk and hobo instruments like banjos and acoustic guitars. In addition to this novel, mixed style of music, oogles listen to crust and anarcho-punk bands like Crass and Leftöver Crack.

Like their crust punk progenitors, oogle culture has a substantial amount of alcohol and drug use, with many spending their panhandled earnings on beer, heroin, and crack.

Oogles pride themselves on traveling the rails, and look down on "home bums," homeless youth who never leave town and stay in one place panhandling.

Mike Brodie, a train hopping photographer known as the Polaroid Kid, has drawn acclaim in the art world for candid work that sometimes captures the oogle lifestyle.

The oogle subculture still exists and members can be found panhandling in almost any major city in America, especially during the warmer months.

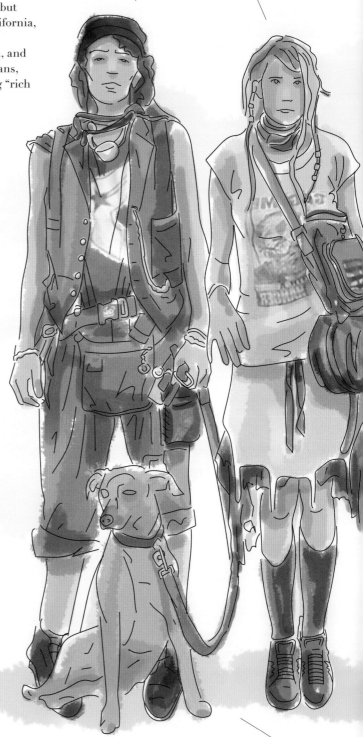

Layers of road filth give oogle outfits a leathery look

Punk rock dreadlocks date to '80s crust bands like Antisect and Doom

Oogles jokingly call dogs "doogles"

THE CULTURE Despite, or perhaps because of their traveling lifestyle, oogles use the Internet freely and often. Many oogle bands have bandcamp pages, and lookatthisfuckingoogle.tumblr.com is a one stop spot for oogle humor, photos, and culture.

OOGLES

ORIGIN: UNITED STATES, 2000s
NEO-HOBO GUTTER PUNKS RIDE THE RAILS AND SPANGE ACROSS AMERICA

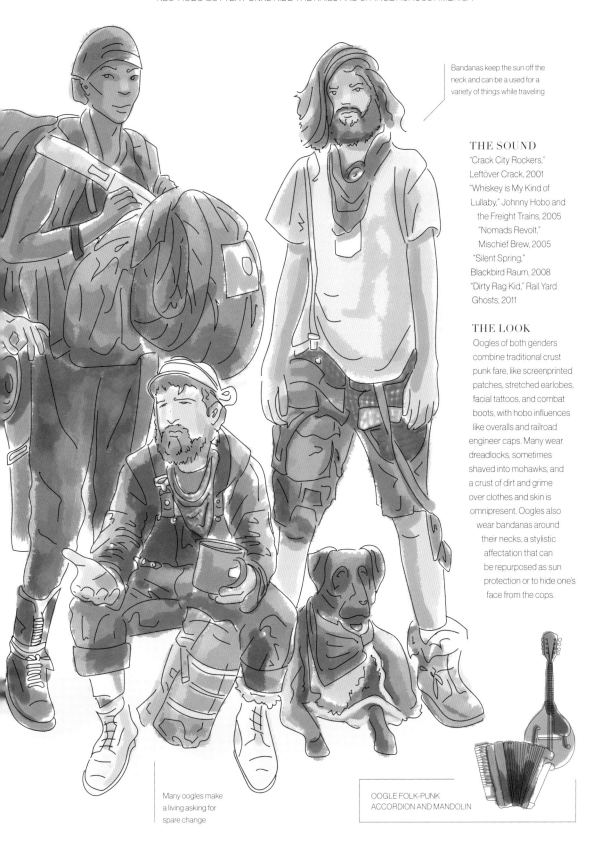

Bandanas keep the sun off the neck and can be a used for a variety of things while traveling

THE SOUND

"Crack City Rockers,"
Leftöver Crack, 2001
"Whiskey is My Kind of
Lullaby," Johnny Hobo and
the Freight Trains, 2005
"Nomads Revolt,"
Mischief Brew, 2005
"Silent Spring,"
Blackbird Raum, 2008
"Dirty Rag Kid," Rail Yard
Ghosts, 2011

THE LOOK

Oogles of both genders combine traditional crust punk fare, like screenprinted patches, stretched earlobes, facial tattoos, and combat boots, with hobo influences like overalls and railroad engineer caps. Many wear dreadlocks, sometimes shaved into mohawks, and a crust of dirt and grime over clothes and skin is omnipresent. Oogles also wear bandanas around their necks, a stylistic affectation that can be repurposed as sun protection or to hide one's face from the cops.

Many oogles make a living asking for spare change

OOGLE FOLK-PUNK
ACCORDION AND MANDOLIN

Emos got their name from emo (short for Emo-core), a mid-'80s offshoot of hardcore pioneered by bands like Washington DC's Rites of Spring. Spurred on by bands like Sunny Day Real Estate, emo grew throughout the '90s, adding both the sound and style of pop punk and indie rock to its mix, before breaking into the mainstream at the turn of the millennium on the back of acts like Dashboard Confessional. Already having attracted sensitive, alienated kids, emo also found a natural new home on the Internet around this time. Online, emo further developed into a subculture with its own norms and look, including flat, straightened black hair, tight jeans, striped T-shirts, piercings, and painted nails. As this online community coalesced into a powerful subcultural force, emo became even more popular, and bands like My Chemical Romance took the style and sound to MTV with hit records and engaging music videos.

Message boards like punknews.org were integral to the development of emo, helping it bridge the gap from punk and indie offshoot to full-fledged subculture with its own developed fashion style and perspective. Myspace was also key to the formation of post-millennial emo culture.

In the late 2000s, *Vice* reported on clashes between emos and punks in Mexico City, claiming some brawls attracted as many as two hundred kids.

Despite having a substantial number of female fans, music critic Andy Greenwald has criticized emo for being a male-dominated art form full of lyrics about being shunned by women.

Emo's popularity created genre offshoots, most notably screamo, so named for its screeching vocals.

After dipping in popularity towards the end of the 2000s, emo is currently experiencing a revival.

Like other punk offshoots, emos dyed their hair

Snap-back caps were popular in the 2000s

THE CULTURE Emos developed their own slang used on instant messengers, Myspace, and in texts. It includes part-emoji statements like "rawr xD," a joking but flirtatious way to say "I love you," and "~~nuzzlez~~:3," which is a show of affection.

Many emos wore band T-shirts and bondage pants like their punk rock predecessors

EMOS

ORIGIN: UNITED STATES, 2000s
TWENTY-FIRST CENTURY SAD KIDS FIND MEANING ONLINE

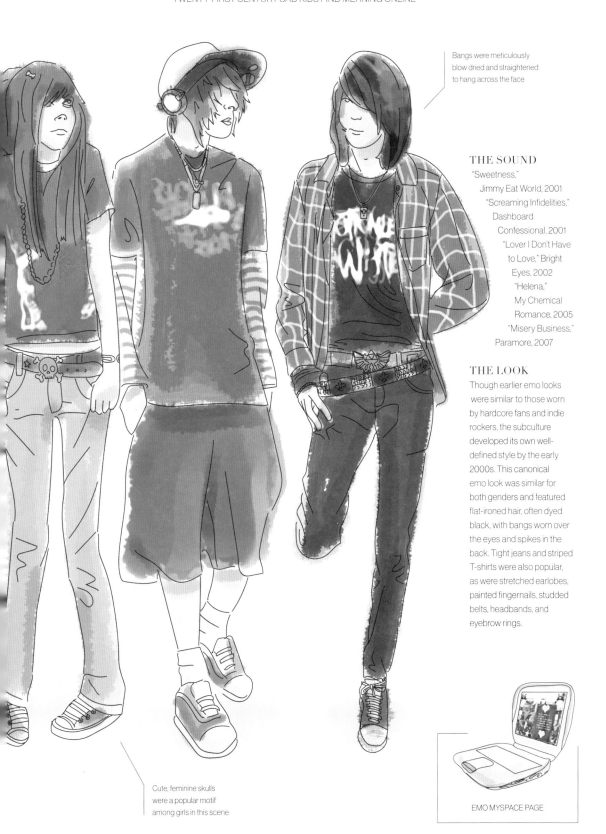

Bangs were meticulously blow dried and straightened to hang across the face

THE SOUND

"Sweetness,"
Jimmy Eat World, 2001
"Screaming Infidelities,"
Dashboard
Confessional, 2001
"Lover I Don't Have
to Love," Bright
Eyes, 2002
"Helena,"
My Chemical
Romance, 2005
"Misery Business,"
Paramore, 2007

THE LOOK

Though earlier emo looks were similar to those worn by hardcore fans and indie rockers, the subculture developed its own well-defined style by the early 2000s. This canonical emo look was similar for both genders and featured flat-ironed hair, often dyed black, with bangs worn over the eyes and spikes in the back. Tight jeans and striped T-shirts were also popular, as were stretched earlobes, painted fingernails, studded belts, headbands, and eyebrow rings.

Cute, feminine skulls were a popular motif among girls in this scene

EMO MYSPACE PAGE

Reggaetoneros are fans and performers of reggaeton, the Puerto Rican musical form that emerged from a mix of influences like Jamaican dancehall, Panamanian reggae en español, and American hip-hop. The reggaeton creation story holds that its roots can be traced to the large number of Jamaican migrant workers recruited to build the Panama Canal between 1904 and 1914. In reality, Jamaicans had been in Panama far longer, initially arriving to help build railroads there in the 1850s. Regardless, both of these migrations established a link between Panama and Jamaica that lead the former to become the home of reggae en Español. In Panama, artists like Nando Boom adopted the "riddim" from Shabba Ranks' 1991 Jamaican dancehall hit "Dem Bow" as their favorite backbeat. When Puerto Rican musicians later encountered Panamanian and Jamaican reggae in New York City, they adopted the "Dem Bow" riddim too, adding their own flavor to it and transforming it into reggaeton by the turn of the millennium.

Reggaeton broke into the mainstream in the early 2000s as artists like Tego Calderon and Daddy Yankee proved audiences around the world would welcome rhythmic pop music with Spanish lyrics.

Daddy Yankee in particular proved popular, as his hit "Gasolina" peaked at number ten on *Billboard*'s Hot Rap Songs chart, while also rising as high as number one on pop charts in countries as disparate as Denmark and Italy.

Though reggaeton peaked commercially among mainstream, largely white audiences in the mid-2000s, it remains a vital musical force, and has produced potent offshoots like Dominican dembow music, which is named for the unifying beat it shares with its Puerto Rican predecessor.

Large hoop earrings were worn for '80s hip-hop look

Dancehall raggamuffins inspired female reggaetoneras to wear knee-high boots

THE CULTURE In the grand tradition of all things cool, the lyrics to Daddy Yankee's hit "Gasolina" mystified white, English-speaking audiences, with some guessing that its chorus "a ella le gusta la gasolina" was a veiled sexual reference. In interviews, Daddy Yankee claimed otherwise, explaining "gasolina" was slang for the fast cars and fast times that drew certain women to life in the streets.

ORIGIN: PUERTO RICO, 2000s

TRANSNATIONAL MUSIC FANS HINT AT THE GLOBAL INTERNET VILLAGE TO COME

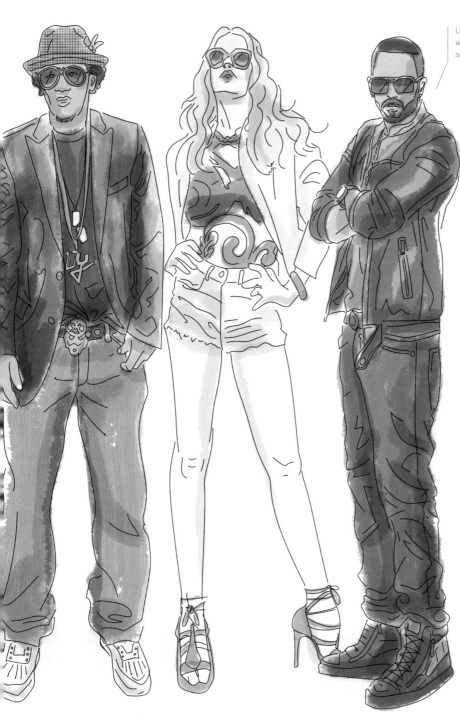

Leather Members Only jacket was inspired by emerging hipster scene of the early 2000s

THE SOUND

"Guasa Guasa,"
Tego Calderón, 2002
"Quiero Bailar,"
Ivy Queen, 2003
"Gasolina,"
Daddy Yankee, 2004
"Reggaeton Latino
(Chosen Few Remix),"
Don Omar featuring Fat Joe,
N.O.R.E. and LDA, 2005
"Rakata,"
Wisin & Yandel, 2005

THE LOOK

Male reggaeton artists like Daddy Yankee and Don Omar wore the baggy jeans, oversized white T-shirts, crisp white Air Force 1s, and platinum jewelry popular among hip-hop artists of the early 2000s, inspiring their reggaetonero fans to dress in a similar manner. Many reggaetoneros augmented this look with oversized sunglasses and nods to traditional Caribbean Latino styles like straw fedoras. Female reggaeton artists and fans created their own powerful, sexually aggressive image in cut-off denim shorts, tall boots, and leather jackets, with allusions to old-school hip-hop style including large gold hoop earrings.

Pristine Nike Air Force 1s were worn "fresh-out-the-box"

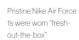

REGGAETON'S DANCE: BAILANDO PERREO

Though vaguely rooted in hip-hop culture, hypebeasts are streetwear fans known for appropriating skateboarding brands, a phenomenon that dates to cult skateshop Supreme's 2002 collaboration with Nike SB on a pair of limited edition Dunks. From here, hypebeasts expanded their interests to clothing, thirsting after non-skate streetwear brands like Japan's A Bathing Ape (BAPE), before moving on to high fashion designers like Raf Simons and Rick Owens.

Hypebeasts first attracted mainstream attention in 2005, when they rioted while awaiting the release of the Nike SB Dunk Low "Pigeon" outside of Lower East Side streetwear shop Reed Space. The following morning, *The New York Post* covered the riot on its front page, introducing the hypebeast phenomenon to the outside world. Hypebeasts would replicate the riot again in 2014, when crowds camped out to buy Supreme's Nike Air Foamposite overwhelmed the block the night before the release, prompting the NYPD to shut down the in-store release of the shoes and consequently forced Supreme to move sales exclusively online.

The hypebeast phenomenon grew when rappers like Pharrell Williams and Kanye West became interested in streetwear, first promoting other brands and shoes in their songs, then going on to release their own.

Pharrell's Billionaire Boys Club line proved popular, getting hypebeasts into tailored varsity jackets and slim, skate-inspired denim, but as the 2000s drew to a close, Kanye became the undisputed pied piper of the hypebeasts, releasing his Nike Air Yeezy 1 sneaker in 2008 and his Louis Vuitton "Don" sneaker in 2009.

After creative differences, Kanye left Nike in 2013, reportedly signing a $10-million-dollar deal to make sneakers with adidas. The move was successful, with Kanye's Yeezy Boost 350 sneakers selling out immediately upon every release and drawing prices as high as $2,000 on the secondary market.

BAPE's duck camo pattern helped make camouflage a hypebeast staple

THE CULTURE Resellers were a major component and sometime-scourge of the hypebeast community. These aggressive capitalists camped out for big sneaker and apparel releases, only to resell rare items online at an inflated price. Resellers reputedly fueled the Nike SB Dunk Low "Pigeon" riot of 2005 as they clamored for shoes that now sell for $6,000 on the secondary market.

HYPEBEASTS

ORIGIN: NEW YORK, 2000s
CERTAIN SNEAKERHEADS ONLY WANT WHAT'S COOL

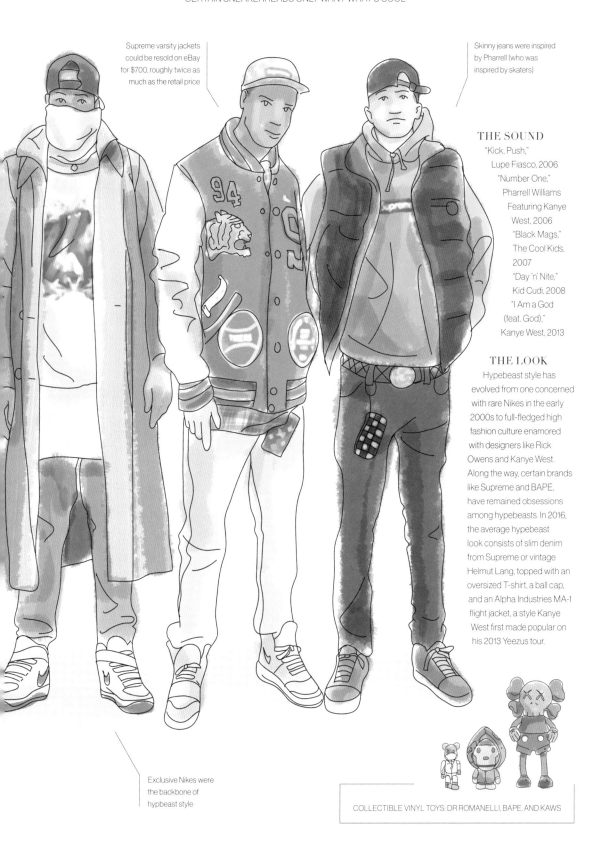

Supreme varsity jackets could be resold on eBay for $700, roughly twice as much as the retail price

Skinny jeans were inspired by Pharrell (who was inspired by skaters)

THE SOUND

"Kick, Push,"
Lupe Fiasco, 2006
"Number One,"
Pharrell Williams
Featuring Kanye
West, 2006
"Black Mags,"
The Cool Kids,
2007
"Day 'n' Nite,"
Kid Cudi, 2008
"I Am a God
(feat. God),"
Kanye West, 2013

THE LOOK

Hypebeast style has evolved from one concerned with rare Nikes in the early 2000s to full-fledged high fashion culture enamored with designers like Rick Owens and Kanye West. Along the way, certain brands like Supreme and BAPE, have remained obsessions among hypebeasts. In 2016, the average hypebeast look consists of slim denim from Supreme or vintage Helmut Lang, topped with an oversized T-shirt, a ball cap, and an Alpha Industries MA-1 flight jacket, a style Kanye West first made popular on his 2013 Yeezus tour.

Exclusive Nikes were the backbone of hypbeast style

COLLECTIBLE VINYL TOYS: DR ROMANELLI, BAPE, AND KAWS

FISCHERSPOONER'S ELECTROCLASH SELECTS

"Space Invaders are Smoking Grass," I-F, 1997

"This Is For You," DJ Hell, 1998

"Come To Me," DMX Krew, 1998

"Emerge," Fischerspooner, 2000

"Euro Trash Girl," Chicks on Speed, 2000

"Frank Sinatra," Miss Kittin & The Hacker, 2000

"Fuck The Pain Away," Peaches, 2000

"Nuisance Lover," Legowelt, 2000

"La Rock 01," Vitalic, 2001

"Vicious Game," David Caretta, 2001

"Extensive Care," Crossover, 2002

"Nite Life," ADULT., 2002

"Father," Anthony Rother, 2004

"Tribulations," LCD Soundsystem, 2005

ELECTROCLASH

Electroclash nods to the analog sounds of post-punk '80s synth pop while adding a modern sensibility

"This Is For You" DJ Hell, 1999

"Miss You," Mirwais, 2000

"Candy Girl," Soviet, 2001

"Hand To Phone," ADULT., 2001

"Playgirl," Ladytron, 2001

"Electrobix," Scissor Sisters, 2002

"Fashionist," Waldorf, 2002

"House of Jealous Lovers," The Rapture, 2002

"Keep It Set (Max Pax Feed It Back Mix)," Sweden, 2002

"Losing My Edge," LCD Soundsystem, 2002

"Keep On Waiting," Hell, 2003

"Ready2Wear (Radio Edit)," Felix Da Housecat, 2005

"Quelle Heure Est-Il (Club Mix)," Tomcraft, 2005

"You Gonna Want Me (Radio Edit)," Tiga, 2005

"Really Rich Italian Satanists (Extended)," Dirty Sanchez, 2006

"Let's Make Love and Listen to Death From Above," CSS, 2006

"Rapture (Original)," My Robot Friend, 2006

"Yr Mangled Heart (Tiga's Congabreak)," Gossip, 2006

"Pogo," Digitalism, 2007

SOUTHERN HIP-HOP

Laid back but still hard, southern hip-hop reflects a strong sense of community and place

"Sippin' On Some Syrup (feat. UGK and Project Pat)," Three 6 Mafia, 2000

"Ms. Jackson," OutKast, 2000

"Awnaw," Nappy Roots, 2001

"Choppin' Blades," UGK, 2001

"Are We Cuttin' (feat. Ms. Jade)," Pastor Troy, 2002

"Get Low," Lil Jon & The East Side Boyz, 2002

"In Da Wind (feat. Cee-Lo & Big Boi)," Trick Daddy, 2002

"What Happened To That Boy (feat. Clipse)," Baby, 2002

"Like A Pimp (feat. Lil Flip)," David Banner, 2003

"Never Scared," Bone Crusher, 2003

"Rubberband Man," T.I., 2003

"Re-Akshon (feat. TI, Bone Crusher & Bun B)," Killer Mike, 2003

"Still Tippin'," Mike Jones, 2004

"Go Crazy," Young Jeezy, 2005

"Hustlin'," Rick Ross, 2005

"Icy (feat. Young Jeezy & Boo)," Gucci Mane, 2005

"Ridin' (feat. Krayzie Bone)," Chamillionaire, 2005

"A Milli," Lil Wayne, 2008

REGGAETON

When dancehall reggae and salsa meet hip-hop, the dance party never stops

"Muévelo," El General, 1991

"Dale Don Dale," Don Omar, 2003

"Gasolina," Daddy Yankee, 2004

"Move Ya Body (feat. Jabba)," Nina Sky, 2004

"Amor Con La Ropa," Speedy, 2005

"Atrévete Te Te," Calle 13, 2005

"Chulin Culin Chunfly (feat. Residente Calle 13)," Voltio, 2005

"Calle," Tito El Bambino, 2006

"Frikitona," Plan B, 2006

"Me Quiere Besar," Alexis y Fido, 2006

"Noche De Entierro (Nuestro Amor)," Luny Tunes & Tainy, 2006

"El Teléfono," Hector Bambino "EL Father", 2007

"Noche de Travesura," Héctor el Father, 2007

"Sexy Movimiento," Wisin & Yandel, 2007

"Baila morena," Héctor y Tito, 2009

"Permítame (feat. Yandel)," Tony Dize, 2009

"Y Así," J. Alvarez, 2009

EMO

Impassioned lyrics meet powerful music for sensitive souls

"How It Feels To Be Something On," Sunny Day
Real Estate, 1998

"Eyesore," New Found Glory, 2000

"Hear You Me," Jimmy Eat World, 2001

"Become What You Hate," Midtown, 2002

"I'd Do Anything," Simple Plan, 2002

"Girl's Not Grey," AFI, 2003

"All That I've Got," The Used, 2004

"Screaming Infidelities," Dashboard Confessional, 2004

"I Write Sins Not Tragedies," Panic! At The Disco, 2005

"Pressure," Paramore, 2005

"Slow Down," The Academy Is..., 2005

"MakeDamnSure," Taking Back Sunday, 2006

"Dead!," My Chemical Romance, 2006

"The Curse Of Curves," Cute Is What We Aim For, 2006

"This Ain't A Scene, It's An Arms Race," Fall Out Boy, 2007

TECKTONIK

Uptempo European electro house that's perfect
for dance battles in the streets or on Youtube

"À Cause des Garçons (TEPR Remix)," Yelle, 2007

"Alive!," Mondotek, 2007

"Bassleader Anthem," Binum, 2007

"Dirty Cash," Antonio & Cristiano, 2007

"Feel the Hard Rock," Hardrox, 2007

"Otherwize Then - Laidback Luke Remix," Steve Angello
& Laidback Luke, 2007

"Punk Shock," Lethal MG, Q-ic, 2007

"Radiator Spring," David Verbek, 2007

"Superbattlerz," Bruno Power, 2007

"Break Down the House," Laidback Luke, 2008

"Come Back," Looney Tunez, 2008

"D Generation," Mondotek, 2008

"No Stress," Laurent Wolf, 2008

"No Sucker," Dim Chris, 2008

"Saturday Night," Michael Feiner ft. Daniel Lindström, 2008

"This is Tecktonik," Marc de Siau, 2008

"What Is Love (Klaas Impact Mix Edit)," - Klaas meets
Haddaway, 2009

GARAGE

Not to be confused with the American proto-punk sound,
this is a faster, leaner, house variant

"Body Groove," Architechs, 2000

"Forgive Me," Lynden David Hall, 2000

"I Don't Smoke," Deekline, 2000

"No Good 4 Me (feat. Megaman, Romeo, and Lisa Maffia),"
Oxide & Neutrino, 2000

"Please Don't Turn Me On," Artful Dodger, 2000

"True VIP!," Youngstar, 2000

"All I Do (feat. Bryan Chambers)," Cleptomaniacs, 2001

"Crazy Love (feat. Elisabeth Troy)," M.J. Cole, 2001

"Do You Really Like It," DJ Pied Piper and the Masters
of Ceremonies, 2001

"Fill Me In," Craig David, 2001

"Little Man," S.I.A., 2001

"21 Seconds," So Solid Crew, 2001

"Gotta Get Thru This," Daniel Bedingfield, 2002

"Blinded By Lights," The Streets, 2004

"JUS 1 KISS," Basement Jaxx, 2005

"Distant Lights," Burial, 2006

"Put You Down," TRG, 2007

"Stop Playing (With My Mind)," Daniel Bovie & Roy Rox, 2008

"Hyph Mngo," Joy Orbison, 2009

Tecktoniks were street dancers who competed against one another in battles set to frenetic techno. The culture arose in 2002 in suburban Paris, where dancers and promoters Cyril Blanc and Alexandre Barouzdin began hosting "Tecktonik Killer" parties at the Metropolis nightclub. These parties took off and tecktonik quickly became synonymous with a certain street dance and fashion style consisting of tight, fluorescent T-shirts and skinny jeans. Though touted as a street culture, Tecktoniks found their true home on YouTube and Dailymotion, video streaming sites where kids found fame uploading their battle videos as they danced to various strains of electro, including dirty, progressive, new beat, and even house. With this digital exposure, Tecktonik culture spread to North Africa and then across Europe, Australia, Japan, and Brazil.

The tecktonik dance, also sometimes simply called "electro dance," was a basic back and forth two-step accentuated with expressive, rave-influenced hand gestures. Glow-sticking, voguing, moonwalking, and smurfing also influenced the dance.

French-German electro artists Mondotek helped expand the popularity of Tecktonik when the video for their 2007 hit "Alive" featured the dance and fashion style.

In 2007, French television channel TF1 became the talent agency for Blanc and Barouzdin and their tecktonik brand, promoting it around the world and helping dancers get booked for photoshoots and commercials.

Unlike many subcultures, the roots of tecktonik were largely white and middle class.

French philosopher Vincent Cespedes criticized tecktonik culture, saying it lacked danger, sexuality, and freedom, and was therefore conformist and hollow.

The tecktonik craze largely died down by the early 2010s, but new videos occasionally still pop up on YouTube.

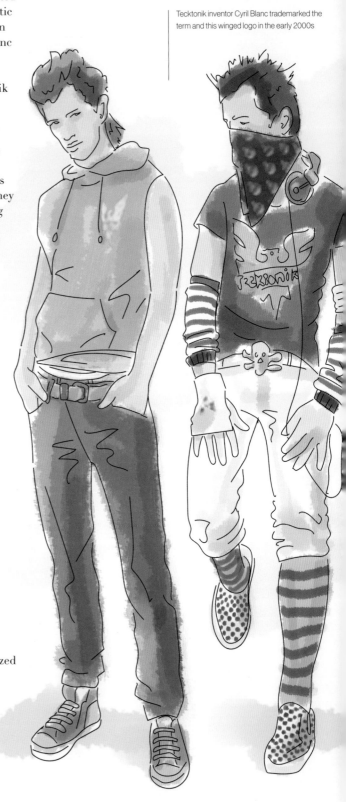

Tecktonik inventor Cyril Blanc trademarked the term and this winged logo in the early 2000s

THE CULTURE Cyril Blanc and Alexandre Barouzdin actually trademarked "Tecktonik," "TCK," and "Tecktonik Killer club nights," and produced a line of clothes, energy drinks, jewelry, and even a Sony Ericsson mobile handset in the mid-2000s. To this day, any nightclub using those names is legally obligated to pay them royalties or obtain their permission first.

TECKTONIK

ORIGIN: PARIS, 2000s
FRENCH STREET DANCERS GET TECK

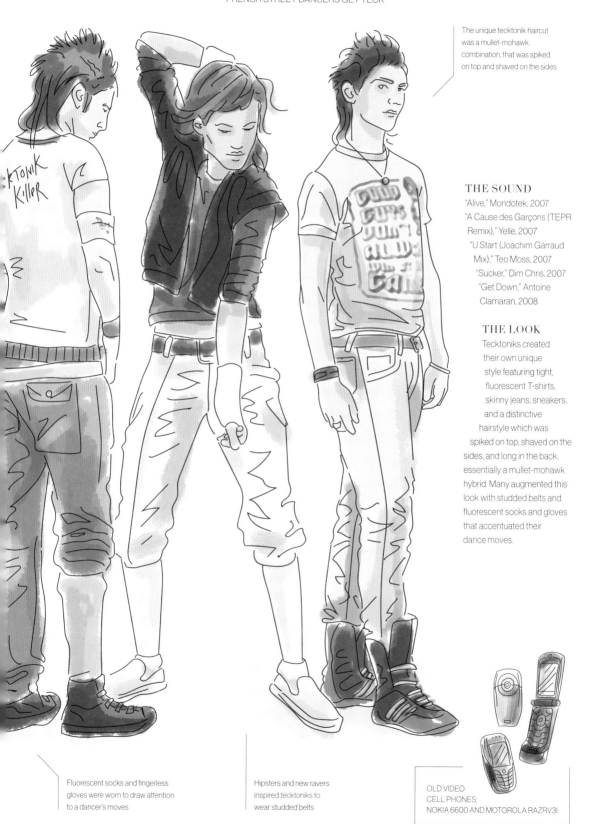

The unique tecktonik haircut was a mullet-mohawk combination, that was spiked on top and shaved on the sides

THE SOUND

"Alive," Mondotek, 2007
"A Cause des Garçons (TEPR Remix)," Yelle, 2007
"U Start (Joachim Garraud Mix)," Teo Moss, 2007
"Sucker," Dim Chris, 2007
"Get Down," Antoine Clamaran, 2008

THE LOOK

Tecktoniks created their own unique style featuring tight, fluorescent T-shirts, skinny jeans, sneakers, and a distinctive hairstyle which was spiked on top, shaved on the sides, and long in the back, essentially a mullet-mohawk hybrid. Many augmented this look with studded belts and fluorescent socks and gloves that accentuated their dance moves.

Fluorescent socks and fingerless gloves were worn to draw attention to a dancer's moves

Hipsters and new ravers inspired tecktoniks to wear studded belts

OLD VIDEO CELL PHONES: NOKIA 6600 AND MOTOROLA RAZRV3I

New Rave arose in England in 2006 on the popularity of bands like Klaxons, who mixed pop with indie rock, electro, and house music. Though bands like Datarock emerged alongside Klaxons with a similar electro-pop sound and hordes of kids paraded around London in fluorescent clothes, New Rave seems to have been as much a media creation as a true subculture. Just as the indie rock scene of Arctic Monkeys and Libertines was dying out, *NME* coined the term New Rave in 2006, right before it launched a "New Rave" tour featuring Klaxons, CSS, and The Sunshine Underground. In 2008, *NME* changed course, officially declaring New Rave dead.

There's still some debate about whether or not New Rave was even big enough to qualify as a style of music or youth movement, with Klaxons, the genre's most famous export and supposed progenitors, claiming it was "a joke that got out of hand."

But real or not, that didn't stop fluorescent-dipped kids from flocking to London clubs like Byte Slasher for a brief time between 2006 and 2008 to take MDMA and dance while waving glow-sticks around.

Even if it was an ill-defined, short-lived music genre, New Rave did launch a distinctly bright fashion style, inspiring artists like MIA and brands like Cassette Playa to wear or produce ultra-bright, graphic T-shirts, trousers, and leggings.

Although New Rave was supposedly dead by 2008, it definitely did presage the comeback of ecstasy as a club drug in the UK and United States, not to mention the EDM revolution and its attendant large outdoor dance festivals like Electric Daisy Carnival, which are perhaps the genre's most lasting legacies.

Fanny packs were a popular accessory among New Ravers

New Rave birthed streetwear brands like Cassette Playa from Paris

THE CULTURE Though it got its name from the original rave culture of the '90s, New Rave style, and even its pop and indie-influenced music, had much more in common with the 2000s hipster style that could be seen at New York City parties like Misshapes.

ORIGIN: LONDON, 2000s
BRIGHT SONGS AND BRIGHTER CLOTHES HERALD A BRIEF RAVE REVIVAL

Skinny jeans were worn as an offshoot of hipster style

THE SOUND

"Computer Camp Love,"
Datarock, 2005
"Gravity's Rainbow,"
Klaxons, 2006
"Umbilical Noose,"
Dandi Wind, 2006
"OK," Shitdisco, 2007
"It's a Rave Dave,"
Trash Fashion, 2007

THE LOOK

New Rave style for both genders was something like hipsters on acid, as adherents wore bright graphic T-shirts, trousers, and other streetwear from brands like Cassette Playa and shops like Colette in Paris. They'd often complement these basic elements with oversized, lensless glasses with fluorescent frames, as well as fitted and snap-back ball caps. Repetitive, allover prints were also popular on New Rave garments of all types.

Dyed hair became popular again during this time, a trend that would later influence seapunk

FLUORESCENT
SHUTTER SHADES AND LENSLESS WAYFARERS

By the late 2000s, Fruity Loops and other sophisticated, inexpensive desktop music programs allowed a whole new generation of teenagers to produce hip-hop right in their bedrooms. A South Central LA dance step and musical style called jerkin' emerged from this bedroom producer revolution, changing the way hip-hop artists dressed for years to follow.

It's difficult to pinpoint the first jerkin' song, but "You're a Jerk" by the New Boyz was the first of its genre to gain widespread airplay—originally in Southern California, and later across the country.

"The Reject" is jerkin's signature move, consisting of a one-two backward hop step that a *New York Times* writer compared to "the Running Man" done "in reverse." Other jerk moves include "the dip," in which a dancer squats down on their ankles before popping up to kick out one or both feet forward, and "the pin drop," where one foot is placed behind the other knee and the dancer drops to the ground only to hop up in a spin.

Jerk dancers may have created a new dance craze, but their greatest contribution to hip-hop culture was sartorial. These South Central teenagers changed hip-hop fashion forever by being among the first from that culture to adopt the skinny jeans and fitted tops popular with skaters at the time. They also helped popularize bright fluorescent colors, and brought skate shoes like Vans and Supras into the hip-hop fashion canon.

Jerkin' wasn't only a young man's game, as Pink Dollaz, a female jerk group from LA, proved with their catchy, obscene songs like "I'm Tasty."

By 2010, jerk music began to mutate—either adopting other dance forms like the Dougie from Dallas, Texas, or spawning its own variants like the Cat Daddy, which originated in Los Angeles.

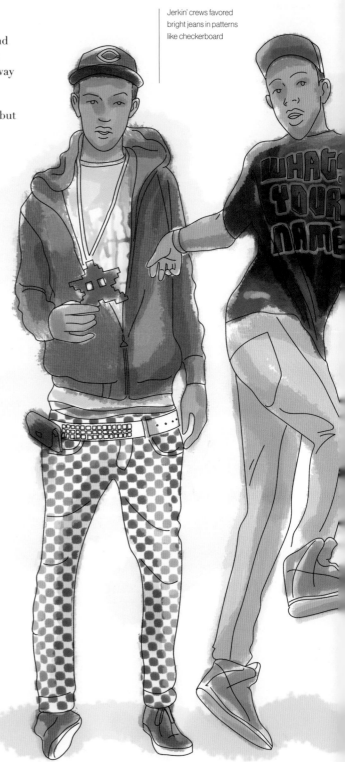

Jerkin' crews favored bright jeans in patterns like checkerboard

THE CULTURE Despite its fun, dance-oriented message, Jerkin' was not immune to the ills of South Central LA, a point proven when Cali Swag District member M-Bone died in a drive-by shooting at the age of twenty-two in 2011.

JERK DANCERS

ORIGIN: LOS ANGELES, 2000s
SOUTH CENTRAL TEENS INVENT A DANCE WITH LASTING STYLE IMPLICATIONS

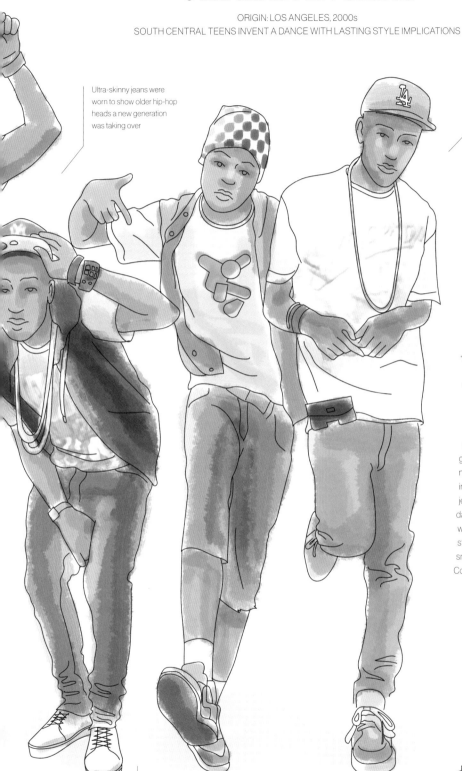

Ultra-skinny jeans were worn to show older hip-hop heads a new generation was taking over

Snapback caps were the key headwear for this scene

THE SOUND

"You're a Jerk,"
New Boyz, 2009
"Teach Me How to Jerk,"
Audio Push, 2009
"I'm Tasty,"
Pink Dollaz, 2009
"Teach Me How to Dougie,"
Cali Swag District, 2010
"Cat Daddy," The Rej3ctz, 2011

THE LOOK

Jerk dancers created a revolutionary look for hip-hop artists, eschewing the baggy denim worn by the past generation and embracing bright, neon colors and a slim, skate-inspired silhouette of skinny jeans and fitted T-shirts. Jerk dancers often paired these items with snap-back caps, Wayfarer-style sunglasses, and high-top sneakers from Supra, Converse, Nike, or Vans.

The Pack's 2006 song "Vans" introduced California hip-hop heads to the popular skate shoe

JERKIN' CREWS LIKE ACTION FIGURE$ AND THE RANGER$ USED DOLLAR SIGNS IN THEIR NAMES

The young teenagers who ride ponies through Dublin's grim suburban housing estates are mostly the children of Irish Traveller families who have been resettled by the government. Despite controversy and sporadic attempts to remove horses from owners, these young people have kept as many as three thousand of these small horses in the tiny courtyards and paddocks of their public housing estates since the 1970s. Irish Travellers still gather monthly in the center of the city at Smithfield Market to show off and sell horses.

The Dublin pony kids ride bareback, using just a bit and bridle to control their horses.

Horses are a source of wealth and status for Irish Travellers, even in settled communities, which explains the persistence of pony culture even in the unlikely confines of the suburban Dublin housing estates.

Settled Irish Traveller communities still face discrimination, and the violent housing estates where they live are riddled with heroin and bereft of educational or employment opportunities. Despite criticisms, owning, caring for, and riding ponies is a source of self-esteem and positivity for kids in rough circumstances.

Despite positive aspects, there is some crossover between pony culture and petty crime and street gangs.

Irish pony kids dress like other low-income youth on housing estates in Ireland and Great Britain, favoring short buzzed hair and adidas or Nike track suits with trainers or running shoes.

Despite laws requiring that ponies be microchipped, the pony culture of Dublin persists to this day.

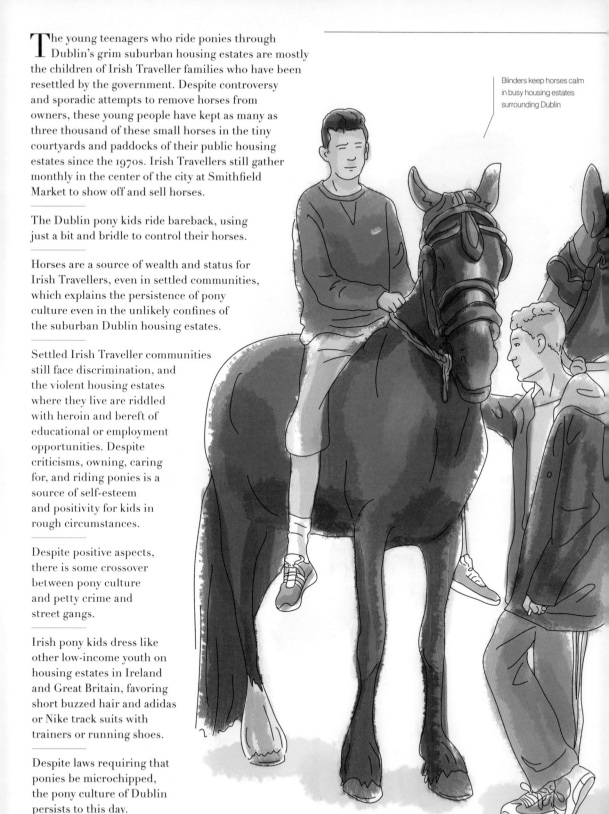

Blinders keep horses calm in busy housing estates surrounding Dublin

THE CULTURE Some housing estates like Ballyfermot and Ballymun actually have large, well-maintained community stables for ponies, and most of the horses are well cared for. Irish Travellers are also respected as some of the best horse breeders in Ireland.

PONY KIDS

ORIGIN: DUBLIN, 2000s
GYPSY TEENS RIDE FREE PONIES IN SUBURBAN IRISH GHETTOS

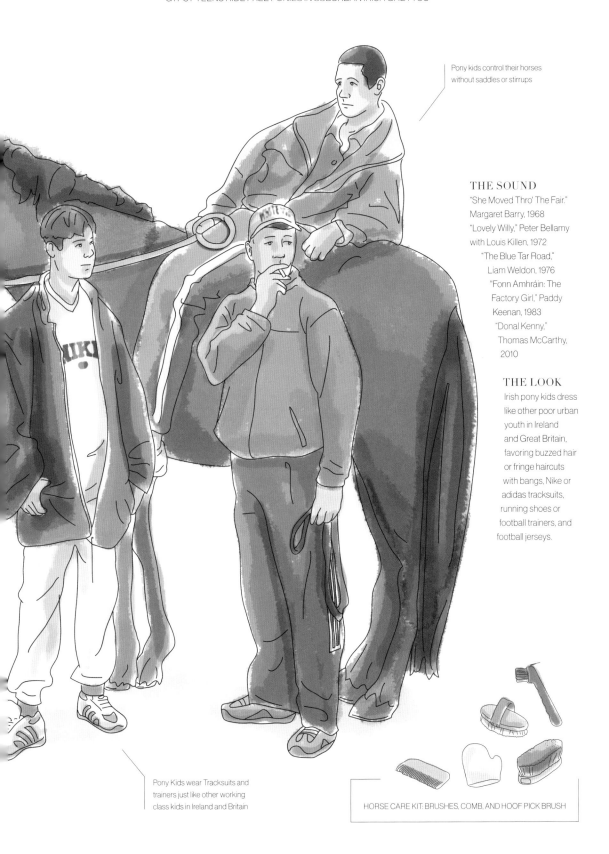

Pony kids control their horses
without saddles or stirrups

THE SOUND

"She Moved Thro' The Fair."
Margaret Barry, 1968
"Lovely Willy," Peter Bellamy
with Louis Killen, 1972
"The Blue Tar Road,"
Liam Weldon, 1976
"Fonn Amhráin: The
Factory Girl," Paddy
Keenan, 1983
"Donal Kenny,"
Thomas McCarthy,
2010

THE LOOK

Irish pony kids dress
like other poor urban
youth in Ireland
and Great Britain,
favoring buzzed hair
or fringe haircuts
with bangs, Nike or
adidas tracksuits,
running shoes or
football trainers, and
football jerseys.

Pony Kids wear Tracksuits and
trainers just like other working
class kids in Ireland and Britain

HORSE CARE KIT: BRUSHES, COMB, AND HOOF PICK BRUSH

Around 2008, an unexpected hipster offshoot blossomed. Wearing big, bushy beards, plaid flannel shirts, American-made selvedge denim, and bearing a jar of artisanal pickles, it was the urban woodsman. Much was made of why this tough-looking, workwear-obsessed new subculture arose in Brooklyn, home to zero woods and plenty of skinny, record-collecting hipsters, but the answer was in the question. In a world where most men were disconnected from manual labor or craftsmanship of any sort, and at a time when many had been disconnected from employment by a worldwide banking crisis, the appeal of dressing like their rough-hewn forefathers was a way to reclaim their masculinity and a sense of all-American authenticity.

Along these lines, the urban woodsman resurrected interest in well-made heritage brands like Filson, Woolrich, and L.L. Bean. More formal urban woodsman finished their looks off with tweed jackets, chambray shirts, and skinny ties.

The urban woodsman also kicked off a craze for organic, farm-to-table food and artisanal hobbies like woodworking. Even though some people found urban woodsmen inauthentic, they jumped at the chance to pay big money for better food and goods, sparking a resurgence in locally-grown produce and handmade goods that continues to this day.

At the same time, the urban woodsman helped popularize the maudlin sounds of Americana-influenced indie rock, like Iron and Wine.

By 2014, the media and hoi polloi finally caught up with the urban woodsman, trying to rebrand him as a "lumbersexual." However, by then, the original urban woodsmen had foregone the trend for sportier fare like athleisure—despite, or perhaps because of, the fact that a study found a full sixty-seven percent of men in New York City were by then growing beards.

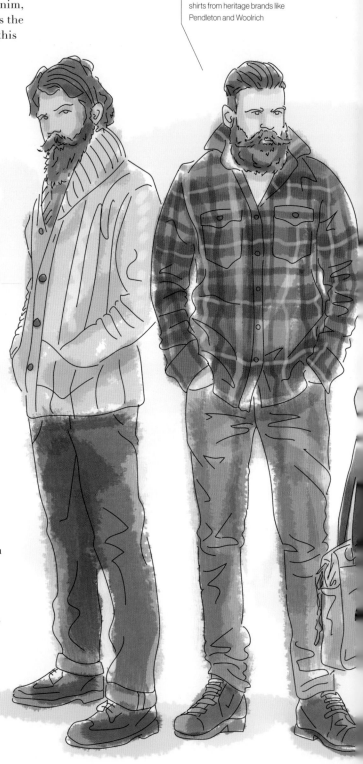

Urban woodsman favored flannel shirts from heritage brands like Pendleton and Woolrich

Waxed Filson bags looked good and were nearly indestructible

THE CULTURE The proper urban woodsmen lived a fully curated life, insisting that everything from their beer to their food, toothpaste, and sheets be made locally and organically. Though pedantic, this predilection spread across the country, influencing restaurants and grocery stores to stock local, organic goods with a well-established provenance, a phenomenon that was probably good for the quality of food and health of the country as a whole.

ORIGIN: BROOKLYN, 2000s
ANACHRONISTIC HIPSTERS YEARN FOR A SIMPLER, HAIRIER TIME

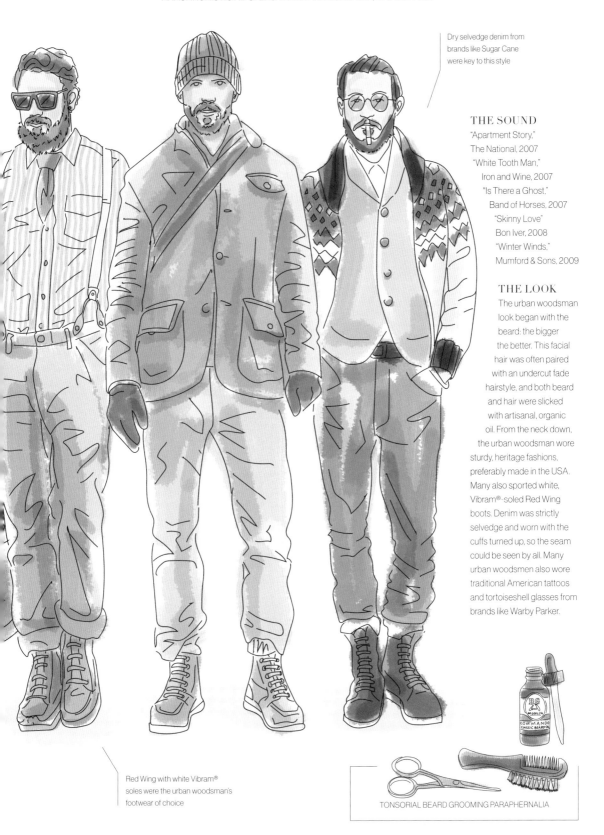

Dry selvedge denim from brands like Sugar Cane were key to this style

THE SOUND

"Apartment Story,"
The National, 2007
"White Tooth Man,"
Iron and Wine, 2007
"Is There a Ghost,"
Band of Horses, 2007
"Skinny Love"
Bon Iver, 2008
"Winter Winds,"
Mumford & Sons, 2009

THE LOOK

The urban woodsman look began with the beard: the bigger the better. This facial hair was often paired with an undercut fade hairstyle, and both beard and hair were slicked with artisanal, organic oil. From the neck down, the urban woodsman wore sturdy, heritage fashions, preferably made in the USA. Many also sported white, Vibram®-soled Red Wing boots. Denim was strictly selvedge and worn with the cuffs turned up, so the seam could be seen by all. Many urban woodsmen also wore traditional American tattoos and tortoiseshell glasses from brands like Warby Parker.

Red Wing with white Vibram® soles were the urban woodsman's footwear of choice

TONSORIAL BEARD GROOMING PARAPHERNALIA

Scraper bikes are bright, custom-made vehicles constructed by kids in Oakland. These rolling pieces of folk art are festooned with colored tape and bright foil salvaged from candy wrappers, each a testament to the ingenuity and creativity of kids from the poorest neighborhoods in one of America's more violent cities. Oakland's bright, custom scraper cars—so named because their huge rims are so big they scrape the wheel wells—inspired the bike culture, which also overlaps with the city's hyphy hip-hop scene.

Scraper bikes have been popular in Oakland for years, but the advent of YouTube in the mid-2000s allowed scene kids to show their bikes off online, particularly in music videos like the Trunk Boiz local 2007 banger "Scraper Bike," which helped take the scene worldwide.

Scrapper bikers don't necessarily dress much differently than other hip-hop fans in Oakland, wearing slim jeans, baggy hoodies, and sneakers like Air Jordans and Vans.

Scrapper bikes can be made from almost any secondhand bike, including BMX frames, road bikes, or beach cruisers. Decorated spokes and rims are the most distinctive characteristic of the bikes, which kids adorn with colorful tape, foil, and cardboard, often matching these elements to the bikes' paint job.

Many scraper bikers view their hobby as something positive that keeps them away from the drug dealing and gang violence prevalent in so many Oakland neighborhoods. To support the scene, Oakland residents like Reginald "Chef Boy RB" Burnette have founded community groups like the Original Scraper Bike Team to support the subculture and help kids keep their lives positive under tough circumstances.

Scraper bikes have spread worldwide thanks to the Internet and scraper scenes now exist in Japan, Jamaica, and Australia.

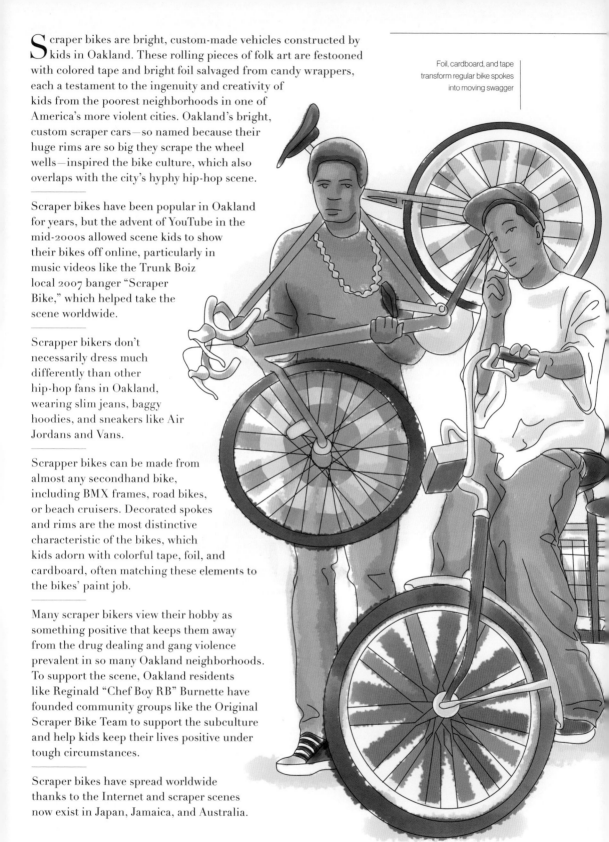

Foil, cardboard, and tape transform regular bike spokes into moving swagger

THE CULTURE Some scraper fans build three-wheeled tricycles so they can hop off and "ghost ride" their bikes, just as E-40 urged scraper car drivers to do on his 2006 hit "Tell Me When To Go," which first immortalized the trend of getting out of one's moving car to dance around it as it keeps rolling.

SCRAPER BIKERS

ORIGIN: OAKLAND, 2000s

KIDDIE CUSTOMIZERS MAKE COOL BIKES INSPIRED BY OAKLAND'S CAR CULTURE

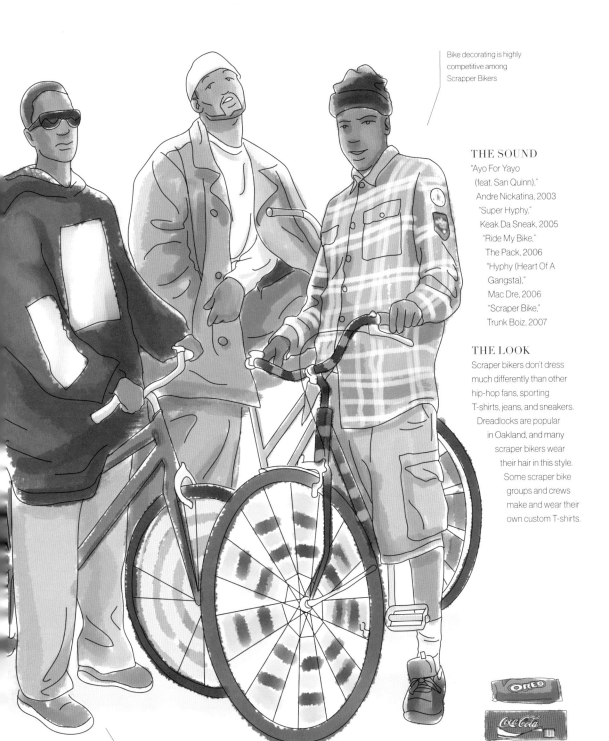

Bike decorating is highly competitive among Scrapper Bikers

THE SOUND

"Ayo For Yayo (feat. San Quinn)," Andre Nickatina, 2003
"Super Hyphy," Keak Da Sneak, 2005
"Ride My Bike," The Pack, 2006
"Hyphy (Heart Of A Gangsta)," Mac Dre, 2006
"Scraper Bike," Trunk Boiz, 2007

THE LOOK

Scraper bikers don't dress much differently than other hip-hop fans, sporting T-shirts, jeans, and sneakers. Dreadlocks are popular in Oakland, and many scraper bikers wear their hair in this style. Some scraper bike groups and crews make and wear their own custom T-shirts.

The unique Bay Area hip-hop scene was one of the first to adopt Vans in the mid-2000s

BIKE DECORATING SUPPLIES

INDIE REVIVAL

*Updating the '80s college rock and '90s DIY scenes
for the Internet generation*

"Agenda Suicide," The Faint, 2001
"Caring Is Creepy," The Shins, 2001
"Hotel Yorba," The White Stripes, 2001
"Love Burns," Black Rebel Motorcycle Club, 2001
"Time for Heroes," The Libertines, 2002
"Maps," Yeah Yeah Yeahs, 2003
"Reptilia," The Strokes, 2003
"Act Nice and Gentle," The Black Keys, 2004
"C'mere," Interpol, 2004
"Neighborhood #1 (Power Out)," Arcade Fire, 2004
"So Says I," The Shins, 2004
"Helicopter," Bloc Party, 2005
"Do You Want To," Franz Ferdinand, 2005
"Consolation Prizes," Phoenix, 2006
"Munich," Editors, 2006
"On a Neck, On a Spit," Grizzly Bear, 2006
"Fake Empire," The National, 2007

INDIE-FOLK

*Folkies add indie rock to confessional lyrics to create
music for the artisanal lifestyle set*

"The Way," Bonnie Prince Billy, 2003
"Homesick," Kings of Convenience, 2004
"Casimir Pulaski Day," Sufjan Stevens, 2005
"Cripple Crow," Devendra Banhart, 2005
"Sovay," Andrew Bird, 2005
"Flume," Bon Iver, 2008
"All I Ever Wanted," Meg Baird, 2007
"Boy With a Coin," Iron & Wine, 2007
"Hands," Tunng, 2007
"Low Bay of Sky," Richard Youngs, 2007
"Seeds of Night," Cave Singers, 2007

"Teardrop," José González, 2007
"Lucky Man," Sun Kil Moon, 2008
"Mykonos," Fleet Foxes, 2008
"To Ohio," The Low Anthem, 2009
"Ghosts," Laura Marling, 2009

INDIE-POP

*Twenty-first century pop rock combines
indie, electro, and psychedelia*

"Pick Up the Phone," The Notwist, 2001
"Heartbeats," The Knife, 2003
"Hendrix With KO," Caribou, 2003
"Run Into Flowers," M83, 2003
"Such Great Heights," The Postal Service, 2003
"Don't Stop," Brazilian Girls, 2004
"Over and Over," Hot Chip, 2006
"Wildcat," Ratatat, 2006
"Hold On," Holy Ghost!, 2007
"Time To Pretend," MGMT, 2007
"You Don't Know Her Name," Maps, 2007
"Young Folks," Peter Bjorn And John, 2007
"Lights & Music," Cut Copy, 2008
"Little Bit Of Feel Good," Jamie Lidell, 2008
"Radio Ladio," Metronomy, 2008
"Wait for the Summer," Yeasayer, 2008
"Walkin on a Dream," Empire of the Sun, 2008
"Crystalized," The XX, 2009
"Life Magazine," Cold Cave, 2009

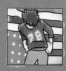

AMERICANA

*What it sounds like when hipsters yearn for a simpler,
more authentic time*

"Answering Bell," Ryan Adams, 2001
"Smoothie Song," Nickel Creek, 2002

"Winner's Casino," Richmond Fontaine, 2002

"Look At Miss Ohio," Gillian Welch, 2003

"Mahgeetah," My Morning Jacket, 2003

"Goddamn Lonely Love," Drive-By Truckers, 2004

"Where There's A Road," Robbie Fulks, 2005

"That Teenage Feeling," Neko Case, 2006

"Cocaine Habit," Old Crow Medicine Show, 2006

"Hank Williams' Ghost," Darrell Scott, 2006

"Our Swords," Band of Horses, 2006

"Beachcomber Blues," Dolorean, 2007

"Brand New Kind of Actress," Jason Isbell, 2007

"By Your Side," Blue Mountain, 2008

"Fortune Teller," Alison Krauss and Robert Plant, 2008

"Space Forklift," Kurt Vile, 2008

"Whatever It Is," Zac Brown Band, 2008

"Laundry Room," The Avett Brothers, 2009

"The Long Way," The Bottle Rockets, 2009

"The Range War," Patterson Hood, 2009

GRIME

This uniquely British form of hip-hop mixes plainspoken tales drawn from everyday urban life with electronic beats from the club

"Creeper," Danny Weed, 2002

"Has It Come to This," The Streets, 2002

"Stop Dat," Dizzee Rascal, 2003

"Cha," Plasticman, 2004

"Destruction VIP (feat. Wiley, Double E, Kano, Durrty Goodz)," Jammer, 2005

"Typical Me," Kano, 2005

"Rhythm 'N' Gash," Rebound X, 2006

"Celebrate That," Roll Deep, 2007

"Follow," Tichy Stryder, 2007

"Grime Kid," Wiley, 2008

"Afar (feat DeNiro, Tinie Tempah)," G FrSH, 2009

"Goin' In," Boy Better Know, 2009

"Next Hype," Tempa T, 2009

"Oh My Gosh," Skepta, 2009

"Pulse X," Musical Mobb, 2009

"When I'm 'Ere," Roll Deep, 2009

"She Said," Plan B, 2010

NEW RAVE

Just like in the Second Summer of Love, when the indie kids discover dance beats, it's time to let the colors explode.

"Easy Love," MSTRKRFT, 2006

"Gravity's Rainbow," Klaxons, 2006

"I Ain't Losing Any Sleep," The Sunshine Underground, 2006

"It's A Rave Dave," Trash Fashion, 2006

"Let's Make Love and Listen to Death From Above," CSS, 2006

"Pop The Clock," Uffie, 2006

"Prick Tease," Neon Plastix, 2006

"The Bomb," New Young Pony Club, 2006

"What's Your Damage? (Digitalism Remix)," Test Icicles, 2006

"Hustler," Simian Mobile Disco, 2007

"I Used to Dance With My Daddy," Datarock, 2007

"Pogo," Digitalism, 2007

"Crank It Up," Hadouken!, 2008

"We Are Rockers," Does It Offend You, Yeah?, 2008

"True No. 9," Golden Silvers, 2009

ELECTRO-POP (SYNTHPOP REVIVAL)

Indie kids love to dance just as much as the club kids do

"Chewing Gum," Annie, 2004

"Like A Child," Junior Boys, 2006

"D.A.N.C.E.," Justice, 2007

"Quicksand," La Roux, 2008

"Vanished," Crystal Castles, 2008

"Deadbeat Summer," Neon Indian, 2009

"I'll Get You," Classixx, 2009

"Left Alone at Night," Toro Y Moi, 2009

"Mouthful of Diamonds," Phantogram, 2009

"Dancing on My Own," Robyn, 2010

"Real Life," Tanlines, 2010

"F.T.F.," TRUST, 2011

"Fineshrine," Purity Ring, 2012

Long before punk rock even had a name, African Americans, Afro-Caribbeans, and Afro-Anglos were making loud, fast, political rock music. Jimi Hendrix's guitar attack hinted at punk, and the band Death from Detroit is now recognized as one of the finest proto-punk bands ever. Don Letts, the English son of Jamaican immigrants, and half-Somali Brit Poly Styrene were both integral members of London's punk scene, while the all–African American Bad Brains brought jazz chops and Afrocentrism to center of the hardcore scene. Still, many black punk fans felt alienated from both the African diaspora and the punk scene. One pioneering filmmaker changed that.

Chuck Berry, the godfather of rock and roll guitar, was likewise the godfather of punk guitar. Steve Jones of the Sex Pistols acknowledged copying his style. Berry himself once reviewed punk records for '80s zine *Jet Lag*, confirming that Jones's guitar on "God Save the Queen" was "like mine."

This chain of influence proved important. Pioneering Rastafarian Afropunks Bad Brains admitted that the Sex Pistols had initially influenced them and they named themselves after a Ramones song.

Bands like Fishbone and Body Count continued the tradition of black punk rock through the '80s and '90s, but still many would-be Afropunks felt left out.

Enter filmmaker and concert promoter James Spooner, who released his documentary film *Afro-Punk* to great acclaim in 2003. Spooner's film gave a name and voice to the thousands of black punks worldwide, codifying the Afropunk experience and helping legitimize it as a subculture. Following his film, the message board on Spooner's website attracted a community of black punk fans. Sensing an opportunity, Spooner and then-partner Matthew Morgan decided to create the Afropunk Festival a free, multi-genre concert in 2005, which still exists today.

Even steampunk-influenced goggles found a home among eclectic Afropunks

Afrocentric items like dashikis were popular for the first time since the late '60s

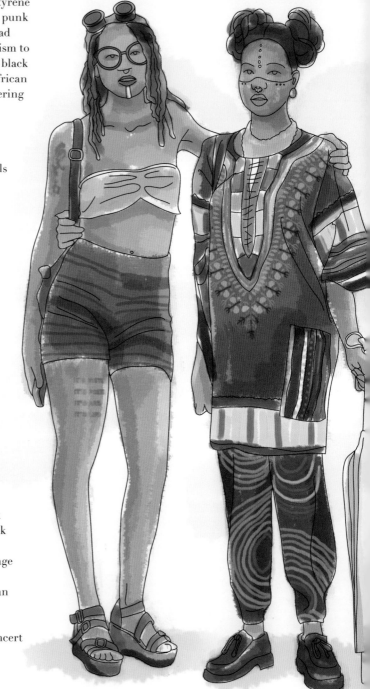

THE CULTURE In addition to punk rock, skateboarding has massively influenced the Afropunk scene. Many Afropunks skateboard for transportation, fun, or both.

AFROPUNK

ORIGIN: NEW YORK, 2000s
AFRICAN AMERICAN YOUTH EMBRACE PUNK ROCK AND ALTERNATIVE LIFESTYLES

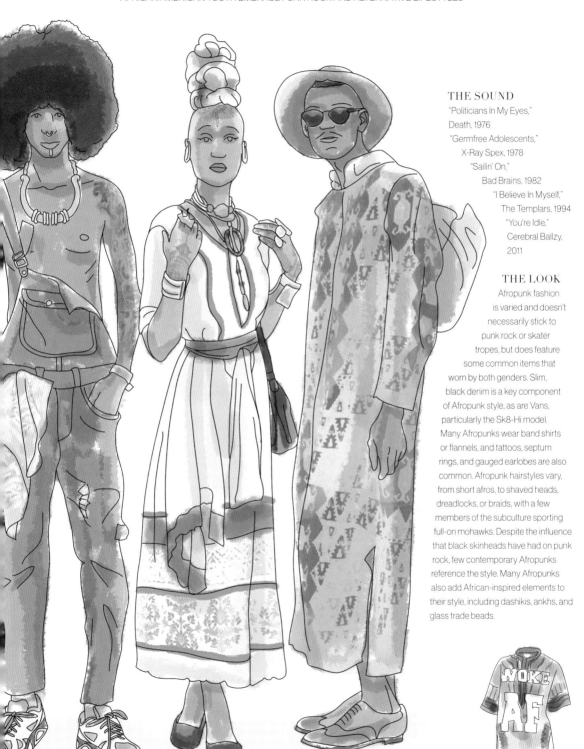

THE SOUND

"Politicians In My Eyes,"
Death, 1976
"Germfree Adolescents,"
X-Ray Spex, 1978
"Sailin' On,"
Bad Brains, 1982
"I Believe In Myself,"
The Templars, 1994
"You're Idle,"
Cerebral Ballzy,
2011

THE LOOK

Afropunk fashion
is varied and doesn't
necessarily stick to
punk rock or skater
tropes, but does feature
some common items that
worn by both genders. Slim,
black denim is a key component
of Afropunk style, as are Vans,
particularly the Sk8-Hi model.
Many Afropunks wear band shirts
or flannels, and tattoos, septum
rings, and gauged earlobes are also
common. Afropunk hairstyles vary,
from short afros, to shaved heads,
dreadlocks, or braids, with a few
members of the subculture sporting
full-on mohawks. Despite the influence
that black skinheads have had on punk
rock, few contemporary Afropunks
reference the style. Many Afropunks
also add African-inspired elements to
their style, including dashikis, ankhs, and
glass trade beads.

Half-unbuttoned
overalls were a nod to
early '90s hip-hop

Henna tattoos and other
accessories were borrowed
from cultures around the globe

A POLITICAL DASHIKI
FOR THE TWENTY-FIRST CENTURY

In the mid-2000s a unique cycling culture made its way from the Caribbean islands of Trinidad and Guyana to the streets of Queens, where young immigrants began building custom bicycles bearing huge speakers. These sound system bikers largely came from the populations of South Asian descent on the islands. They spent their time riding through Queens blasting soca, reggae, hip-hop, and chutney, and tinkering with their bikes, always hungry to add more speakers, more bass, and more power to their mobile sound systems.

These sound system bikers built truly unique machines, sometimes pedaling around massive, homemade PA systems that blast out tunes at 5,000 to 6,0000 watts each.

Per participants, the sound system bike scene started in Trinidad, where it was much more popular.

Though not sartorially distinctive, sound system bikers dressed similarly to other teenagers in New York City during the mid-2000s. Most wore puffer jackets, hoodies, baggy jeans, basketball sneakers, or Timberland boots.

One crew of sound system bikers called itself Legal Intentionz and made a business of installing car stereos and building sound systems and bikes for other people.

Chutney, one genre of music that was popular with the sound system bikers, is a mix of Indian Bhojpuri music, Caribbean rhythms, and singing styles from Trinidad, Guyana, and Jamaica.

Some sound system bikes carried gear worth as much as $8,000.

The bass subwoofers on some sound system bikes were reportedly so powerful that they could be heard simultaneously in two hundred separate houses in densely-packed Queens. Despite this sonic onslaught, sound system bikers seem to have avoided overt harassment from New York city cops.

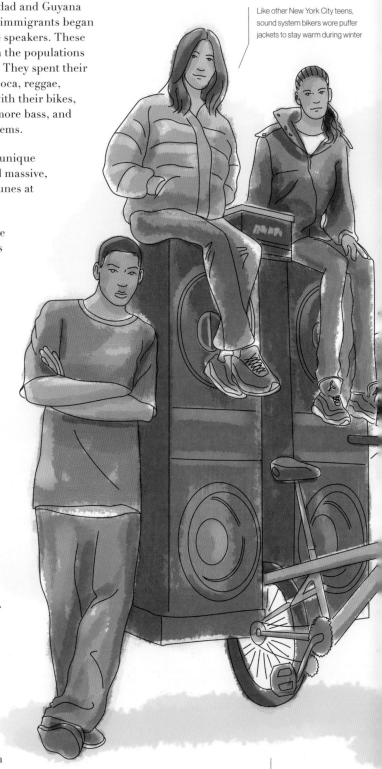

Like other New York City teens, sound system bikers wore puffer jackets to stay warm during winter

Even humble BMX bikes were redesigned to carry massive sound systems

THE CULTURE Most sound system bikers were between the ages of sixteen and nineteen. In addition to the Legal Intentionz crew, other stereo bike groups gave themselves names like Future Shock.

SOUND SYSTEM BIKERS

ORIGIN: QUEENS, NY 2000s
INDO-GUYANESE TEENS ROLL DEEP AND LOUD ON BIKES OF THEIR OWN DESIGNS

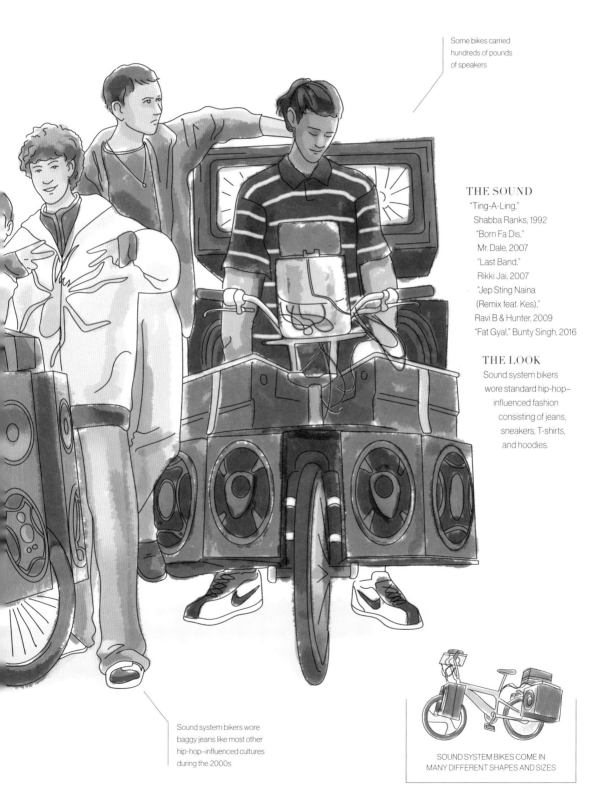

Some bikes carried hundreds of pounds of speakers

THE SOUND

"Ting-A-Ling,"
Shabba Ranks, 1992
"Born Fa Dis,"
Mr. Dale, 2007
"Last Band,"
Rikki Jai, 2007
"Jep Sting Naina
(Remix feat. Kes),"
Ravi B & Hunter, 2009
"Fat Gyal," Bunty Singh, 2016

THE LOOK

Sound system bikers
wore standard hip-hop–
influenced fashion
consisting of jeans,
sneakers, T-shirts,
and hoodies.

Sound system bikers wore
baggy jeans like most other
hip-hop–influenced cultures
during the 2000s

SOUND SYSTEM BIKES COME IN
MANY DIFFERENT SHAPES AND SIZES

Skateboarding is destructive. It destroys property, boards, and bodies. It also periodically destroys itself, erasing the styles and tricks of previous generations, replacing them with something new. At the turn of the millennium, while the skateboarding industry was riding high on X Games attention, video game profits, and the sale of puffy shoes, a new group of skaters came to the fore, establishing tight pants and punk rock as skateboarding's go-to style. They were followed by another generation who took that style and expanded it, adding a combination of artistic flare and dad-core blandness to the mix, ultimately influencing everyone from the kid learning kickflips at the local park to high-fashion institutions like *Vogue*.

In 1999, Tony Hawk and his Birdhouse Skateboards were feasting on video game money and acclaim acquired after he did the first ever 900 live on ESPN. But one of Hawk's best young riders, Andrew Reynolds, didn't feel that this squeaky clean image fit him and his friends. So he put out his own video, *Baker Bootleg*, which introduced the world to his wild hesher crew, the Piss Drunx, and their taste for tight jeans, leather jackets, and big handrails, eventually turning the project into one of the most successful skateboard companies of all time.

But, by the 2010s, skaters were again looking for something new. They found it when a crew of young, ambitious skaters from LA company Fucking Awesome hooked up with New York City skate shop Supreme to film *Cherry*, a video that changed skateboarding and fashion upon its release in 2014. Suddenly, pants went from tight to wide and cropped. Tucked-in T-shirts became cool and everyone from Kylie Jenner to Justin Bieber were wearing *Thrasher* hoodies and dad caps, marking skateboarding's period of greatest influence on high fashion and pop culture.

Hesh skaters brought back tight jeans and leather jackets after getting into Sid Vicious and The Sex Pistols

THE CULTURE The Piss Drunx crew who started the trend for tight jeans and rocker gear in skateboarding made their names and early careers on drug- and alcohol-fueled antics. Now, as they approach middle age, former Piss Drunx like Andrew Reynolds, Jim Greco, Andrew Ellington, and Ali Boulala are all now proudly sober.

ORIGIN: CALIFORNIA AND NEW YORK, 2000s AND 2010s
TIGHT PANTS, BIG STUNTS

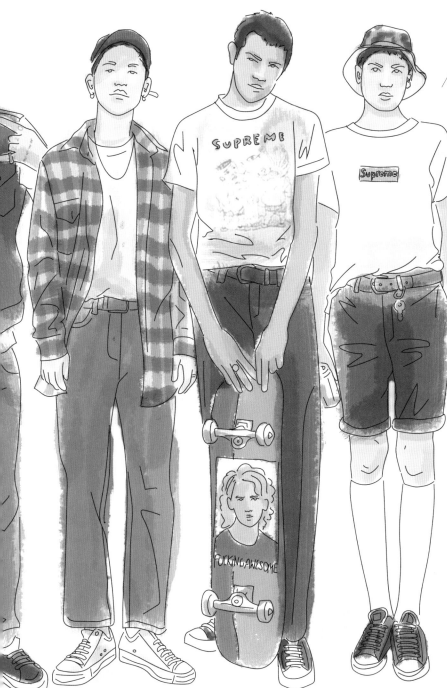

New York skate shop
Supreme helped change
skate style with the 2014
video *Cherry*

THE SOUND

"Beat on the Brat,"
The Ramones, 1976
"Chinese Rocks,"
The Heartbreakers, 1977
"Reckless Life,"
Hollywood Rose, 1984
"Never Tear Us Apart,"
INXS, 1987
"Stop," Jane's Addiction,
1990

THE LOOK

The hesh skaters of
Baker Bootleg favored
a punk rock look of tight
black jeans and black
leather jackets, offset with
extravagant accessories
like headscarves and wide-
brimmed shepherd hats.
During this time, skate shoes
went from puffy to minimal as
classic canvas Vans exploded
in popularity. In 2014, young
skaters changed things up,
making cropped, light-wash
jeans, tucked in T-shirts, and
low-profile "dad caps" cool.
Most finished this look off with
high top Converse All-Stars
which became key skate shoes
for the first time since the '80s.

Skate company Fucking Awesome brought
split veneer boards back into style for the first
time since Life made them in the early '90s

Chuck Taylors became popular among
skaters in the 2010s after Nike began
to make them with Lunarlon insoles

NEW AND OLD SKATE
VIDEO CAMERAS.
PANASONIC HVX200 HD AND SONY VX1000

Heavy metal fans are known for their passion and dedication to metal above all else. Despite trends or derision from the press, metalheads are dedicated to their beloved music no matter what. No one proves this dedication quite like Botswana's unlikely subculture of metalheads. Nicknamed renegades after a gallery show by photographer Frank Marshall, the first journalist to bring them to Western attention, Botswana's metalheads not only love the music, but also the style, creating some of the most unique, most outlandish outfits in the world. But this is no mere fan culture, as Botswana has small but thriving metal scene with bands like Skinflint, Crackdust, and Overthrust regularly playing shows and releasing top notch metal records over the past decade or so.

Like metalheads everywhere, Botswana's renegades love leather, studs, and band T-shirts, which they mix with cowboy hats, fringe, and local creativity to construct outfits that are completely original, plenty heavy, and totally awesome. It's not uncommon to see a renegade in head-to-toe leather, from his boots to his cowboy hat, looking like some sci-fi Rob Halford intent only on headbanging and shredding.

According to Marshall, the renegades owe their extreme fashion style to competitiveness within their scene, where they try and outdo one another with their outfits.

Despite only coming to Western attention recently, Botswana has had a thriving rock scene since the 1970s.

Though scene leaders Skinflint play classic metal in the vein of Iron Maiden, death metal is the country's most popular genre. Botswana bands Overthrust, Crackdust, and Wrust all play death metal, complete with growled vocals and morbid lyrics, which they sometimes mix with African musical traditions and imagery.

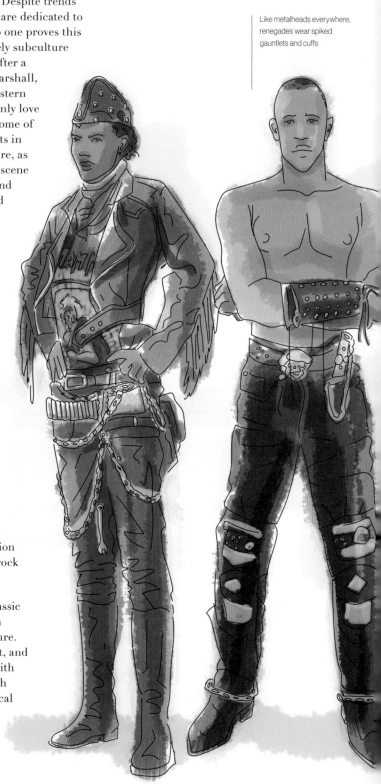

Like metalheads everywhere, renegades wear spiked gauntlets and cuffs

THE CULTURE Like Cannibal Corpse lead singer George "Corpsegrinder" Fisher, many renegades have heavy metal nicknames, including gems like Dead Demon Rider, Ishmael Phantom Lord, and White Devil.

RENEGADES

ORIGIN: BOTSWANA, 2000s
AFRICAN METALHEADS COMPETE TO DRESS THE MOST HARDCORE

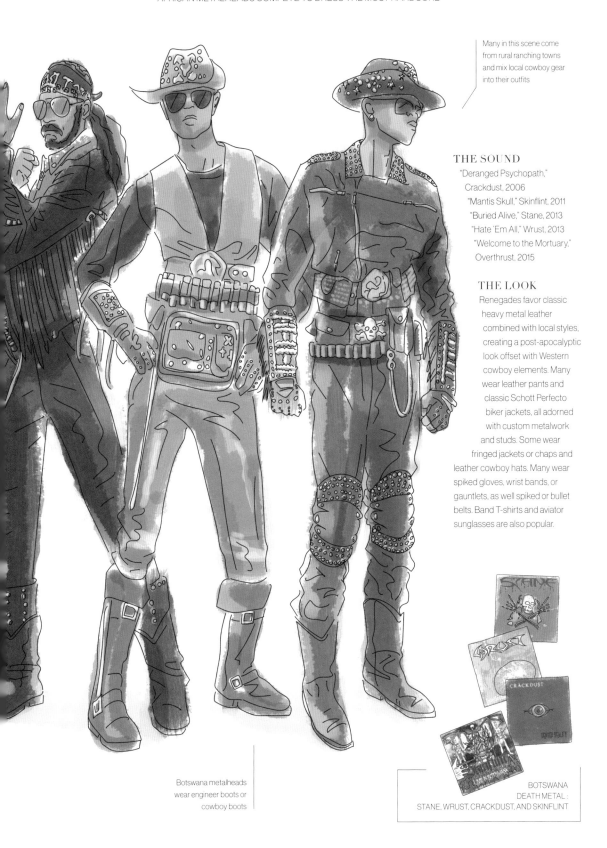

Many in this scene come from rural ranching towns and mix local cowboy gear into their outfits

THE SOUND

"Deranged Psychopath,"
Crackdust, 2006
"Mantis Skull," Skinflint, 2011
"Buried Alive," Stane, 2013
"Hate 'Em All," Wrust, 2013
"Welcome to the Mortuary,"
Overthrust, 2015

THE LOOK

Renegades favor classic heavy metal leather combined with local styles, creating a post-apocalyptic look offset with Western cowboy elements. Many wear leather pants and classic Schott Perfecto biker jackets, all adorned with custom metalwork and studs. Some wear fringed jackets or chaps and leather cowboy hats. Many wear spiked gloves, wrist bands, or gauntlets, as well spiked or bullet belts. Band T-shirts and aviator sunglasses are also popular.

Botswana metalheads wear engineer boots or cowboy boots

BOTSWANA
DEATH METAL :
STANE, WRUST, CRACKDUST, AND SKINFLINT

In recent years, a new style has emerged in the United Kingdom. Part yardie, part chav, with a touch of football casual and a load of attitude, it's the roadmen, so called because these street-savvy youths spend all their time out on the roads. The roadman phenomenon has risen alongside a new wave of grime music, the British hip-hop that's been bubbling up from depressing council estates since the early 2000s. This go 'round, grime boasts a slew of charismatic young MCs like Skepta and Stormzy, who are taking the very British music style worldwide, thanks in part to Youtube and Soundcloud. This irresistible mix of roadman fashion and music has created what English writer Louis Bradley called the first "worthy subculture in a long time."

Black or white monochrome sportswear is key to the roadman look. A typical outfit might include track pants and a Stone Island hoodie worn under a matching Moncler puffer jacket, finished off with Nike Air Max '95 runners (called "110s," because that's what they cost in British pounds sterling) and a low-profile ball cap with a curved brim. Many roadmen also carry small shoulder bags where they store their multiple burner cell phones and weed stashes.

The creators of the roadman look and lifestyle are primarily the teenage sons of West Indian or African immigrants from rough neighborhoods like Thornton Heath in South London. But with the explosive popularity of second wave grime, the roadman look has expanded well beyond England's poorest neighborhoods, inspiring both working-class and wealthy youth to adopt the roadman's sporty look.

The roadman phenomenon recently crossed the Atlantic. Canadian rapper Drake has been seen sporting roadman staples like Stone Island and recently signed a deal to help expand and distribute Skepta's BBK record label, a partnership that's sure to expand the roadman phenomenon worldwide.

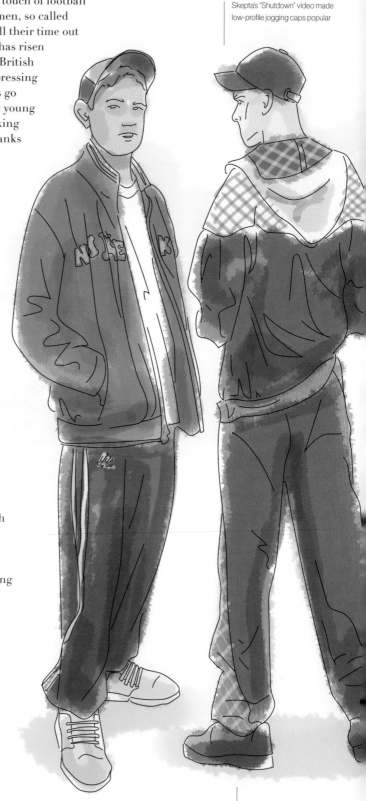

Skepta's "Shutdown" video made low-profile jogging caps popular

Hip-hop artists like Drake have made black Timberland work boots popular in Britain

THE CULTURE Roadman slang is heavily influenced by Jamaican patois and features word like "rudeboy," "shotta," and "drawing gyal" that were borrowed from their yardie forbearers.

ROADMEN

ORIGIN: UNITED KINGDOM, 2010s
LONDON CORNER DROOGS FOR THE TWENTY-FIRST CENTURY

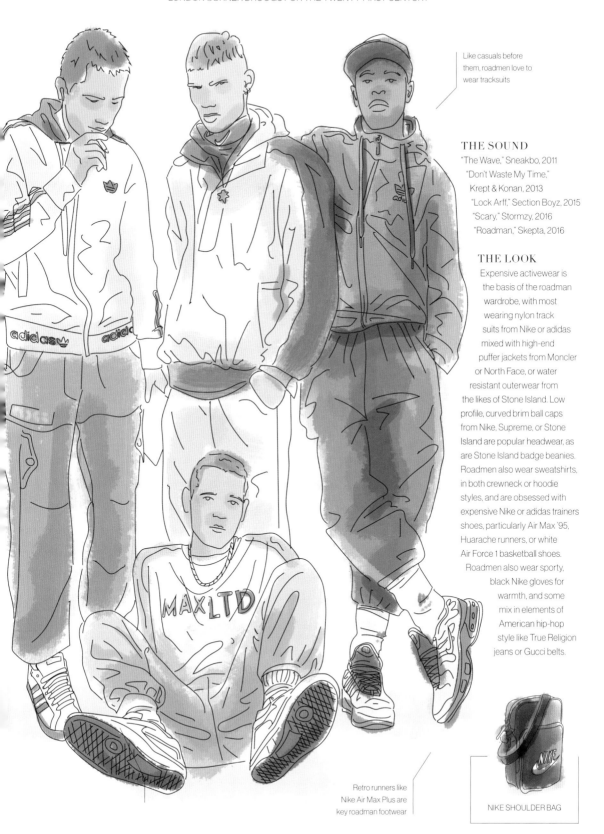

Like casuals before them, roadmen love to wear tracksuits

THE SOUND

"The Wave," Sneakbo, 2011
"Don't Waste My Time,"
Krept & Konan, 2013
"Lock Arff," Section Boyz, 2015
"Scary," Stormzy, 2016
"Roadman," Skepta, 2016

THE LOOK

Expensive activewear is the basis of the roadman wardrobe, with most wearing nylon track suits from Nike or adidas mixed with high-end puffer jackets from Moncler or North Face, or water resistant outerwear from the likes of Stone Island. Low profile, curved brim ball caps from Nike, Supreme, or Stone Island are popular headwear, as are Stone Island badge beanies. Roadmen also wear sweatshirts, in both crewneck or hoodie styles, and are obsessed with expensive Nike or adidas trainers shoes, particularly Air Max '95, Huarache runners, or white Air Force 1 basketball shoes. Roadmen also wear sporty, black Nike gloves for warmth, and some mix in elements of American hip-hop style like True Religion jeans or Gucci belts.

Retro runners like Nike Air Max Plus are key roadman footwear

NIKE SHOULDER BAG

In the late 1990s, rappers from the long-ignored South and Midwest began to rise. By the year 2000, rappers like OutKast from Atlanta, The Hot Boy$ from New Orleans, and Nelly from Saint Louis came to dominate the charts, putting a chokehold on the industry that they'd never relinquish.

Though Houston rap group the Geto Boys had a hit in 1991 with "Mind Playing Tricks on Me," the greater culture largely ignored Southern hip-hop until the late 1990s, when Outkast and Lil Jon from Atlanta and Master P and the Hot Boy$ from New Orleans began to garner national airplay and hit records.

This initial ascent of Southern hip-hop was merely the first wave of an explosion that took over the rap charts almost completely during the 2000s and 2010s. During this time Atlanta trap rappers like Young Jeezy and Gucci Mane vied for attention against Lil Wayne from New Orleans and Academy Award winners Three 6 Mafia from Memphis.

At the same time, the Midwest was rising against all odds as eccentric Chicago upstart Kanye West went from producing beats for Jay Z to making his own records, eventually becoming the king of hip-hop and a fashion and sneaker impresario.

West paved the way for Chicago underground mixtape artists like Chief Keef, the most famous proponent of ultra-violent drill music, which rose alongside Chicago's alarming murder rate in the early 2010s.

Kanye and Keef, though different artistically, are both known for their love of skinny jeans and high fashion. West has taken this style in a Euro-goth direction, wearing designers like Raf Simons and Haider Ackermann, while Keef has consistently gone for a harder look paring Balmain biker jeans with Gucci belts, Air Jordans, dreads, and polo shirts.

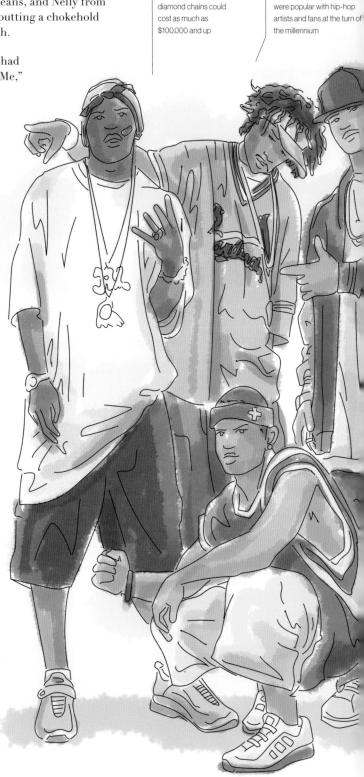

Custom gold and diamond chains could cost as much as $100,000 and up

Throwback baseball jerseys were popular with hip-hop artists and fans at the turn of the millennium

THE CULTURE The rise of Southern and Midwestern hip-hop is directly tied to the Internet, which allowed artists like Lil Wayne, Gucci Mane, and Chief Keef to release seemingly endless informal, free mixtapes on websites like Dat Piff, keeping their names in the headlines, even as their official record labels waited for albums.

ORIGIN: THE SOUTHERN AND MIDWESTERN UNITED STATES, 2000s–2010s
HUSTLING FROM THE TRAP TO THE 'NET

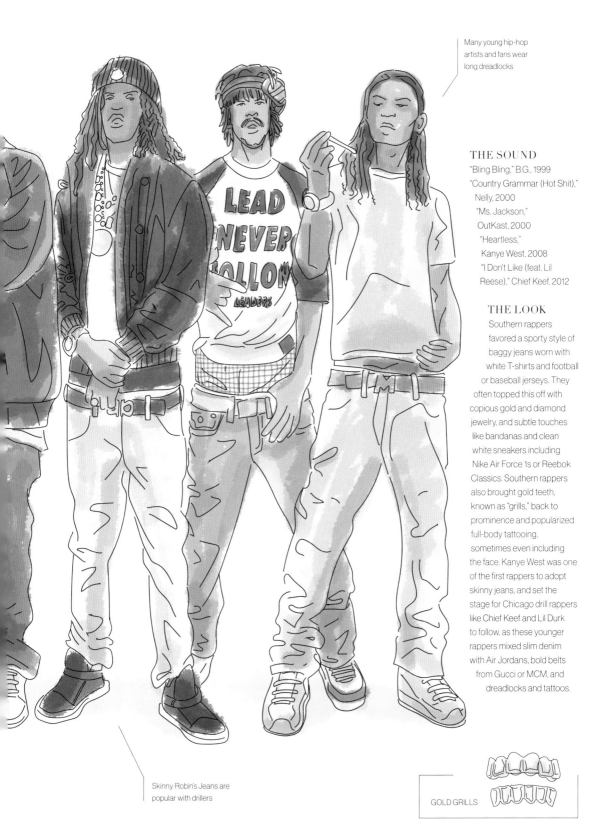

Many young hip-hop artists and fans wear long dreadlocks

THE SOUND

"Bling Bling," B.G., 1999

"Country Grammar (Hot Shit)," Nelly, 2000

"Ms. Jackson," OutKast, 2000

"Heartless," Kanye West, 2008

"I Don't Like (feat. Lil Reese)," Chief Keef, 2012

THE LOOK

Southern rappers favored a sporty style of baggy jeans worn with white T-shirts and football or baseball jerseys. They often topped this off with copious gold and diamond jewelry, and subtle touches like bandanas and clean white sneakers including Nike Air Force 1s or Reebok Classics. Southern rappers also brought gold teeth, known as "grills," back to prominence and popularized full-body tattooing, sometimes even including the face. Kanye West was one of the first rappers to adopt skinny jeans, and set the stage for Chicago drill rappers like Chief Keef and Lil Durk to follow, as these younger rappers mixed slim denim with Air Jordans, bold belts from Gucci or MCM, and dreadlocks and tattoos.

Skinny Robin's Jeans are popular with drillers

GOLD GRILLS

A$AP FERG'S
TRAP (HIP-HOP) TOP FIVE

"B.M.F.," Rick Ross, 2010
"I Don't Like (Remix feat. Kanye West, Pusha T, Jadakiss & Big Sean)," Chief Keef, 2012
"Wild for the Night (feat. Skrillex & Birdy Nam Nam)," A$AP Rocky, 2013
"Work REMIX (feat. A$AP Rocky, French Montana, Trinidad James & ScHoolboy Q)," A$AP Ferg, 2013
"Old English (feat. Freddie Gibbs & ASAP Ferg)," Young Thug, 2015

TRAP (HIP-HOP)

When the gangster persona loses its outlaw romance, trap reveals the grimy truth

"Fuck U," Slim Dunkin, 2010
"Hard In Da Paint," Waka Flocka Flame, 2010
"HAM," Kanye West & Jay Z, 2011
"Way Too Gone (feat. Future)," Young Jeezy, 2011
"I Don't Like," Chief Keef, 2012
"No Lie (feat. Drake)," 2 Chainz, 2012
"Same Damn Time (Remix) (feat. Diddy & Ludacris)," Future, 2012
"Trap Back," Gucci Mane, 2012
"Pop That (feat. Rick Ross, Drake & Lil Wayne)," French Montana, 2013
"Bandz a Make Her Dance," Juicy J, 2013
"Quintana," Travis Scott, 2013
"Trap Boy," Fredo Santa, 2013
"Fight Night," Migos, 2014
"Boomin'," Fetty Wap, 2015
"Cartel," Rich Homie Quan, 2015
"No Flex Zone," Rae Sremmurd, 2015
"On Deck (feat. Young Thug)," Boosie Badazz, 2015
"2 Phones," Kevin Gates, 2015
"Digits," Young Thug, 2016
"Hunnid (feat. Pusha T)," Yo Gotti, 2016
"Purple Lamborghini," Skrillex and Rick Ross, 2016
"Timmy Turner," Desiigner, 2016

SEAPUNK

A glitchy blend of techno, trap, and pop, coming to your computer speakers from 20,000 leagues beneath the sea

"Boys of Paradise," Unicorn Kid, 2011
"Blockz," LOL Boys, 2011
"Places," Shlohmo, 2011
"Omamori," Elite Gymnastics, 2011
"Stunts," Teams, 2011
"And My Hands Denied Me My Right," arrange, 2012
"babeland," airsports, 2012
"Cool Party," Groundislava, 2012
"Fairyland," Temporary Suicide, 2012
"Feels," Giraffage, 2012
"Static," Kid Smpl, 2012
"Urchin," Labyrinth Ear, 2012
"Babe," Evenings, 2013
"Stoopid," Wave Racer, 2013
"Summer of Pan," Swing Delux, 2013
"Durutti Shores," Lemonade, 2014
"Girls," Slow Magic, 2014
"Softpretty," Doss, 2014
"Subsonic," Com Truise, 2014
"Wedding Bells," Cashmere Cat, 2014
"Cold Stares (feat. Chance the Rapper & Maceo Haymes)," Nosaj Thing, 2015
"Based Love," Teams, 2015
"Fanta," easyFun, 2015
"Coral Castlez," Rustie, 2015

DRILL

Born in Chicago, drill's starkly realistic lyrics are as chilling as its deapan, effects-heavy delivery

"Get Smoked," Lil Mouse, 2012
"Love Sosa," Chief Keef, 2012

"Roll'n (feat. Leak)," 5'Star, 2012

"Pop Out (feat. King Louie)," Katie Got Bandz, 2013

"STR8," Capo, 2013

"Baby Daddy Broke," Gucci Mane & Chief Keef, 2014

"Bang Like Chop" (feat. Chief Keef & Lil Reese)," Young Chop, 2014

"Bobby Bitch," Bobby Shmurda, 2014

"Ice Cream Truck," Montana of 300, 2014

"On the Corner (feat. Lil Durk and KD Young Cocky)," G Herbo, 2014

"Play for Keeps," L'a Capone, 2014

"Ain't Heard 'Bout You," Lil Bibby & Lil Herb, 2015

"All That Hatin," Lil Reese, 2015

"Burn One," SD, 2015

"Dope Game (feat. Chief Keef)," Fredo Santana, 2015

"Like Me (feat. Jeremih)," Lil Durk, 2015

"Live and Die in Chicago," King Louie, 2015

"100 Days 100 Nights," G Herbo, 2015

"Peephole," Lil Mister & Smylez, 2015

TRAP (ELECTRO)

Electro music uses the grimy snares
and aggressive high hats of Southern hip-hop
to get the dance floor moving

"Original Don," Major Lazer, 2011

"Butters Theme (feat. Billy The Gent & Long Jawns)," Diplo, 2012

"Harlem Shake," Baauer, 2012

"Higher Ground," TNGHT, 2012

"Pop That Pussy Like This," R3, 2012

"Trapped In Sydney," Craze and Codes, 2012

"The Drop," Bro Safari, 2013

"Are We Faded (Original Mix)," Keys N Krates, 2014

"Assembly Line," Gladiator, 2014

"Attak (feat. Danny Brown)," Rustie, 2014

"Back Up On It (Jasmine)," DJ Fire, 2014

"Boss Mode," Knife Party, 2014

"Core," RL Grime, 2014

"CULT," Woolymammoth, 2014

"Maybe," Carmada, 2014

"Rage the Night Away (Flosstradamus Remix) (feat. Waka Flocka Flame)," Steve Aoki, 2014

"Turn Up," Gent & Jawns, 2014

"Don't Want It (feat. Sayyi)," Brenmar, 2015

"Drop Top (feat. Travis Porter)," Flosstradamus, 2015

"Febreze (feat. 2 Chainz)," Jack Ü, 2015

"I Like Tuh (feat. I LOVE MAKONNEN)," Carnage, 2015

"Propaganda," DJ Snake, 2015

"Silhouettes," Echos, 2016

ELECTRONIC POP

Art school electro goes pop with slick production
and charismatic stage shows

"Born This Way," Lady Gaga, 2011

"Carried Away," Passion Pit, 2012

"Oblivion," Grimes, 2012

"Alive," Krewella, 2013

"We Can't Stop," Miley Cyrus, 2013

"Claire de Lune (feat. Christine Hoberg)," Flight Facilities, 2013

"Goddess," Banks, 2014

"Gooey," Glass Animals, 2014

"Koto," ODESZA, 2014

"Retrograde," James Blake, 2014

"Time," Jungle, 2014

"Uptight Downtown," La Roux, 2014

"Two Weeks," FKA Twigs, 2014

"Waited 4 U," Slow Magic, 2014

"All It Ever Was," Miami Horror, 2015

"Never Sleep Alone (feat. Tess Comrie)," Kaskade, 2015

"Fantasy," Allure, 2015

"My Everything," Owl City, 2015

"Film Noir," Pyramid, 2015

"Generate," Eric Prydz, 2015

"I'm A Ruin," Marina & The Diamonds, 2015

"Leave A Trace," CHVRCHES, 2015

"Loud Places (feat. Oliver Sim)," Jamie XX, 2015

"Panic Room," Auetre Ne Veut, 2015

"River," Ibeyi, 2015

"Secrets (feat. JNS MSC)," Futurecop!, 2015

"To Know You," Wild Nothing, 2015

"Too Bad, So Sad," Metric, 2015

"U Don't Know (feat. Wayne Coyne)," Alison Wonderland, 2015

"Welcome to Love," Young Ejecta, 2015

Few subcultures begin in dreams, but seapunk did. In 2011, DJ and online raconteur Lil Internet dreamt about a leather jacket studded with barnacles instead of metal spikes. The next day, he and Lil Government, his partner in digital mayhem, tweeted about the dream, adding #seapunk as a joke. Some of their online friends caught on, and this small group spent the summer tweeting puns about the ocean, punk, and the Internet. Much to its creators surprise, this dream-joke struck a nerve, resulting in an invitation-only Facebook page set up by DJ Albert Redwine. Then the media tuned in. In 2011, *DIS Magazine* published "WTF Is Seapunk?," an online story consisting of nothing but images of turquoise hair, pictures of Blink-182 at the beach, and a dolphin bearing the caption "#seapunk," which helped codify the seapunk aesthetic. Lil Internet and Lil Government had intuited something in the zeitgeist. Suddenly, Soulja Boy was tweeting about his "Ocean Gang," including #seapunk for emphasis. Like a 56K modem-made Frankenstein's monster, seapunk escaped its creators' original punny, aimless intentions.

With this online history intact, seapunk became a fashion style and Tumblr aesthetic, made up of dyed, ocean-blue hair and Web 1.0 graphics.

In 2012, people began throwing seapunk-themed parties in Chicago and New York.

Over time, Redwine helped make seapunk a distinct sound, consisting of tropical chill-out mixed with glitchy house, and song names that played off ocean puns and Internet culture.

By 2013, seapunk had burned itself out, leaving its creators, practitioners, and Tumblr-centric fans dazed by the rise and fall of one of the first online subcultures.

Some seapunks wore blue or green hair inspired by Gwen Stefani and New Ravers

Retro '90s choker necklaces were embraced by seapunks

THE CULTURE Born on Twitter and raised on Tumblr, seapunk was one of the first true Internet subcultures, raising questions about the nature of subversion in an era when people could meet and flourish online, never needing to physically congregated in real time to thrive.

SEAPUNK

ORIGIN: UNITED STATES, 2010s
A FUN IN-JOKE BECOMES ONE OF THE WORLD'S FIRST TRUE INTERNET CULTURES

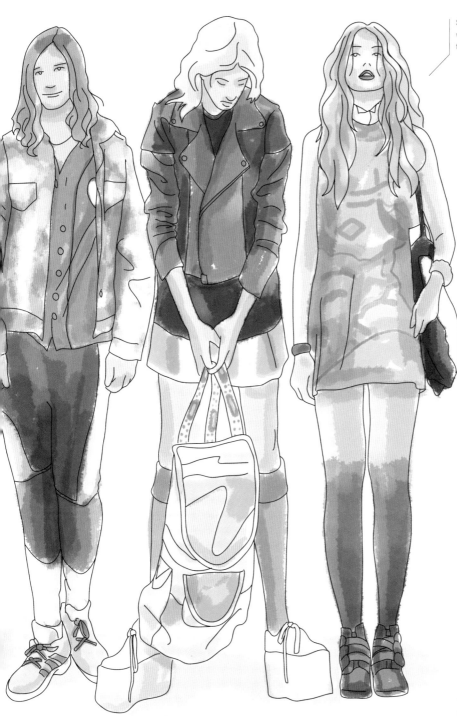

Sea green, blue, and aqua were key to the seapunk look, from hair to clothes

THE SOUND

"In the Water,"
Beat Connection, 2010
"Tropocalypse," Zombelle &
Myrrh Ka Ba, 2011
"Boys Of Paradise,"
Unicorn Kid, 2011
"Rhinoceropolis,"
Lil Internet, 2011
"Diamonds,"
Rihanna, 2012

THE LOOK

Seapunk style was a neo-rave mashup of dyed turquoise hair worn with digitally printed shirts, skirts, or leggings featuring ocean-centric graphics and colors. The seapunk aesthetic captured in these graphics was largely created on Tumblr and bore similarities to other online cultures of the early 2010s (like vaporwave), and heavily featured graphics of dolphins set over endless oceans, palm trees, and geometric shapes rendered in an anachronistic Web 1.0 style.

Original '90s club kids like Astro Erle inspired seapunks to wear platform sneakers

BARNACLE-CRUSTED LEATHER JACKET

Despite media representations to the contrary, black and Latino youth have always been part of underground movements like punk and goth. But it wasn't until the late 2010s that these influences coalesced and directly intersected with hip-hop, creating the distinct street goth look that spread worldwide via the Internet.

The GHE20G0TH1K parties thrown by DJ Venus X in New York between 2009 and 2014 served as a key influence for the street goth look. They gave like-minded individuals a place to share ideas and dance to everything from house to dembow to Lil' Kim. These parties were also creative incubators for fashion designers like Telfar, Shayne Olivier of Hood by Air, and Heron Preston of #BEENTRILL#, who all helped create the ensuing street goth style, adding hip-hop elements to the "goth ninja" looks that were popular at New York City retailers like Oak in the 2000s.

With these influences in place, Harlem rapper A$AP Rocky and his affiliate A$AP Mob codified the street goth look when they gained worldwide fame in 2011, combining noirish high-end designers like Rick Owens, Raf Simons, and vintage Helmut Lang with streetwear from labels like Supreme and BAPE.

By 2014, street goth had become a parody of itself, with Internet critics pointing to young men dipped head to toe in #BEENTRILL# as "fuccbois." That year, A$AP Rocky killed street goth, dissing Hood by Air and #BEENTRILL# on his song "Multiply," despite modeling for the former and repping the latter mere months before.

In spite of its rapid rise and fall, street goth proved massively influential, inspiring submovements like health goth and Rihanna's Fenty line for Puma.

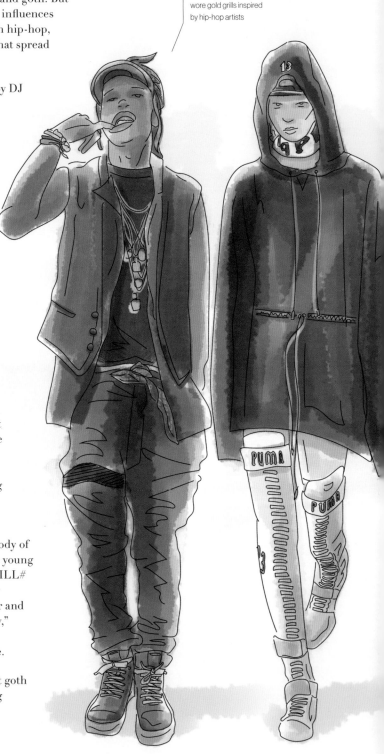

Some street goths wore gold grills inspired by hip-hop artists

THE CULTURE Though street goth arose in New York City, Southern rap music from the '90s influenced its bleak sound and dark outlook. The ultra-slow, codeine-fueled Houston rap known as screw music mixed with Memphis's cassette-based murder and horror rap to provide haunting, druggy sounds that inspired street goth's spare, black looks. Both of these influences are apparent in A$AP Rocky's early music.

STREET GOTH

ORIGIN: NEW YORK, LATE 2010s
GOTH MEETS HIP-HOP IN DOWNTOWN NEW YORK

Street goths fetishized the striking, graphic logos of Hood by Air and Pyrex Vision

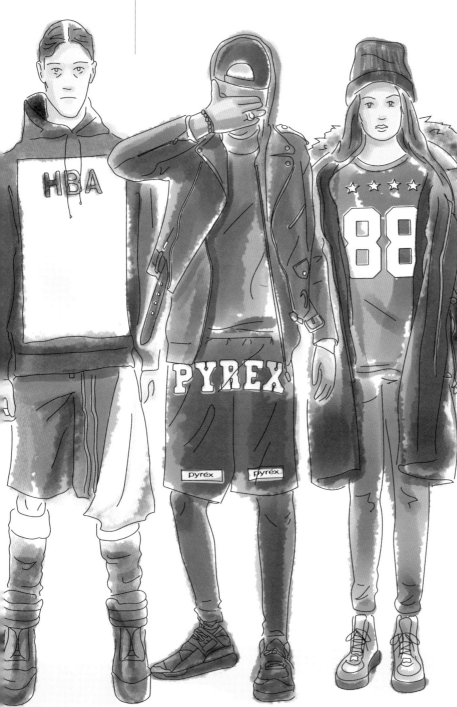

THE SOUND

"Big Momma Thang," Lil' Kim, 1996
"Impulso Biomecánico," Amduscia, 2006
"Purple Swag: Chapter 2 (feat. SpaceGhostPurrp and A$AP Nast)" A$AP Rocky, 2011
"Actin' Up (feat. 3D Na'Tee & Lola Monroe)," Trina, 2012
"Multiply (feat.Juicy J)," A$AP Rocky, 2014

THE LOOK

Street goths wore black leather biker jackets with hoodies, shorts, leggings, and black Nike Air Force 1 sneakers. Draped garments and skirts inspired by Rick Owens were also popular, as were black leather joggers, skinny black denim, biker jeans, and snapback caps.

GRAPHICS AND LOGOS USED ON LOGO JAMMING T-SHIRTS AND KNITWEAR

Dark, chunky sneakers by Rick Owens, Margiela, or Nike were key to the street goth look

Athletic shorts were worn over leggings

Around 2010, a new trend appeared in the small Mexican city of Matehuala, where cowboy style had long reigned supreme. Male residents were updating their traditional Western look by stretching the points of their cowboy boots to heights never seen before. These *botas picudas*, or "pointy boots," curled up from the toe into long skinny points that sometimes reached as high as the wearer's waist. The trend arose alongside tribal guarachero, a new form of music pioneered in Mexico City but perfected by teenage DJs like Erick Rincon and his 3BallMTY crew in Monterrey. Tribal guarachero, or simply trival, mixed pre-Columbian musical influences with house, Cuban rhythms, and cumbia, birthing a new subculture when the boots met the beat.

The name guarachero is the masculine form of the word for someone who sings Cuban guaracha music, one of the main influences on trival.

It's mostly men who dance to trival in their pointy boots, forming crews and troupes to show off their moves together.

Guaracheros also wear skinny jeans, a departure from traditional Western boot-cut trousers.

The pointy boot gaurachero trend has spread to the United States and is reputedly now more popular in Texas than anywhere in Mexico.

Guaracheros prefer their pointy boots as flashy as possible, commissioning custom-made pairs in bright colors and sequins that go way beyond the traditional cowboy dandyism of materials like ostrich or snakeskin.

French-Japanese high fashion label Comme des Garçons included a pair of $515 pointy boots in its Spring/Summer 2015 runway collection.

Despite press and high-fashion rip-offs, the pointy boot guarachero look remains popular among trival fans and dancers.

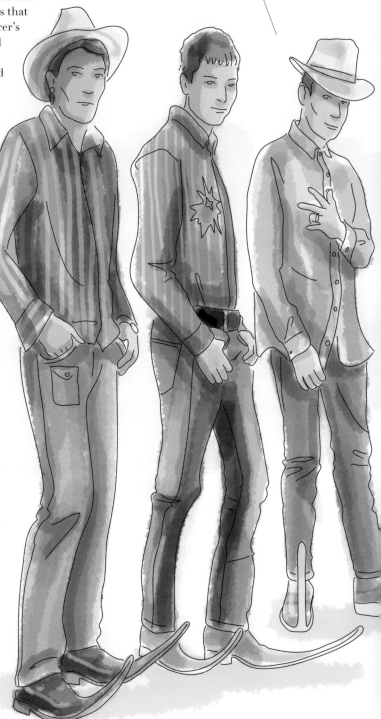

Guaracheros take cowboy boots to flashy levels in color combos like pink and blue

THE CULTURE Shoemakers construct the long, pointed toes of botas picudas out of plastic foam and charge about 500 pesos (around $25) per 6 inches of length. Youth who can't afford these prices have been known to use garden hose to make their own.

GUARACHEROS

ORIGIN: MATEHUALA, 2010s
MEXICAN COWBOY DANDIES TAKE POINTY BOOTS TO NEW HEIGHTS

THE SOUND
"Manos Arriba 2.0,"
3BallMTY, 2010
"Diablo," DJ Otto, 2010
"Cuando Bailas Tribal
(feat. Nikki X and Kike
Play)," DJ Cobra, 2011
"Don't Stop the Music,"
Ricardo Reyna, 2013
"Turn Down For What
(Sheeqo Beat Remix),"
Sheeqo Beat, 2015

THE LOOK
Guaracheros mix their pointy
cowboy boots with tight,
skinny jeans, cowboy hats,
Western shirts, and rodeo
belt buckles. These items are
often worn in bright colors or
patterns, like teal or checks,
but also come in more
subdued, traditional Western
colors. Guaracheros often add
eye-catching embellishments
like shiny stars or disco balls
to the points of their boots for
extra emphasis.

Trival fans prefer skinny
jeans to traditional
bootcut denim

The huge pointy toes on botas picudas
are held in place by plastic foam, which
local cobblers will insert at rate of 500
pesos for every six inches

LIGHT-UP LED COWBOY HAT

South African pantsula are mostly male street dancers who practice and perform in groups and crews. In Zulu, the word pantsula alludes to walking like a duck and comes from the dancer's signature low, flat-footed steps. Despite a massive recent resurgence in popularity, pantsula dancing actually originated during the 1950s in black Johannesburg townships like Sophiatown and Alexandra, partly in protest of apartheid policies that forcibly moved residents from these areas to the more segregated Soweto township. The first pantsula combined local Basotho dances with American jazz steps like the Charleston to create a precise, syncopated ensemble style of performance. Later, American breakdancing movie *Beat Street* (1984) influenced pantsula, adding more radical moves and increasing the importance of confrontational dance battles between rival crews.

Pantsula never abandoned the movement's political origins, later using the dance to inform people about AIDS, protest against apartheid, and as a show of solidarity during the state of emergency declared by South Africa's government during 1985 and 1986.

The first pantsula subversively wore outfits inspired by apartheid-era gardeners' uniforms, which may explain the culture's lasting love of bucket hats and overalls. Today, pantsula crews still wear matching gear, often including button-up shirts, trousers, and even bow ties.

Originally, pantsula crews danced to South African musicians like Aaron "Big Voice" Jack Lerole and Bra Sello, later favoring foreign influences once radios became more readily available. By the '80s and '90s, pantsulas were listening to Michael Jackson and American hip-hop from Puff Daddy and Bad Boy records, as well as house and local kwaito music, all of which remain popular today.

Right now, there are more pantsula than ever, with the artform finally receiving international attention, while also influencing other South African subcultures like the controversial skhothane.

Crews wear matching outfits

Converse All-Stars are a staple of coordinated crew outfits

THE CULTURE In addition to referring to members of dance crews, the word pantsula has taken on macho associations over the years, coming to describe any streetwise township tough guy.

PANTSULA

ORIGIN: SOPHIATOWN AND ALEXANDRA, 1950s
SOUTH AFRICAN STREET DANCERS PROTEST APARTHEID

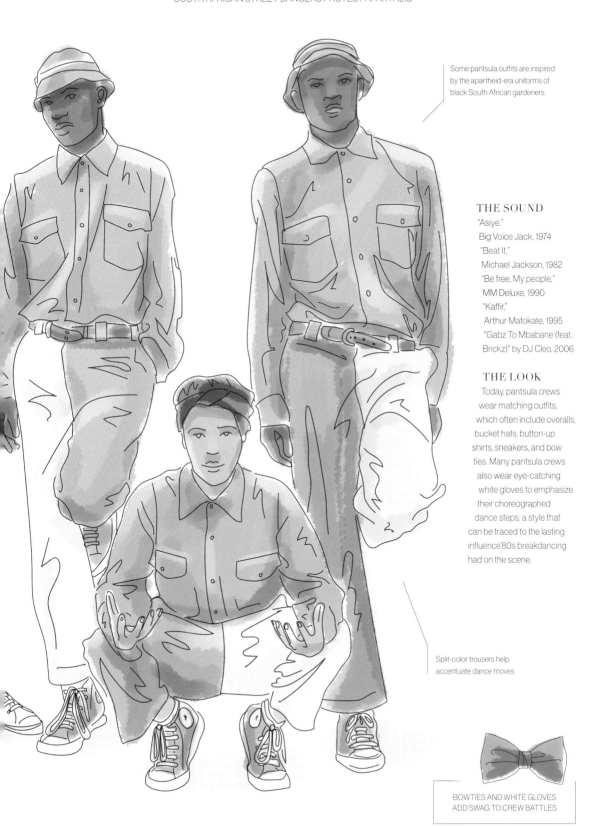

Some pantsula outfits are inspired by the apartheid-era uniforms of black South African gardeners

THE SOUND

"Asiye,"
Big Voice Jack, 1974
"Beat It,"
Michael Jackson, 1982
"Be free, My people,"
MM Deluxe, 1990
"Kaffir,"
Arthur Mafokate, 1995
"Gabz To Mbabane (feat. Brickz)" by DJ Cleo, 2006

THE LOOK

Today, pantsula crews wear matching outfits, which often include overalls, bucket hats, button-up shirts, sneakers, and bow ties. Many pantsula crews also wear eye-catching white gloves to emphasize their choreographed dance steps, a style that can be traced to the lasting influence '80s breakdancing had on the scene.

Split-color trousers help accentuate dance moves

BOWTIES AND WHITE GLOVES ADD SWAG TO CREW BATTLES

Normcore surfaced in late 2014, with the name originally coming from a "trend forecast" put out by digital art collective K-Hole, who intended the term to convey the freedom of being able to conform to any situation. Almost simultaneously a viral article in *New York Magazine* linked it to a spare, mundane, 1990s-inspired street style look, heavily influenced by early Internet aesthetics and 56K modem culture.

Normcore style for both genders included '90s favorites like high-waisted, stonewashed denim, often paired with ironically functional footwear, including white Reebok trainers, Tevas, or Crocs. Turtlenecks, low profile caps, and technical outerwear were also normcore staples.

Although it was named and identified in New York City, normcore was as much a product of the Internet as any specific geographic location, emerging on Instagram and Tumblr.

Normcore didn't have its own musical genre, instead assuming children of the Internet listened to anything and everything at anytime, including contemporary pop ranging from Vaporwave to Drake or Taylor Swift.

Almost as soon as observers like *New York Magazine* named the subculture, an online backlash erupted, claiming that the description of movement wasn't accurate or was simply online clickbait.

Unlike many other subcultures, normcore wasn't overtly rebellious. "Normcore isn't about rebelling against or giving into the status quo" Fiona Duncan wrote in *New York Magazine*. "It's about letting go of the need to look distinctive, to make time for something new."

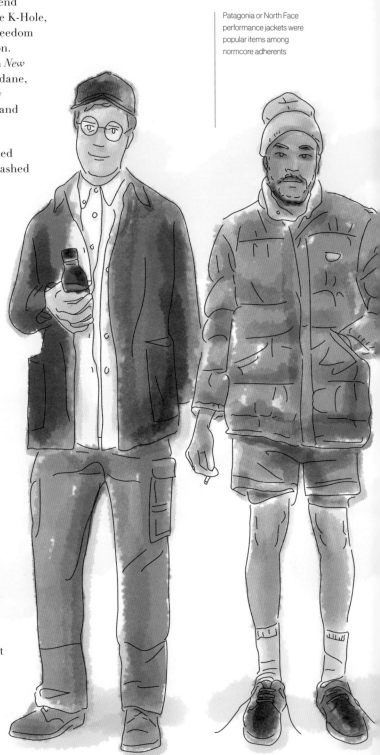

Patagonia or North Face performance jackets were popular items among normcore adherents

THE CULTURE As an Internet subculture with no physical home, normcore often used Net slang verbally, bringing abbreviations like TBH (to be honest), # (hashtag), and IRL (in real life) to spoken conversation.

NORMCORE

ORIGIN: NEW YORK, 2010s
NOSTALGIC '90s BABIES RECREATE THE BLAND STYLES OF THEIR YOUTH

"Dad style" items like mock-turtlenecks were key to dressing subversively normal

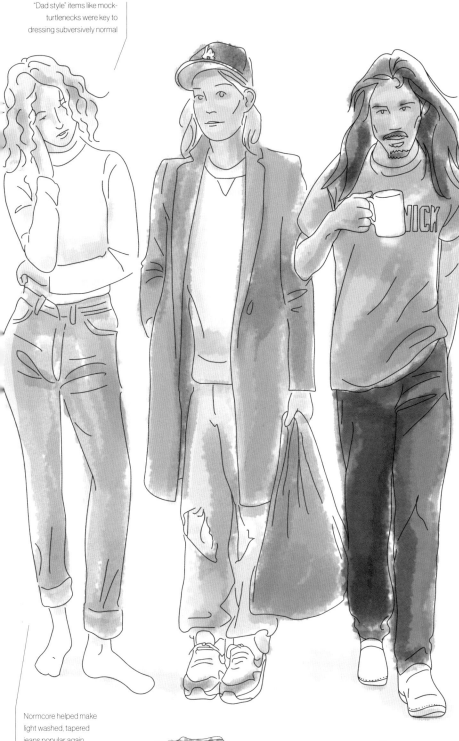

Normcore helped make light washed, tapered jeans popular again

THE SOUND

"リサフランク420 / 現代のコンピュー," Macintosh Plus, 2011
"My Boo (Remix)," Balam Acab, 2011
"22," Taylor Swift, 2012
"You're Not Good Enough," Blood Orange, 2013
"Started From the Bottom," Drake, 2013

THE LOOK

Normcore adherents of both genders wore light, stonewashed denim, barn coats, and polar fleece or technical outerwear from companies like Patagonia. Retro '90s sportswear from brands like Calvin Klein, DKNY, and Tommy Hilfiger was also popular, as were sweatpants and wheat Timberland 6-inch workbooks, Reebok trainers, Birkenstocks, soccer slides (sometimes worn with socks), clogs, and low-profile "dad caps." Both genders favored nondescript hairstyles.

BIRKENSTOCK BOSTON CLOG,
TEVA ORIGINAL UNIVERSAL,
NEW BALANCE CLASSIC M574

Cholombianos are young people from Monterrey, Mexico, who've created a culture focused on fun, good music, and amazing hairstyles. They draw their name from their love for Colombian cumbia music, which has been popular in the working-class Monterrey neighborhoods of La Independencia and La Campana since at the 1960s. DJ Gabriel Dueñes and his Sonido Dueñes sound system are closely associated with cumbia in Monterrey, accidentally creating the city's favored local style—cumbia rebajada—when one of his tape players melted down at a party in the '60s. Attendees loved the slowed-down style, demanding he make more. Monterrey DJ Toy Selectah claims migrant workers brought cumbia rebajada to Houston, Texas, where it's ultraslow sound inspired DJ Screw to create his infamous "chopped and screwed" style of hip-hop. Whatever the case, Cumbia, in its classic and rebajada forms, remains the music of choice among Cholombianos.

In contrast to Mexico's reputation for violent drug gangs, cholombianos are a peaceful subculture, preferring dancing and dedicating songs to their girlfriends or boyfriends on local radio stations to crime or interacting with Monterrey's narcos.

Hair is the most important aspect of cholombiano style. Most adherents wear some version of the haircut known as estilo Colombiano, featuring a shaved back and rat tail, with razor sharp bangs and long sideburns they meticulously paste down with huge amounts of hair gel. Some cholombians also wear ballcaps perched high atop their heads.

Many cholombianos wear religious style icons called escapularios around their necks. Borrowing the style from monks, cholombiano escapularios might feature San Judas Tadeo, Santa Muerte, or, increasingly embroidered crew names like Foxmafia or La Dinastia de los Rapers.

Despite facing occasional harassment from cops and thugs, cholombiano culture remains vibrant.

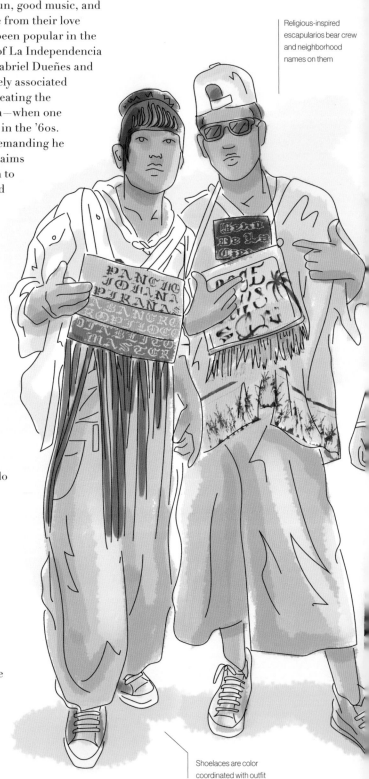

Religious-inspired escapularios bear crew and neighborhood names on them

Shoelaces are color coordinated with outfit

THE CULTURE The 7-Eleven in the Latino Tower in downtown Monterrey is a favorite cholombiano hangout spot. The Tower houses the cholombianos favorite radio station, XEH 1420 AM, making that 7-Eleven the perfect spot to hang out and call in on-air requests and romantic dedications.

ORIGIN: MONTERREY, 1970s
MEXICAN TEENS WITH TERRIFIC HAIRCUTS ARE JUST OUT FOR A GOOD TIME

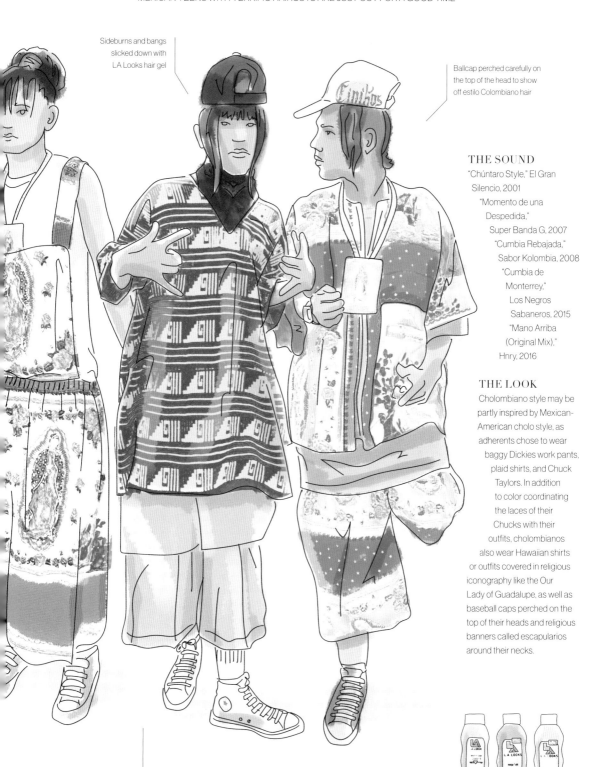

Sideburns and bangs
slicked down with
LA Looks hair gel

Ballcap perched carefully on
the top of the head to show
off estilo Colombiano hair

THE SOUND

"Chúntaro Style," El Gran
Silencio, 2001
"Momento de una
Despedida,"
Super Banda G, 2007
"Cumbia Rebajada,"
Sabor Kolombia, 2008
"Cumbia de
Monterrey,"
Los Negros
Sabaneros, 2015
"Mano Arriba
(Original Mix),"
Hnry, 2016

THE LOOK

Cholombiano style may be
partly inspired by Mexican-
American cholo style, as
adherents chose to wear
baggy Dickies work pants,
plaid shirts, and Chuck
Taylors. In addition
to color coordinating
the laces of their
Chucks with their
outfits, cholombianos
also wear Hawaiian shirts
or outfits covered in religious
iconography like the Our
Lady of Guadalupe, as well as
baseball caps perched on the
top of their heads and religious
banners called escapularios
around their necks.

Baggy shorts hit below the knee,
possibly in imitation of Mexican-
American cholo style

LA LOOKS MEGA-HOLD HAIR GEL

There are two separate, but related, cultures of living dolls. In one, men wear women's clothes, rubber body suits, and masks to create idealized female personae. In the other, young women and men use plastic surgery and makeup to turn themselves into living Barbie® and Ken® dolls. A dedication to appearing "perfect" unites both cultures and is something both versions of living dolls cite repeatedly as their goal. Curiously, neither culture claims that their dedication to appearing plastic and doll-like is a sexual fetish.

Men who wear bodysuits and masks to appear as female living dolls are also known as "maskers." Most are straight, many are married, and almost all claim that their living doll lifestyle is more about getting attention and feeling immaculate than it is about sexuality or fetish.

The masker version of the living doll lifestyle is almost entirely safe and harmless, but some adherents do risk getting non-medical saline injections in their chests to temporarily mimic female breasts. They close these injection site wounds with superglue.

The other version of the living doll lifestyle is far more extreme. Here, men and women use makeup, colored contacts, and plastic surgery to look like living Ken® and Barbie® dolls. Famous Ukrainian real-life Barbie Valeria Lukyanova claims she's never had surgery and achieves her doll-like look via makeup and cosmetic contacts, but Brazilian human Ken doll Rodrigo Alves can make no such claim. In 2016, he almost died from necrosis when his surgically-altered nose began rotting.

With or without surgery the human doll trend continues, as Ukrainian living Barbie Lolita Richi began her supposedly natural transformation when she was only sixteen years old.

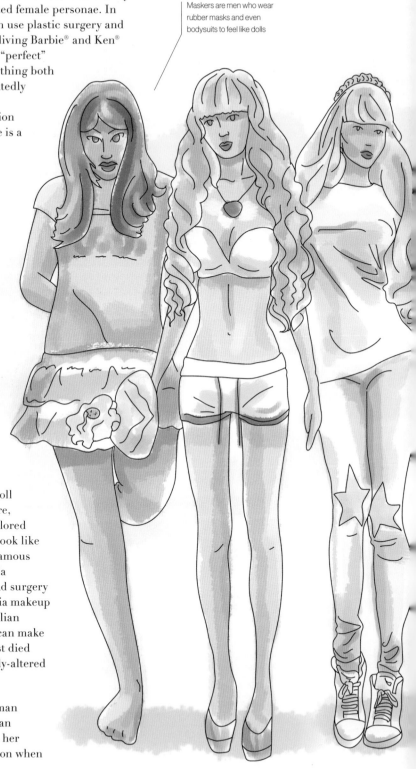

Maskers are men who wear rubber masks and even bodysuits to feel like dolls

ORIGIN: UNITED KINGDON, BRAZIL, UKRAINE, 2010s
MEN AND WOMEN USES SURGERY AND MASKS TO TRY AND LIVE LIKE PERFECT LITTLE DOLLS

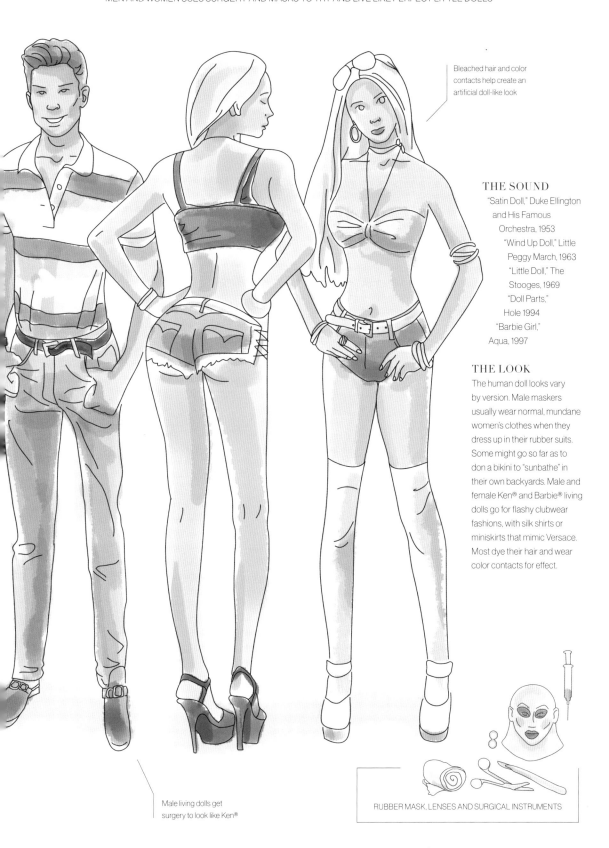

Bleached hair and color contacts help create an artificial doll-like look

THE SOUND

"Satin Doll," Duke Ellington and His Famous Orchestra, 1953
"Wind Up Doll," Little Peggy March, 1963
"Little Doll," The Stooges, 1969
"Doll Parts," Hole 1994
"Barbie Girl," Aqua, 1997

THE LOOK

The human doll looks vary by version. Male maskers usually wear normal, mundane women's clothes when they dress up in their rubber suits. Some might go so far as to don a bikini to "sunbathe" in their own backyards. Male and female Ken® and Barbie® living dolls go for flashy clubwear fashions, with silk shirts or miniskirts that mimic Versace. Most dye their hair and wear color contacts for effect.

Male living dolls get surgery to look like Ken®

RUBBER MASK, LENSES AND SURGICAL INSTRUMENTS

The 12 O'Clock Boys are a crew of dirt bike riders from the rough West Baltimore neighborhood. Since a 2013 documentary brought their lifestyle to the world, the name of this particular crew has become synonymous with any member of a culture of young people who ride illegal dirt bikes through the streets of Eastern cities like Baltimore, Philadelphia, and New York. The name 12 O'Clock Boys originates from the way in which a perfectly popped wheelie mimics the hands of a clock at noon or midnight. These unlicensed dirt bikes, which often lack headlights or turn signals, are illegal to ride on most city streets, but ironically, it's the rider's own bravado that helps protect them from police. Because it's so dangerous to chase these bikers, police departments in Baltimore, Philadelphia, and New York City all have policies banning pursuit, and cops have resorted to trying to find and confiscate dirt bikes where they're stored instead.

Dirt bike crews often take to city streets en masse, with hundreds of riders at a time shutting down roads, riding against traffic, and popping wheelies at will.

Many dirt bike crews also include four-wheeled ATVs in their cliques, vehicles which are also capable of popping wheelies.

Some dirt bike stunt riders deflate their rear tires to make it easier to hold a wheelie. The best riders can hold a wheelie for many city blocks and won't hesitate to take the trick to highways where it's performed at speeds over 80 miles per hour. Other daredevil dirt bikers will ride on the wrong side of city streets, going against traffic in dangerous displays of courage.

The illegal dirt bike culture features famous rappers like Philadelphia's Meek Mill among its adherents. Mill released a mobile dirt bike app called "Bike Life" in 2015.

Because of such exposure, illegal dirt bike culture has spread down the coast to Atlanta and the South, where it only seems to be growing.

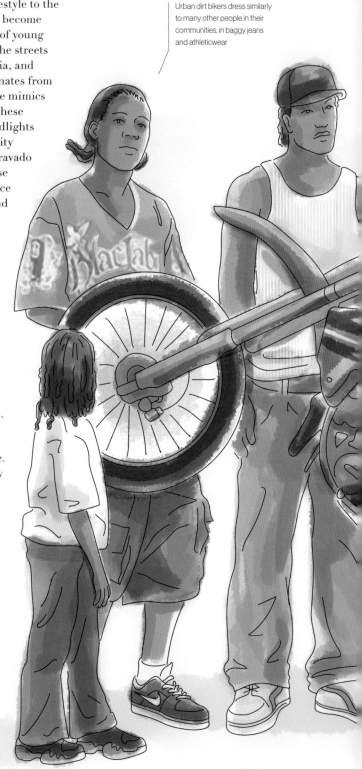

Urban dirt bikers dress similarly to many other people in their communities, in baggy jeans and athleticwear

THE CULTURE Many urban dirtbikers love to capture their rides on helmet-mounted GoPro cameras, uploading the videos to Facebook and Youtube to brag.

ORIGIN: BALTIMORE, PHILADELPHIA, AND NEW YORK, 2010s
HANGIN' 12 AND HANGIN' TUFF

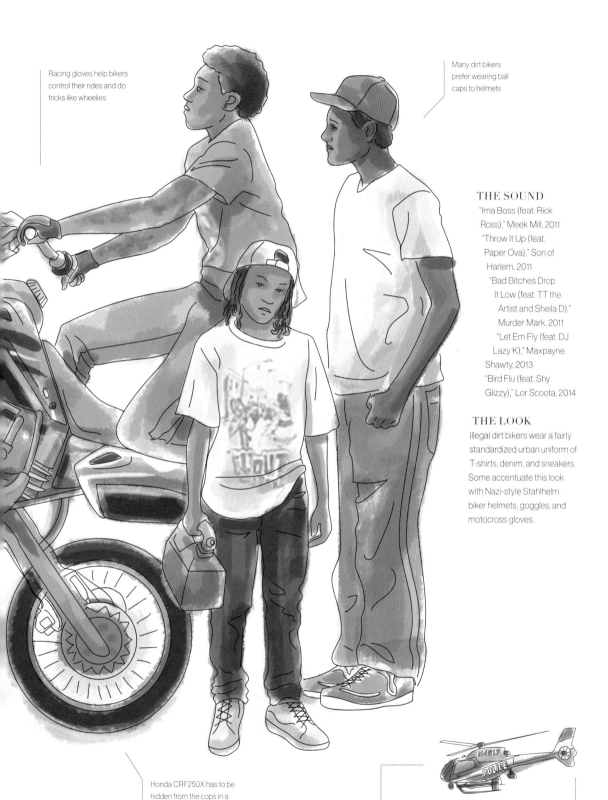

Racing gloves help bikers control their rides and do tricks like wheelies

Many dirt bikers prefer wearing ball caps to helmets

THE SOUND

"Ima Boss (feat. Rick Ross)," Meek Mill, 2011
"Throw It Up (feat. Paper Ova)," Son of Harlem, 2011
"Bad Bitches Drop It Low (feat. TT the Artist and Sheila D)," Murder Mark, 2011
"Let Em Fly (feat. DJ Lazy K)," Maxpayne Shawty, 2013
"Bird Flu (feat. Shy Glizzy)," Lor Scoota, 2014

THE LOOK

Illegal dirt bikers wear a fairly standardized urban uniform of T-shirts, denim, and sneakers. Some accentuate this look with Nazi-style Stahlhelm biker helmets, goggles, and motocross gloves.

Honda CRF250X has to be hidden from the cops in a shed off the street

COPS USE HELICOPTERS TO SURVEIL BIKERS

Skhothane are South African street dancers who throw lavish dance battles in which they compete with rival crews to display their wealth by destroying as much expensive clothing, money, electronics, liquor, and food as possible. The skhothane, which is local slang for boasting, arose in Johannesburg townships like East Rand and Soweto in the early aughts, and have obvious predecessors like fellow street dancers the pantsula and the 1950s swenka subculture of miners who wore expensive tailored suits. The skhothane come from South Africa's poorest classes and thus wearing—and destroying—expensive clothes and goods is a way to prove their upward mobility and reserves of cash.

Skhothane come from the "born free" generation of South Africans who have no memory of apartheid. They're known to wear outfits costing as much $1,200 and favor designer Italian labels like Arbiter, Rossi Moda, and Sfarzo.

During crew battles, some skhothane wear multiple pairs of pants or shirts, taking one off to destroy it while revealing yet another expensive garment just beneath it. Other skhothane prefer to show their wealth by buying multiple pairs of expensive Italian Carvela shoes in different colors and then wearing them in mismatched sets with one on each foot.

Skhothane destroy luxury goods by burning, ripping, biting, or stomping. In addition to luxury clothes, skhothane destroy bottles of Johnnie Walker Blue Label scotch, fried chicken, smartphones, and even cash during their battles.

Skhothane listen to hip-hop and house from the United States and South Africa, but are particularly tied to local kwaito music, which mixes those genres with township influences and slang.

After years of negative media attention and a crackdown on street parties by South African cops, the skhothane seem to be dying out, shifting to other less destructive but still luxury-obsessed crews of street dancers.

Wearing two different expensive shoes at the same time is a display of wealth

THE CULTURE Skhothane crews boast vibrant names, like the Commandos, the 18 Boys, the Milano Boys, Reflection Destructor Crew, the Sexy Boys, and the Material Boys.

SKHOTHANE

ORIGIN: EAST RAND AND SOWETO, 2000s
TOWNSHIP STREET DANCERS WITH MONEY TO BURN

Athletic warm-up pants
are layered over expensive
designer trousers

Bucket hats cross over
from pantsula dancers

Skhothane crews favor
bright floral prints

THE SOUND

"Izkhothane,"
Imali Yami, 2012
"The Calling (Full Truck),"
Bekzin Terris, 2013
"Babize Skhothane,"
Benga Boys, 2013
"Mlume Bobby (feat.
D-zaya and Scandalous),"
Shisaboy, 2014
"Too Much Information (Laolu
Remix (Edit))," Dele Sosimi
Afrobeat Orchestra, 2015

THE LOOK

Skhothane wear piles
of expensive Italian
clothes from labels like
Arbiter, Rossi Moda, and
Sfarzo. They love bright
floral prints and outlandish
colors, sometimes turning
to flashy activewear from Nike
to complement their high end
Italian looks. Skhothane also
wear bucket hats and Carvela
loafers or Nike sneakers and
soccer shoes in the brightest
colors they can find. Unlike the
related pantsula, skhothane
crews don't wear matching
outfits, instead opting for
bright florals and prints in
complementary color palettes.

STATUS LIQUOR:
JOHNNIE WALKER BLUE LABEL

Mike Saes started the urban run crew phenomenon, founding the NYC Bridge Runners after jogging over the Williamsburg Bridge to pick his son up from school one afternoon when he couldn't catch a cab. Realizing that running could be an adventure, he enlisted some downtown friends to join him, creating a new athletic subculture that mixed exercise and urban adventure with a little bit of partying.

Other crews soon followed, notably, Black Roses NYC, which spun off from the NYC Bridge Runners, and Run Dem Crew in London, founded by poet and DJ Charlie Dark in 2007.

Sensing an opportunity, big shoe companies like Nike took an interest in these run crews, sponsoring some and urging them to promote themselves (and their corporate backers) on Instagram with hashtags like #bridgethegap.

Corporate involvement, hasn't sat well with everyone. Orchard Street Runners founder Joe DiNoto has been particularly critical of corporate involvement among run crews, claiming it weakens the scene and attracts more traditional jockish runners.

These run crews illuminate some of the changing meanings of subcultures in the twenty-first century. Like many newer subcultures, they have strong Internet presences. They aren't afraid of corporations, and unlike past subcultures like the Polo-obsessed Lo Lifes, it's hard to say that run crews are subverting corporate influence by repositioning brands and logos to suit their own needs. However, with their insistence that running be an adventure, not to mention their partying, the urban run crews stand in opposition to more traditional organizations like the New York Road Runners. Like subcultures of the past, they also exist to meet up in person and are deeply tied to their home cities, where they definitely overlap with and draw power from influences like hip-hop and dance music.

Many members of run crews combine activewear with streetwear prints like camouflage

Rare running shoes are popular with run crews

THE CULTURE Many run crews conduct their outings at night, giving them the opportunity to explore and socialize at an hour traditional run clubs have deemed dangerous.

ORIGIN: NEW YORK, 2000s
URBANITES MIX RUNNING WITH ADVENTURE AND PARTYING

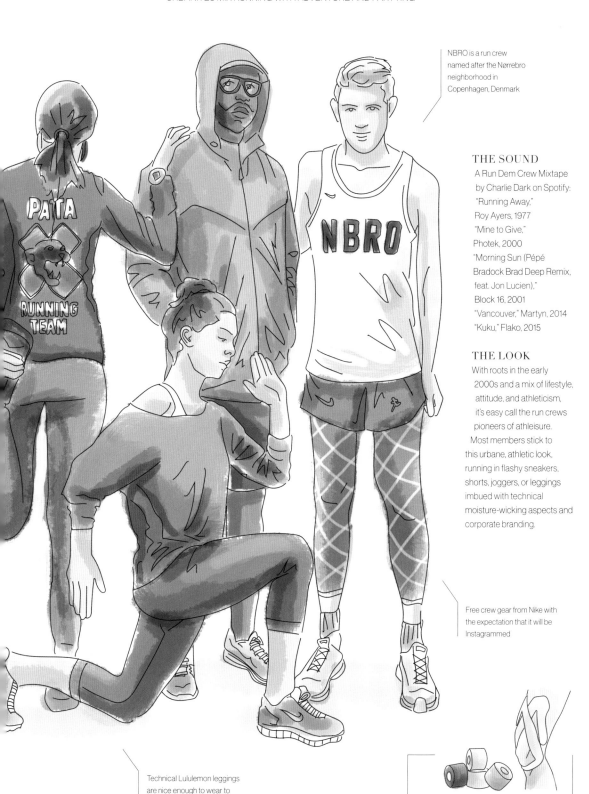

NBRO is a run crew named after the Nørrebro neighborhood in Copenhagen, Denmark

THE SOUND

A Run Dem Crew Mixtape by Charlie Dark on Spotify:
"Running Away,"
Roy Ayers, 1977
"Mine to Give,"
Photek, 2000
"Morning Sun (Pépé Bradock Brad Deep Remix, feat. Jon Lucien),"
Block 16, 2001
"Vancouver," Martyn, 2014
"Kuku," Flako, 2015

THE LOOK

With roots in the early 2000s and a mix of lifestyle, attitude, and athleticism, it's easy call the run crews pioneers of athleisure. Most members stick to this urbane, athletic look, running in flashy sneakers, shorts, joggers, or leggings imbued with technical moisture-wicking aspects and corporate branding.

Free crew gear from Nike with the expectation that it will be Instagrammed

Technical Lululemon leggings are nice enough to wear to drinks after running session

KINESTHETIC TAPE SUPPORTS INJURIES

Cutesters are a loosely-defined culture of English twentysomething adults who prefer nostalgia, sweetness, cartoons, and cereal to drinking, drugs, and music. As a primarily online culture, they have no set areas in which they hang out, and are more likely to converse on Twitter and Tumblr than in real life. That said, cutesters are known to attend fun, community-driven events like London's Secret Cinema, and enjoy eating breakfast cereal at places like the Cereal Killer Cafe on Brick Lane. In contrast to attitude-driven, drug-addled hipsters, cutesters are friendly and open, preferring to be inclusive instead of alienating people.

Cutester fashion focuses on comfort and cartoon graphics, with T-shirts and sweatshirts bearing cartoon characters like Spongebob Squarepants and Hello Kitty. Part of this style is Tumblr driven and has high-end influences like Miley Cyrus, Katy Perry, and Jeremy Scott.

Instead of traditional sailor tattoos, cutesters get tattoos of things like emojis.

Despite not necessarily being unified by music, cutesters prefer happy pop music from the likes of Taylor Swift to anything hip and dark.

Vice UK recently claimed cutesters were a symptom of a gentrifying London and accused them of trying to live a quaint, twee lifestyle in one of the the largest, roughest cities in the world.

At the same time, the *Evening Standard* traced the rise of cutesters to the decline of traditional hipster industries, like television and print media, claiming cutesters were able to happily support themselves because of their innate millennial talents for using social media platforms like Twitter and Tumblr.

Whether cutesters prove to be a blip on the cultural radar or a long-lasting influence on youth culture remains to be seen.

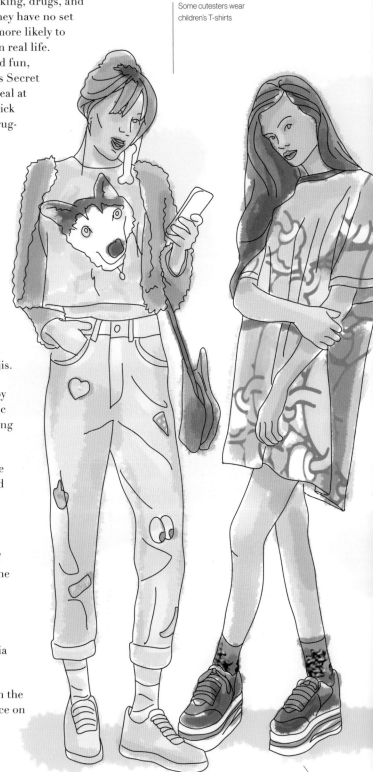

Some cutesters wear children's T-shirts

Flatform sneakers and other '90s retro styles are popular with cutesters

THE CULTURE As millennials, cutesters have a streak of '90s nostalgia, idealizing things like Nickelodeon's cartoons of the day, including Doug and Rugrats.

ORIGIN: LONDON, 2010s
ADULTS LOOK TO KEEP CHILDLIKE WONDER ALIVE IN LONDON

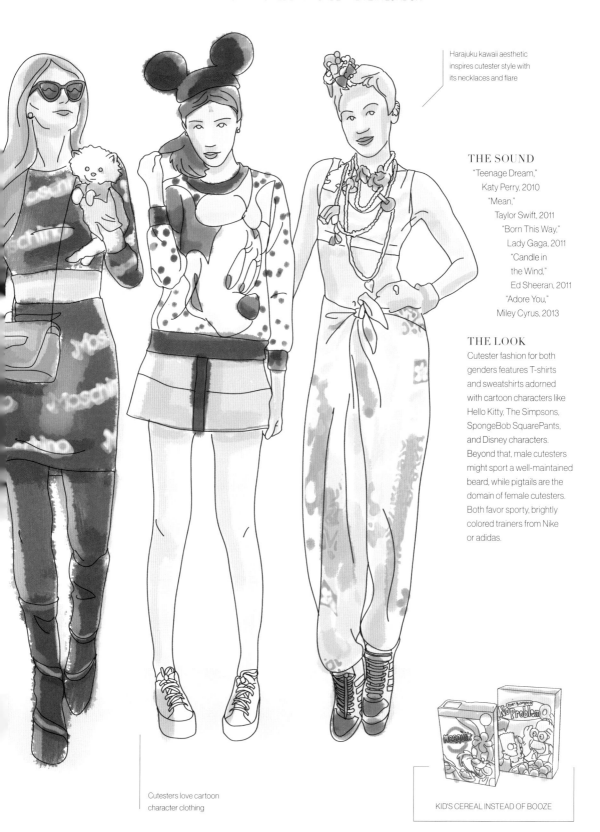

Harajuku kawaii aesthetic
inspires cutester style with
its necklaces and flare

THE SOUND

"Teenage Dream,"
Katy Perry, 2010
"Mean,"
Taylor Swift, 2011
"Born This Way,"
Lady Gaga, 2011
"Candle in
the Wind,"
Ed Sheeran, 2011
"Adore You,"
Miley Cyrus, 2013

THE LOOK

Cutester fashion for both
genders features T-shirts
and sweatshirts adorned
with cartoon characters like
Hello Kitty, The Simpsons,
SpongeBob SquarePants,
and Disney characters.
Beyond that, male cutesters
might sport a well-maintained
beard, while pigtails are the
domain of female cutesters.
Both favor sporty, brightly
colored trainers from Nike
or adidas.

Cutesters love cartoon
character clothing

KID'S CEREAL INSTEAD OF BOOZE

VAPORWAVE

As retro-inspired as chillwave, but with a darker,
subtly sardonic side to the pretty, drifting tunes

"Beach Walk," Whitewoods, 2010

"Everything Is Working," Games, 2010

"Watching Your Dance," 18 Carat Affair, 2011

"Find Out What's On Carrie Bradshaw's iPod,"
James Ferraro, 2011

"I Need a Moment," Teamm Jordann, 2011

"World of Regret," Ford & Lopatin, 2011

"Omni Island," Dreams West, 2012

"Rejoice," Napolian, 2012

"Teen Pregnancy," Blank Banshee, 2012

"Uptown Psychedelia," Tim Hecker & Daniel Lopatin, 2012

"Banned From Living," GLOOMCVLT, 2013

"Milo De Venus," Jacob 2-2, 2013

"Ryan Gosling," Mensa Group International, 2013

"Saint Pepsi," Private Caller, 2013

"Social," Everglade, 2013

"Summer Night," ESPRIT, 2013

"Windows '95 Mind Travel Software," CYBEREALITY, 2013

"Adorn Your Ankle," Phil Gerus, 2014

"Cimarron," Luxury Elite, 2014

"Whispers.wav," ESPRIT 空想, 2014

"恢复," 2 8 1 4, 2015

TRIBAL

Shine up your boots— the pointier the better—
and head onto the floor where EDM synths
meet cumbia beats.

"Los Acordeones," Dj Manuel Palafox, 2009

"Lambada," Dj Tetris & Aycan, 2010

"Virus", Dj Mouse, 2010

"Inténtalo (ft. El Bebeto, América Sierra)," 3Ball MTY, 2011

"Tierra Azteca (Aztecs in Berlin)," Dj Erik Rincón, 2011

"Botas Picudas," Dj Elmo, 2012

"El Berimbau," Ricardo Reyna, 2012

"El Boom," Danny Guillén, 2012

"Barrio Loco (ft. Kuntry Locos)," DH Sheeqo, 2013

"Grito Badú," Clap Freckles, 2013

"Porque el amor manda (ft 3Ball MTY)," América Sierra, 2013

"Ritmo Suelto," Dj Alan Rosales, 2014

"Dum Dum," Tribal Beats, 2015

"Enamorado de tu culo," Ghetto Kids, Happy Colors, Alan
Rosales, 2015

"Quetzal," DJ Otto, 2015

"Quiero tenerte," Sergio Lugo, 2015

"Tlaloc," Alfonso Luna, 2015

"Trapanera (ft Erick Rincón)," El Dusty, 2015

"Aerosol Can (Ghetto Kids & Alan Rosales Remix),"
Major Lazer, 2015

"Universe Tribal," Yamil, 2015

EDM

Rave returns as pop under the umbrella of electronic
dance music, which combines house, techno, dubstep,
and trap, often at massive outdoor festivals

"Pon De Floor," Major Lazer, 2009

"Scary Monsters and Nice Sprites," Skrillex, 2010

"Levels," Avicii, 2011

"Promises," Nero, 2011

"Greyhound," Swedish House Mafia, 2012

"Icarus," Madeon, 2012

"Let's Go (feat. Ne-Yo)," Calvin Harris, 2012

"Money Makin," A Trak, & Fillon Francis, 2012

"Take You Down," Bassnectar, 2013

"Shotgun," Zedd, 2012

"The Alphabet," David Guetta, 2012

"We Own The Night (feat. Luciana)," Tiesto
& Wolfgang Gartner, 2012

"Boneless," Steve Aoki, 2013

"Power Glove," Knife Party, 2013

"Hadouken," Zeds Dead, 2014

"Love Death Immortality," The Glitch Mob, 2014

"Selfie," The Chainsmokers, 2014

"Let's Go," Calvin Harris ft. Ne-Yo, 2012

 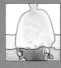 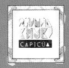

NU-CUMBIA

*Cumbia for the twenty-first century, complete with digital
beats and nods to the genre's folkloric past*

"Cumbia sobre el río," Celso Piña, 2001

"Cumbion Mountain," Up, Bustle & Out, 2007

"Bienvenidos," Systema Solar, 2009

"Bocanegra!," Sonido Gallo Negro, 2009

"Cumbia," Instituto Mexicano del Sonido, 2009

"Fuego," Bomba Estéreo, 2009

"Sodoma y Gamarra," Bareto, 2009

"Ariwacumbé," Frente Cumbiero, 2010

"Half Colombian Half Mexican Bandit," Toy Selectah, 2010

"Popcorn Andino," Chicha Libre, 2010

"Queremos paz (King Koya Remix)," Gotan Project, 2011

"Capicúa," Animal Chuki, 2012

"Cumbio," Campo, 2012

"Cumbia Espacial," Ondatrópica, 2012

"Cumbia Rebelde," Puerto Candelaria, 2012

"Chichón," Dengue Dengue Dengue!, 2013

"Crop Circles," Frikstailers, 2013

"Viene de mi," La Yegros, 2013

"Jardines," Chancha via Circuito, 2014

"Colibria," Nicola Cruz, 2015

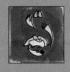 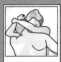

CHILLWAVE

*Like a faded Polaroid, the smooth sounds of the late '70s
and early '80s get filtered through a modern DIY vibe*

"Camouflage," Small Black, 2010

"You Can Count On Me," Panda Bear, 2010

"Hey Moon," John Maus, 2011

"Polish Girl," Neon Indian, 2011

"Within And Without," Washed Out, 2011

"Yes I Know," Memory Tapes, 2011

"Obedear," Purity Ring, 2012

"Belief & Experience," Leif, 2013

"In Two," Blue Hawaii, 2013

"Rose Quartz," Toro Y Moi, 2013

"While You Dooooo (Extended)," Teebs, 2013

"Without You," Lapalux, 2013

"Lipstick," Ariel Pink, 2014

"Stop Suffering," Tropic of Cancer, 2015

"Backbone," Beacon, 2016

"Body Wash," Mndsgn, 2016

"Kathy Lee," Jessy Lanza, 2016

"Nothing But Scenery," Nite Jewel, 2016

"Oh," Mt. Si, 2016

"Sunspot," Com Truise, 2016

TROPICAL HOUSE

*Deep house grooves get a dancehall lilt
and some Balearic bounce*

"Jubel (Nora En Pure Remix)," Klingande, 2014

"Clean Break, (feat. Raphaella)," LCAW, 2016

"Metaphysical (feat. Janelle Kroll)," Autograf, 2015

"Dreamreacher (feat. Chevrae & Dumang)," Bakermat, 2016

"Sommer Am Meer (Original)," Felix Jaehn, 2014

"Cheerleader (Felix Jaehn Remix)," OMI, 2015

"Show Me Love," Sam Feldt

"Epsilon," Kygo, 2013

"Make Me Feel Better," Alex Adair, 2016

"Stay (feat. Maty Noyes)," Kygo, 2016

"Sunday (Klangkarussell Remix)," Max Manie, 2013

"In Too Deep," Lost Frequencies, 2016

"Come With Me," Nora En Pure, 2014

"Faded (Original Mix)," Zhu, 2014

"On Trees And Birds And Fire (Sam Feldt & Bloombox Remix)," I
Am Oak, 2014

"Sonnentanz," Klangkarussell, 2014

"Body Talk (Bakermat Remix)," Foxes, 2015

"Coming Over," James Hersey, 2015

"Fast Car (feat. Dakota)," Jonas Blue, 2015

"Ocean Drive (Extended Mix)," Duke Dumont, 2015

"Simple Life," Seeb, 2015

"Talking Body (Gryffin Remix)," Tove Lo, 2015

"Me Without You (Ghosts of Venice Remix)," Le Youth, 2016

"This Girl (Kungs Vs. Cookin' On 3 Burners)," Kungs, 2016

12 O'Clock Boys. Directed by Lotfy Nathan. Los Angeles: Mission Films/Prospekt, 2013.

"1964: Mods and Rockers Jailed after Seaside Riots." BBC News. May 18, 1964. Accessed July 27, 2016. http://news.bbc.co.uk/onthisday/hi/dates/stories/may/18/news-id_2511000/2511245.stm.

"200 Youths in City Gang Brawl." The Age. August 1, 1966. Accessed October 1, 2016. https://news.google.com.au/newspapers?id=NwIRAAAAIBAJ&sjid=YZM-DAAAAIBAJ&pg=4362,4918&dq=mods%20sharpies&hl=en.

80 Blocks from Tiffany's. Directed by Gary Weis. New York: Above Average Productions Inc., 1979.

Abbots, Jennifer. "True 'Skinheads' Are Not the Racist Thugs of Media Fame." The New York Times. April 18, 1994. Accessed July 7, 2016. http://www.nytimes.com/1994/04/19/opinion/l-true-skinheads-are-not-the-racist-thugs-of-media-fame-829412.html.

"Accent On Youth in Wash 'N' Wear; Survey Expects Ivy League Style to Lift '58 Sales in Summer Suits Decline Seen for Wool." The New York Times. August 14, 1957. Accessed October 1, 2016. http://query.nytimes.com/gst/abstract.html?res=9405E1DE133EE23BBC4C52DFBE66838C649EDE.

Allen, Samantha. "How Hipsters Are Spreading Zika in Miami." Daily Beast. August 4, 2016. Accessed July 20, 2016. http://www.thedailybeast.com/articles/2016/08/04/how-hipsters-are-spreading-zika-in-miami.html.

Anderson, Tammy L. "Understanding the Alteration and Decline of a Music Scene: Observations from Rave Culture." Sociological Forum 24, no. 2 (June 2009): 307–36.

"Another Battle in an Unwinnable War." The Economist. May 29, 2010. Accessed July 27, 2016. http://www.economist.com/node/16219727.

Aoki, Shōichi. Fresh Fruits. London: Phaidon, 2005.

Arvidsson, Adam. Marketing Modernity: Italian Advertising from Fascism to Postmodernity. London: Routledge, 2003.

Associated Press. "Ken Kesey's Original Magic Bus Being Restored." Today. January 20, 2006. Accessed August 2, 2016. http://www.today.com/id/10792061#.V3hF2ZMrJ8c.

Auslander, Philip. "I Wanna Be Your Man: Suzi Quatro's Musical Androgyny." Popular Music 23, no. 1 (2004): 1–16.

———. Performing Glam Rock: Gender and Theatricality in Popular Music. Ann Arbor, MI: University of Michigan Press, 2006.

Azerrad, Michael. Come as You Are: The Story of Nirvana. New York: Random House, 1993.

———. Our Band Could Be Your Life: Scenes from the American Rock Underground 1981–1991. Boston: Little, Brown, 2001.

Bacardi, Francesca. "Human Barbie Valeria Lukyanova Answers Plastic Surgery Questions and Talks the Misconceptions of Her Looks." E! Online. June 28, 2016. Accessed August 2, 2016. http://www.eonline.com/news/776381/human-barbie-valeria-lukyanova-answers-plastic-surgery-questions-and-talks-the-misconceptions-of-her-looks.

Back, Les. "Voices of Hate, Sounds of Hybridity: Black Music and the Complexities of Racism." Black Music Research Journal 20, no. 2 (2000): 127–49.

Bailey, Marlon M. "Engendering Space: Ballroom Culture and the Spatial Practice of Possibility in Detroit." Gender, Place & Culture 21, no. 4 (2013): 489–507.

Baldwin, Guy, and Joseph W. Bean. Ties That Bind: The SM/leather/fetish Erotic Style: Issues, Commentaries, and Advice. Los Angeles: Daedalus Pub, 2003.

Balsley, Gene. "The Hot-Rod Culture." American Quarterly 2, no. 4 (Winter 1950): 353–58.

Banks, Alec. "5 African Fashion Subcultures That You Should Know About." Highsnobiety. May 30, 2016. Accessed November 5, 2016. http://www.highsnobiety.com/2016/05/30/african-fashion-subcultures.

Banks, Jeffrey, and Doria de La Chapelle. Preppy: Cultivating Ivy Style. New York: Rizzoli, 2011.

Barger, Ralph, Keith Zimmerman, and Kent Zimmerman. Hell's Angel: The Life and Times of Sonny Barger and the Hell's Angels Motorcycle Club. New York: William Morrow, 2000.

Barrère, Albert, and Charles Godfrey Leland. A Dictionary of Slang: Embracing English, American, and Anglo-Indian Slang, Pidgin English, Gypsies' Jargon and Other Irregular Phraseology. London: George Bell & Sons, 1897.

Barry, John. "I Against I." Baltimore City Paper. October 15, 2008. Accessed August 19, 2016. http://www.citypaper.com/bcp-i-against-i-20150313-story.html.

Bayart, Jean-François. Global Subjects: A Political Critique of Globalization. Cambridge, UK: Polity, 2008.

Bayer, Gerd. Heavy Metal Music in Britain. Farnham, UK: Ashgate, 2009.

Beck, Laura. "Human Ken Almost Dies after a Key Body Part Starts Dissolving." Cosmopolitan. April 16, 2016. Accessed August 2, 2016. http://www.cosmopolitan.com/lifestyle/news/a56978/human-ken-almost-dies/.

Bennett, Colette. "Otaku: Is It a Dirty Word?" Geek Out. CNN. September 12, 2011. Accessed August 11, 2016. http://geekout.blogs.cnn.com/2011/09/12/otaku-is-it-a-dirty-word/.

Bentley, Jules. "Everyone Hates the Oogles: Exploring the Animosity towards New Orleans' Panhandling Punks." Antigravity Magazine. Accessed August 9, 2016. http://www.antigravitymagazine.com/2012/09/new-orleans-oogle/.

"Biker Gang Ranks Fall below 10,000." Japan Times. February 11, 2011. Accessed August 28, 2016. http://www.japantimes.co.jp/news/2011/02/11/national/biker-gang-ranks-fall-below-10000/.

Birnbach, Lisa. The Official Preppy Handbook. New York: Workman Pub., 1980.

Birnbach, Lisa, and Chip Kidd. True Prep: It's a Whole New Old World. New York: Alfred A. Knopf, 2010.

Bisbort, Alan. Beatniks: A Guide to an American Subculture. Santa Barbara, CA: Greenwood Press/ABC-CLIO, 2010.

Bloom, Clive. "Teenage Rampage: Mods vs Rockers, 1964." History Today 64, no. 7 (July 2014). Accessed August 11, 2016. http://www.historytoday.com/clive-bloom/teenage-rampage-mods-vs-rockers-1964.

Bloom, Joshua, and Waldo E. Martin, Jr. Black against Empire: The History and Politics of the Black Panther Party. Berkeley, CA: University of California Press, 2013.

Blush, Steven. American Hair Metal. Los Angeles: Feral House, 2006.

Blush, Steven, and Dom Franceschi. American Hardcore. Rosières-en-Haye: Camion Blanc, 2010.

Bock, Jannika. Riot Grrrl: A Feminist Re-interpretation of the Punk Narrative. Saarbrücken: VDM Verlag Dr. Müller, 2008.

Bollen, Christopher. "Michael Alig." Interview Magazine. April 13, 2010. Accessed August 30, 2016. http://www.interviewmagazine.com/culture/michael-alig/.

Bradley, Louis. "The Rise of the Ralph Lauren Roadman." Tab Manchester. November 11, 2015. Accessed August 2, 2016. http://thetab.com/uk/manchester/2015/11/1/rise-ralph-lauren-roadman-15638.

Brake, Mike. Comparative Youth Culture: The Sociology of Youth Cultures and Youth Subcultures in America, Britain, and Canada. London: Routledge & K. Paul, 1985.

Brewin, John. "Hooliganism in England: The Enduring Cultural Legacy of Football Violence." ESPNFC. February 4, 2015. Accessed August 25, 2016. http://www.espnfc.us/blog/espn-fc-united-blog/68/post/2193850/hooliganism-in-england-the-enduring-cultural-legacy-of-football-violence.

"Britain: The Skinheads." TIME. June 8, 1970. Accessed July 27, 2016. Accessed August 24, 2016. http://content.time.com/time/magazine/article/0,9171,909318,00.html.

Brook, James. Reclaiming San Francisco: History, Politics, Culture. San Francisco: City Lights Books, 1998.

Brown, Cecil. Stagolee Shot Billy. Cambridge, MA: Harvard University Press, 2003.

Browne, David. So Many Roads: The Life and Times of the Grateful Dead. Boston, MA: Da Capo Press, 2015.

Bui, Paul. "The Secrets of the Living Dolls." i-D. January 6, 2014. https://i-d.vice.com/en_us/article/the-secrets-of-the-living-dolls.

Burdick, Eugene. "The Politics of the Beat Generation." Political Research Quarterly 12, no. 2 (1959): 553–55.

Busselen, Lies. "Lemma Kindoubil." Academia. Accessed October 1, 2016. Accessed August 2, 2016. http://www.academia.edu/3270646/Lemma_Kindoubil.

Butler, Oobah. "I Tried to Find and Join Britain's Remaining Style Tribes." Vice. September 20, 2016. Accessed August 20, 2016. http://www.vice.com/en_uk/read/i-tried-to-ingratiate-myself-with-britains-remaining-style-tribes-subculture.

Cabral, Javier. "Why Do Mexican Americans Love Morrissey So Much?" Washington Post. October 8, 2014. Accessed August 11, 2016. https://www.washingtonpost.com/posteverything/wp/2014/10/08/why-do-mexican-americans-love-morrissey-so-much/.

Cacciottolo, Mario. "The Return of the English Disease?" BBC News. April 6, 2007. Accessed August 2, 2016. http://news.bbc.co.uk/2/hi/uk_news/6532989.stm.

Calderón-Douglass, Barbara. "The Folk Feminist Struggle Behind the Chola Fashion Trend." Vice. April 13, 2015. Accessed July 2, 2016. http://www.vice.com/read/the-history-of-the-chola-456.

Califia, Patrick, and Robin Sweeney. The Second Coming: A Leatherdyke Reader. Los Angeles: Alyson Publications, 1996.

Callahan, Kat. "The Bosozoku Are Japan's Disappearing Rebels Without a Cause." Jalopnik. October 4, 2014. Accessed August 28, 2016. http://jalopnik.com/the-bosozoku-are-japans-disappearing-rebels-without-a-c-1642416129.

Calvert, John. "A Beginner's Guide to No Wave, New York's Middle Finger to the World." FACT Magazine. March 10, 2014. Accessed August 1, 2016. http://www.factmag.com/2014/03/10/a-beginners-guide-to-no-wave/.

Cameron, Keith. Mudhoney: The Sound and the Fury from Seattle. Stillwater, MN: Voyageur Press, 2014.

Capistrano, Daniela. "Afro-Punk Scene, Inspired by Santogold, TV On The Radio and More, Explodes into a Multi-Genre Movement." MTV. September 12, 2008. Accessed August 22, 2016. http://www.mtv.com/news/1601283/afro-punk-scene-inspired-by-santogold-tv-on-the-radio-and-more-explodes-into-a-multi-genre-movement/.

Carone, Angela. "Mexican Pointy Boots Have Me Speechless." KPBS Public Media. May 16, 2011. Accessed August 2, 2016. http://www.kpbs.org/news/2011/may/16/mexican-pointy-shoes-have-me-speechless/.

Casburn, Melissa M. "A Concise History of the British Mod Movement." Greater Bay Area Costumers Guild. 2003. Accessed August 2, 2016. http://www.gbacg.org/costume-resources/original/articles/mods.pdf.

Catarinella, Alex. "Venus X: These Are a Few of Her Favorite Things." *MTV*. February 4, 2013. Accessed July 27, 2016. http://www.mtv.com/news/2518218/venus-x-these-are-a-few-of-her-favorite-things/.

Cateforis, Theo. *Are We Not New Wave?: Modern Pop at the Turn of the 1980s.* Ann Arbor, MI: University of Michigan Press, 2011.

Cawelti, John G. *Mystery, Violence, and Popular Culture: Essays.* Madison, WI: University of Wisconsin Press, 2004.

Century, Douglas. *Street Kingdom: Five Years inside the Franklin Avenue Posse.* New York: Warner Books, 1999.

Chang, David. "ATVs Confiscated During 'Ride Out' for Meek Mill." *NBC 10 (Philadelphia).* March 21, 2015. Accessed July 27, 2016. http://www.nbcphiladelphia.com/news/local/Police-Confiscate-ATVs-Dirt-Bikes-During-Ride-Out-for-Meek-Mill-297136401.html.

Chang, Jeff. *Can't Stop, Won't Stop: A History of the Hip-hop Generation.* New York: St. Martin's Press, 2005.

"Charlie Dark & Run Dem Crew." Sonos Studio. August 8, 2015. Accessed July 27, 2016. http://studio.sonos.com/article/charlie-dark-run-dem-crew.

Chensvold, Christian. "Damned Dapper: The Preppy 'Go-to-Hell' Look." *Huffington Post.* June 1, 2010. Accessed July 27, 2016. http://www.huffingtonpost.com/christian-chensvold/damned-dapper-the-preppy_b_512406.html.

Chidester, Brian. "Eden Ahbez: The Hippie Forefather's Final Statement to the World." *L.A. Weekly.* February 18, 2014. Accessed October 1, 2016. http://www.laweekly.com/music/eden-ahbez-the-hippie-forefathers-final-statement-to-the-world-4439667.

The Children's Society. *New Travellers, Old Story.* London: The Children's Society, 2010. Accessed July 27, 2016. https://schools-secure.essex.gov.uk/pupils/EMTAS Ethnic Minority and Traveller Achievement Service/Gypsy_Roma_Travellers/Documents/New Travellers Report - The Childrens Society.pdf.

Childs, Peter, and Mike Storry. *Encyclopedia of Contemporary British Culture.* London: Routledge, 1999.

Christe, Ian. "Seven African Metal Bands to Check Out." Noisecreep. August 14, 2012. Accessed August 1, 2016. http://noisecreep.com/african-heavy-metal-bands/.

Clarity, James F. "Ireland's Range War: Urban Cowboys vs. the Law." *The New York Times.* November 12, 1996. Accessed August 21, 2016. http://www.nytimes.com/1996/11/13/world/ireland-s-range-war-urban-cowboys-vs-the-law.html?pagewanted=1.

Clayton, Jace. "Tribal Guarachero: Mexican Teens & Aztec History." *The FADER.* October 13, 2010. Accessed August 3, 2016. http://www.thefader.com/2010/10/13/feature-in-tribal-guarachero-teenage-wilders-rebirth-aztec-history/.

Clemente, Deirdre. "Caps, Canes, and Coonskins: Princeton and the Evolution of Collegiate Clothing, 1900 -1930." *The Journal of American Culture* 31, no. 1 (2008): 20–33.

Clifton, Jamie. "The Illegal Dirt Bike Gangs of Baltimore." *Vice.* July 3, 2012. Accessed August 7, 2016. http://www.vice.com/read/the-wheelying-dirt-bike-gangs-of-baltimore-twelve-o-clock-boyz-lofty-nathan.

Coates, Stephen, ed. *X-Ray Audio: The Strange Story of Soviet Music 'On the Bone.'* London: Strange Attractor Press, 2015.

Cobo, Leila. "Daddy Yankee Remembers 'Gasolina' 10 Years Later: 'I Knew It Was a Home Run'" *Billboard.* August 10, 2014. Accessed August 21, 2016. http://www.billboard.com/articles/columns/latin-notas/6207108/daddy-yankee-on-gasolina-barrio-fino-reggaeton-10-years-later-i-knew-it-was-a-home.

Cohen, Edwin. "Neither Hero nor Myth: Woody Guthrie's Contribution to Folk Art." *Folklore* 91, no. 1 (1980): 11–14.

Collin, Matthew. *Altered State: The Story of Ecstasy Culture and Acid House.* London: Serpent's Tail, 1998.

Conley, Kirstan, and Natasha Velez. "NYPD: Let Dirt Bikers Go 'Flee.'" *New York Post.* June 24, 2013. Accessed August 16, 2016. http://nypost.com/2013/06/24/nypd-let-dirt-bikers-go-flee/.

Conor, Liz. *The Spectacular Modern Woman: Feminine Visibility in the 1920s.* Bloomington, IN: Indiana University Press, 2004.

Copsey, Nigel, and John E. Richardson, ed. *Cultures of Post-War British Fascism.* Routledge Studies in Fascism and the Far Right. New York: Routledge, 2015.

Coscarelli, Joe. "Tapers' at the Grateful Dead Concerts Spread the Audio Sacrament." *The New York Times.* July 5, 2015. Accessed August 11, 2016. http://www.nytimes.com/2015/07/06/arts/music/tapers-at-the-grateful-dead-concerts-spread-the-audio-sacrament.html.

Covey, Herbert C. *Street Gangs throughout the World.* Springfield, IL: Charles C. Thomas, Publisher, 2003.

Crenner, James. "The Dance in the School Gym." *The Antioch Review* 46, no. 1 (1988): 79.

Cuellar, Jose. "The Rise and Spread of Cholismo as a Border Youth Subculture." Presentation at the Southwest Border Regional Conference's Third Annual Binational Border Governors' Conference, Tijuana, BC, Mexico, September 21, 1982.

Cummings, Laura. *Pachucas and Pachucos in Tucson: Situated Border Lives.* Tucson, AZ: University of Arizona Press, 2009.

Cummings, Scott, and Daniel J. Monti. *Gangs: The Origins and Impact of Contemporary Youth Gangs in the United States.* Albany, NY: State University of New York Press, 1993.

Dalphond, Denise. "Detroit Techno." In *African American Music: An Introduction,* 2nd ed., edited by Portia K. Maultsby, 335–53. New York: Routledge, 2014.

Dalton, Tim. *Album Rescue Series.* Raleigh, NC: Lulu, 2015.

Daruvalla, Abi. "Dutch Ravers Can Mellow Out as Official Tests Make Ecstasy 'Safe.'" *The Independent.* October 14, 1995. Accessed August 1, 2016. http://www.independent.co.uk/news/world/dutch-ravers-can-mellow-out-as-official-tests-make-ecstasy-safe-1577713.html.

Daschuk, M. Douglas. "Messageboard Confessional: Online Discourse and the Production of the 'Emo Kid.'" *Berkeley Journal of Sociology* 54 (2010): 84–107.

Davidson, Bruce. *Brooklyn Gang.* Santa Fe, NM: Twin Palms Publishers, 1998.

Debord, Guy. *The Society of the Spectacle.* New York: Zone Books, 1994.

De Koningh, Michael. *Suedehead Box Set.* CD TJETD169. London: Trojan Records, 2004.

DeLeon, Jian. "Interview: Just Blaze Breaks Down His Massive Polo Collection." *Complex.* May 9, 2012. Accessed August 21, 2016. http://www.complex.com/style/2012/05/interview-just-blaze-breaks-down-his-massive-polo-collection/.

———. "The Evolution of the Hypebeast: An Illustrated Guide." *Complex.* August 22, 2013. Accessed August 3, 2016. http://www.complex.com/style/2013/08/evolution-of-the-hypebeast/.

Department of Water Resources (State of California). "The California Drought-1976." May 1976. Accessed July 21, 2016. http://www.water.ca.gov/waterconditions/docs/11_drought-1976.pdf.

Detrick, Ben. "Little Mermaid Goes Punk: Seapunk, a Web Joke with Music, Has Its Moment." *The New York Times.* March 3, 2012. Accessed August 21, 2016. http://www.nytimes.com/2012/03/04/fashion/Seapunk-a-Web-Joke-With-Music-Has-Its-Moment.html.

DeVille, Chris. "12 Bands to Know from the Emo Revival." *Stereogum.* October 1, 2013. Accessed August 2, 2016. http://www.stereogum.com/1503252/.

DeWitt, Jack. "Cars and Culture: The American Hot Rod." *The American Poetry Review* 38, no. 3 (May/June 2009): 16–17.

DeWitt, John. *Cool Cars, High Art: The Rise of Kustom Kulture.* Jackson, MS: University of Mississippi Press, 2001.

Diaz, Angel. "Lo End Theory: The Secret History of the Lo-Life Crew." *Complex.* September 23, 2015. Accessed August 1, 2016. http://www.complex.com/style/lo-life-crew-history.

Dinerstein, Joel. "America's National Folk Dance: The Lindy Hop." In *Modernity, Technology, and African American Culture between the World Wars,* 250–282. Amherst: University of Massachusetts Press, 2003.

Dines, Mike. "The Sacralization of Straightedge Punk: Bhakti yoga, Nada Brahma and the Divine Received: Embodiment of Krishnacore." In *Musicological Annual* 50, no. 2 (2014), 147–56.

Dodd, David G., and Diana Spaulding. *The Grateful Dead Reader.* New York: Oxford University Press, 2000.

Dogtown and Z-Boys. Directed by Stacy Peralta. Topanga, CA: Agi Orsi Productions, 2001.

Downey, Tom. "The Beau Brummels of Brazzaville." *Wall Street Journal Magazine.* September 29, 2011. Accessed August 21, 2016. http://tomdowney.net/portfolio/wsj-magazine-september-29-2011/.

Drewery, George. "3 Skulls, Wings & Outlaws – Motorcycle Club Insignia & Cultural Identity." *Inter-Cultural Studies: A Forum on Social Change & Cultural Diversity* 3, no. 2 (Spring 2003), 25–35.

Dubasik, Zac. "10 Years Later: The Nike Pigeon Dunk Riot." *Sole Collector.* February 20, 2015. Accessed August 21, 2016. http://solecollector.com/news/2015/02/10-years-later-the-nike-pigeon-dunk-riot.

Ducker, Eric. "Jerky Boys and Girls: New Boyz, Rej3ctz and More Lead a New Youth Movement." *Los Angeles Times.* June 14, 2009. Accessed August 15, 2016. http://latimesblogs.latimes.com/music_blog/2009/06/jerky-boys-and-girls.html.

Ducreay, Safra. "Cassette Playa Interview." *Sneaker Freaker.* December 15, 2008. Accessed August 21, 2016. http://www.sneakerfreaker.com/articles/Cassette-Playa-Interview/.

Dulaney, William L. "A Brief History of 'Outlaw' Motorcycle Clubs." *International Journal of Motorcycle Studies.* November 2005. Accessed July 10, 2016. http://ijms.nova.edu/November2005/IJMS_Artcl.Dulaney.html.

Duncan, Fiona. "Normcore: Fashion for Those Who Realize They're One in 7 Billion." *The Cut.* February 26, 2014. Accessed July 7, 2016. http://nymag.com/the-cut/2014/02/normcore-fashion-trend.html.

Duncan, Ian. "Baltimore Police Launch Dirt Bike Task Force." *Baltimore Sun.* July 7, 2016. Accessed August 21, 2016. http://www.baltimoresun.com/news/maryland/baltimore-city/bs-md-ci-dirt-bike-task-force-20160707-story.html.

Dunning, Eric, Patrick Murphy, and John Williams. "Spectator Violence at Football Matches: Towards a Sociological Explanation." *The British Journal of Sociology* 37, no. 2 (1986): 221–44.

Echeverri, Natalia. "Cholombianos: An Urban Subculture in Mexico." *Polis*. June 2011. Accessed November 5, 2016. http://www.thepolisblog.org/2011/06/cholombianos-mexican-urban-subculture.html.

Echols, Alice. *Hot Stuff: Disco and the Remaking of American Culture*. New York: W. W. Norton, 2010.

Edgar-Hunt, Robert, Kirsty Fairclough-Isaacs, and Benjamin Halligan. *The Music Documentary: Acid Rock to Electropop*. London: Routledge, 2013.

Edmonds, Kevin. "The CIA, the Cold War, and Cocaine: The Connections of Christopher 'Dudus' Coke." *The North American Congress of Latin America (NACLA)*. Accessed October 1, 2016. https://nacla.org/news/cia-cold-war-and-cocaine-connections-christopher-"dudus"-coke.

Eicher, Joanne B., and Phylissa G. Tortora. "Boardshorts: A Perfect Fit, Sara Oka, Berg Encyclopedia of World Dress and Fashion." *Berg Fashion Library*. 2011. Accessed August 11, 2016. http://www.bergfashionlibrary.com/view/bewdf/BEWDF-v10/EDch101115.xml.

Elan, Priya. "It's Blitz: Birth of the New Romantics." *The Guardian*. May 14, 2010. Accessed August 12, 2016. https://www.theguardian.com/music/2010/may/15/blitz-boy-george-steve-strange-visage.

Elash, Anita. "Dance Craze Tecktonik Spreads Through Europe." *NPR*. April 10, 2010. Accessed August 16, 2016. http://www.npr.org/templates/story/story.php?storyId=88251883.

Empire, Kitty. "Rousing Rave from the Grave." *The Guardian*. October 14, 2006. Accessed August 11, 2016. https://www.theguardian.com/music/2006/oct/15/1.

Enck-Wanzer, Darrel, ed. *The Young Lords: A Reader*. New York: New York University Press, 2010.

Englis, Basil G., Michael R. Solomon, and Anna Olofsson. "Consumption Imagery in Music Television: A Bi-Cultural Perspective." *Journal of Advertising* 22, no. 4 (1993): 21–33.

Epstein, Emily Anne. "The REAL Warriors: Captivating Pictures of the '70s Bronx 'Reapers' Gang That Was Feared and Admired in Equal Measure." *Daily Mail*. September 4, 2012. Accessed August 21, 2016. http://www.dailymail.co.uk/news/article-2198374/The-REAL-Warriors-Stunning-images-inside-captivating-world-feared-70s-Bronx-gang-known-The-Reapers.html.

Eror, Aleks. "How 'Terracewear' Went from Football Casuals to Drake's Wardrobe." Highsnobiety. August 17, 2015. Accessed August 1, 2016. http://www.highsnobiety.com/2015/08/17/football-casual-fashion/.

Evancie, Angela. "The Surprising Sartorial Culture of Congolese 'Sapeurs.'" *NPR*. May 7, 2013. Accessed August 21, 2016. http://www.npr.org/sections/picture-show/2013/05/07/181704510/the-surprising-sartorial-culture-of-congolese-sapeurs.

Ewens, Hannah. "Normcore vs. Health Goth vs. Cutester: I Tried All Three to See Which Sucks Least." *Vice*. December 22, 2015. Accessed August 21, 2016. http://www.vice.com/read/what-i-learnt-from-dressing-up-as-media-invented-london-stereotypes-655.

———. "Why Cybergoth Refuses to Die." *Vice*. March 14, 2016. Accessed August 11, 2016. http://www.vice.com/read/the-past-and-future-of-cybergoth-the-most-maligned-uk-subculture.

Eyerman, Ron, and Scott Barretta. "From the 30s to the 60s: The Folk Music Revival in the United States." *Theory and Society* 25, no. 4 (1996): 501–43.

Fenston, Jacob. "Scraper Bike Fever Spreads, Thanks to YouTube." *NPR*. September 13, 2008. Accessed August 28, 2016. http://www.npr.org/templates/story/story.php?storyId=94318161.

"Flappers Flaunt Fads in Footwear." *The New York Times*. January 29, 1922. Accessed October 1, 2016. http://query.nytimes.com/mem/archive-free/pdf?res=9E0CEF-D91239E133A2575AC2A9679C946395D6CF.

Fletcher, Dan. "Hipsters." *Time*. July 29, 2009. Accessed August 27, 2016. http://content.time.com/time/arts/article/0,8599,1913220,00.html.

Flyin' Cut Sleeves. Directed by Henry Chalfant and Rita Fecher. Sunrise, FL: Alliance Entertainment, 1993.

Flynn, Michael, and David Brotherton. *Globalizing the Streets: Cross-cultural Perspectives on Youth, Social Control, and Empowerment*. New York: Columbia University Press, 2008.

Ford, Dana. "Bandidos vs. Cossacks: Was Biker Shootout over Territory?" *CNN*. May 19, 2015. Accessed August 21, 2016. http://www.cnn.com/2015/05/18/us/biker-brawl-bandidos-cossacks/.

Frank, Gillian. "Discophobia: Antigay Prejudice and the 1979 Backlash against Disco." *Journal of the History of Sexuality* 16, no. 2 (2007): 276–306.

Freeman, Nate. "Extending Street Cred into Outer Space." *The New York Times*. December 14, 2013. Accessed August 21, 2016. http://www.nytimes.com/2013/12/15/fashion/the-street-wear-designer-heron-preston-has-his-eyes-on-nasa.html.

Fresh Dressed. Directed by Sacha Jenkins. New York: Mass Appeal, 2015. Friedman, Amy L. "Being Here as Hard as I Could: The Beat Generation Women Writers." *Discourse* 20, no. 1/2 (Spring 1998): 229–44.

Frost, Amber. "Sharpies: The Mulleted Rocker Kids of '70s Australia." *Dangerous Minds*. June 24, 2013. Accessed July 1, 2016. http://dangerousminds.net/comments/sharpies_the_mulleted_rocker_kids_of_70s_australia#iY1Wc2UdofwVcoLD.99.

Fürst, Juliane. "Prisoners of the Soviet Self?: Political Youth Opposition in Late Stalinism." *Europe-Asia Studies* 54, no. 3 (2002): 353–75.

Galbraith, Patrick W., Huat Kam, Thiam, and Kamm, Björn-Ole. *Debating Otaku in Contemporary Japan*. New York: Bloomsbury Academic, 2015.

Garcia, Mauricio. "Emos vs. Punks." *Vice*. June 1, 2008. Accessed July 1, 2016. http://www.vice.com/read/emos-vs-punks-124-v15n6.

Gartman, David. "Three Ages of the Automobile: The Cultural Logics of the Car." *Theory, Culture & Society* 21, no. 4–5 (October 2004): 169–195.

Garza, Rob. "Listen to Rob Garza's Burning Man Playlist." *Billboard*. August 25, 2014. Accessed July 1, 2016. http://www.billboard.com/articles/news/6229296/thievery-corporation-rob-garza-burning-man-playlist.

Bradley, Adam, and Andrew DuBois. *The Anthology of Rap*. New Haven, CT: Yale University Press, 2010.

Gelder, Ken. "Anachronistic Self-fashioning: Dandyism, Tattoo Communities and Leatherfolk." In *Subcultures: Cultural Histories and Social Practice*, 122–39. New York: Routledge, 2007.

Ginsberg, Allen. *Howl, and Other Poems*. San Francisco: City Lights Pocket Bookshop, 1956.

Glasper, Ian. *Burning Britain: The History of UK Punk, 1980–1984*. London: Cherry Red, 2004.

———. *The Day the Country Died*. Oakland, CA: PM Press, 2014.

"GNI per Capita, Atlas Method." The World Bank, World Development Indicators. 2015. Accessed July 31, 2016. http://data.worldbank.org.

Gearhart, Sarah. "The Genesis of Urban Running Crews." *Strava*. February 3, 2016. Accessed October 1, 2016. http://blog.strava.com/the-genesis-of-urban-running-crews-11328/.

Glasspopcorn. "WTF IS SEAPUNK?" *Dis Magazine*. December 12, 2011. Accessed July 27, 2016. http://dismagazine.com/blog/26777/wtf-is-seapunk/.

Godwin, Richard. "The Cutester: Meet London's Latest Social Stereotype." *Evening Standard*. December 16, 2014. Accessed August 24, 2016. http://www.standard.co.uk/lifestyle/london-life/the-cutester-meet-londons-latest-social-stereotype-9927767.html.

Goehner, Amy Lennard, and Arpita Aneja. "How Grateful Dead Fans Became Deadheads." *Time*. June 26, 2015. Accessed August 21, 2016. http://time.com/3919040/history-deadheads/.

Goldberg, Abbie E. *The Sage Encyclopedia of LGBTQ Studies*. 3 vols. London: SAGE Publications 2016.

Gondola, Ch. Didier. *Tropical Cowboys: Westerns, Violence, and Masculinity in Kinshasa*. Bloomington, IN: Indiana University Press, 2016.

———. "Dream and Drama: The Search for Elegance among Congolese Youth." *African Studies Review* 42, no. 1 (April 1999): 23–48.

Gotty, John. "Reliving The Nike 'Pigeon' Dunk Riot of 2005 with Jeff Staple." *Uproxx*. February 22, 2015. Accessed August 21, 2016. http://uproxx.com/smokingsection/reliving-the-nike-pigeon-dunk-riot-of-2005/.

Government, Lil, and Lil Internet. "Seapunk Washes Up." *Noisey*. March 8, 2012. Accessed July 20, 2016. http://noisey.vice.com/blog/seapunk-washes-up.

Green, Joshua. "Management Secrets of the Grateful Dead." *The Atlantic*. March 2010. Accessed July 28, 2016. http://www.theatlantic.com/magazine/archive/2010/03/management-secrets-of-the-grateful-dead/307918/.

Greenfeld, Karl Taro. *Speed Tribes: Days and Nights with Japan's Next Generation*. New York: HarperCollins, 1994.

Greenwald, Andy. *Nothing Feels Good: Punk Rock, Teenagers, and Emo*. New York: St. Martin's Griffin, 2003.

Gregory, Stanford W., and Jerry M. Lewis. "Symbols of Collective Memory: The Social Process of Memorializing May 4, 1970, at Kent State University." *Symbolic Interaction* 11, no. 2 (1988): 213–33.

Griffin, James. "Made in Queens Documentary." *Bonafide Magazine*. June 25, 2009. Accessed July 15, 2016. http://www.bonafidemag.com/made-in-queens/.

Grossman, Perry. "Identity Crisis: The Dialectics of Rock, Punk, and Grunge." *Berkeley Journal of Sociology* 41:19–40.

Gunst, Laurie. *Born Fi' Dead: A Journey through the Jamaican Posse Underworld*. New York: Henry Holt &, 1995.

Haenfler, Ross. *Straight Edge: Clean-living Youth, Hardcore Punk, and Social Change*. New Brunswick, NJ: Rutgers University Press, 2006.

———. *Subcultures: The Basics*. New York: Routledge, 2014.

Hagedorn, John. *The Insane Chicago Way: The Daring Plan by Chicago Gangs to Create a Spanish Mafia*. Chicago, IL: University of Chicago Press, 2015.

Halfacree, Keith H., Robert M. Kitchin, and Robert M. Kitchen. "'Madchester Rave On': Placing the Fragments of Popular Music." *Area* 28, no. 1 (March 1996): 47–55. The Royal Geographical Society (with the Institute of British Geographers).

Hall, Stuart. "What Is This 'Black' in Black Popular Culture?" In *Black Popular Culture*, edited by Gina Dent, 21–33. Seattle, Bay Press, 1992.

Hall, Stuart, and Tony Jefferson. *Resistance through Rituals: Youth Subcultures in Post-war Britain*. London: Hutchinson, 1976.

Halnon, Karen Bettez. "Heavy Metal Carnival and Dis-alienation: The Politics of Grotesque Realism." *Symbolic Interaction* 29, no. 1 (Winter 2006): 33–48.

Hansen-McKnight, Erin. "Fashion Fridays: Jamaica's Love Affair with the Mesh Marina." Large Up. June 20, 2014. Accessed July 27, 2016. http://www.largeup.com/2014/06/20/fashion-fridays-jamaicas-love-affair-with-the-mesh-marina/.

Harilela, Divia. "The Business of Blogging: Hypebeast." The Business of Fashion. December 05, 2013. Accessed July 15, 2016. https://www.businessoffashion.com/articles/business-blogging/the-business-of-blogging-hypebeast.

Harper, Adam. "Indie Goes Hi-Tech: The End of Analogue Warmth and Cosy Nostalgia." Talk, CTM Festival, Berlin, November 3, 2014. Posted December 30, 2014. Rouge's Foam. http://rougesfoam.blogspot.co.uk/2014/12/indie-goes-hi-tech-end-of-analogue.html.

———. "What Health Goth Actually Means." The FADER. February 16, 2015. Accessed July 21, 2016. http://www.thefader.com/2015/02/16/adam-harper-on-health-goth.

Harper, Phillip Brian. " 'The Subversive Edge': Paris Is Burning, Social Critique, and the Limits of Subjective Agency." Diacritics 24, no. 2/3 (1994): 90.

Harris, John. "The New Wave of Old Rubbish." The Guardian. October 13, 2006. Accessed July 17, 2016. https://www.theguardian.com/music/2006/oct/13/electronicmusic.popandrock.

Haslam, Dave. Life after Dark: A History of British Nightclubs and Music Venues. London: Simon & Schuster UK, 2015.

Havlin, Laura. "Teddy Girls: The Style Subculture That Time Forgot." Another. November 25, 2015. Accessed July 15, 2016. http://www.anothermag.com/fashion-beauty/8064/teddy-girls-the-style-subculture-that-time-forgot.

Hayes, Bill. The Original Wild Ones: Tales of the Boozefighters Motorcycle Club. St. Paul, MN: Motorbooks, 2009.

Hazlehurst, Kayleen M., and Cameron Hazlehurst. Gangs and Youth Subcultures: International Explorations. New Brunswick, NJ: Transaction Publishers, 1998.

Healey, Claire M. "Siouxsie, the Batcave and the Legacy of 80s Goth." Dazed. July 27, 2015. Accessed July 20, 2016. http://www.dazeddigital.com/fashion/article/24865/1/siouxsie-sioux-the-batcave-and-the-legacy-of-80s-goth.

———. "The Photographer Who Lensed Japan's Harajuku Trailblazers." Dazed. January 12, 2016. Accessed July 15, 2016. http://www.dazeddigital.com/fashion/article/29001/1/fruits-future-pop-fashion.

Healey, Claire Marie. "Remembering Japan's Badass Schoolgirl Gangs." Dazed. December 5, 2015. Accessed July 30, 2016. http://www.dazeddigital.com/fashion/article/28261/1/remembering-japans-badass-70s-schoolgirl-gangs.

Hebdige, Dick. Subculture: the Meaning of Style. London: Methuen, 1979.

———. Cut 'n' Mix: Culture, Identity, and Caribbean Music. London: Methuen, 1987.

Hendlin, Yogi, Stacey J. Anderson, and Stanton A. Glantz. " 'Acceptable Rebellion': Marketing Hipster Aesthetics to Sell Camel Cigarettes in the US." Tobacco Control 19, no. 3 (June 25, 2010): 213–22.

Hendry, Joy. Interpreting Japanese Society: Anthropological Approaches. London: Routledge, 1998.

Hernandez, Rigoberto. "Wonderful, Ridiculous, Head-Scratchingly Pointy Mexican Boots Are Now a Designer Item." NPR. March 26, 2015. Accessed July 20, 2016. http://www.npr.org/sections/codeswitch/2015/03/26/395391623/wonderful-ridiculous-head-scratchingly-pointy-mexican-boots-are-now-a-designer-i.

Hetherington, Kevin. New Age Travellers: Vanloads of Uproarious Humanity. London: Cassell, 2000.

Hill, Daniel. "Chuck Berry Reviews Classic Punk Records in Unearthed Zine from 1980." Village Voice. July 1, 2014. Accessed July 15, 2016. http://www.villagevoice.com/music/chuck-berry-reviews-classic-punk-records-in-unearthed-zine-from-1980-6642327.

Hindess, Barry. "Folk Devils Rise Again." Social Alternatives 34, no. 4 (October 1, 2015).

Holland, Julie. Ecstasy: The Complete Guide: A Comprehensive Look at the Risks and Benefits of MDMA. Rochester, VT: Park Street Press, 2001.

Holmes, John Clellon. " 'This Is the Beat Generation' by John Clellon Holmes." The New York Times Magazine. November 16, 1952. http://www.litkicks.com/ThisIsTheBeatGeneration.

Houghton, Edwin. "How Jamaica Fell for the Desert Boot: The Story of Reggae's Love Affair with Clarks." Vogue. October 28, 2015. Accessed October 1, 2016. http://www.vogue.com/13365577/history-between-jamaica-and-the-desert-boot-clarks/?mbid=social_twitter

Howard, J. R. "The Flowering of the Hippie Movement." The ANNALS of the American Academy of Political and Social Science 382, no. 1 (1969): 43–55.

Howe, Susanna. Sick: A Cultural History of Snowboarding. New York: St. Martin's Griffin, 1998.

Hsu, Hua. "The Brooklyn Street Crews That Boosted Ralph Lauren and Invented Their Own Style." New Yorker. July 8, 2016. Accessed July 20, 2016. http://www.newyorker.com/culture/photo-booth/the-brooklyn-street-crews-who-boosted-ralph-lauren-and-invented-their-own-style.

Ice-T, and Douglas Century. Ice: A Memoir of Gangster Life and Redemption—from South Central to Hollywood. New York: One World/Ballantine Books, 2011.

Inggs, Alice, and Karl Kemp. "Exploring the Demise of Skhothane, the Controversial Subculture Destroyed by the Media." Vice. January 5, 2016. Retrieved November 6, 2016. http://www.vice.com/read/skhothane-south-africa-karl-kemp-992.

"In Pictures: Renegades—the Heavy Metal Sub-culture of Botswana." BBC News. February 20, 2013. Accessed July 15, 2016. http://www.bbc.com/news/in-pictures-21509571.

Ishizu, Shosuke, Toshiyuki Kurosu, Hajime Hasegawa, and Teruyoshi Hayashida. Take Ivy. New York: PowerHouse Books, 2010.

Izan, Carlos. "Aspects of the Downhill Slide." SkateBoarder Magazine 2, no. 2 (Fall 1975).

J., Violent, and Hobey Echlin. ICP: Behind the Paint. Royal Oak, MI: Psychopathic Records, 2003.

Jackson, John A. American Bandstand: Dick Clark and the Making of a Rock 'n' Roll Empire. New York: Oxford University Press, 1997.

Jackson, Julian. France: The Dark Years, 1940–1944. Oxford: Oxford University Press, 2001.

Janson, Carl-Gunnar. "Juvenile Delinquency in Sweden." Youth & Society 2, no. 2 (December 1970): 207–31.

Jarnow, Jesse. "Acid Tests Turn 50: Wavy Gravy, Merry Prankster Ken Babbs Look Back." Rolling Stone. November 30, 2015. Accessed July 22, 2016. http://www.rollingstone.com/music/news/acid-tests-turn-50-wavy-gravy-merry-prankster-ken-babbs-look-back-20151130#ixzz4DIJ6HCPU.

"Jeff Noon on The Modernists." BBC. May 2003. Accessed July 15, 2016. http://www.bbc.co.uk/southyorkshire/stage/2003/05/mods/index.shtml.

Jenks, Chris. Subculture: The Fragmentation of the Social. London: Sage Publications, 2005.

Jesse. "Never Run Alone: A Conversation with Run Dem Crew and NYC Bridge Runners." Freshness Mag. December 11, 2012. Accessed July 17, 2016. http://www.freshnessmag.com/2012/12/11/never-run-alone-a-conversation-with-run-dem-crew-and-nyc-bridge-runners/.

Johnson, David. "Spandau Ballet, the Blitz Kids and the Birth of the New Romantics." The Guardian. October 03, 2009. Accessed July 12, 2016. https://www.theguardian.com/music/2009/oct/04/spandau-ballet-new-romantics.

Jones, Daisy. "The Black Punk Pioneers Who Made Music History." Dazed. November 19, 2015. Accessed July 15, 2016. http://www.dazeddigital.com/music/article/28419/1/the-black-punk-pioneers-who-made-music-history.

Jones, Steven T. The Tribes of Burning Man: How an Experimental City in the Desert Is Shaping the New American Counterculture. San Francisco, CA: Consortium of Collective Consciousness, 2011.

Jordan, M. F. "How Jazz Got Francisé: A Case Study in the Ongoing Construction of Cultural Identity." French Cultural Studies 13, no. 38 (2002): 187–208.

Jorgensen, Kaja E. "Sapologie: Performing Postcolonial Identity in the Democratic Republic of Congo." Contemporary Art, Design and New Media Histories, May 2014.

Josephs, Brian. "Is Afropunk Fest No Longer Punk?" Vice. August 17, 2015. Accessed July 18, 2016. http://www.vice.com/read/is-the-afropunk-festival-no-longer-punk-813.

Jovananovic, Rozalia. "A Brief Visual History of Riot Grrrl Zines." Flavorwire. November 8, 2010. Accessed July 11, 2016. http://flavorwire.com/128822/a-brief-visual-history-of-riot-grrrl-zines.

Kahn-Egan, Chrys. "Degeneration X: The Artifacts and Lexicon of the Rave Subculture." Studies in Popular Culture 20, no. 3 (April 1998): 33–44.

Kameir, Rawiya. "The True Story of How Afropunk Turned a Message Board into a Movement." The FADER. August 21, 2015. Accessed July 28, 2016. http://www.thefader.com/2015/08/21/james-spooner-afropunk.

Kaplan, Ilana. "The DJ and Nightlife Arbiter Venus X Shares Her Inspirations." T: The New York Times Style Magazine. April 29, 2015. Accessed July 27, 2016. http://tmagazine.blogs.nytimes.com/2015/04/30/dj-venus-x-inspirations/.

Kaplan, Josh. "What Real Roadmen Think of Your New Grime Obsession." The Tab. December 15, 2015. Accessed July 15, 2016. http://thetab.com/2015/12/15/what-real-roadmen-think-of-your-new-grime-obsession-65894.

Kawamura, Yuniya. Fashioning Japanese Subcultures. Oxford: Berg Publishers, 2012.

Kegan, Yrjänä. Subgenres of the Beast: A Heavy Metal Guide. Saltaire, UK: AMF Publishing, 2015.

Kelley, Mike. "Cross Gender/Cross Genre." PAJ: A Journal of Performance and Art 22, no. 1 (2000): 1.

Kerouac, Jack. On the Road. New York: New American Library, 1958.

Kersten, Joachim. "Street Youths, Bosozoku, and Yakuza: Subculture Formation and Societal Reactions in Japan." Crime & Delinquency 39, no. 3 (July 1, 1993): 277–95.

Kilgannon, Corey. "Bicycles That Carry Powerful Beats, and Even a Rider or Two." The New York Times. November 29, 2007. http://www.nytimes.com/2007/11/29/nyregion/29bikes.html.

———. "3 Days of Peace and Music, 40 Years Later." The New York Times. March 18, 2009. Accessed July 20, 2016. http://www.nytimes.com/2009/03/19/arts/artsspecial/19love.html?pagewanted=all.

Killip, Teofilo. "A Guide to the Fashion Subcultures of Japan." Complex. February 14, 2013. Accessed July 17, 2016. http://www.complex.com/style/2013/02/a-guide-to-japanese-fashion-subcultures/.

Kilpatrick, Nancy. The Goth Bible: A Compendium for the Darkly Inclined. New York: St. Martin's Griffin, 2004.

King, Anthony. "The Postmodernity of Football Hooliganism." The British Journal of Sociology 48, no. 4 (1997): 576.

Kinsella, Sharon. "What's Behind the Fetishism of Japanese School Uniforms?" *Fashion Theory: The Journal of Dress* 6, no. 2 (2002): 215–37.

Knight, Nick. *Skinhead*. London: Omnibus, 1982.

Knopp, W. *Kriminalität und Gefährdung der Jugend; Lagebericht bis zum Stande Vom 1. Januar 1941*. Berlin: W. Limpert, 1941.

Kondo, Annette. "Deerskin or Leather, White Bucks Still Hot." *News of Delray Beach*. August 16, 1987. Accessed October 1, 2016. https://news.google.com/newspapers?nid=1291&dat=19870816&id=sChUAAAAIBAJ&sjid=f40DAAAAIBAJ&pg=5588,3861405&hl=en.

Kozinets, Robert V. "Can Consumers Escape the Market? Emancipatory Illuminations from Burning Man." *Journal of Consumer Research* 29, no. 1 (2002): 20–38.

Kreps, Daniel. "Insane Clown Posse Win Appeal in FBI Gang Lawsuit." *Rolling Stone*. September 18, 2015. Accessed July 21, 2016. http://www.rollingstone.com/music/news/insane-clown-posse-win-appeal-in-fbi-gang-lawsuit-20150918.

Kvinta, Paul. "Surfonomics 101." *Fortune*. June 4, 2013. Accessed July 15, 2016. http://fortune.com/2013/06/05/surfonomics-101/.

Laderman, Scott. *Empire in Waves: A Political History of Surfing*. Berkeley, CA: University of California Press, 2014.

Ladouceur, Liisa, and Gary Pullin. *Encyclopedia Gothica*. Toronto: ECW Press, 2011.

Lamb, Gordon. "Welcome to Oogleville." *Vice*. April 26, 2012. Accessed July 14, 2016. http://www.vice.com/read/welcome-to-oogleville.

Lanari, Massimo. "Nuovi Paninari—La Cucina Italiana." *La Cucina Italiana*. January 12, 2016. Accessed July 11, 2016. http://www.lacucinaitaliana.it/news/trend/nuovi-paninari/.

Lanham, Robert. *The Hipster Handbook*. Edited by Bret Nicely and Jeff Bechtel. New York, NY: Anchor Books, 2003.

Larsson, Milene. "Raggare Love Hot Rods and Rock 'n' Roll." *Vice*. July 21, 2013. http://www.vice.com/read/raggare-love-hot-rods-and-rock-n-roll-000926-v20n2.

Laurenson, John. "Tecktonik Tremors Jolt France." *BBC News*. March 5, 2009. Accessed July 15, 2016. http://news.bbc.co.uk/2/hi/europe/7923658.stm.

Leach, Alec. "The Complete Illustrated Guide to Kanye West's Sneaker Designs." Highsnobiety. February 11, 2015. Accessed July 23, 2016. http://www.highsnobiety.com/2015/02/11/kanye-west-sneakers-design/.

Lee, Jennifer. "The Young Lords' Legacy of Puerto Rican Activism." *City Room*. August 24, 2009. Accessed July 20, 2016. http://cityroom.blogs.nytimes.com/2009/08/24/the-young-lords-legacy-of-puerto-rican-activism/?pagemode=print.

Lee, Tommy, and Vince Neil. *The Dirt: Confessions of the World's Most Notorious Rock Band*. New York, NY: HarperCollins World, 2001.

Leland, John. *Hip: The History*. New York: Ecco, 2004.

Lenig, Stuart. *The Twisted Tale of Glam Rock*. Santa Barbara, CA: Praeger, 2010.

Leon Talley, André. "Eye." *Women's Wear Daily*. March 30, 1976, 4.

Lewis, Danny. "When Rock Was Banned in the Soviet Union, Teens Took to Bootlegged Recordings on X-Rays." *Smithsonian*. December 10, 2015. Accessed July 28, 2016. http://www.smithsonianmag.com/smart-news/soviet-hipsters-bootlegged-banned-music-bone-records-180957505/?no-ist.

Lewis, Tim. " 'The Birth of the London Club Scene': Bowie Nights at Billy's Club in Pictures." *The Guardian*. January 25, 2013. Accessed July 15, 2016. https://www.theguardian.com/music/gallery/2013/jan/25/bowie-nights-billys-club-pictures.

Lock Swarr, Amanda. "'Stabane,' Intersexuality, and Same-Sex Relationships in South Africa." *Feminist Studies* 35, No. 3, (Fall 2009): 524-548.

Lockyer, Bill. "Annual Report to the Legislature." California Department of Justice. 2003. Accessed July 1, 2016. http://ag.ca.gov/publications/org_crime.pdf.

Lomax, Alan. *Mister Jelly Roll: The Fortunes of Jelly Roll Morton, New Orleans Creole and "inventor of Jazz"* Berkeley: University of California Press, 2001.

Lowey, Ian, and Suzy Prince. *The Graphic Art of the Underground: A Countercultural History*. New York: Bloomsbury Visual Arts, 2014.

Lyons, Patrick. "A$AP Rocky Explains Hood By Air & BEEN TRILL Disses In 'Multiply.'" Hot New Hip-Hop. November 6, 2014. Accessed July 25, 2016. http://www.hotnewhiphop.com/asap-rocky-explains-hood-by-air-and-been-trill-disses-in-multiply-news.12748.html.

MacArthur, Paul J. "The Top Ten Important Moments in Snowboarding History." *Smithsonian*. February 5, 2010. Accessed July 15, 2016. http://www.smithsonianmag.com/history/the-top-ten-important-moments-in-snowboarding-history-6.

Macias, Patrick, and Izumi Evers. *Japanese Schoolgirl Inferno: Tokyo Teen Fashion Subculture Handbook*. San Francisco, CA: Chronicle Books, 2007.

Made in Queens. Directed by Nicolas Randall and Joe Stevens. New York: MTV2 Films, 2008.

Malcolm, Jean. "Nightfall at Notting Hill: A Study in Black and White." *The Phylon Quarterly* 19, no. 4 (1958): 364.

Malik, Kenan. "All Mouth and Trousers—the Rise of Joe Bloggs." *The Independent*. June 18, 1994. Accessed July 17, 2016. http://www.independent.co.uk/news/uk/home-news/all-mouth-and-trousers-the-rise-of-joe-bloggs-1423650.html.

"Manners & Morals: The Drapes." *Time*. January 30, 1950. Accessed October 1, 2016. http://content.time.com/time/magazine/article/0,9171,856482,00.html.

Manning, Emily. "Documenting 30 Years of the Lo Lifes, Brooklyn's Ralph Lauren Obsessed Crew" *i-D*. July 6, 2016. Accessed July 15, 2016. https://i-d.vice.com/en_us/article/documenting-30-years-of-the-lo-lifes-brooklyns-ralph-lauren-obsessed-crew.

Mansell, Don, and Joseph S. Hall. "Hot Rod Terms in the Pasadena Area." *American Speech* 29, no. 2 (May, 1954): 89–104.

Mansnerus, Laura. "Timothy Leary, Pied Piper of Psychedelic 60's, Dies at 75." *The New York Times*. June 31, 1996. Accessed July 28, 2016. http://www.nytimes.com/1996/06/01/us/timothy-leary-pied-piper-of-psychedelic-60-s-dies-at-75.html?pagewanted=all.

Marcus, Daniel. *Happy Days and Wonder Years: The Fifties and the Sixties in Contemporary Cultural Politics*. New Brunswick, NJ: Rutgers University Press, 2004.

Marcus, Mr. "Traditions in Leather Continue." *Bay Area Reporter*. February 15, 2007. Accessed October 1, 2016. http://ebar.com/arts/art_article.php?sec=mrm&article=90.

Markman, Rob. "Cali Swag District Rapper M-Bone Killed in Drive-By Shooting." *MTV*. May 16, 2011. Accessed July 15, 2016. http://www.mtv.com/news/1663922/cali-swag-district-m-bone-shooting-death/.

Marks, Craig, and Rob Tannenbaum. *I Want My MTV: The Uncensored Story of the Music Video Revolution*. New York, NY: Dutton, 2011.

Marsh, Graham, and J. P. Gaul. *Ivy Look: Classic American Clothing: An Illustrated Pocket Guide*. Edited by Stuart Hall and Tony Jefferson. London: Frances Lincoln, 2010.

Marshall, Frank. "Botswana's Cowboy Metalheads." *Vice*. April 1, 2011. Accessed July 19, 2016. http://www.vice.com/read/atlas-hoods-botswanas-cowboy-metal-heads.

Marshall, George. *Skinhead Nation*. Dunoon, UK: S.T. Pub., 1996.

Marshall, Wayne. "Giving up Hip-Hop's Firstborn: A Quest for the Real after the Death of Sampling." *Callaloo* 29, no. 3 (2006): 868–92.

———. "Dem Bow, Dembow, Dembo: Translation and Transnation in Reggaeton." *Song and Popular Culture*, 2008, 131–51.

Martin, Clive. "Cutesters: The Horrific New Trend That's Consuming London." *Vice*. December 22, 2014. Accessed July 28, 2016. http://www.vice.com/read/cutesters-and-london.

Martin, Douglas. "Pepper LaBeija, Queen of Harlem Drag Balls, Is Dead at 53." *The New York Times*. May 26, 2003. Accessed July 15, 2016. http://www.nytimes.com/2003/05/26/arts/pepper-labeija-queen-of-harlem-drag-balls-is-dead-at-53.html.

Martin, Michel. "Bones and Grooves: The Weird Secret History of Soviet X-Ray Music." *NPR*. January 9, 2016. Accessed July 10, 2016. http://www.npr.org/2016/01/09/462289635/bones-and-grooves-weird-secret-history-of-soviet-x-ray-music

Martin, Phyllis. *Leisure and Society in Colonial Brazzaville*. Cambridge, MA: Cambridge University Press, 1995.

Martins, Chris. "Kanye West Leaves Nike for Adidas and a Reported $10 Million." *Spin*. December 3, 2013. Accessed July 24, 2016. http://www.spin.com/2013/12/kanye-west-adidas-deal-10-million-nike-air-yeezy/.

Marx, W. David. *Ametora: How Japan Saved American Style*. New York, NY: Basic Books, 2015.

———. "The Miyuki-Zoku: Japan's First Ivy Rebels." *Ivy Style*. November 24, 2009. Accessed July 15, 2016. http://www.ivy-style.com/the-miyuki-zoku-japans-first-ivy-rebels.html.

———. "The Man Who Brought Ivy to Japan." *Ivy Style*. August 30, 2010. Accessed July 15, 2016. http://www.ivy-style.com/the-man-who-brought-ivy-to-japan.html.

Mattern, Joanne. *Famous Fashion Designers: Ralph Lauren*. Infobase Learning, 2013.

Matthews, Kevin, Ii Joseph H. Hancock, and Zhaohui Gu. "Rebranding American Men's Heritage Fashions through the Use of Visual Merchandising, Symbolic Props and Masculine Iconic Memes Historically Found in Popular Culture." *Critical Studies in Men's Fashion* 1, no. 1 (2014): 39–58.

Matthews, Sam, Gianclaudio Angelini, and Paul Ewen. "Bosozoku Girls of Japan." *Vocativ*. December 2, 2013. Accessed July 15, 2016. http://www.vocativ.com/37410/bosozoku-girls-japan/.

Mattioli, Heath, and David Spacone. *Disco's out... Murder's In!: The True Story of Frank the Shank and L.A.'s Deadliest Punk Rock Gang*. Port Townsend, WA: Feral House, 2015.

Mayard, Judnick. "Interview: Venus X of GHE20G0TH1K Is Bigger than Nightlife." *Complex*. April 23, 2015. Accessed August 5, 2016. http://www.complex.com/music/2015/04/venus-x-rbma-interview.

McDonnell, John. "The New York Gang That Only Wears Ralph Lauren." *The Guardian*. July 27, 2011. Accessed July 28, 2016. https://www.theguardian.com/lifeand-style/2011/jul/27/new-york-gangs-ralph-lauren.

McKay, George. *Senseless Acts of Beauty Cultures of Resistance since the Sixties*. London: Verso, 1996.

McNally, Dennis. *The History of the Grateful Dead*. New York, NY: Random House, 2007.

McNeil, Legs, and Gillian McCain. *Please Kill Me: The Uncensored Oral History of Punk*. New York: Grove Press, 1996.

Melendez, Miguel. *We Took the Streets: Fighting for Latino Rights with the Young Lords.* New York, NY: St. Martin's Press, 2003.

Meriwether, Nicholas. "Documenting the Dead: Taping the Dead." Dead.net. September 15, 2015. Accessed July 15, 2016. http://www.dead.net/features/document-ing-dead/documenting-dead-taping-dead.

Michel, Benjamin. "Video: Meet the Scraper Bike Team of East Oakland." KQED Arts. March 30, 2016. Accessed August 2, 2016. http://ww2.kqed.org/arts/2016/03/30/video-meet-east-oaklands-scraper-bike-team/.

Middleton, Britt. "This Day in Black History: Oct. 15, 1966." *BET.* October 15, 2014. Accessed July 15, 2016. http://www.bet.com/news/national/2012/10/15/this-day-in-black-history-oct-15-1966.html.

Miller, Steve. *Juggalo: The Insane Clown Posse and the World They Made.* Cambridge, MA: Da Capo Press, 2016.

Mitsui, Tôru. *Made in Japan: Studies in Popular Music.* New York / Abingdon: Routledge, 2015.

Moorhouse, H. F. "Football Hooliganism and the Modern World." *International Review of Modern Sociology* 32, no. 2 (Autumn 2006): 257–75.

Moran, J. "Juke Box Britain: Americanisation and Youth Culture, 1945–60. By Adrian Horn." *Twentieth Century British History* 20, no. 4 (2009): 561–63.

Morikawa, Kaichirô. おたく/*Otaku/Geek.* Berkeley, CA: Center for Japanese Studies, University of California, Berkeley, 2012.

"Mothers Complain That Modern Girls 'Vamp' Their Sons at Petting Parties." *The New York Times.* February 17, 1922. Accessed July 27, 2016. http://query.nytimes.com/mem/archive-free/pdf?res=9F01EFD91E30EE3ABC4F52DFB4668389639E-DE.

Mowbray, Nicole. "Japanese Girls Choose Whiter Shade of Pale." *The Guardian.* April 3, 2004. https://www.theguardian.com/world/2004/apr/04/japan.nicolemowbray.

Moynihan, Michael, and Didrik Søderlind. *Lords of Chaos: The Bloody Rise of the Satanic Metal Underground.* Los Angeles, CA: Feral House, 2003.

Muggleton, David. *Inside Subculture: The Postmodern Meaning of Style.* Oxford: Berg, 2000.

Muggleton, David, and Rupert Weinzierl. *The Post-Subcultures Reader.* Oxford: Berg, 2003.

Mullaney, Jamie L. "'Unity Admirable but Not Necessarily Heeded': Going Rates and Gender Boundaries in the Straight Edge Hardcore Music Scene." *Gender & Society* 21, no. 3 (2007): 384–408.

Muller, Marissa G. "Michael Musto on the Prevailing Influence of Club Kid Fashion." The FADER. May 2, 2014. Accessed July 22, 2016. http://www.thefader.com/2014/05/02/michael-musto-on-the-prevailing-influence-of-club-kid-fashion.

Murphy, Tim. "Peter Gatien, Club King Without a Club." *The New York Times.* September 21, 2011. Accessed July 19, 2016. http://www.nytimes.com/2011/09/22/fashion/peter-gatien-the-fallen-king-of-night-life.html.

Musto, Michael. "Remembering The Early Days of the Michael Alig Crime Coverage." *Village Voice.* May 17, 2013. Accessed July 17, 2016. http://www.villagevoice.com/blogs/remembering-the-early-days-of-the-michael-alig-crime-coverage-6377470.

Nathan, Lotfy. "*Riding with the 12 O'Clock Boys.*" *The New York Times.* December 2, 2013. Accessed July 15, 2016. http://www.nytimes.com/2013/12/03/opinion/riding-with-the-12-oclock-boys.html.

Naylor, Tony. "Crystal Castles: An Astonishing Debut from the Canadian Digital Noiseniks." *NME.* May 2, 2008. Accessed July 28, 2016. http://www.nme.com/reviews/crystal-castles/9659.

Negrón-Muntaner, Frances. "The Look of Sovereignty: Style and Politics in the Young Lords." *CENTRO Journal* 27, 1 (Spring 2015): 4–33.

Nicks, Denver. "Confessions of a Lumbersexual." *Time.* November 25, 2014. Accessed July 15, 2016. http://time.com/3603216/confessions-of-a-lumbersexual/.

Nkosi, Sibongile. "Burn After Wearing: Township Kids' Hottest Fashion Statement." *Mail & Guardian.* October 28, 2011. Accessed November 6, 2016. http://mg.co.za/article/2011-10-28-burn-after-wearing-township-kids-hottest-fashion-statement.

Nowell, David. *Too Darn Soulful: The Story of Northern Soul.* London: Robson Book, 2001.

O'Brien, Glenn. "Style Makes the Band." *Art Forum,* October 1999.

O'Dell, Tom. "'Chevrolet... That's a Real Raggarbil!': The American Car and the Production of Swedish Identities." *Journal of Folklore Research* 30, no. 1 (Spring 1993): 61–73.

Ogunnaike, Lola. "Willi Ninja, 45, Self-Created Star Who Made Vogueing into an Art, Dies." *The New York Times.* September 05, 2006. Accessed July 20, 2016. http://www.nytimes.com/2006/09/06/arts/dance/06ninja.html?_r=0.

Oi, Mariko. "Japan Harnesses Fashion Power of Gals." BBC News. August 30, 2012. http://www.bbc.com/news/world-asia-19332694.

Oke, Tobi. "Why Is Drake Using So Much UK Slang?" *Complex UK.* October 8, 2014. Accessed July 11, 2016. http://uk.complex.com/music/2014/10/drake-london-road-man.

Okubo, Miki. "Harajuku – District for Anti-Fashion." Semiotix Design Style and Fashion. Accessed July 8, 2016. http://fashion.semiotix.org/2014/02/harajuku-district-for-anti-fashion/.

Oldham, Andrew Loog, and Nikola Acin. *Rolling Stoned.* Paris: Flammarion, 2006.

Olvera Gugiño, José Juan. *La Colombia de Monterrey: Descripción de Algunos Elementos de la Cultura Colombiana en la Frontera Norte.* Monterrey, Mexico: Centro Cultural Guadalupe, 1996

O'Neil, Luke. "What Does Normcore Sound Like?" Dazed. August 28, 2014. Accessed July 17, 2016. http://www.dazeddigital.com/music/article/19061/1/the-music-of-normcore.

O'Neill, Natalie. "The Bearded-hipster Trend Has Truly and Utterly Taken over New York." *New York Post.* April 12, 2016. Accessed July 27, 2016. http://nypost.com/2016/04/12/the-bearded-hipster-trend-has-truly-and-utterly-taken-over-new-york/.

Ortiz, Erik. "Insane Clown Posse Lawsuit Against FBI for 'Gang' Designation Wins Appeal." *NBC News.* September 18, 2015. Accessed July 15, 2016. http://www.nbcnews.com/pop-culture/music/insane-clown-posse-lawsuit-against-fbi-gang-designation-wins-appeal-n429801.

Osborne, Ben. *The A–Z of Club Culture: Twenty Years of Losing It.* London: Sceptre, 1999.

The Other One: The Long, Strange Trip of Bob Weir. Directed by Mike Fleiss. Midway, UT: Next Entertainment/Netflix, 2014.

O'Toole, Fintan, and Perry Ogden. "Pony Kids: Urban Cowboys." *The Independent.* February 5, 1999. Accessed August 22, 2016. http://www.independent.co.uk/life-style/pony-kids-urban-cowboys-1069074.html.

Page, Thomas. "How Buffalo Bill Became a Hero in Congo." *CNN.* December 8, 2015. Accessed July 1, 2016. http://www.cnn.com/2015/12/08/africa/kinshasa-cowboys-bills/.

Pamyu, Kyary Pamyu. "Kyary Pamyu Pamyu's Playlist: Ylvis, Michael Jackson, Marilyn Manson." *The Guardian.* May 27, 2016. Accessed July 28, 2016. https://www.theguardian.com/music/2016/may/27/kyary-pamyu-pamyus-playlist-yl-vis-michael-jackson-marilyn-manson.

Pappalardo, Anthony. "John Porcelly and the Origins of 'Youth Crew.'" Green Room Radio. March 28, 2016. Accessed July 15, 2016. http://greenroom-radio.com/2016/03/28/john-porcelly-on-the-origins-of-youth-crew/.

Pappalardo, Anthony, and Max G. Morton. *Live... Suburbia.* Brooklyn, NY: PowerHouse Books, 2011.

Paris Is Burning. Directed by Jennie Livingston. New York: White Productions, Inc., 1990.

Patterson, Dayal. *Black Metal: Evolution of the Cult.* Port Townsend, WA: Feral House, 2014.

Peiss, Kathy. *Zoot Suit: The Enigmatic Career of an Extreme Style.* Philadelphia, PA: University of Pennsylvania Press, 2011.

Perlmutter, Dawn. "The Sacrificial Aesthetic: Blood Rituals from Art to Murder." *Antipoetics* 5, no. 2 (Fall 1999).

Perone, James E. *Mods, Rockers, and the Music of the British Invasion.* Westport, CT: Praeger Publishers, 2009.

Petras, Elizabeth McLean. *Jamaican Labor Migration: White Capital and Black Labor, 1850– 1930.* Boulder, CO: Westview Press, 1988.

Petridis, Alexis. "Youth Subcultures: What Are They Now?" *The Guardian.* March 20, 2014. Accessed July 15, 2016. http://www.theguardian.com/culture/2014/mar/20/youth-subcultures-where-have-they-gone.

Petrus, Stephen. "Rumblings of Discontent: American Popular Culture and Its Response to the Beat Generation, 1957–1960." *Studies in Popular Culture* 20, no. 1 (October 1997): 1– 17.

Phro, Preston. "A Brief History of Japanese Rockabilly: Not Just for Your Grandparents." *Japan Today.* July 10, 2014. Accessed July 20, 2016. http://www.japantoday.com/category/arts-culture/view/a-brief-history-of-japanese-rockabilly-not-just-for-your-grandparents.

Pichevin, Aymeric. "Furious Electro-dance Style Sweeps France." Reuters. March 29, 2008. Accessed July 15, 2016. http://www.reuters.com/article/music-tecktonik-dc-idUSN2943062220080329.

Popoff, Martin. *The Big Book of Hair Metal: The Illustrated Oral History of Heavy Metal's Debauched Decade.* London: Voyageur Press, 2014.

Postol, Todd. "Reinterpreting the Fifties: Changing Views of a 'Dull' Decade." *The Journal of American Culture* 8, no. 2 (1985): 39– 46.

Potocki, Rodger P., Jr. "The Life and Times of Poland's 'Bikini Boys'" *The Polish Review* 39, no. 3 (1994): 259– 90. University of Illinois Press on Behalf of the Polish Institute of Arts & Sciences of America.

Poveda, David. "Literacy Artifacts and the Semiotic Landscape of a Spanish Secondary School." *Reading Research Quarterly* 47, no. 1 (January/February 2012): 61–88.

Punk: Attitude. Directed by Don Letts. London: Freemantle Home Entertainment, 2005.

The Punk Singer. Directed by Sini Anderson. New York: Opening Band Films, 2013.

Q, Mike. "NOLA Vogue: MikeQ's Top 10 Vogue Anthems of All Time." *Okayplayer.* February 30, 2014. Accessed August 12, 2016. http://www.okayplayer.com/news/vogue-mikeqs-top-10-vogue-anthems-mp3.html/2.

Radoz. "Transcending NormCore with Health Goth." AMDISCS Futures Reserve Label. April 7, 2014. Accessed July 19, 2016. http://amdiscs.com/normcore-health-goth/.

Radulova, Lillian. "Tattoos and Talons: Inside the World of Japan's Bosozoku Gang Girls Where the Women Are Just as Bad as the Men." Daily Mail. April 2, 2014. Accessed July 30, 2016. http://www.dailymail.co.uk/femail/article-2594830/Japanese-Bosozoku-bikie-gang-girls-bad-ass-feminine.html.

Reilly, Morgan. "Living Dolls or Just Living?" Huffington Post. January 14, 2014. Accessed July 27, 2016. http://www.huffingtonpost.co.uk/morgan-reilly/living-dolls-or-just-livi_b_4588983.html.

Renshaw, David. "Skepta Confirms Drake Has Signed with His BBK Label." NME. May 9, 2016. Accessed July 13, 2016. http://www.nme.com/news/skepta/93453.

Rex, Richard. "The Origin of Beatnik." American Speech 50, no. 3/4 (1975): 329.

Reynolds, Simon. Generation Ecstasy: Into the World of Techno and Rave Culture. Boston, MA: Little Brown &, 1998.

———. Retromania: Pop Culture's Addiction to Its Own past. London: Faber & Faber, 2011.

Richardson, Whitney. "South Africa's Pantsula Dancers Bring Life to the Streets." The New York Times. January 27, 2016. Accessed November 6, 2016. http://lens.blogs.nytimes.com/2016/01/27/south-africa-pantsula-break-dancing-townships-chris-saunders/?_r=0.

Richie, Donald. Viewed Sideways: Writings on Culture and Style in Contemporary Japan. Berkeley, CA: Stone Bridge Press, 2011.

Rimmer, Dave. The Look: New Romantics. London: Omnibus Press, 2003.

Rivadavia, Eduardo. "The History of the New Wave of British Heavy Metal." Ultimate Classic Rock. May 8, 2015. Accessed July 20, 2016. http://ultimateclassicrock.com/new-wave-of-british-heavy-metal/.

Rivera, Raquel Z. New York Ricans from the Hip Hop Zone. New York: Palgrave Macmillan, 2003.

Rivera, Raquel Z., Wayne Marshall, and Deborah Pacini Hernandez. Reggaeton. Durham, NC: Duke University Press, 2009.

Roberts, Sam. "Shifts in 80's Failed to Ease Segregation." The New York Times. July 14, 1992. Accessed July 29, 2016. http://www.nytimes.com/1992/07/15/nyregion/shifts-in-80-s-failed-to-ease-segregation.html.

Robinson, Eleanor M. "Hot Rod Magazines: A Harmless Diversion?" The English Journal 54, no. 1 (January 1965): 36–38.

Rodriguez, Olga R. "Mexico Town's Bizarre Pointy Boots Creating a Craze." Salt Lake Tribune. May 16, 2011. Accessed July 20, 2016. http://archive.sltrib.com/story.php?ref=/sltrib/world/51817592-68/boots-pointy-dance-added.html.csp.

Rodriguez Castro, Laura. "Photographing the Horse Riding Nike Wearing Tough Kids of Dublin." Vice. July 09, 2014. Accessed July 20, 2016. http://www.vice.com/read/dublins-teenage-horse-thugs.

Roediger, David R. Working toward Whiteness: How America's Immigrants Became White: The Strange Journey from Ellis Island to the Suburbs. New York: Basic Books, 2005.

Rose, Mikelah. "Style & Vibes: A Look Back at Dancehall Fashion, Pt. 1: The 1970s." Large Up. August 19, 2011. Accessed July 27, 2016. http://www.largeup.com/2011/08/19/style-vibes-a-look-back-at-dancehall-fashion-pt-1-the-1970s/.

———. "Style & Vibes: A Look Back at Dancehall Fashion, Pt. 2: The 1980s." Large Up. August 26, 2011. Accessed July 27, 2016. http://www.largeup.com/2011/08/26/style-vibes-a-look-back-at-dancehall-fashion_pt_2-the-1980s/.

———. "Style & Vibes: A Look Back at Dancehall Fashion, Pt. 3: The 1990s." Large Up. September 9, 2011. Accessed July 27, 2016. http://www.largeup.com/2011/09/09/style-vibes-a-look-back-at-dancehall-fashion-pt-3-the-90s/.

Rosenberg, Noah. "'Stereo Bikes' Rock South Queens." QNS. September 24, 2008. Accessed July 27, 2016. http://qns.com/story/2008/09/24/stereo-bikes-rock-south-queens-3/.

Rubble Kings. Directed by Shan Nicholson. New York: Saboteur Media, 2015.

Rubin, Gayle. "The Valley of the Kings: Leathermen in San Francisco, 1960–1990." Ph.D. dissertation, University of Michigan, 1994.

Rubin, Martin. "'Make Love Make War': Cultural Confusion and the Biker Film Cycle." Film History 6, no. 3 (Autumn 1994): 355–81.

Salesky, Bernard L. "The Fashion-Conscious American Male." Challenge 11, no. 1 (1962): 29–32.

Samaha, Albert. "NYPD Shuts Down Foamposite Sneaker Release Because of Big Crowd." Village Voice. April 3, 2014. Accessed July 22, 2016. http://www.villagevoice.com/news/nypd-shuts-down-foamposite-sneaker-release-because-of-big-crowd-6664850.

Samuel, Gerry. "Shifts in Pantsula in a Performance Context in KawZulu-Natal: a Case Study of Pearl Ndaba's Golden Dancers Between 1998-2001." In Footsteps Across the Landscape of Dance in South Africa edited by Karen Arnfred Vedel and Jill Wateran, 53–58. Shuttle 02—a Cultural Exchange Project between Denmark and South Africa. Salisbury: Armstrong & Associates, 2001.

Sanchez, Karizza. "Clothes Get Weirder: What Is Street Goth?" Complex. January 10, 2013. Accessed August 27, 2016. http://www.complex.com/style/2013/01/what-is-street-goth/.

Sandberg, Patrik. "Living Doll: Valeria Lukyanova." V Magazine. November 8, 2012. Accessed August 11, 2016. http://vmagazine.com/article/living-doll/.

Sanneh, Kelefa. "Harlem Chic." The New Yorker. March 18, 2013. Accessed August 9, 2016. http://www.newyorker.com/magazine/2013/03/25/harlem-chic.

Satō, Ikuya. Kamikaze Biker: Parody and Anomy in Affluent Japan. Chicago: University of Chicago Press, 1991.

Satowoct, Julie. "Miles, Then Margaritas: For New York Running Crews, Exercise Mixes with Partying." The New York Times. October 18, 2013. Accessed August 28, 2016. http://www.nytimes.com/2013/10/20/nyregion/for-new-york-running-crews-exercise-mixes-with-partying.html.

Savage, Jon. England's Dreaming: Anarchy, Sex Pistols, Punk, and Beyond. London: Faber and Faber, 1991.

———. Teenage: The Creation of Youth Culture. New York: Viking, 2007.

Saxon, Kurt. Wheels of Rage. London: New English Library, 1974.

Schaefer, Brian. "Vogueing Is Still Burning Up the Dance Floor in New York." The New York Times. July 21, 2015. Accessed July 27, 2016. http://www.nytimes.com/interactive/2015/07/22/arts/dance/20150726-vogue.html.

Schmidt, Robert A., and Barbara L. Voss. Archaeologies of Sexuality. London: Routledge, 2000.

Schrum, Kelly. Some Wore Bobby Sox: The Emergence of Teenage Girls' Culture, 1920–1945. New York: Palgrave McMillan: 2004.

Schwartz, G., P. Turner, and E. Peluso. "Neither Heads nor Freaks: Working Class Drug Subculture." Journal of Contemporary Ethnography 2, no. 3 (1973): 288–313.

Scott, Michael. "Chicago Gang Study" December 26, 2013. Accessed July 27, 2016. http://www.stonegreasers.com/.

Scott, Mike. Great American Youth: A True Saga. Bloomington, IN: Authorhouse, 2011.

Secrets of the Living Dolls. Directed by Nick Sweeney. London: Channel 4 Television Corporation, 2014.

Seeger, Pete, and Peter Blood. Where Have All the Flowers Gone: A Singer's Stories, Songs, Seeds, Robberies. Bethlehem, PA: Sing Out, 1993.

Sendejas, Jesse, Jr. "Top 10 Bands for Oogles, Gutterpunks and 'Travel Kids'" Houston Press. September 11, 2013. Accessed July 27, 2016. http://www.houstonpress.com/music/top-10-bands-for-oogles-gutterpunks-and-travel-kids-6775420.

Sfetcu, Nicolae. Dance Music. Raleigh, NC: Lulu, 2014.

Shapira, J.A. "The Ivy Style Primer." Gentleman's Gazette. July 27, 2015. Accessed October 1, 2016. https://www.gentlemansgazette.com/ivy-style-primer/.

Shattuck, Colin. Scooters: Red Eyes, Whitewalls and Blue Smoke. Denver, CO: Speck, 2005.

Shenk, David, and Steve Silberman. Skeleton Key: A Dictionary for Deadheads. Monroe, WA: Main Street Books, 1994.

Sherman, George. "Soviet Youth: Myth and Reality." Daedalus 91, no. 1 (Winter 1962): 216–37. Published by The MIT Press on Behalf of American Academy of Arts & Sciences.

Shoji, Kaori. "Our Yankii Are Different from Your Yankees." Japan Times. July 5, 2002. Accessed August 10, 2016. http://www.japantimes.co.jp/life/2002/07/05/language/our-yankii-are-different-from-your-yankees/#.V4F3wpMrLos.

Sidell, Misty White. "GHE20G0TH1K Party Initiates New Fashion Trend." Daily Beast. April 11, 2013. Accessed July 28, 2016. http://www.thedailybeast.com/articles/2013/04/11/ghe20-g0th1k-party-initiates-new-fashion-trend.html.

Sikorski, David. "The Man Behind the Music of Burning Man." Spin. September 16, 2015. Accessed August 28, 2016. http://www.spin.com/2015/09/syd-gris-burning-man-interview/.

Silcott, Mireille. Rave America: New School Dancescapes. Toronto: ECW Press, 1999.

Sims, John. Scootermania: A Celebration of Style and Speed. London: Conway, 2015.

Sisario, Ben. "A Brief, Noisy Moment That Still Reverberates." The New York Times. June 11, 2008. Accessed August 28, 2016. http://www.nytimes.com/2008/06/12/books/12nowa.html?_r=0.

Spacey, John. "The 12 Types of Japanese Otaku." Japan Talk. June 15, 2009. Accessed August 28, 2016. http://www.japan-talk.com/jt/new/12-types-of-otaku.

Spinks, Rosie J. "Soweto Style." Slate. July 2014. Accessed November 6, 2016. http://www.slate.com/articles/news_and_politics/roads/2014/07/soweto_s_skhothanes_inside_the_south_african_township_s_ostentatious_youth.html.

Spivack, Emily. "Where'd You Get Those Creepers?" Smithsonian. May 16, 2013. Accessed July 29, 2016. http://www.smithsonianmag.com/arts-culture/whered-you-get-those-creepers-63707339/?no-ist.

St. James, James. Party Monster: A Fabulous but True Tale of Murder in Clubland. New York: Simon & Schuster, 2003.

Stearns, Marshall Winslow, and Jean Stearns. Jazz Dance: The Story of American Vernacular Dance. New York: Macmillan, 1968.

Steele, Valerie. Fifty Years of Fashion: New Look to Now. New Haven: Yale University Press, 1997.

Stepenoff, Bonnie. The Dead End Kids of St. Louis: Homeless Boys and the People Who Tried to Save Them. Columbia, MO: University of Missouri Press, 2010.

Stewart, Gary. Rumba on the River: A History of the Popular Music of the Two Congos. London: Verso, 2000.

Stibal, Mary E. "Disco: Birth of a New Marketing System." Journal of Marketing 41, no. 4 (1977):

Stimpson, Catharine R. "The Beat Generation and the Trials of Homosexual Liberation." Salmagundi 58/59 (Winter 1983): 373–92.

Stolzoff, Norman C. *Wake the Town and Tell the People: Dancehall Culture in Jamaica.* Durham, NC: Duke University Press, 2001.

Street, Joe. "The Historiography of the Black Panther Party." *Journal of American Studies* 44, no. 2 (May 24, 2009): 351–75.

Strong, Catherine. *Grunge: Music and Memory.* Farnham, Surrey, UK: Ashgate, 2011.

Stuart, Forrest, as told to Elly Fishman. "Dispatches from the Rap Wars." *Chicago.* September 19, 2016. Accessed October 1, 2016. http://www.chicagomag.com/Chicago-Magazine/October-2016/Chicago-Gangs/.

Sullivan, John. "2 Men Plead Guilty in Killing of Club Denizen." *The New York Times.* September 10, 1997. Accessed July 29, 2016. http://www.nytimes.com/1997/09/11/nyregion/2-men-plead-guilty-in-killing-of-club-denizen.html.

Suzuki, Tadashi, and Joel Best. "The Emergence of Trendsetters for Fashions and Fads: Kogaru in 1990s Japan." *Sociological Quarterly* 44, no. 1 (2003): 61–79.

Syckle, Katie Van. "A$AP Rocky Expands on His Hood by Air Beef." The Cut. November 6, 2014. Accessed July 29, 2016. http://nymag.com/thecut/2014/11/aap-rocky-expands-on-his-hood-by-air-beef.html.

Takamura, Zeshū. *Roots of Street Style.* Tokyo: Graphic-Sha, 1997.

Tamony, Peter. "Beat Generation: Beat: Beatniks." Western Folklore 28, no. 4 (October 1969), 274–277.

———. "The Hell's Angels: Their Naming." *Western Folklore* 29, no. 3 (July 1970): 199–203.

Tang, Dennis. "Why 'Athleisure' Replaced the Urban Lumberjack." *Esquire.* June 25, 2015. Accessed July 16, 2016. http://www.esquire.com/style/mens-fashion/news/a35965/athleisure-urban-lumberjack/.

Tatum, Charles M. *Encyclopedia of Latino Culture: From Calaveras to Quinceañeras.* Cultures of the American Mosaic. Portsmouth, NH: Greenwood, 2013.

Thelin, John R. *The Cultivation of Ivy: A Saga of the College in America.* Cambridge, MA: Schenkman Pub., 1976.

Thiel-Stern, Shayla, Sharon R. Mazzarella, and Rebecca C. Hains. "'We Didn't Have Adventures Like That': The Lure of Adventure Stories and Courageous Females for Girls Growing Up in the United States During the Mid-20th Century." *Journal of Communication Inquiry* 38, no. 2 (2014): 131–48.

Thomas, Pauline W. "About Us." Fashion-era.com. Accessed August 1, 2016. http://www.fashion-era.com/about_us.htm.

Thompson, B., and C. Greek. "Mods and Rockers, Drunken Debutants, and Sozzled Students: Moral Panic or the British Silly Season?" *SAGE Open* 2, no. 3 (2012).

Thompson, Hunter S. *Hell's Angels: A Strange and Terrible Saga.* New York: Modern Library, 1999.

Thompson, Robert Farris. "The Beat Generation Writers for the Mambo Age." *Aperture* 206 (Spring 2012): 38–43.

Thompson, Stephen. "Death: A '70s Rock Trailblazer, Reborn." *NPR.* March 17, 2010. Accessed October 14, 2016. http://www.npr.org/templates/story/story.php?storyId=124710357.

Thorne, Tanis. "Legends of the Surfer Subculture: Part One." *Western Folklore* 35, no. 3 (1976): 209.

Thornton, Phil. *Casuals: Football, Fighting & Fashion: The Story of a Terrace Cult.* London: Milo Books, 2003.

Timothy Leary Papers 1910–2009. MssCol 18400. Manuscripts and Archives Division, The New York Public Library. Accessed July 10, 2016. http://archives.nypl.org/mss/18400.

Trebay, Guy. "Hip-Hop's New Steps." *The New York Times.* November 21, 2009. Accessed August 1, 2016. http://www.nytimes.com/2009/11/22/fashion/22jerking.html?_r=0.

Tutton, Mark, and Errol Barnett. "'Africa Is the Last Frontier for Metal': Botswana's Metal Heads Still Rocking." CNN. December 8, 2015. Accessed August 22, 2016. http://www.cnn.com/2014/02/13/world/africa/africa-botswana-metal-heads/.

"U.S. Will Ban 'Ecstasy,' a Hallucinogenic Drug." *The New York Times.* June 1, 1985. Accessed July 28, 2016. http://www.nytimes.com/1985/06/01/us/us-will-ban-ecstasy-a-hallucinogenic-drug.html.

Vaughan, Andrew. "Metal Muthas: How the NWOBHM Got Its Start." Gibson. September 6, 2010. Accessed September 1, 2016. http://www.gibson.com/News-Lifestyle/Features/en-us/nwobhm-0906.aspx.

Verner, Amy. "Givenchy Resort 2017 Collection." *Vogue.* June 9, 2016. Accessed October 12, 2016. http://www.vogue.com/fashion-shows/resort-2017/givenchy.

Versluis, Ari, and Ellie Uyttenbroek. *Exactitudes.* Rotterdam: 010 Publishers, 2002.

Vigil, James Diego. *Barrio Gangs: Street Life and Identity in Southern California.* Austin, TX: University of Texas Press, 1988.

Võ, Linda Trinh. "Transnational Beauty Circuits: Asian American Women, Technology, and Circle Contact Lenses." Edited by Tasha G. Oren, Shilpa Dave, and Leilani Nishime. *Global Asian American Popular Cultures,* 2016, 304–20.

Vulliamy, Ed. "Love and Haight." *The Guardian.* May 20, 2007. Accessed August 27, 2016. https://www.theguardian.com/music/2007/may/20/popandrock.features8.

Waddell, Ray. "Grateful Dead Fare Thee Well Sets Attendance Record at Chicago's Soldier Field." *Billboard.* July 4, 2015. Accessed August 28, 2016. http://www.billboard.com/articles/news/grateful-dead/6620076/grateful-dead-fare-thee-well-sets-record-attendance-at-chicagos.

Waksman, Steve. *This Ain't the Summer of Love: Conflict and Crossover in Heavy Metal and Punk.* Berkeley, CA: University of California Press, 2009.

Walker, Alastair. *The Cafe Racer Phenomenon (Those Were the Days).* Poundbury, UK: Veloce Publishing, 2009.

Walker, Karyl. "Burry Boy and Feathermop: The Violent Duo That Helped and Shamed the PNP." *Jamaica Observer News.* January 20, 2008. Accessed August 30, 2016. http://www.jamaicaobserver.com/news/131579_Burry-Boy-and-Feathermop--The-violent-duo-that-helped-and-shamed-the-PNP.

———. "'General Starkey' Lived Only One Score and Six Years." *Jamaica Observer News.* February 3, 2008. Accessed August 27, 2016. http://www.jamaicaobserver.com/news/132101_-General-Starkey--lived-only-one-score-and-six-years.

Walker, Klive. *Dubwise: Reasoning from the Reggae Underground.* Toronto: Insomniac Press, 2005.

Wall, Tim. "Out on the Floor: The Politics of Dancing on the Northern Soul Scene." *Popular Music* 25, no. 3 (2006): 431.

Wanzer-Serrano, Darrel. *The New York Young Lords and the Struggle for Liberation.* Philadelphia, PA: Temple University Press, 2015.

Warshaw, Matt. *The History of Surfing.* San Francisco, CA: Chronicle Books, 2010.

Watkins, Lee William. "Keeping It Real: Amaxhosa Iimbongi Making Mimesis Do Its Thing in the Hip-Hop and Rap Music Of The Eastern Cape." *African Music* 8, No. 4 (2010): 24–47.

Weal, John D. *The Leatherman's Protocol Handbook: A Handbook on "Old Guard" Ritual, Traditions, and Protocols.* Las Vegas, NV: Nazca Plains, 2011.

Weinstein, Deena. *Heavy Metal: The Music and Its Culture.* Boston, MA: Da Capo Press, 2000.

Weiss, Eric M. "A Reinvention of the Wheel: Annandale Teen's Idea Brought Skateboarding Back to Life." *Washington Post.* August 16, 2004. Accessed June 29, 2016. http://www.washingtonpost.com/wp-dyn/articles/A6502-2004Aug16.html.

Wiener, Jocelyn. "Teens in Oakland, Calif., Find an Outlet in 'Scraper Bikes'" *Christian Science Monitor.* December 08, 2008. Accessed August 2, 2016. http://www.csmonitor.com/The-Culture/2008/1208/teens-in-oakland-calif-find-an-outlet-in-scraper-bikes.

Wilks, Saul. "Paninaro Style: The Italian Youth Culture Born out of a Sandwich Bar." *Sabotage Times.* March 23, 2016. Accessed July 10, 2016. http://sabotagetimes.com/style/paninaro-style-the-italian-youth-culture-born-out-of-a-sandwich-bar.

Willett, Ralph. "Hot Swing and the Dissolute Life: Youth, Style and Popular Music in Europe 1939–49." *Popular Music* 8, no. 2 (1989): 157.

Willis, Susan. "Hardcore: Subculture American Style." *Critical Inquiry* 19, no. 2 (1993): 365–83.

Wilson, Rob, and Christopher Leigh Connery, ed. *The Worlding Project: Doing Cultural Studies in the Era of Globalization.* Berkeley, CA: North Atlantic Books, 2007.

Winter, Katy. "Yet ANOTHER 'Human Barbie' Emerges from Ukraine." *Daily Mail.* April 19, 2014. Accessed July 2, 2016. http://www.dailymail.co.uk/femail/article-2729023/Yet-ANOTHER-Human-Barbie-emerges-Ukraine-living-doll-just-16-claims-shes-no-surgery.html.

Wolfe, Tom. *The Kandy-Kolored Tangerine-Flake Streamline Baby.* New York: Farrar, Straus & Giroux, 1965.

———. *Mauve Gloves & Madmen, Clutter & Vine, and Other Stories, Sketches, and Essays.* New York: Farrar, Straus and Giroux, 1976.

Woods, Bret. "Industrial Music for Industrial People: The History and Development of an Underground Genre." Master's thesis. Florida State University, 2007.

Yaeger, Lynn. "Slammed Then, Celebrated Now, Marc Jacobs's Perry Ellis Grunge Show Was a Collection Before Its Time." *Vogue.* August 31, 2015. Accessed October 1, 2016. http://www.vogue.com/13293785/marc-jacobs-perry-ellis-grunge-collection-90s-fashion/.

Zuckerman, Ethan. *Digital Cosmopolitans: Why We Think the Internet Connects Us, Why It Doesn't, and How to Rewire It.* New York: W. W. Norton & Company, 2013.

ACKNOWLEDGEMENTS

This project could not have happened without
the passion and expertise of all who participated.
We are exceedingly grateful to our contributors,
families, friends, and colleagues.

Thanks to: *Larry Jackson and Apple Music,
Dr. Raquel Z. Rivera, John Hendrickson, Jason Thome,
Wendy Lee Williamson, Ty Kube, Dr. Darrel Wanzer-Serrano,
Sam Trotman, Chelsea Fairless, Michelle Martini,
Christina Mannatt, Richard Agerbeek, and Leja Kress*

Special thanks to: *Shannon Davenport,
Peter Scanavino, Jessica Glasscock, Dana Meyerson,
Merck Mercuriadis, Ryan Cunningham, Theola Borden,
James Kaliardos, and Cecilia Dean*

COOL: STYLE, SOUND, AND SUBVERSION
Greg Foley & Andrew Luecke

Contributors: *Susanne Bartsch, Ice-T, Kelis, Shepard Fairey,
A$AP Ferg, Fischerspooner, Sasha Frere-Jones, Larry Jackson,
Merck Mercuriadis, Glenn O'Brien, Marky Ramone, Nile Rodgers,
Stefan Sagmeister, Peter Saville, Michael Stipe,
Andrew W.K., and Zaldy*

Playlists and Editorial Guidance: *Paul Parreira @ Co.Cue*
Co.Cue Contributors: *Stewart Mason, Jim Allen,
Philip Mlynar, Daniel Geiselhart, Cammila Collar*
Additional Contributors: *José E. Plata, Máxime Pasquier,
Yuko Shimozato, Marc Schroeder*

Design Associate: *Jeemin Shim*
Infographic Design: *Carlos Monteiro, Eli Rosenbloom*
Illustration Associates: *Adam Blake, Rachel Derbyshire, Martin Diegor*
Image Research: *Nikki Igol, Nelson Harst*
Copy Assistants: *Sam Fortier, Alicia Bernlohr, Katie Drozynski*

For Rizzoli International Publications, Inc.:
Publisher: *Charles Miers*
Editor: *Jessica Fuller*
Production Manager: *Susan Lynch*

PLAYLISTS IN ASSOCIATION WITH

 MUSIC

First published in the United States of America in 2017 by
Rizzoli International Publications, Inc.
300 Park Avenue South
New York, NY 10010
www.rizzoliusa.com

2017 2018 2019 2020 2021 / 10 9 8 7 6 5 4 3 2 1

Printed in China

ISBN-13: 978-0-7893-3284-4
Library of Congress Control Number: 2016958882